■ The Visible Word

The

Experimental Typography and Moderr

Visible Word

Art, 1909–1923 ■ Johanna Drucker

The University of Chicago Press
Chicago & London

The University of Chicago Press, Chicago 60637
The University of Chicago Press, Ltd., London
© 1994 by The University of Chicago
All rights reserved. Published 1994
Paperback edition 1996
Printed in the United States of America
03 02 01 00 99 98 97 96 2 3 4 5

ISBN: 0–226–16501–9 (cloth)
ISBN: 0–226–16502–7 (paperback)

Library of Congress Cataloging-in-Publication Data

Drucker, Johanna, 1952–
 The visible word: Experimental typography and modern art,
 1909–1923 / Johanna Drucker.
 p. cm.
 Includes bibliographical references and index.
 1. Printing—History—20th century. 2. Art, Modern—20th century.
 3. Art and literature. 4. Avant-garde (Aesthetics)—History—20th
 century. I. Title.
 Z124.D78 1994
 686.2'09—dc20 93-39657
 CIP

■ Contents

■ Acknowledgments

Research for this project was begun under the sponsorship of a Regents' Fellowship from the University of California, at Berkeley, in 1983. A Fulbright Fellowship provided funds for study in Paris in 1984–85 and a University of California Graduate Research Grant allowed me to return in the summer of 1986, as did a Faculty Research Grant from the University of Texas at Dallas in 1987. A Mellon Faculty Fellowship to Harvard University's Department of Fine Arts in 1988–89 permitted an initial rewriting and rethinking of the dissertation. To all of these sponsoring institutions I am extremely grateful. Additional acknowledgments go first to the faculty at the Department of Architecture and program in Visual Studies at the University of California, Berkeley, especially Tony Dubovsky, Marc Treib, and Penny Dhaemers, without whose support I would never have begun, let alone finished, graduate work. Additional thanks for support and mentoring go to Jim Melchert, Hayden White, and Yakov Malkiel. Ralf Weber, Kim Dovey, Paul Groth, Ray Lifchez, Lars Lerup, Maria McVarish, and Emily McVarish all made larger contributions than they probably realize. André Markowitz, Regis Gayraud, and Hélène Zdanevich were invaluable in all areas pertaining to Zdanevich research. Olga Meerson provided final information for the captions of *zaum* work. Harvey Graff, Gwen Raaberg, Mike Montgomery, Judith Piper, and Hilary Radner offered criticism, insight and arguments, followed in this thankless task most recently by Dennis Tedlow, Charles Bernstein, Gino Lee, Alice Mansell, Sheila Butler, Amelia Jones, and Natalie Kampen.

Finally, however, my greatest dept of gratitude is to Tony Dubovsky, Julian Boyd, and, above all, Bertrand Augst for their enthusiasm and engagement at all levels—professional, intellectual, and personal. This work is dedicated to all three of them with profound respect and ongoing affection.

■

Introduction: Background, Parameters, and Terminology

The research for this book was begun in an era in which semiotics was considered a useful interpretive tool, but the writing is concluded at a moment in which semiotics itself has become the object of historical and historiographic inquiry. What began as a semiotic analysis of typography produced by artists in the 1910s has evolved into an inquiry into the transformation of semiotically based critical practices in the course of the twentieth century. The study of typographic experimentation offers an excellent case study for such an inquiry. Because of its interdisciplinary character, the treatment of typography within critical interpretation can be used to trace the transformations in the premises on which both literary and visual arts criticism conceive of their object. The place granted to typographic work within historical accounts of early modern art as well as the conceptual premises on which it is evaluated are symptomatic of the developments in criticism in the course of the twentieth century. Fundamental issues with regard to the nature and structure of both visual and verbal modes of signification are necessarily raised in analyzing typographic practice, as well as profound issues about the formation of subjectivity and history within critical analysis in the semiotic tradition.

My decision to focus on experimental typography combined an in-

tellectual interest with an autobiographical impetus. Typographic experiment, particularly the visually striking work of experimenters within Dada, Futurism, and other artistic movements of the 1910s and 1920s, offered the opportunity to move between the fields of literary and art historical studies in a manner which seemed closer to the activity of the early twentieth-century artists than the pursuit of either field on its own. Straddling the border between these realms, typographic experiment embodies the synaesthetic investigations of many early twentieth-century artists and poets. The challenge put forth by these complex aesthetic projects was to develop a critical method which was not derived exclusively from either literary criticism or visual arts theory and which would build on the sources and positions that had informed the original typographic work. At the time I began working on this research, I was also intent on defining a legitimate theoretical basis for typographic experimentation in my own writing practice. As a printer and artist I had become actively involved in making use of page format, type style, and graphic design considerations in the structure of experimental prose works. These works incurred a highly negative attack on the part of the circle of poets with whom I was involved in the late 1970s and early 1980s in California, though they found positive reception elsewhere and later. The need both to validate my own work and to inquire into the strong prejudice against acknowledgment of the visual component in literary work put an emotional spin on the intellectual project.

My original focus was on evaluating the effect of the manipulation of the visual form of language on the production of linguistic meaning (specifically, in literary practice). I expanded from this base to an investigation of critical theory and to construction of a theoretical model of materiality which would be adequate for the interpretation of typographic signification. I have eschewed selection of works which incorporate visual images per se and limited my analysis to works which only contain words—albeit, words which form images, are manipulated through their visual form, appear as visual phenomena—but are, still, recognizable producers of linguistic value. In addition, the artists whose work forms my major focus all had a more or less direct relationship with the production of their work in visual form—they either provided sketches and mockups for layout or worked directly in the print shop in production of the work. By using these criteria, I was able to insist on a relation between the literary conception and visual production of the work. This selection puts the work I have investigated into contrast with texts transformed by a designer or printer—such as the dynamically intriguing *For the Voice* written by Vladimir Mayakovsky. Given its visual form by

Lazar El Lissitzky, such a piece does not come within the scope of this project since it raises additional issues about the nature of collaboration. The theoretical problems of materiality, visuality, verbal meaning, and signification do pertain to such works, however, as much as to the works of Guillaume Apollinaire, Tristan Tzara, Filippo Marinetti, and the other artists I have investigated.

The use of semiotics as an interpretive tool, as I first made use of it in the early stages of this work, had the advantage of offering a means of distinguishing the visual manipulation of the linguistic signifier from the verbal signified in the process of linguistic signification. This (albeit artificial) distinction provided the leverage to insist on the role of that visual manipulation and call attention to the material character of the typographic signifier within poetic practice. Because I had selected typographic work whose visual manipulation was highly conspicuous, attention to the visual form was almost unavoidable. However, I would be willing to push my basic argument to an extreme: I believe that the issue of visual materiality pertains in the case of all written forms of language and that acknowledging this is central to placing visual language within the historical context of its production.

There was another consideration involved in selecting semiotics as a tool: its historical contemporaneity with the typographic works under investigation. I had decided to examine the status of writing, the visual form of language, within the realms in which it had received theoretical treatments. The formation of structural linguistics thus formed an important aspect of this study. The strong historical links between linguistics, formalist criticism, and artistic practice (particularly prominent in the work of the Russian theorists—but a part of the activity of Cubism and Futurism as well) offered one justification for this approach. More broadly, I was interested in the problems of signification as they had been conceived within artistic practice and literary practice in the first decades of the twentieth century and, later, came to be validated through the efforts of French and American critics building on the structuralist and semiotic models derived, in some cases, from the work of Russian formalists, as well as from that of Charles Peirce and Ferdinand de Saussure.

I was initially drawn to the typographic work produced within the context of what is generally termed the avant-garde—Russian and Italian Futurism, Dada, Cubism, etc.—because of its flamboyance and visual excitement, and because the typographic style developed in those movements proliferated widely and came to be seen as a signature style of the work of that period. As I began my research, I was struck by the

relative paucity of materials dealing with the typographic activity in any serious or systematic manner—especially by contrast to the veritable industry of publications on the visual art and literature of the same period.[1] As I began to inquire into the cause of this neglect—as conspicuous to my perception as the equally conspicuous presence of the typographic work within the early twentieth-century avant-garde— questions about the basis on which the history of the early period was being constructed led me to new questions.

It became clear that the development of criticism in both literary and visual arts had, by midcentury, come to define these realms in terms of a mutually exclusive set of assumptions. Within the visual arts, the high modernist stance of such historians and critics as Michel Seuphor, Alfred Barr, and Clement Greenberg (to name only the most obvious) was predicated on the assertion that visuality was equivalent to muteness, that modern art had fulfilled its teleological aim through achieving a condition of plenitudinous presence, and that all ties with literature, literary modes, or linguistic signification had been severed as part of the so-called autonomy of modern art. The distortions introduced by such assertions into the history and theoretical understanding of early modernism are enormous, and I will be concerned with them in detail in a later section. Suffice to say for the moment that the stance of oppositional definition—that visuality was defined in part by its exclusion of literary or linguistic activity—was echoed by the definition of literature within American New Criticism, and somewhat differently within French Structuralist criticism. Here literary value was pursued as a play of verbal terms which functioned as signs, surrogates, for a proliferating but always absent meaning—a meaning unsullied by such contingencies as authorship, intention, or historical circumstances.

The distinction between visual presence and semiotic/literary absence rendered experimental typography an aberration within the well-defined guidelines of high modernist criticism. Deconstructive and poststructuralist strategies have had more use for the complexities of signifying practices which do not conform to the well-ordered code of disciplinary distinctions, but the most potent aspect of typography's form—its refusal to resolve into either a visual or a verbal mode—raises issues which have not, I think, been fully explored in theoretical terms. Critical interest in materiality and poetics and the function of visuality in poetic form *has* increased significantly, however.[2] But my intention here has been to make a start at defining an adequate theoretical basis specifically concerned with the analysis of typographic practice. To do this I have traced the vicissitudes of critical theory and history to which the

4

typographic experimentation has been subjected in order to define what the limitations of that critical interpretation were with respect to typographic practice. This, in turn, has led me to an understanding and questioning of the basis of these critical practices.

My earlier use of semiotics has thus been transformed into an inquiry into the premises of semiotic methodology, into assumptions about the nature of visual and verbal representation and form—and their apprehension through critical interpretation. My assessment of the work of the early twentieth-century typographic artists has expanded from an inquiry into the role of the visual manipulation of the signifier into the way in which the materiality of signifying practices (in this case typographic expression) is inextricably bound up with the production of history and subjectivity in artistic practice.

As it stands, this work is a proposition: that the theoretical model of materiality I am putting forth to explain and interpret experimental typographic practice in the early twentieth-century avant-garde movements has implications for a metacritical inquiry into the premises on which visual and verbal modes are presumed to operate, and on which the disciplinary boundaries according to which that history was constructed are themselves premised. Ultimately, semiotics as a formalist methodology is fundamentally unable to escape its basis in idealist philosophy with its belief in universal and transcendent structures. Consequently, it cannot incorporate a concept of subjectivity and struggles with the notion of historical specificity with respect to production. Poststructuralist and deconstructive reformulations and critiques have attempted to come to terms with this limitation with varying degrees of success. It is from these sources, most particularly the work of Jacques Derrida and Julia Kristeva, that I have derived the prime points of departure for the concept of materiality.

Any theoretical model claiming universal applicability and usefulness is doomed to the most miserable failure: I don't claim that the concept of materiality proposed here is universally applicable except insofar as it suggests that the interaction of elements taken into an interpretive account be as specific to the historical moment of their production *and* the historical moment of their interpretation as possible. The one point on which I would insist, however, is that form (whether visual or verbal) is historically inflected and that neither the subject, nor history, nor interpretation can escape the specific constraints of their circumstances of production.

A few words on terminology: the term *materiality*, which I will discuss at length in chapter 1, is meant to invoke linguistics, semiotics, and

Marxist theory; but it is not to be confused with the concept of *material-ism* against which the artists of the late nineteenth century and early twentieth were in strong opposition. That concept, the materialist notion, was a product of nineteenth-century rationalism. The response of the Symbolist artists, in particular, to the restraints of that conceptual premise was to insist on an immanence and a possible transcendence through and in representation and to object to the constraints put on imagination and spirituality by a merely scientific and empirical inquiry. Thus the phrase "antimaterialist" is a frequent one in the writings of even those theoreticians of form prominent among early twentieth-century artists: Mondrian and Kandinsky, as well as the late nineteenth-century writers associated with Symbolism. The concept of materiality I propose is not defined by the same empirical, rational basis as the materialist inquiry of the nineteenth century—of which semiotics and structural linguistics, as well as phenomenology, are themselves an extension—for the simple reason that I propose the concept to resolve some of the theoretical problems which are the legacy of that stance. In particular, the central role I posit for subjectivity as a historically and culturally specific aspect of artistic production is fundamentally opposed to the premise of objectivity on which nineteenth-century materialism was based. Even the concept of the subject as a social construction, which is an integral part of twentieth-century materialist theories of language (and fundamentally opposed to the transcendent subject of idealist philosophy), has not been grounded in the materiality of production processes but seen as a mere instance of their functioning.[3]

I use the term *modern* to apply to work produced in the period up through the 1920s, which forms the corpus of primary material. The term modernist I apply, as per the convention in art history (see Frascina, Harrison, etc.), to the critical and historical work produced at midcentury to theorize and comment upon the work of early modern artists and their midcentury modernist successors. Artistic work produced within the legacy of modern aesthetics, and of a later generation already steeped in the history and burden of that history of the early avant-garde, I term modernist. While this distinction is blurry at best in terms of its historical demarcation, it serves very well to distinguish the critical gloss of Clement Greenberg from the original propositions of, for instance, Pierre Reverdy or Guillaume Apollinaire. The terms, therefore, have both a historical and critical specificity since they identify the early and later part of the century and original work and historical/critical commentary.

The term *avant-garde* also needs qualification. My preference is to

use the word very specifically to indicate those endeavors which had a strong conviction about the political effect of artistic expression. I do not, therefore, use the word more generally to randomly indicate any or all of the various activities of the early twentieth century. I prefer to restrict its use so that it becomes a distinct term identifying certain practices within modern art, rather than being applied haphazardly to all of them, or to activity later in the century which has completely different institutional and aesthetic bases for operation.[4]

The above mention of Symbolism brings me to another point in defining the parameters of this project. I have chosen, for purposes of linguistic fluency and aesthetic consistency, to limit my investigation to those works in French and English (and sometimes Russian) which have strong links to the legacy of Symbolism. Most of the work I deal with has in its background the phantoms of Charles Baudelaire, Arthur Rimbaud, Stéphane Mallarmé, René Ghil, and others. I have therefore avoided the German and Polish practitioners of typographic experimentation, as well as others. There was ample material among the French and English publications on which to develop my arguments; there has been no dearth of research on the work of the German experimental writers and artists, and my arguments would have needed a careful refinement with respect to social conditions and circumstances to be extended to include Raoul Haussman, Johannes Baader, Kurt Schwitters, and the other important figures within German Dada who made extensive use of typographic form in their work. I make no excuse for this, or apology; I simply acknowledge the limits of the scope of this work.

The field has changed considerably since I began this research more than a decade ago. There is now much excellent work, both monographic and thematic, on which to build. Where there were, for the longest time, mainly the compendia of Herbert Spencer, Willard Bohn's lone text, and the landmark article by Robert Rosenblum, there is now extensive work by Timothy Mathews, Marjorie Perloff, Gerald Janacek, Renée Reise Hubert, and many others. My own work as a writer and typographer is no longer under the kind of derisive attack it suffered a decade ago and the changed climate of critical theory does not require the same defensive charge on my part that it elicited when I began this work. The project therefore appears more modest for having more company and can function more in a dialogue with other work than as an independent manifesto. It seems less necessary to offer a corrective to the exclusion of typography from historical accounts and more useful to continue to examine how that exclusion came to be structured in the first place.

My intention, then, is to offer a theoretical model which synthesizes research and theory in art history and poetics and proposes a concept of materiality as a means of accounting for the nature and effect of typographic signification. I begin by sketching this model and then by tracing the historical context of aesthetic and poetic practice within which the experimental typography of the early twentieth century appeared. I have chosen a limited number of works and artists to analyze in some detail and have sketched in the larger field for the sake of showing the variety and range of these practices. Finally, I have traced the fate of typography within the history of literary and visual arts theory and suggested the ways in which materiality as a concept has fared within critical theory, including the developments of later poststructuralism and deconstruction. It now seems to me that problems of subjectivity and history are the only interesting issues left to work on from within the field of semiotics and structuralism and that, to a great extent, the inquiries into signification and the structure of visual and linguistic representation were abstractions whose time has passed. My own project has become historicized as well as historical, and that suggests to me that this is an appropriate moment at which to draw it to an end.

■ 1

Semiotics, Materiality, and Typographic Practice

The experimental typography which proliferated in the early decades of the twentieth century as an integral and highly visible aspect of modern art and literary movements was as much a theoretical practice as were the manifestos, treatises, and critical texts it was often used to produce. To come to terms with the complexity of this typographic work requires a critical inquiry into its structure, forms, and processes. In this regard, semiotics is more than a useful tool: the history of literature and visual form in the twentieth century is bound up in a dialogue with philosophy and criticism, and the premises which underlay the formulation of basic semiotic principles were intricately intertwined in the production of visual and verbal works of art.[1] Furthermore, the various critiques of semiotics in philosophical and political terms provide insights on which a basic concept of materiality as a theoretical model can be founded.[2]

The critical examination of typographic work also engages with the discussion of written language more generally and with the metaphysical dimensions of writing as it has been considered within a philosophical framework. It is hardly incidental that the semiotic analysis of language which formed the basis of structural linguistics in the work of Ferdinand de Saussure and initial texts in the work of phenomenologist

Edmund Husserl were both contemporary with the experimental typo-
graphic work produced in the context of modern art.[3] Both strains of
interpretive methodology—semiotic and phenomenological—made
an assessment of the character, function, and operation of writing:
Saussure in the posthumously published version of his lectures, *The
Course in General Linguistics,* and Husserl in *The Origins of Geometry.*
That these two authors, and their work on writing, served as a crucial
point on which the arguments of Jacques Derrida, the late twentieth-
century critic of semiotics as a metaphysical tradition, were based dem-
onstrates the force of their influence across the century and the potency
of questions still raised by their positions.[4] In this study I will be consid-
erably more concerned with semiotics and structural linguistics than
with phenomenology, largely because the critical interpretation of ty-
pography requires a language-based theoretical framework. In addi-
tion, however, the problems posed by the visual aspects of typographic
work need to be considered—both from within the limitations and pos-
sibilities of a semiotic theory of visual form and from the long tradition of
phenomenological approaches to the interpretation of visual images.
Some general remarks on phenomenology, particularly with respect to
Husserl's conception of the sign, and Derrida's critique, will be made
here, but they are largely subsumed under the general problem of con-
structing an adequate theoretical framework for the analysis of typo-
graphic work.

It seems evident that any theoretical propositions about the charac-
ter of typography as a visual form of written language must take into
account the status of writing within the critical evolution of semiotic and
phenomenological discussions. It also seems important, however, to
come down to cases: the typography under investigation in this study
was produced in the context of early twentieth-century artistic experi-
ment. Within that context, the theme of materiality, the self-conscious
attention to the formal means of production in literature and the visual
arts (as well as music, dance, theater, and film, it could be added), cuts
across the lines which otherwise separate Cubism from Futurism, Dada
from Nunism, Vorticism from the rest.[5] While the intentions, effects,
and processes involved in this self-conscious use of materiality vary widely
(from, for instance, a desire to define universals to the drive to locate all
form within a social sphere) the insistence upon the autonomous status
of the work of art (visual or literary) which veritably defines the founding
premise of modernism was premised upon the capacity of works to claim
the status of *being* rather than *representing.*[6] To do this, the materiality

of their form had to be asserted as a primary in-itself condition not subordinate to the rules of imitation, representation, or reference.

Generalities of this scope, however useful they are in establishing a framework for discussion, become most interesting as they are refined into specifics. The range of typographic practices within Russian and Italian Futurism, Swiss, German, and American Dada, French Cubism, and so forth offer the possibility of demonstrating the manner in which typography helped to define the relations among poetics, linguistics, politics, and visual arts as social practices. In addition, the variety of positions vis-à-vis the structure and operation of the individual artist or author as subject, the very construction of subjectivity through artistic practice, offers another opportunity to render specific the otherwise generalized terms for interpreting modern art practice. The analysis of materiality, of subjectivity, of language and image as socially coded symbolic systems was already integral to the development of these artistic practices. Apart from the works of Saussure and Husserl (and of course Freud and Marx), the critical writings of Guillaume Apollinaire, Pierre Reverdy, Filippo Marinetti, Alexander Kruchenyk and Velimir Khlebnikov, Wassily Kandinsky and Piet Mondrian, Ezra Pound and Wyndham Lewis are only the most outstanding in the long list of works produced in the intersection of critical and artistic practice to begin to define the theoretical parameters of modern art.

To understand typographic experimentation as a theoretical practice requires analysis of specific works within the context of writings about the character of materiality in both literary and visual arts domains. From such a study we can understand typographic experiment as a modern art practice which participated in many of the same operations as literature and art: the blurring of lines between high and low (so-called) cultural practices, the challenge to the romantic subject, the assertion that the transformation of symbolic systems was a politically significant act, and the proposition that a new aesthetic form would bring about, construct, envision, a new utopian vision of the world. The fundamental metaphysical premise underlying these practices—the modern artist's assertion that the artistic work approaches the condition of *being*—must however be subject to an investigation: in this case, the investigation of typography within a metaphysics of writing.

The intersection of typography with critical theory and a discussion of the metaphysics of writing will therefore form the focus of this chapter. The elaboration of the place of typography within modern art practice will be the focus of the next.

Preliminary: Typography and Linguistics

The place of writing within the science of linguistics was ill understood and even more poorly formulated at the beginning of the twentieth century. The critical apprehension of writing as a challenge to the metaphysics of both semiotic and phenomenological positions in theory only became fully articulated in the latter part of the twentieth century. The development of critical theory which uses structural linguistics and semiotic formulations as its base forms much of the history of literary criticism and linguistic study in the interim. The critical analysis of visual images has only more recently been subject to a semiotic analysis, and that with moderate success, while the widespread endorsement of aspects of phenomenological methodology have dominated the field of visual arts criticism and analysis. The limitations of both phenomenology and semiotics have been pointed out by critics intent on challenging the idealist premise of their critical apparatus.[7] Such challenges have come from both the materialist-based practitioners of critical theory and from deconstructionist philosophers. The hybrids of these various fields proliferate as well—for instance the attempt to reconcile a semiotic analysis of language (or image) as an instance of a cultural and social code with the position of an individual (historically specific and psychoanalytically constructed) speaking subject.[8] To understand both the necessity for and difficulty of such hybrid positions requires some critical background.

The fundamental premise of structural linguistics was that language functioned as a system. The arbitrary character of the linguistic sign put forth in Saussure's lectures was in marked contrast to the investigations of languages in terms of their historical evolution, which had been central to the neo-grammarians and philologists of the nineteenth century. Whatever its history, Saussure asserted, language was comprehensible as a synchronic system, and structural linguistics demonstrated that the elements of language were defined in relation to each other rather than through their history or through reference to any world or system outside of language.[9] Written forms of language had been made use of extensively within the field of linguistic study, but writing as such had steadily lost ground as a field for scholarly research. This was especially true as the decipherment of ancient languages was achieved through correlations to the phonological structure of those languages, and the old myths of the visual quality of hieroglyphic and Chinese characters were mooted by archaeological research.[10]

The significance of Saussure's retrieving written language from its

place of neglect cannot be underestimated—any more than the metaphysical underpinnings of his semiotic disposition can be wished away. Thus the first step in establishing the basis of the study of semiotics in relation to writing and typography is an examination of Saussure's discussion: the new status he assigned to written language and the basis on which he laid the groundwork for a theory of materiality in signification.

Saussure's Contribution

The role assigned to writing within the science of linguistics in the nineteenth century was riddled with paradoxes and problematic conflicts. On one hand, writing was the necessary, indispensable tool of the linguistic discipline, and linguistic studies were largely, if not entirely, based upon the ritual examination of written texts subjected to detailed morphological analysis.[11] In addition, writing played a part in the transcription necessary for analysis of "spoken" language (still a very limited area of inquiry in the nineteenth century).[12] It also served to record languages that did not possess a written form—an industry that had been spurred on by the combined missionary and commercial zeal of colonial expansion. This had required the development of phonetic notation systems which could be called upon to perform the nearly impossible—a precise rendering of all the features of speech. The science of phonetics, whether grounded in articulated sounds or acoustic sounds, demanded a means of recording, or at least of accurately transcribing, these phenomena. The paradox was that it was the inscription, the written text, which was ultimately subjected to analysis and not the elusive, ephemeral sound. This relationship of dependence went largely unnoted, until the work of Ferdinand de Saussure. But throughout the nineteenth century, writing aided linguistics with the modesty and unassuming propriety of a well-trained servant.

Writing, then, though the very basis of linguistic study, was considered insignificant and invisible, as beneath mention or notice. The indispensable adjunct to linguistic scholarship, without which there would have been no object of study, writing went unnamed and unrecognized. Not only were the forms and material properties of writing, or even of written texts, not a distinct object of inquiry, but its very *existence*, the *fact* that it served as language, went unacknowledged. The explanation for this can be sought in examination of the processes by which linguistics was establishing its own grounds of legitimacy, partic-

ularly in the way in which its claim to the status of a science was linked to the careful circumscription of its object. One area where this process offers a vivid example is in the changing parameters of the linguistic study of exotic and ancient languages.

When the Rosetta stone was discovered in 1799, it not only allowed the final veil to be drawn back from the mysterious image of the hiero-glyph, it also ended the long-standing belief that hieroglyphics func-tioned as a form of language which was directly apprehendable through the eye. The clue to hieroglyphic decipherment was the relation be-tween visual signs and a spoken language for which they were the repre-sentation. Once it was clear that hieroglyphics corresponded to this spoken language, the properties of their identity as visual signs ceased to be significant to linguists—except insofar as they provided access or rec-ognition. Here the linguistic notion of the *present* signifier serving a function as surrogate substitute for the *absent* signified is apparent in its most fundamental form. The hieroglyph, for so long the site of fantas-matic projection onto the visual, material image of writing, was reduced to serving an incidental function relative to the all-important linguistic *text*. The price of decipherment was that writing lost its autonomous ex-istence; hieroglyphics are the example which most dramatically and romantically typifies this process, but the same process of rendering transparent the evident material properties of writing occurred as the forms of cuneiform, linear Cretan scripts, and other ancient inscriptions were deciphered.[13] The notion of linguistic transparency implies *imma-teriality*, that which is insignificant in its materiality, to which nothing of linguistic value is contributed by the form of the written inscription which serves merely to offer up the "words" in as pure and unmediated a form as possible. The act of repression on which this notion depends is monumental, really, since it requires continual negation of the very evi-dent fact of the existence of what is immediately before the eyes in the name of its signified value.[14]

The condemnation of the visual aspects of hieroglyphic writing to a subordinate, even insignificant, role was the harbinger of what would be typical of the nineteenth-century linguist's attitude toward all writing. For if the glaringly pictorial values of Egyptian writing could not main-tain their value in the face of an attitude which privileged the so-called spoken language (a contradiction since it existed *only* in written form, at the risk of overstressing the obvious), then the fate of less glamorous scripts, Linear A and B, runes and cuneiform, was to be completely dis-regarded with respect to the possibility of granting any value to the specifically visual features of these scripts. With a kind of terrible self-

righteousness, linguistic authority asserted itself against writing. No apology or even hint of acknowledgment accompanied this effacement, this negation of the visibility of writing.

As the linguistic enterprise evolved, taking its clue from the German study of comparative philology and from the relatively guaranteeable data of laws of sound change, the fact that the texts which were being used were always written, that their capacity to function as the foundation of inquiry depended upon their being written, continued to be ignored. The "sounds" of language formed the focus of discussion. These coincident developments—that exotic languages were deciphered by their link to "spoken" languages and that linguistics transformed itself from the study of languages to a phonological science—both contributed to the disappearance of writing. The profile of writing collapsed, its image erased from the face of language.[15]

It should be clear by now that the linguistics of the nineteenth century defined itself as scientific largely by isolating the phonological basis of its object of study, language.[16] This became even more true in the twentieth century, when, in the first decades, the study of linguistics was almost synonymous with an examination of phonological features and structures—leaving aside topics such as semantics and pragmatics. Writing posed a particular threat to these legitimating grounds. Specifically, writing ventured away from the quantifiable and objectifiable phenomena of sound, and it was the study of sound, its acoustic and articulatory dimensions, which had been the cornerstone of the new linguistic edifice. The issues raised by writing seemed more suspect, closer to the kind of speculative work which had been concerned with the origins of language, with the metaphysical and philosophical aspects of a language study not grounded or groundable in any kind of scientific investigation. Since writing was the means for providing access to spoken language, any of the aspects of its function which might suggest autonomy (writing as a visual medium distinct from spoken language) were necessarily eliminated—not as undesirable, but as *inconceivable,* a position whose exclusion was far more fundamental and non-negotiable.

As a final bit of paradoxical evidence, I want to mention the peculiar fascination of nineteenth-century linguistics with apparatuses designed to fix the spoken language in a visible *trace.* This was not writing in the pedestrian sense, but a strange, distorted version of the process by which language can be recorded and made visible. A wide range of experiments were conducted which attempted to transform the spoken word into a visible graph. As the mechanics of both articulatory and acoustic aspects of language came under greater and greater scrutiny,

the number of these experiments grew rapidly among French and German linguists.

While the examples are many and varied, a single citation will be used to demonstrate the point. The work of Theodore Rosset, *Recherches Experimentales pour l'Inscription de la Voix Parlée (Experimental Research for Inscribing the Spoken Voice)*, published in 1911, illustrates the contortions which the phonological prejudice in linguistic study forced the medium of language to undergo and the odd transformation of spoken language back into a written form for the sake of making it available to study.[17] A mechanical device consisting of a tube, a mouthpiece, a drum, and a vibrating needle was used to transform the disturbance of air produced by the pronunciation of specific sounds into a trace on paper. The result was a graphic line, a piece of visible evidence, which could then be subjected to analysis. Even when not investigating written forms of actual texts, phonology became dependent upon an inscription of its own invention. This reinscription, this trace of spoken language, was even more obvious as a form of writing for having been introduced, reinvented just to provide a visible trace of spoken language. This was, of course, not considered writing, but inscription, the image of the sound. Again, its value as an image disappeared under the weight of its real job, to "show" the sound. In summary, then, a phonological bias existed in nineteenth-century linguistics, and those aspects of the study of language which were firmly related to writing as a visual medium were systematically excluded. Linguistics did not merely privilege the phonemic, phonetic, acoustic, and articulatory aspects of language, it did everything possible to ensure that the visual support of language was unacknowledged, unnamed, in short, invisible. Ferdinand de Saussure changed this.

In the years 1906 to 1911, the Swiss linguist, Ferdinand de Saussure, gave a series of lectures outlining a structural approach to the study of language.[18] The importance of this material for the development of critical theory in the twentieth century cannot be underestimated, and I would argue that the fact that this work occurred contemporaneously with the kinds of explorations in art practice discussed earlier is far from coincidental. While there is little indication that Saussure was influenced by the arts of the period, there is evidence to suggest that a number of poets and writers were actively concerned with linguistics in France, in Russia, and, later, in England and the United States.[19] But the question of influence, direct or indirect, is not under examination here; rather, I am concerned to point out that the basis for a critical in-

terpretation of the independent manipulation of the signifier within the art practices of writing and the visual arts was present within Saussure's work. Specifically, it is the deconstruction of the unity of linguistic representation into the distinct realms of signifier and signified which permits a conceptual investigation of their independent, though inextricably linked, operations.

Saussure's assumptions about the applicability of a semiotics grounded on his linguistic model to visual forms went untested in his own work, and the problems which arise from transfer of a conceptual apparatus from a linguistic base into the critical study of visual forms has inherent flaws. While the structure of Saussure's model had suggestive possibilities for analysis of the material manipulation of signification, very specific problems arise when it is applied to visual materials.[20]

Saussure's importance to my argument, therefore, is threefold. First, he has a historical importance within the history of writing because he reinserts writing, by naming it, into the domain of language. Second, his work demonstrates that there was, at the time in which modern art practice was concerned with the investigation of materiality, a contemporary critical position that was, while inadequate, establishing the basis for analysis of those practices. Finally, the critical terms on which the analysis of literature and the visual arts become distinguished by their exclusive oppositional definitions grounded on the operative notions of absence and presence within their own self-conceived identity has a relation to Saussure's original formulations. The application of his work to the very specific realm of the *image* of *language,* its limitations in addressing the visual aspects of typographic work, can be useful in shedding light on the inherent differences between visual and verbal representation in semiotic terms.

The importance of Saussure's achievement can only be appreciated against the background of the repression of writing sketched out earlier: Saussure *named* writing, addressed its existence, and defined a place for it within the science of linguistics. Whether the role he prescribed was sufficient is certainly open to question. But the radical significance of his act was that it admitted the existence of writing, granted it a presence, an actuality. It would be ridiculous to claim that Saussure's sense of writing was in any way similar to the role carved out for it in the visual, graphic, and literary arts in which its fuller potential was explored. Saussure definitely assigned to writing a secondary role in which the significance of its particular qualities was not appreciated, and in which its primary function was to provide a convenient, if inaccurate, record of speech. Saus-

sure made this immediately and unequivocally clear, as is represented by the material at the beginning of Chapter 6 of the transcribed version of his lectures, *Course in General Linguistics*.[21]

> Language and writing are two distinct systems, the only reason for the existence of writing is to represent language. The linguistic object is not defined by the combination of written and spoken language, spoken language alone constitutes it. But the written word merges itself so intimately with the spoken word of which it is the image, that it ends up usurping the primary role; and in the process an equal—or even greater —importance gets assigned to the representation of the vocal sign than to the sign itself. It is as if one believed it were better to get to know someone through their photograph than directly by their face.[22]

Saussure went on to explain what he thought the basis of this bias toward writing was and in so doing called attention to many of the problems inherent in a linguistics dependent on a system whose existence and specificity it was determined to ignore.

Saussure had indicated that he believed a bias existed *in favor* of writing because of the way the graphic image strikes the eye as a permanent, solid object and makes a more lasting impression than that of spoken sounds. While he did not pursue the implications inherent in these observations to investigate the actual materiality of the visual signs, what was implied in the statement was the basis for an understanding of the difference between visual and verbal signs, an understanding that they *are* different and that this difference has a substantial bearing upon their function and perception. The second factor contributing to the prestige of writing (which he was criticizing) was what Saussure termed the domination of the literary code. By this he meant the emphasis which education placed upon orthography, reading and general literacy, all of which depended upon an ability to manipulate written language, resulting in a situation where "the natural rapport is reversed."[23]

The use of the word "natural" here, and the use of the word "tyranny" a few pages further on in his discussion, are examples of points at which a pejorative tone is evident in his attitude toward writing. And where this negativity came into his tone, it was a negativity toward the confusion between speech and writing, between sounds and letters, rather than a criticism of writing itself.[24] Saussure understood the role writing had played in serving the study of language; it was only when writing was mistakenly conceived to *be* language that it came in for sharp criticism. Thus he proceeds from the statement that "we generally learn about languages only through writing," as an acknowledgment of

its function, to the summation that: "The preceding discussion boils down to this: writing obscures language . . ."[25]

That there was a clear distinction between the two systems, and that they operated without clear regard for each other according to Saussure's presentation, is an indication of the extent to which Saussure recognized writing's status as an independent entity. His further statements on the nature of writing provided insight into its character as a representational mode. He differentiated between two ways of processing visual, written material: either letter by letter, or in whole chunks. As he continued his discussion of writing, Saussure made the observation that there were two types of writing systems, one which he called *ideographic,* a writing in which single signs functioned without relation to sounds (he supposed that the Chinese writing system, for instance, was one such—though in fact it is largely a logosyllabic system), and the other which he called *phonetic,* in which a sequence of sounds is represented. At stake were the inadequacies and pitfalls of representing language—spoken language—in written form.

Saussure's idea was that written representation was essentially inaccurate but necessary, though vigilance against its trickery must be observed. He noted, for instance, that at the point when the Greek alphabet was invented there was considerable harmony between the alphabet and the spoken language, so that a single sound could be dependably and exclusively signaled by a particular letter. There was little need for either duplication of letters or of sounds such as occurred in the condition of evolved modern languages in relation to an essentially roman alphabet. Language had evolved in its phonetic form, writing had changed very slowly, and discrepancies had introduced a wider and wider separation between the two systems; they were in an essentially nonsynchronous relation with each other so that: "The obvious result of all this is that writing veils the face of language, it is not a guise, but a disguise . . . nothing remains of the image of language."[26] The question of what constitutes the "image" of language besides the visible form of writing went unanswered in Saussure's discussion, and the use of the visual metaphor as the basis of the discussion made him vulnerable to a range of criticisms.

The concept of *pronunciation* became the grounds for investigation of another area where the assumed bias in favor of writing had inverted what Saussure continued to term the "natural" relation between speech and language. Saussure claimed this "natural" relation on the basis that all relations between written and spoken forms were necessarily artificial, conventional, secondary and surrogate, and did not have the direct-

ness of sounds in relation to the fundamental structure of the sign. Once again, though writing was not slandered as unnatural, the relation between writing and a pronunciation which belonged to spoken language was given this unnatural characterization.

"The tyranny of the letter goes even further . . ." began the final section of chapter 6. This is the section in which the confusion between spoken and written forms was clearly described, with the intention of demonstrating that any assumption that a particular pronunciation belonged to a particular *letter* was incorrect. The criteria of pronunciation, according to Saussure, belonged to the spoken realm, it was a matter of correctly articulating phonetic and phonemic units which belonged to the *language* at a particular moment in history:

> Whoever says that a certain letter must be pronounced a certain way is mistaking the written image of a sound for the sound itself. For French *oi* to be pronounced *wa*, this spelling would have to exist independently; actually *wa* is written *oi*. To attribute this oddity to an exceptional pronunciation of *o* and *i* is also misleading, for this implies that language depends on its written form and certain liberties may be taken in writing, as if the graphic symbols were the norm.[27]

The relationship between letters and phonemes, the basic units of, respectively, written and spoken language, remained ambiguous, changeable, and in every respect unfixed. The only thing "natural" in spoken language was that the act of pronunciation was necessarily a separate act from that of writing, or noting, or representing, and the consequence of the confusion between the two was that "When someone says that a certain letter must be pronounced in this or that manner, the image is mistaken for the model . . ."[28]

The confusion here results from Saussure's putting these two domains, written and spoken language, into a relation of dependence. Each can and does, in many situations, function independently, preserving its own autonomy and specificity. The link between them was not necessarily one of *representation* such that one must dominate and the other subordinate the relation, as Saussure insisted, but it could have been seen as a complementary relation, an alignment, in which each set of signs, either graphic or phonic, could be said to indicate the other without one necessarily taking precedence. Saussure, however, held to the position that the linguistic sign, although conceptual and non-material, was constituted in spoken language. But the discussion of the sign only makes sense within an investigation of Saussure's ideas about

the structure of the signifying process, within which his ideas about the role and function of writing could be situated.

■

The key elements in Saussure's study of signification, as he articulated it in the study of language which served as the basis of the *Course*, has implications for both linguistics and the semiotics which modeled itself upon this linguistic base. Primary among these are: the notion of the double articulation of the sign, or the separation of the signifier and signified, the naming of these two elements, and the assignment of a particular role to each in the signification process; the arbitrary nature of the sign; the finite nature of the linguistic system; the possible effect of materiality in the signifying process (which remains embryonic in Saussure's *Course*); and the distinction between *langue* and *parole*. All of these can be used to analyze graphic systems of communication, specifically, typography, but with careful attention to the limits of Saussure's formulations and the reflection which can be brought to bear upon the semiotic sign by the study of visual material. To these could be added the distinction between diachronic and synchronic studies of language, but the relevance of this point to my discussion is limited, so I will concentrate mainly on Saussure's elaboration of the structure of the sign and signification, then on the problem of *langue/parole* as it relates to written language.

Saussure's objective in defining the nature of the sign was to define an appropriate object for the science of linguistics and thereby legitimize linguistics as a science distinct from philology or philosophy. The sign which Saussure defined was therefore specifically linguistic in nature.[29] It was derived from the careful observation of language, rather than conceived, as in the semiotics of Charles Peirce, as a set of logical relations of which linguistic ones were merely an instance. This must be kept in mind both because it limits Saussure's project and, also, underscores some of the issues involved in transferring the basic formulation to other disciplines.

The linguistic sign, as Saussure defined it, was a *psychic* entity, and this characterization is fundamental to understanding what follows. The sign is composed of two parts, a *concept* and an *acoustic* image. The concept is completely mental, it is the *thought value* of the sign; the acoustic image is composed of sound syllables insofar as they may be held in

mind, defined as mental. Saussure made a clear distinction between the phonemes which composed spoken language and the *acoustic image.* The actual phoneme was a feature of articulatory speech, but it was a participatory element in language only when it functioned in relation to the acoustic image, the mental impression, which gained no substantial value from the phoneme. However, this complicated distinction, whose attendant paradoxes will be discussed below, allows for independent exploration of both the conceptual aspect, the *signified,* of the sign and the idea of the acoustic image, or *signifier.*

> The psychological character of our sound images becomes apparent when we observe our own speech. Without moving our lips or tongue, we can talk to ourselves or recite mentally a selection of verse. Because we regard the words of our language as sound images, we must avoid speaking of the "phonemes" that make up the words. This term which suggests vocal activity, is applicable to the spoken word only, to the realization of the inner image in discourse. We can avoid that misunderstanding by speaking of the sounds and syllables of a word provided we remember that the names refer to the sound image.[30]

The distinction between signifier and signified, Saussure goes on to state, is only theoretical. He never intended it to be interpreted as the literal designation of two discrete elements. Nonetheless, this conceptual distinction established the terms of difference within the sign, which was the structural basis of semiotic signification. While they could not exist separately, and did not, the named and defined independence of the two elements allowed them to be manipulated independently. This was the basis of much of the investigation of formalist poetics and linguistics, as well as later semiotic bases for structuralist analysis. The peculiar construction of the materially insignificant but materially based nature of the signifier is essential to the paradoxical structure of Saussure's sign. Initially, it is important to understand Saussure's treatment of the acoustic image in relation to phonetic material—then consider what the problems with this are for written language and visual images.

Saussure had good reason to distinguish the acoustic image or signifier from the phoneme: "A succession of sounds is not linguistic unless it is the support of an idea. Considered by itself, it is only the material of a physiological study."[31] The sound, *per se,* is insignificant in any inherent or essential sense and contributes nothing in itself to the signification process except its capacity to function as a distinctive unit. The value of the linguistic sign is determined relative to other linguistic signs within a culturally bound system where all these signs function according to a set

of rules. Any set of sounds could have been determined to be functional. It is their discreteness, not their substance, which allows the sounds which form the phonemic basis of language to function, and Saussure insisted that these sounds had no direct bearing upon the structure of the sign or its components. "The linguistic entity is only determined when it is delimited, separated."[32]

What is fundamental in this formulation is the link between the acoustic image of those sounds, whatever they are, and the mental concept, the link between signifier and signified in the sign. "The division between acoustic chains must be the same as the divisions of conceptual chains."[33] He emphatically restates that, with respect to both its components, the sign depends upon two factors: the rules of the system in which it operates and the distinctions of one sign from another. This leads him again to point out the lack of importance materiality would play in the signifier.

> This is even more true of the linguistic signifier, it is not essentially phonic, it is noncorporeal and constituted not by its material substance, but by the differences which separate its acoustic image from any and all others.[34]

Earlier on, Saussure had made this point by stating that "phonation" is separate from the system of language because phonation is concerned only with the material substance of words.[35]

With this line of argument firmly established, there would seem to be no possibility of generating a concept of materiality out of Saussure's theory of the sign. There is one loophole in his argument, however, through which this notion may be inserted, and one paradoxical aspect of his formulation which becomes the basis of a recasting of the characterization of the signifier in almost all subsequent semiotic theory. The loophole resides in his suggestion of a latitude of interpretation and depends upon the extent to which Saussure considers inflection a means of effectively altering the value of the sign through manipulation of the signifier. "If it (phonation) has any bearing on language as a system of signs, it is only indirectly, by the change in interpretation which results."[36]

Such interpretation goes beyond the realm of semantics and syntax to the realm of what Charles Morris would term pragmatics, to the effect and function of linguistic signs depending on their context, rendition and the subsequent effect upon signification.[37] This is a field into which Saussure did not venture, limiting his discussion to the basic definitions of the system in which signs functioned. But the question as it relates to typography, and to writing, is to determine at what point that latitude of

interpretation becomes a function of the sign itself, particularly in relation to the signifier. There is procedural difficulty in accepting a notion of the acoustic image as being capable of sustaining differentiation without dependence upon its material basis. A signifier must be capable of articulating difference in material terms, and its effect upon the signified is bound up with the range to which that material identity is to be restricted and thus retain its self-identity. If Saussure's signifier is indeed the acoustic image which is not identical with the phoneme, or any other part of articulatory sound, then its materiality is totally unimportant. This, in fact, is what Saussure finally says: "In language, as in any semiologic system, what distinguishes a sign is what constitutes it. It is difference which defines character, as it makes value and unity."[38]

The linguistic sign could not get its value from its substance, because it had no substance. But is it possible that the acoustic image Saussure defined is really as without materiality as he claimed? For the sign to be arbitrary, for its value to depend upon its place in a finite system of signs rather than upon any essential value in itself as a sound, image, or other material form, it was necessary to strip the signifier of any effect of its materiality. The question of whether the signified is actually arbitrary belongs to the realm of debates on epistemology. But the status of the signifier as arbitrary is quickly affirmed by Saussure, who asserts that the signifier could be replaced by anything whatsoever which would remain functionally distinct. But distinct from what? From other signifiers, certainly, but according to what kinds of features? Immaterial ones? Of what, finally, could the acoustic image be composed?

If the phonemes, which are the distinctive features of spoken language, and the letters, which are the discrete elements of written language, are both discounted from the signifier, then the so-called acoustic image which exists, as a psychic entity, must be defined as an autonomous unit, as something directly linked to the signified concept. What is the purpose of the study of the phoneme, then, as the basis of a "natural" language, if it has to also function as a surrogate, as a signifier of a signifier? If the acoustic image is not the same as the material in which it can be represented, then the argument against writing is irrelevant; and if the acoustic image is immaterial, then the problematic status of materiality persists. Without either or both of these material forms, the basis on which the acoustic image functions loses its value. What becomes important as a result is the opening left in Saussure's logic.

This, then, is the paradox created by Saussure. In his system, the signifier becomes a noncorporeal entity nonetheless linked to the system of phonemes which function as the discrete elements of language

(any language—that is, they are not particular elements of sound, but exist as structural units whose definition depends on their relation to each other, whose materiality is insignificant as such, that is, as this or that particular sound) but which nonetheless is material, very definitely. The paradox is that Saussure on the one hand eliminates materiality and on the other creates a system which depends upon it. It is on the basis of this paradox that an argument for the materiality of the signifier as playing a part in the process of signification is grounded; and further evidence of this is to be seen in the manner in which the concept of the signifier becomes transformed in later semiotic theory, where it becomes a pedestrian habit to describe it as the tangible, material, perceptible element of the sign. The paradox cannot be resolved in Saussure's work; he does not resolve it. Even in the work he did on anagrams, also published posthumously, which depended to a greater extent upon the material evidence of language to provide the basis on which Saussure constructed his interpretation, he held back from a full acknowledgment of the functionality of that material aspect except in the most noncorporeal sense.

> In using the word anagram, I do not mean in any way to introduce the idea of writing, either in relation to Homeric poetry, or to any other ancient Indo-European poetry.[39]

And Jean Starobinksi commented that although Saussure's work depended on:

> . . . a link of distant analogy with the traditional anagram, which functions only through graphic signs . . . it will not, therefore, be a case of redistributing aggregates limited to visual signs . . . [40]

While he wants to depend upon the usefulness of those discrete elements, be they letters or phonemes, Saussure wanted to stop short of acknowledging any role their material forms might have, or effect this materiality might have, on the production of meaning. Ultimately, it is in the deconstruction of the sign into two elements which may be independently considered and manipulated that Saussure makes the conceptual contribution for analysis of experimental typographic practice. For if the elements of a linguistic sign could be, even conceptually, distinguished, then they were inextricably linked not through a condition of *identity*, but through a *relationship* in which their difference from each other was significant. It is thus in the very structure of Saussure's sign, its double articulation and differential nature, that theoretical basis for understanding the manipulation of the signifier had been established. Saus-

sure's rejection of the materiality of the signifier as substantive, as having a role to play in the production of meaning, had been motivated by his desire to establish the grounds for a purely differential system of linguistic function. Had Saussure been willing (or able) to look beyond language in the investigation of his semiotic principles, he would have encountered some of the contradictions involved in denying the material base of production.

The last feature of Saussure's work with implications for the analysis of typography is the distinction he made between *langue* and *parole*. The way he conceptualized their relation provides grounds for investigating some of the elements of a typographic system of representation.

Saussure's purpose in making a separation between *langue* and *parole* was to allow a distinction between a set of rules which define a closed system which is located in a culturally bound context and the individual, actual instances of its use.

Saussure defined *langue* as "complete in itself, acquired and conventional" and as exterior, unavailable to modification by the individual.[41] "Complete in itself" because it is the sum of rules and guidelines which govern the use of language, the structure of utterances, and the use of semantic and syntactic categories; "acquired" because it is learned; and "conventional" because it is arbitrary, agreed upon, and functions by the place it occupies within those conventions, held in place as and by the conventions. *Parole*, on the other hand, is defined as "individual use, voluntary and intelligent," but kept within the bounds of the rules set by the *langue*.[42] While the *langue* is susceptible to change, and does change by virtue of the influences of the individual instances of *parole* which gradually come to affect the rules of the *langue, parole* is considerably restrained by its need to be intelligible, functional, as communication. The concept of individual subjectivity as a function of language can barely be supported within such a formulation, though the distinction between *langue* and *parole* permits the latter to function as the instance of individual expression. The concept of subjectivity cannot expand much beyond this instantiation, however, in such a rule-bound and systemic model; it is highly mechanistic and restricted, and the subject so implied is individuated only as an utterance, not as a psychic process in formation.[43]

In summary, then, Saussure's contribution to the status of writing at the turn of the century can be assessed as follows: while writing had come into its own as an object of study in the fields such as graphology and commercial printing, which had paid considerable attention to its materiality as a visual medium, writing had been systematically ex-

cluded from the study of linguistics, which was nonetheless dependent upon written language as a basis on which to found its own studies. One of Saussure's important acts was to name writing within the science of linguistics and to establish a role for it in relation to language, even if that role was subordinate and can be criticized. Most important, it was in the fundamental deconstruction of the sign into two independent, but linked, elements that Saussure established the basis of examination of the manipulation of the signifier. Within this articulation of the structure of the linguistic sign, Saussure created a difficult-to-resolve paradox between a sign independent of all materiality and also dependent upon it. It is in the space created by this paradox that the exploration of the significance of the materiality of the visual representation of language will find its place.

The Materiality of the Signifier

The materiality of typographic character was given theoretical treatment by a number of the poet practitioners and designers of the early to mid-twentieth century. Essays by Velimir Khlebnikov, Alexei Kruchenyk, Ilia Zdanevich, Jan Tschichold, and Herbert Bayer, for instance, take up particular issues of the relations between typographic form and linguistic expression. But none of these writers used specifically semiotic vocabulary or posed their analyses in terms of a structural linguistics. And the issue of the specific quality of written language was studiously, even systematically, avoided by both linguists and semioticians. The development of a semiotic approach to the typographic signifier has to be made indirectly, by assessing the ways materiality has been construed within semiotics more generally.

Between the period at which Saussure articulated the bases of his structural linguistics and the point at which the deconstructive analysis of his premises occurred in the work of Jacques Derrida, there were marked developments in the analysis of language, poetics, and visual imagery in semiotic terms.[44] Arguably the most influential and most developed investigations of semiotics in the 1920s and 1930s were those which took place in the context of Russian Formalism and then of the Prague School or Prague Linguistics Circle.[45] While an analysis of these efforts is outside the scope of this project, it seems important to at least summarily chart the ways in which the concept of materiality comes to be construed with respect to linguistic and visual signification in the pe-

riod between the 1910s and the mainstream of French structuralism in the 1960s, which gave rise to the activity of deconstruction.

Saussure's signifier, the *acoustic image*, was not granted a material character as such. The materiality it possessed, as noted above, was systematically excluded by Saussure from any role in signifying practice; it was necessary, but incidental—in other words it was nonsignificative, insignificant, that is, not signifying *in itself*. The paradox of this allowed that the more important partner in the signifying operation was the signified, the content, substance, or value which was meaningful. Inextricably linked to the acoustic image, that peculiar phantom, the signified was nonetheless peculiarly independent of it. While the status of materiality remains unclear in the work of subsequent writers, the signifier comes to be characterized as the "perceptible, material" aspect of the sign in fairly short order, and this characterization is used as the point of departure for phonological study as well as inquiries into poetics.

The two developments in linguistic theory which substantially altered this situation were, first, much attention to the nature of poetic language and, second, the emergence of a more refined model of the distinctions between linguistic expression and linguistic content. Both of these developments are evident in the work of the Formalists and continued in Prague circles, amidst other concerns of the heterogenous groups.[46] The Russian theorists of language, not all of whom adopted the etiquette "formalist," had been in direct contact with the linguistic activities in France and Geneva. The most direct conduit was Sergei Karcevskij, who arrived in 1917 in Moscow to participate in the activities of the Linguistic Circle there after having spent several years as Saussure's student in Geneva. But other contacts, less direct, also supported the connection.[47] The ready receptivity of the Russian groups fostered dramatic developments in linguistics and poetics along structuralist lines.

It is somewhat artificial to separate the developments in Russian Formalism from the context of poetic and avant-garde activities in which they were spawned; but the linguistic structures elaborated in the work of Moscow Linguistic Circle and the St. Petersburg Society for the Study of Poetic Language added the dimensions of careful phonetic analysis and systematic investigation of the character of literariness to the structuralist model.[48]

In the mid to late 1910s, the concept of aesthetic function emerged in the Moscow group. This notion permitted literary and artistic forms to be distinguished from utilitarian or functional uses of language, arts, and elements of theater. The constitution of the aesthetic function was a

self-conscious attention to the making, *faktur*, of poetry or art, which permitted such forms to be distinguished from those in which language (in particular—the problem of visual arts was more complex and not directly addressed until later) was assumed to be a transparent medium merely bearing meaning. In poetic form, Roman Jakobson later wrote, "language is perceived in itself and not as a transparent or transitive mediator of something else."[49] The nature of this "in itself" character would form the focus of Jakobson's work for much of his long career through his systematic investigation of the effect of expressive form on the production of linguistic meaning within poetic form.[50]

Jakobson realized that there were no hard and fast criteria according to which the poetic uses of language could be distinguished from daily usage: patterns of rhyme, alliteration, punning, and metaphor were sprinkled throughout quotidian language. But the argument at the center of Jakobson's theory of poetic language was that it was in poetics that such activity was self-consciously foregrounded. The analysis of linguistic material required detailed structural analysis of poetic devices, phonological patterns, and linguistic structures—all of which were given consideration for their expressive effect. In the late 1910s, Jakobson described the substance of poetics in terms very close to those of the avant-garde poets' (particularly the *zaum* poets Khlebnikov, Kruchenyk, and Zdanevich), stating that "poetry" was the "expressive intent of the verbal mass."[51] Both the vocabulary and the emphasis in this phrase betray the Futurist influence, but the conviction that language *had* mass, that is, that it had real material substance, remained a consistent feature of Jakobson's position. In the essays of the 1930s onward, which are his major works, this conviction was systematically expanded into an analytic methodology.[52] In the important 1933–34 essay, "What is Poetry," written in the context of Prague Circle activities, he wrote that "Poetry is present when a word is felt as a word and not a mere representation of the object being named or an outburst of emotion, when words and their composition, their meaning, their external and internal form acquire a weight and value of their own instead of referring indifferently to reality."[53] While discounting the referential function, Jakobson was, in addition, calling attention to the material components of signification, sound value.

Jakobson's ideas in the consideration of aesthetic function found an echo in the work of other theorists of literature and language for whom the question of the way literariness was constituted became a major area of critical inquiry. For all his attention to the poetic function of language, Jakobson resisted endorsement of an art for art's sake stance. Stating

that "none of us preaches that art suffices unto itself," he stressed that all "art is part of the social edifice." But the investigation of the social role of art, the ideological function and production of language, was not central to his analytic projects—at least, not to the degree sustained in the work of Bakhtin and Medvedev, and then Mukarovsky or Bogatyrev.

While the aesthetic function of language was being investigated in Moscow, a more intimate analysis of the sound structures in language was carried out in the St. Petersburg group.[54] Here the linguists worked under the influence of Baudouin de Courtenay's lectures on the function of sounds in language, and the research developed in different directions than those pursued by the Muscovite researchers. Between 1916 and 1921, for instance, Ossip Brik took up the charge of the *zaum* poet Kruchenyk that "sound was greater than meaning" and studied patterns of sound in poetic language. The conviction of the *zaum* poets that sound was capable of affecting the unconscious, of being directly apprehended and thus bypassing the rational modes of learned language, opened the door to investigation of universals in sound. Khlebnikov had been convinced of the existence of such universals, sounds whose primal value would affect the listener without recourse to meaning. While these concepts were inassimilable into a systematic linguistic analysis, the attention to the material character of sound as a primary feature of poetic language guaranteed attention to the expressive character of language in these groups.

Viktor Shklovsky, the theorist of prose language, Boris Eichenbaum, Yuri Tynjanov, and Boris Tomachevsky were all active in the St. Petersburg scene. Their interests extended to the investigation of what they termed the literary device, and their definition of a literary work came close to the idea that it consisted in "the sum of its devices." Attention to devices, as structural formations, and as linguistic, narrative, and literary forms made a contribution to the analysis of prose texts. The purpose of such devices was analyzed variously—Shklovsky stressed the capacity of the revealed device to contribute the character of "making strange" while Tynjanov was concerned with the literary system and the device as a system-dependent operation. But sound as material, poetic phonetics and self-conscious attention to device became cornerstones of the methodology the Formalists bequeathed to the Prague School.

A major critique of Russian Formalism (allowing the term to be more inclusive than it technically is and extending, for instance, to Jakobson, though he never called himself a Formalist) was mounted in the late 1920s by Bakhtin and Medvedev. *The Formal Method in Literary Scholarship,* first published in 1928, both extended and criticized the

Formalist methodology.[55] Its arguments were for a sociological poetics, one which anchored the analysis of sound in ideology and attributed an ideological dimension to all artistic form. The Formalists were criticized for their indulgence in a poetic ideal, their preoccupation with inner form at the expense of attention to the activity of social mediation. Medvedev and Bakhtin, arguing for a Marxist approach to the study of literature and poetics, stressed the necessity to understand the ideological aspect of all form, material, and device. In their work, the concept of material necessarily included the Marxist sense of ideological value, one which was coded into substance, stuff, things, in a manner which contributed to their content in the production of meaning. Most important to Bakhtin and Medvedev was the central theme of history and the need to escape from the ahistorical method of Formalism. For them the idea that a literary work was merely "the sum of its devices" was tautological and vapid, and the analysis of device, sound value, and material form was only useful insofar as it could be used to demonstrate the interactive relation between specific works and specific circumstances of production. At the same time that they criticized the ahistorical character they perceived in Formalist methodology, they criticized the a-literary character they perceived rampant among Marxists and sought a synthesis. They felt that the Formalists had provided the means to achieve a higher degree of specificity in the analysis of literary form than had been previously possible, and Bakhtin and Medvedev built on this basis to establish the fundamentals of their sociological poetics. Through their work the concept of artistic and literary materiality acquired an ideological as well as a formal and theoretical character.

Roman Jakobson moved to Prague in the 1920s, as did Petyr Bogatyrev, and there the methodologies based in the linguistic analysis of poetics expanded into a wider field of cultural inquiry. The developments made in the 1930s by the critics in Prague continued their work in linguistics and semiotics and extended from the analysis of language into the analysis of such domains of human activity as folkloric costume, theater, music, dance, narrative, and the visual arts. This is in part attributable to the strong effect of the work of Bogatyrev, whose analyses of theater extended to all its many components, using a structuralist methodology to do a semiotic analysis of nonlinguistic forms. In his work in the 1930s, Bogatyrev was attentive to the manner in which elements of material reality were transformed into signs.[56] Pointing out that not all elements of, for example, costume were signs, he worked to define the processes by which they acquired a semiotic function. The relationships he posited were between material fact and systemic relations, noting

that only objects/things/material which functioned under systematic constraints could be signs. The difficulties of using a structuralist method based in linguistic analysis to understand the semiotic operations of other media were only hinted at in these early essays.

Bogatyrev, Jakobson, and Mukarovsky all turned their attention to visual elements, and Jakobson's famous essay, "On the Distinction between Visual and Auditory Signs," and the Mukarovsky essays, "Art as Semiotic Fact" (1934) and "The Essence of the Visual Arts" (1944), called attention to the material specificity of each medium and the contribution of that material to the differences in meaning production in visual versus verbal arts. Mukarovsky, in the earlier of these essays, referred to the signifier as the "perceived" aspect of the sign—no longer abstracting and dematerializing as had Saussure's very mental concept of the acoustic image. The constitution of the sign, and the production of signification, were made in collective consciousness and took into account the "total context of social phenomena."[57] Mukarovsky didn't take up pictorial materiality at length in this essay, being more concerned to promote the concept of the necessary links between sign and context as the basis of his semiotics. But in the 1944 essay, he discussed material as the primary means by which one art form was distinguished from another. The visual arts, for instance, were "tangible, inorganic and unchangeable" by contrast to music, literature, and dance.[58] He then went on to elaborate on the role of material saying it was "not a merely passive basis of artistic activity, but is an almost active factor that directs the activity and constantly intervenes."[59]

The idea that materiality was more than a vehicle, an idea which had been central to (if not fully articulated in) Russian Formalist analyses of sound, became most clearly discussed in the late Prague School writing of Yuri Veltrusky. In "Some Aspects of the Pictorial Sign" (1973), he wrote that "the materiality of the *signifiant* [signifier] affects considerably the specific way in which the picture conveys meaning." Veltrusky at that late date, drawing on the work of Meyer Schapiro as well as on the Prague School precedents, discussed the difficulties of assessing what might constitute a visual sign. The lack of clear boundaries and "units" in the visual arts (as, in fact, pointed out by Emile Benveniste, was true in almost all cases except linguistics) and the distinctly "intrinsic" characteristics of color (that they receded or came forward on a picture plane merely by virtue of their pigment) distinguished visual from verbal signs. In addition, visual signs could function in relation to a referent through analogy and similarity, as well as through the kinds of nonmimetic relations which had been the subject of Schapiro's work in "On Some

Problems in the Semiotics of Visual Art: Field and Vehicle in Image-Signs." The complexities of analyzing visual elements according to a semiotic method were many, but what visual arts had to offer to semiotics was a clearcut case of the role of materiality. The difference between the "meaning" of a statue carved in marble and the exact same image carved/cast in soap or wax made this clear—while such a distinction was harder to conceive of in linguistic forms.

But it was the work of the phonologist Nikolai Trubetzkoy that had the most direct influence on the development of semiotics and structuralism in Paris. Trubetzkoy's *Principles of Phonology*, published in Prague in 1939, was translated and published in France in 1949. Ladislav Matejka points out that Trubetzkoy made use of certain features of Bogatyrev's work, appropriating some of his methodological principles for analysis of folk costume. Matejka states that these became seminal instances of semiotic analysis in their influence on the work of Roland Barthes, whose own semiotic works began to develop in the late 1950s (his work on fashion as a sign-system was first published in the 1960s, but the earlier *Mythologies* have a distinctly structuralist character). It is arguable that other influences can be marked in the French semiotic and structuralist development, not least of which are the developments of Hjelmslev's linguistics, Morris's semiotics, and the closer to home contributions of Claude Lévi-Strauss, as well as the direct reading of Saussure and Marx and the host of other intellectual works which had spun out a critical methodology from similar and shared source materials.[60] But the direct relation between the development of French structuralism and Prague School semiotics links the strict concept of sign/signification to this lineage, and with that lineage came a recognition of the role of materiality. It is also arguable that this concept of materiality remained undeveloped in a serious, systematic theoretical way, until the 1960s and 1970s, when it began to be more clearly articulated in the work of Julia Kristeva, Roland Barthes, and others. Assuredly, the shift of attention to the "play of signifiers" central to Derridian critical analysis necessarily required investigation of the signifier's material character.

But as the French semioticians developed their theory of the sign, the concept of the signifier they invoked was fairly banal. The definition provided, for instance, by the 1979 *Lexique Semiotique* of Josette Rey-Debove reads as follows: "The sensible part of the sign, which is linked to the signifier."[61] The very use of the French term "sensible" emphasizes the availability of the signifier to the senses, the processing of material phenomena, rather than the Saussurean abstraction. This signifier is not only not mental, it is clearly physical, tangible, and material. Roland

Barthes, in *Mythologies*, described the activity of a signifier in terms of a distinction between a black and white pebble (echoing the essay by Bogatyrev which invoked Theseus's sails as black = dead, white = alive signifiers whose materiality included their color as well as their usefulness as canvas sheets held to the wind).[62] Barthes wrote, "or take a black pebble. I can make it signify in several ways, it is a mere signifier."[63] The black pebble, a stone, a physical object, is being described here as a "mere signifier." Barthes takes the position that the signifier is essentially unimportant without a link to the signified, the signifier does not determine or evoke a signified, but is linked to it through arbitrary conventions. Nonetheless, the black pebble has a different effect in terms of its function than the acoustic/mental image: certainly its functional operation is only affected when it has a mental counterpart, but the signifier exists outside that mental construction, as a grossly material, physical object. It is not valuable in accord with its inherent material properties, but it does make use of them to operate within a signifying practice.

Umberto Eco put the credit for this shift from a Saussurean model of the sign, with its vaguely specified signifier and signified, on Louis Hjelmslev. It was Hjelmslev's insistence on the distinction between the plane of *content* and the plane of *expression* which granted a (partially) autonomous existence to the latter. The potential for manipulation of the realm of the signifier formalized by Hjelmslev's propositions was not, however, taken up by the Danish linguist himself. In fact, Hjelmslev was inclined to disregard the material properties of what he called the expression-form as insignificant instances, mere variants, of linguistic invariants. If the form of expression changed enough to be significant, to signify, then the expression was of a different content. As in the case of Saussure, Hjelmslev offered a theoretical possibility for examination of the materiality of the signifier but did not himself develop its potential. Hjelmslev even went in the other direction—asserting that it didn't matter what form the expression took—it could still be linked to the same content.[64]

Implications for the examination of the visual materiality of the typographic signifier exist in all of these semiotic and linguistic texts. But they are never clearly spelled out. The problems of incorporating both the concept of the arbitrary (or at least, conventional) character of the linguistic sign with the more complex features of the visual sign (whose very existence as a unit or bounded element is itself highly problematic) with its inherent qualities and infinity of possible variations, remains. Typography can be analyzed in semiotic terms, especially in the broader

terms set by the Prague School semioticians, with its stress on the social and historical limitations imposed on a sign system. Even though semiotics is a useful descriptive tool for typographic analysis, it remains locked into its own conceptual limitations.

Note that none of the above investigations challenges the metaphysical premises of the semiotically based linguistic sign, though they do establish a convention in which the materiality of the signifier is taken into account (and for granted) as a participating aspect of signification. The extent to which the activity of such materiality could be theorized within such work was limited by the structuralist orientation of semiotics—and it was this which was subsequently challenged by the developments in poststructuralist and deconstructive criticism.

Critiques of Semiotics and Structural Linguistics

Stepping back from the intimate details of Saussure's work and the foundation it established for semiotic analysis, it becomes evident that there are a number of points on which the semiotic method is open to critique, and also to comparison with phenomenology. The semiotic methodology is distinctly different from that of phenomenology. The structural aspect of Saussure's linguistics anchored his semiotic interpretations in a social frame: language was inherently cultural, ideological, and specific to a particular time and place; the structure of the sign as an abstraction he posited as universal, but all linguistic signs were specific to the system within which they gained value. However, as Jacques Derrida has pointed out, semiotics contained an unacknowledged transcendental aspect since it assumed that, ultimately, all signification was predicated on a fundamental assumption of the simple fact of *being*.

Edmund Husserl's phenomenology also contained this central premise. Dispensing with the systemic character of the structural mode of semiotics, Husserl proposed a philosophical method by which phenomena might be grasped in their essential form by consciousness. This central aim was articulated in "Philosophy as Rigorous Science" (1911) and remained the methodological premise of his phenomenology.[65] Husserl's concept of essence was nonempirical and nonpsychological, but in terms of metaphysics it also assumes *being* as a fundamental condition. Phenomenology as a method is less concerned with describing systems than semiotics (in its vogue it was applied to every conceivable social system) and provides a method for unmasking the assumptions

which underlie any conscious interpretation of experience. While not strictly speaking Husserlian, phenomenologically based practices, that is, those which attempt to apprehend the essence of an image or object through interpretation that is not strictly empirical or psychological, are widespread in the history of aesthetics and art criticism. In a very general sense, the formalist methodology of art historical practice, any methodology which does not proceed from an iconographical or social analysis, has to some extent been premised on phenomenology. The British aestheticists, Clive Bell and Roger Fry, establish this premise early in the history of the formalist method, since they divorce the study of the visual object from history, from context, and from social conditions in order to privilege its form. The assumption that this form is apparent, apprehendable, and inherent in the object misses the phenomenological emphasis on the consciousness of the individual subject which, for instance, Michael Fried would return to the formalist method at midcentury. But it can be argued that early formalism operates on a phenomenological basis without acknowledgment, though it claimed to proceed from the positivist base of nineteenth century objective inquiry.[66]

What semiotics and phenomenology shared with that positivism was a desire to scientificize and purify their methodology. While Saussure's linguistics, engaging as it does with the complexities of actual language, cannot achieve the scientific objectivity of his semiotic predecessor Charles Peirce (whose semiotic was conceived of as a form of logic: an analysis of relations), it nonetheless aims at establishing a systematic basis for understanding the function of language at a macrolevel and microlevel: from the rules of *langue* and the limits on *parole* down to the organized structure of the phonemic elements.[67]

Where semiotics and phenomenology differ—and thus open the way toward two very distinct approaches to interpretation—is in the conception of value in the object. Phenomenological apprehension of an object is grounded in consciousness—in the operations by which the essence of a thing, experience, situation may be intuited. The semiotic approach denies the significant operation of individual consciousness, opting for the structure of the system as the basis for the production of value; and that value, in semiotic terms, is never essential, but always differential, namely, it is produced through relations of difference. The semiotic sign is never significant in itself or through substance, while the phenomenological is fundamentally essential, though only significant insofar as it appears to consciousness. It could be argued, demonstrated even, that the semiotic system of Saussure's structuralism leaves open

the possibility of individual subjectivity in the operation of parole. The Marxian critiques of structuralism insert this subject, but make it a subject whose individual existence is produced by the system (language, ideology, cultural apparatuses) which is external and self-sufficient in itself. The psychoanalytic critique of structuralism, by contrast, requires that the interior life of the individual, which is structured in and through language, be taken into account. This interior life must understood in relation to psychic drives and the idiosyncratic experience of, especially, the family narrative and cannot be accounted for only in terms of the social production of individual expression. Both semiotics and phenomenology resist historical specificity—for both, meaning is ultimately transcendent and guaranteed by what Derrida terms the fictive unity of Being.[68] The phenomenological approach "brackets" out the specifics of historical circumstances, while the semiotic approach as originally formulated simply did not take it into account. The various attempts at modifying semiotics into a model for Marxist analysis of culture and sign systems wrought some changes in this original formulation which will be discussed below.

Returning to the issue of written language, it is necessary to examine the primacy accorded speech in Saussure's methodology and its relation to the denigration of writing. Underlying this negative position is a sense that the written form has a basic impurity to it, a surrogate character. This is not merely the distaste of the linguist for the written surrogate of speech, but a basic distrust of that which threatens the authoritative circumstances of spoken language. Speech, in its utterance, has a time-based immediacy and purity because it is linked to a subject and situation. While Saussure did not factor such considerations into the production of meaning, his emphasis on speech was, in fact, an emphatic insistence on the singularity and unity of language. This supposition, that language's purity resided in the possibility of its unity and singularity can be understood as a belief in the concept of language as a presence, self-identical and without division. In such a supposition, the signifier and signified are necessarily indistinguishable in the utterance, as they occur simultaneously (supposedly).[69] Writing, the written trace, shatters this unity because it divides the utterance from an embodiment which cannot be one and the same as that utterance. The elaboration of the concept of linguistic unity as a metaphysical concept is the basis of both Derrida's investigations of Saussure in *Of Grammatology* and his critique of Husserl's concept of the sign in *Speech and Phenomena*.[70]

Derrida proposes that writing always renders linguistic unity impossible. The recoverable meaning (absent) of the written form of lan-

guage (a signifier in play with other signifiers) remains absent and also proliferates—or, to use Derrida's own term, *disseminates*. Without following the elaborate detail of Derrida's argument, I will make a brief summary: the gist of Derrida's position is that writing, which in Husserl's *The Origins of Geometry* was supposed to stabilize meaning as a memory device, fix it in permanent form, actually serves the opposite end.[71] For writing is already the embodiment of absence—the statement which is not present, no longer present at all, and, also, marks the absence of the speaker, the instance of speaking, and the circumstances of the utterances' production. The form of written language is continually open to interpretation, cannot ever be fixed (nor can that of speech, which, by demonstration through these arguments on writing, ends up subordinate to the arche-trace of writing in the grammatology of Derrida's analysis), and meaning will always proliferate through the play of signifying operations.[72] Commonly misunderstood as a free-for-all of meaning production, this play of signification is in fact delimited and demarcated strictly by the specific structure and character of a discourse—writing/language cannot "mean anything," it simply cannot be resolved into a closed and final meaning. One important aspect of Derrida's critique is that it demonstrates that the metaphysical proposition that language (as a signifying system) produces meaning as a simple fact (as *being*) is fictive. There are no simple facts of being outside of a metaphysics which is theological in character (or a theology which is metaphysical in character)—that is, a metaphysics which is ultimately defined by a belief in a transcendent condition of being as Being. The condition of being necessary for language to function as a pure system capable of producing signification as a simple fact only exists as a subset of this metaphysical belief. Thus, Derrida proposes that metaphysics itself must be rethought—in fact, he claims, brought to a close—through the realization that signification is a process, not a product, and meaning production a continual operation, not a condition of being.[73]

Both semiotics and phenomenology had at their center this metaphysical proposition. Writing, within the common perception which Husserl conceives, served as the means of fixing meaning in permanent form. Derrida redefines writing as *écriture* and acknowledges its fixity and permanence as the instrument of continual invention. What is interesting, however, is that Derrida stops short of returning to the study of writing as such and to the role of the mere and actual materiality of the signifying forms in the production of the disseminating signification which he proposes as writing's fundamental activity. This is not surprising—his intention was to effectively bring closure on the histori-

cal trajectory of Western metaphysics, not to propose a postsemiotic analysis of poetic or visual works. But there is also a gap in Derrida's position which remains problematic—because the concept of *écriture*, of writing as trace, which he defines as a process and continual coming into being of the conditions for signification (the *différance* of his vocabulary), does not contain a condition for the apprehension of materiality. In fact, Derrida's concept of signification is fundamentally opposed to materiality in the manner which it will be proposed below. Very simply, this is because the Derridian concept of signification as difference cancels the possibility of ever apprehending *substance*. The metaphysical basis for presuming the existence of material substance is dissolved, in Derrida's analysis, into the continual play of difference. There cannot be substance, and materiality cannot be interpreted as substance, since these activities are presumably based on the very metaphysics of being which Derrida is so intent to dismantle through the technique of the endless play of deconstructive difference.

The concept of materiality, then, cannot simply be grounded in a Derridian deconstruction. Nor can it, after Derrida's critique, return to a placid and unquestioning acceptance of the concept of substance as self-evident presence or being. The question of whether it is possible to posit the existence of material as substance without a metaphysics of presence lurking inevitably behind remains to be resolved.

The critique of semiotics did not derive only from a metaphysical basis within the deconstructive methodology of Derrida. There are other, important critical positions that raise issues which will be brought to bear on the concept of materiality: specifically, those brought by Marxian critics of semiotics and those brought by psychoanalytically influenced theories of language and culture. Both positions insist on anchoring language, semiotics, and signifying practices in a specific historical context and understanding signification itself as an ideologically coded activity. If Derrida offers a cogent criticism of the metaphysical assumptions underlying most theories of signification, he still does not offer a means to deal with either history or subjectivity—both of which are also intimately related to the operations of writing.

A systematic summary of the criticisms of the Marxist-based theoretical stance is outlined in Rosalind Coward and John Ellis's *Language and Materialism*.[74] While the reconciliation of literary and artistic practices with a Marxist analysis of culture has been a project weaving its way through most strains of the avant-garde in the twentieth century, the specific analysis of semiotics and structuralism from such a perspective is more circumscribed. The work of Roland Barthes, Louis Althusser,

and Frederic Jameson serves as a partial (selective) corpus in which these issues have been directly articulated.[75] While the initial critique of semiotics—its basis in idealist philosophy and belief in a transcendent condition of being—are fundamentally at odds with a Marxist analysis of the material conditions for the production of culture and ideology (in which any subscription to idealism is merely a repetition of the theological foundation of bourgeois religious beliefs), Marxism itself is a structuralist system of analysis.

The work of Barthes, Althusser, and Jameson also moves toward the inscription of a subject within the structuralist system. For much of his career, Barthes conceived of this subject as a product of the system, as an instance of the expression of the codes of language and signification, rather than as either the free-willed individual of humanism (which he countered) or the psychoanalytic subject of language (which really only appears in his last works).[76] Althusser, and Jameson writing in relation to his work in *The Political Unconscious,* saw the necessity for linking ideological production to a motivated, psychoanalytically complex subject as a means of explaining the efficacy of ideological form. Their work is poststructuralist in this regard: it goes beyond the mechanistic external character of the structuralist system and proposes an ongoing engagement with the unconscious of the individual as part of the apparatus of ideological production. The individual is no longer a mere instance of the cultural and social codes of the linguistic or ideological system, but an active and selective agent of ideological processes.

The fate of the semiotic sign in this poststructuralist analysis need not be subject to the same deconstructive critique as that raised by Derrida, though both Althusser and Jameson struggle to locate the processes of signification within a historically specific context. Still, the combination of Derridian *différance,* with its refusal of unified meaning, with a Marxist analysis of culture, which, at its core, asserts the existence of structures whose condition of being is assumed, contains certain obvious contradictions. One of the most important of these is the status of history. For if the process of signification is ongoing, and if it requires and engages and is continually produced through the participation of individual subjects, then to what extent are these processes themselves historically determined? Do they ascend to the condition of the transcendental, claiming a universality in their capacity to describe the conditions in which signification is produced? Or must they, themselves, be qualified and rendered context specific and historically delimited?

How to return language, writing, and signification to history? This is the problem of materialist Marxists who found in all of semiotics a

transcendence out of historical circumstance or social conditions of production. The timeless character accorded to language was anathema to the materialists, who posited instead an external apparatus for production and signification—that of the social and cultural codes. Writing and the problem of history: the very statement conjures the sound of huge rolling thunder behind this phrase, a portentous statement suggesting huge theoretical considerations rising as conceptual thunderheads from the innocent space of the page. But the paradox is that writing, which seemed to be about history, was in fact the cause of its disappearance, to some extent because of the separation of the document (expression) from its circumstances of production (indication).[77] This stance can be countered, however, by recognizing that the materiality of the document is part of that history and recoverable insofar as materiality is acknowledged as part of the document's existence.[78]

These questions had a very specific relevance to the problem of writing, since writing was considered to be the process which, functioning as an "incarnation" of the historical text, the transcendental is in fact set free.[79] Writing, as the basic tool and premise of history, set free the text from historical circumstance and allowed it to function with an appearance of this (transcendental) objectivity. Writing, according to Husserl, was not merely the evidence of objectivity, but its precondition—since it permitted the text to function as if it had a fully autonomous and authoritative existence. We shall return to this issue later with respect to the contrast in the literary use of the marked and unmarked typographic text and the manner in which these modes of production present the fiction of transcendent authority.

Julia Kristeva, in her discussion of what she called the speaking subject and the signifying system, also takes up the problems of history, ideology, and signification and offered certain unique contributions to this inquiry.[80] Kristeva's concept of the speaking subject is not the transcendent consciousness of Husserl's (and Heidegger's) phenomenology, nor the instance of articulation of the linguistic system of Saussure and Barthes, but a highly specific psychoanalytic subject whose engagement with language is a motivated one and a formative ongoing process. Kristeva refines the notion of subjectivity into the proposition that subjectivity can only be understood as positionality. The relation of elements—speaker, system, ideology, desire, power—to each other in a situation of articulation describes a position which the subject occupies. Subjectivity is inseparable from this position, and signification becomes the study of the specific conditions in which various positions are themselves defined. The historical specificity of such a theoretical model per-

mits it to describe very particular conditions, or what Kristeva considers a "historical typology of signifying practices."[81] Signification, in Kristeva's analysis, does not result in meaning any more than it does in Derrida's deconstruction. It is, like writing, a process, an ongoing production.

Kristeva differs from both the strict Marxist position and the Derridian one with respect to the analysis of signification because she insists on the historical specificity of the formation of the subject in terms of the relations of conscious and unconscious; because she offers a different conceptual description of the elements of signification—the symbolic and semiotic; and because she does not return her analysis of signification to the field of the signifier, as Derrida does, but continues to engage with a model of signification as a whole. For Derrida, restricting signification to the domain of the signifier delimited the play of signification and foreclosed the risk of transcendence (the signified always being the signified of Being). According to Kristeva such a restraint repeats the "formal gestures" of literary modes of interpretation.[82] If signification is engaged with subjectivity, and if subjectivity is describable only as a process of positionality, then the signifier cannot "play" by itself, it is put into play as part of the formative activity of the subject.

Kristeva's description posits the elements of signification as the semiotic and symbolic. Her distinction allows, as no other theory of semiotics, for elements which are extralinguistic and not coded within the structure of language as the symbolic to be included for consideration within analysis. The process she terms the semiotic is associated with the pulsions and drives of the pre-Oedipal condition of development, though it remains an active process in signification. By granting a place to this semiotic process, Kristeva is able to extend her analysis of signifying practices to activities of visual and kinetic rhythm, of material, of the range of experiences and expressions associated with the somatic realm.[83] The relevance of this to a theory of materiality is that it reincorporates into the system of signification elements which had been eliminated or neglected by classical semiotics. The symbolic process she defines in fairly standard psychoanalytic terms as the linguistic activity through which the subject is continually produced, but which effects the ongoing ideological formation of the subject as well. Kristeva insists on the complexity of relations of elements in the signifying system and of the historical specificity of these relations at any given moment or with respect to any particular literary or linguistic or artistic articulation. The subject and the signifying system constrain, but do not determine, each other, and the processes of signification are both historically specific and

also psychoanalytically motivated; the functions of language are not all-encompassing, but modified by the effect of the semiotic process. Kristeva's positing of forces and processes which escape the defining activity of the symbolic also engenders the possibility of subversive intervention through exercise of those forces.[84]

The Model of Materiality

A model of materiality which can answer the above critiques and function as a means of analyzing the processes of signification by which typography operates has to synthesize aspects from each of the above discussed positions. The result is a hybrid theoretical model which contains certain internal and irresolvable contradictions. The viability of the model depends, to some extent, on the degree to which these contradictions may be sustained without destroying the conceptual framework which unites them.

Such a model includes two major intertwined strands: that of a relational, insubstantial, and nontranscendent difference and that of a phenomenological, apprehendable, immanent substance. Each of these must be examined in turn, as well as the relation they have to each other in interpretation. The basic conflict here—of granting to an object both immanence and nontranscendence—disappears if the concept of materiality is understood as a process of interpretation rather than a positing of the characteristics of an object. The object, as such, exists only in relation to the activity of interpretation and is therefore granted its characteristic forms only as part of that activity, not assumed a priori or asserted as a truth.

Invoking the term materiality begs two questions immediately: that of matter, with all the self-referential attention to questions of production which were central to the activities of early twentieth-century art and literature, and, second, that of materialism and the discourses of cultural theory which index the analysis of the social conditions, contexts, and claims for political effects of signifying activity.

The challenge is to take into account the physical, substantial aspects of production as well as the abstract and system-defined elements. By proposing that materiality combine the two, a dialectic relation is assumed in which neither presence as substance nor absence as difference can ever be left fully alone; each continues to irrupt into the domain of the other and interfere in the happy play of signifiers and in the dismal

insistence on self-evident appearance. Typography and written language evidence clear physical attributes whose specificity can only be understood in relation to the historical conditions of their production. The material form of the trace, the embodied visual aspect which letters, words, inscriptions present as evidence, is always subject to the rules of linguistic usage and mechanical means which the culture has at its disposal. The historical inflection present in the visual, material form is largely significant (that is, capable of signifying) only to the extent that the form is part of a cultural code. A good example of this is the use of majuscules in relation to lower case letters, which come into play as a secondary level of distinction within written language only in certain alphabetic systems. Once in place, they function to different degrees and to different purposes, not by any inherent value. However, by virtue of their size, or in the virtual form of their greater visual stature, they distinguish themselves as more than the minuscules—not a natural hierarchy, but one communicated as value in physical form, this relation of "moreness" or "greater than" is apparent and is grasped through apparency, through substance.

The notion of relational difference and insubstantial, nontranscendent processes also links the model of materiality to the cultural system of value production, places the analysis of form into the systems of meaning which both encode and reproduce ideological value. Writing, however, is not, as Husserl suggested, merely objective, or granted transcendent status through its autonomous condition of existence. It is, in fact, in the very stuff, substance, form of inscription that history and the situation of enunciation enter into the linguistic process. There can be no separation of writing, any instance of inscription, from the material conditions of its existence. A document may be lost, translated, reconfigured in written form and then bear evidence of a new and different historical moment, but the material fact of history is always part of any written text. The relation of individual subjectivity to written forms is more complex, since the spectrum of writing reaches from the highly individual (in fact, index of individuality as personality) realm of handwriting, to forms which resist the inflection of individual subjectivity—metal type and computer printout. At that latter extreme, subjectivity becomes linked to the linguistic properties of enunciation and to the situation of production (access to equipment, social position, skill level, technical access, enablement, etc.).

The very concept of difference forecloses any production of signification not predicated on the concept of culturally based operations. As it rejects inherence and essence, it depends on a framework within which

value and signification can be established. The relation of the process to the framework is one of dependence—and, again following Kristeva, has to be further qualified by a description of the specific opportunity afforded by a set of historical circumstances for such a relation to have its particular form. This relation is neither the product nor the producer of ideology, it is the very formative operation of ideological value. Thus the concept of relational difference must take into account the specific structure of the system within which signification is produced, the position of the subject and opportunity for articulation within the system, restraints and conditions of production, all of which in sum begin to describe the specific ideological formation of value. Several major difficulties exist in establishing a semiotic basis for the analysis of visual images: one is that images are infinite, rather than finite, elements and belong to an open-ended, not closed, system; and second, the issue of what constitutes and bounds a sign is highly problematic. Unlike language, in which words, letters, phonemes, and morphemes have clearly defined identities and where rules of grammar and syntax are at least identifiable, the visual domain has no set rules for defining what elements within an image are "signs" and which are not and what the grammar of their relations might be.[85] Images and visual forms do, however, function through their capacity to produce difference, but their value cannot be determined through the finitude of a systemic structure.

The investigation of phenomenological apparence must also, contrary to Husserl's transcendent and disembodied concept of consciousness, be linked to a specific historical moment. But the stuff of apparency, the matter of production, cannot be contained within the relational aspects of the signifying activity. The force of stone, of ink, of papyrus, and of print all function within the signifying activity—not only because of their encoding in a cultural system of values whereby a stone inscription is accorded a higher stature than a typewritten memo, but because these values themselves come into being on account of the physical, material properties of these different media. Durability, scale, reflectiveness, richness and density of saturation and color, tactile and visual pleasure—all of these factor in—not as transcendent and historically independent universals, but as aspects whose historical and cultural specificity cannot be divorced from their substantial properties. No amount of ideological or cultural valuation can transform the propensity of papyrus to deteriorate into gold's capacity to endure. The inherent physical properties of stuff function in the process of signification in intertwined but not determined or subordinate relation to their place within the cultural codes of difference where they also function. Subjec-

tivity as taste, whim, preference—no structural system can account for this, and it exists. The point is not to force Kristeva's semiotic into binaristic opposition with the symbolic, but to see the two as intertwined, to understand materiality as the simultaneous operation of both, not independent of each other except insofar as their theoretical apprehension requires that each be discussed in relation to different factors in the signifying process.

The implications of this model of materiality for analysis of writing and typography is probably best examined through application. But before proceeding to an analysis of typography according to this model of materiality, it seems useful to consider the way materiality was conceived of in the theoretical writings and practices of early twentieth-century artists and writers.

Summary and Conclusion

In that area of human activity which came to define itself as the science of linguistics, particularly structural linguistics, the theoretical description of the sign required attention to and developing dependence on the materiality of the signifier. The idea that writing, written forms, possessed their own specific materiality, however, was articulated only by poets, practitioners, and never by those professionals with an investment in maintaining the subordinate, passive role of writing. For linguists, writing, and its subset, typography, had no distinct function. The authority of language resided in its capacity to signify, not its mutability. It is this attachment to authority which kept most writers attached to pedestrian conventions of production. The threat to linguistic authority made by the manipulation of the words on the page was that it returned the written language to the specific place, instance, conditions of production—it became a highly marked text. The unmarked text, the even gray page of prose and poetic convention, appeared, as it were, to "speak itself." Its production codes lent the text a transcendent character. The text appeared, was there, and the unmarked author was indeed the Author of the Text as pure Word—with all the requisite theological resonance.

So, though linguists could not recognize the visual material of the linguistic signifier sufficiently to theorize its active role, poets both theorized and practiced the manipulation of typographic language. Meanwhile, the semioticians whose point of departure had been structural

linguistics but who had broadened their area of inquiry to scrutinize theater, costume, visual images and music, while they preserved the linguists reticence where typography was concerned, nonetheless developed insights into materiality which laid the groundwork for later evaluation.

It hardly seems important at the remove of the better part of a century to demonstrate convincingly that the typographic signifier is an identifiable and describable entity with particular characteristics and effects. That seems evident, even obvious. That it took so long, and that the investment in ignoring its functional operation, its effectiveness and affectiveness, within the linguistic profession, is the more telling point.

Meanwhile, however, the philosophical investigation of writing placed a high priority upon its material function—Husserl's *The Origin of Geometry* depended for its conception of history upon the materiality of written forms of language. In other areas as well, the popular games of psychics, the legal domain of graphological analysis, the developing study of ancient languages, and the realms of advertising and graphic arts, writing had come to be recognized, granted autonomous and distinct status.

It remains, however, to examine the ways in which the theorization of both poetic and visual materiality within the arena of modern arts practices was conducive to and supportive of the typographic experiments which are, arguably, one of the distinctive features of early twentieth-century modernism.

■ 2

Visual and Literary Materiality in Modern Art

Typographic experimentation in early twentieth-century modern art partakes of two independent and very differently structured disciplines: the visual arts and literature. The conceptual underpinnings of these two domains throughout the period from the turn of the century through to the mid 1920s, in which typographic experimentation flourished so conspicuously, need to be established if the practice of typography is to be understood. Within the mainstream of what is known as the avant-garde in this period—Futurism, Dada, Cubism, Vorticism—typographic experiment was uniquely suited to express the cross-disciplinary approach to representation which formed one of the central tenets of much artistic practice. In this burgeoning of cross-disciplinary, sometimes synaesthetic, activity typography participated in the investigation of both visuality and literariness and in the characteristics attributed to both the *imago* and *logos* as representational modes. An assertion of the self-sufficiency of both visual arts and literature as nonreferential, replete, and autonomous was dependent on the concept of materiality: the relations between form and expression, between matter and content, were assumed to depend largely on the capacity of the image, the poem, the word, or the mark to *be,* to exist in its own right on an equal stature with the tangible, dimensional objects of the real world.

This insistence on the ontological status of what had been consid-
ered representation as equivalent to the status of real being was theo-
rized in the work of a number of artists and writers within the various
groups and circles of avant-garde activity. The aims of these are as varied
as the locations and dispositions of their authors. The concept of mate-
riality which surfaces in the 1912 essay by Kandinsky, "Concerning the
Spiritual in Art," is at variance with that proposed by Albert Gleizes and
Jean Metzinger in Paris or Filippo Marinetti in Milan in 1912 as well.
There is no homogeneous synthesis available from these dispersed and
disparate positions. But there is a single common central theme of at-
tention to materiality as the basis of autonomous, self-sufficient replete-
ness so that artistic forms are considered to *be* and not to *represent*. The
concept of being, in terms of an artistic object, generally depended
upon a belief in the inherent characteristics of the material means of its
production, but the semiotic notion of differential meaning can be lo-
cated within the theoretical discussions as well, though in less clearly
articulated terms.

The Legacy of Mallarmé

The aesthetic legacy of Symbolism played an important part in the de-
velopment of early twentieth-century art, and this is nowhere more true
than in the influence of the prominent Symbolist poet, Stéphane Mal-
larmé. A *Throw of the Dice* stands as the single most striking precedent
for avant-garde experiment with the visual form of poetic language. The
radical work was first given a published typographic treatment approx-
imating Mallarmé's original sketches in 1914. The enigmatic text of the
poem, rendered doubly complex by the graphic, spatial, visual inscrip-
tion, remains a touchstone of both historical and aesthetic reference for
all subsequent twentieth-century typographic experimental poetry.
While the poets to be discussed in depth in the next chapter were less
concerned with the metaphysics of the *book*, which was central to Mal-
larmé's project, and more interested in the politics of poetic and graphic
form, all of them had aesthetic links to the Symbolist tradition, even if
only as that mode from which they sought to distance themselves. Ma-
rinetti, Apollinaire, and Zdanevich, in particular, were aware of Mal-
larmé's as the prominent voice of the preceding generation, and they
almost universally owed key features of their own aesthetic practice to
his theoretical vocabulary.[1] Not surprisingly, the aesthetic premises of

their approach to materiality are closer in sensibility to that of the Symbolist poet than are those of Tzara. Marinetti and Zdanevich, in particular, stayed within an intellectual tradition in which the synaesthetic properties of material form were considered fundamental to poetic practice.

The late work of Stéphane Mallarmé can be considered the demarcating point from which modernity, as a radical rethinking of representational strategy within the field of poetics, comes into being and comes before a literary audience, especially within the francophone poetics of much of Western Europe and Russia.[2] Many aspects of Mallarmé's work bear directly upon the creation of later avant-garde experiments in typography in spite of the marked distinctions between his aesthetic intentions and those of the early twentieth-century writers whose work will be the focus here.

First, and most literally, there is the bold fact of his having made use of the possibility of visually scoring the poetic page by the use of different sizes and fonts of typographic letterforms. Mallarmé's work in this regard is unique and without precedent within literature. The literary form in which visual play with typographic arrangement existed prior to the sketched out plan for A Throw of the Dice was the pattern poem.[3] The reductive iconicity of these works, with their limited pictorial imagery and generally popular or religious tone, was a far cry from the abstract metaphysics of Mallarmé's work—as indeed were the display techniques of advertising typography which may have provided the visual inspiration for the hierarchization of the text in A Throw of the Dice.[4]

Second, Mallarmé clearly distinguished his poetic practice from the quotidian forms of language in use in the mass media of the press, as did other Symbolists, namely, Baudelaire, Verlaine, and Rimbaud. Literariness as such began to gain its definition in this period more through its distinction from pedestrian usage than through prescriptive literary formulas. Differentiation and negation, a sense that poetry was in part defined by a contrast with what it was not: this harbingers the typically modern definition of artistic practices as self-consciously situated within cultural contexts where they gain their identity through contrast. Such a definition marks out the activity of resistance as a fundamental task for aesthetics. Here the avant-garde evidences clear dependence upon the bourgeois culture against which it is defined, functioning as the protected arena for discourse otherwise lost within the emerging culture of industrial capitalism. Mallarmé's disdain for journalistic writing, combined with his ambivalence about the success of newspaper as a popular

form, embodies the strategic paradox of the avant-garde whose elitist aesthetics alienated them from the very masses to and for whom they wished to write.

Third, Mallarmé clearly dissolved and subverted the enunciation of the individual subject, which had been central to romanticism, thus rendering problematic the relation between individual authorship and subjectivity.[5]

Many aspects of the poetic activity of the later avant-garde were not represented in Mallarmé's work, most particularly the political, anticlassical and antihistorical tactics of such writers as Wyndham Lewis and Tristan Tzara, whose aims in the 1910s could not have been further from the idealist metaphysics of the Symbolist poet. But Mallarmé's work laid the foundation for the orchestral verse of the Russian poet Ilia Zdanevich, for the antisubjective work of Marinetti, and for some (limited) aspects of the figurative presentations in Apollinaire's work. Other aspects of the symbolist aesthetic, especially notions of synaesthesia and correspondence, had a transformed legacy in the distinctly different treatments of the Russian and Italian Futurists.

The spatial and visual manipulation of the poetic text desired by Mallarmé in *A Throw of the Dice* embodies a curious paradox.[6] On the one hand this poem, the most hermetic of Mallarmé's works, was the expression of his desire to " . . . break away completely from the phenomenal world and toward a poetry of absolute purity."[7] But on the other hand, in the process of bringing forth an idea in form in order to render it perceptible, Mallarmé invested in a highly material practice. He manipulated the typographic form, paying close attention to its visual features, spatial distribution, and capacity to organize the text into a hierarchized figural order. Antimaterial though he may have been in his intentions, his means, in this work, suggest the possibilities for a materially investigative practice.

The typographic features of this work can be readily enumerated, though the interpretation of their effects remains resistant to any closure. This is, in part, due to the complexity added to the work by the manipulation of material means and, in part, owing to the already fully abstract character of Mallarmé's language. In fact, Mallarmé chose to use only one typeface, Didot, a classic and simple face without undue decoration in the serifs, or extreme thick/thin variations, or oblique angling of the counters (open spaces in letters like "a") or extreme descenders or ascenders (on "p" or "d"). The typeface, then, was relatively neutral—unlike the more fussy appearance of the Elzevir face which had been used for the first publication of the work—and Mallarmé em-

ployed it in both roman and italic and in a range of sizes. In spite of his stated love of poster art, he restrained his choices, keeping to one typeface and to text sizes, rather than those large letters used for display.

Mallarmé employs the type to separate the text into several registers, to link elements of the work throughout the entire sequence, across pages, gutters, and spaces, and to make figures or ideogrammatic constellations of words upon the page. In the process, he allows the roman face to take advantage of its more strictly vertical form as visually stable and the italic to use its forward slant for dynamic contrast. The separation of registers begins immediately, in the first lines of the poem, which also serve as its title. The words "A throw of the dice" ("Un coup de dés") stand alone on the first recto page. The next turning or opening (the double-page spread in a book is known as an "opening" and includes the verso on the left and a recto side on the right) only contains type on the right page (figure 1). This text begins with "never" ("jamais") in the same point size as that of the opening words. This opening phrase is picked up in the fourth and eighth openings, to be completed by the words "will abolish" and "chance" (figure 2). By visually linking these elements Mallarmé stretches the sentence across other textual passages, keeping the syntactic closure suspended. The visual clue allows the phrase to be read intact, but only in relation to the rest of the poem, which serves as a field of other figurative elements while also providing a context for this phrase. While poetry regularly makes use of recurrent themes, suspended and fragmented elements which reconnect in associative processes, one of Mallarmé's unique contributions is this visual marking of themes to force the connections.

As the smaller size of roman letters proceeds, the axis of each page develops as the center of a sequence of dynamics. The words move forward and downward on the page, following conventional reading patterns, but they do so with the effect of creating a central axis on which they balance or hang, also suspended. This is an effect of graphic design, as well as a tool, and the layout mockups for even the most banal of commercial printers always attended to the various axes established through the visual centerpoint, or balance line, of lines of type (figure 3). With the advent of highly coded rules for asymmetrical typography in the 1920s, this sensibility would be subject to serious discipline. In the 1890s there was more tolerance for the combination of centered and off-center blocks of type within a single document, and the tensions which arise from having multiple axes of balance in a piece are made use of in Mallarmé's arrangements. One of the effects of this is to provide a spatial illusion, as if the elements of language achieved their relative size on the

JAMAIS

QUAND BIEN MÊME LANCÉ DANS DES CIRCONSTANCES
ÉTERNELLES

DU FOND D'UN NAUFRAGE

Figure 1. Page opening from Stéphane Mallarmé's *Un Coup de dés* (Paris: 1914); the 1914 edition in accord with Mallarmé's notes.

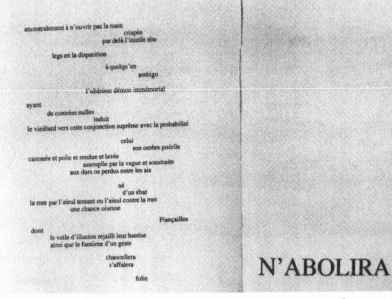

ancestralement à n'ouvrir pas la main
 crispée
 par delà l'inutile tête

 legs en la disparition

 à quelqu'un
 ambigu

 l'ultérieur démon immémorial

ayant
 de contrées nulles
 induit
 le vieillard vers cette conjonction suprême avec la probabilité

 celui
 son ombre puérile
 caressée et polie et rendue et lavée
 assouplie par la vague et soustraite
 aux durs os perdus entre les ais

 né
 d'un ébat
 la mer par l'aïeul tentant ou l'aïeul contre la mer
 une chance oiseuse

 Fiançailles

 dont
 le voile d'illusion rejailli leur hantise
 ainsi que le fantôme d'un geste

 chancellera
 s'affalera

 folie

N'ABOLIRA

Figure 2. Page opening from *Un Coup de dés* showing the continuation of sentence from second page opening. (Stéphane Mallarmé, *Un Coup de dés*, Paris: 1914)

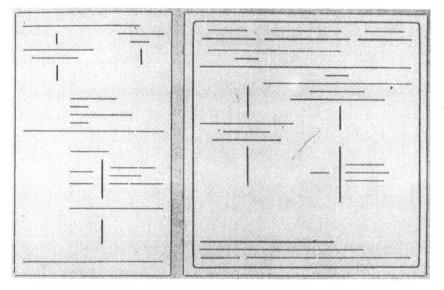

Figure 3. Pages from a journal produced for the advertising and commercial printing trades showing various "axes" according to which pages may be structured.

page by a contrast of real, physical weight and the optical effect of distance. As in the case of a stellar constellation, the appearance of the words as figures on a flat plane seems to be the result of their having been schematicized on a single picture plane, rather than of their actually existing in the same spatial plane. Thus the changes in size create an illusionistic space as well as a graphic and abstract *espace* within the white blankness of the page.

Insofar as figures are created in Mallarmé's poem, they are abstract and dynamic, registering the movement of the listing ship and the scintillating vibration of stars, rather than charting any literal course through seas or heavens or providing any iconic point of reference for the text. Mallarmé's concept of the figure is itself already so abstract that his engagement with the manipulation of material to figurative ends increases that antimimetic ordering. It is in part for this reason that the work is so resistant to interpretive closure. The "figures" refuse to be read in terms which might reduce them to an equivalent either named or sketched. The textual elements forge links of meaning in their visual and verbal relations but those relations function as their own gestalt, not as the trace or image of some other figurative form.

Mallarmé manipulates these typographic elements at every level. In one annotation of early proofs he requested a substitution for the letter "f" in a font where the top and bottom curls were not symmetrical. Line by line he adjusted spacing, as in the second turning where the first three lines, "SO BE IT / that / the Abyss" ("SOIT / que / l'Abyme") make a rapid descent, one from the next, emphasizing the downward fall, and then have that movement slowed in the continual movement of the next eight lines simply by the closing up of space (figure 4).

In every opening, the shape of the lines as a whole has been carefully attended to. In the fifth opening, for instance, the first and last lines, "as if" in both cases, act as two magnetic poles on the central figure, pulling equally in opposite directions, while the central axis is, in this case, the gutter of the page, returning the reader to the physical fact of the book's existence as well as to its literary form (figure 5). A fuller analysis of the links between page structure, typographic manipulation and poetic meaning in this work would elaborate the many levels of these connections.[8] But the poem is no more containable within a close reading than is a constellation available to closure as a figure through approach—from a distance the stars present the gestalt of a figure. Moving closer one moves through them, aware that the visual bonds which forged the figurative image dissolve into illusion. The figurative aspect of Mallarmé's work is similarly relational and dynamic, not fixed and closed.

Mallarmé's inspiration for the visual appearance of *A Throw of the Dice* derived in part from his negative reaction to the habits of reading formed in response to the daily press, to the tedious patterns of verbal presentation. Criticizing the mechanization of reading induced by these journals, Mallarmé staked out another of the tenets so essential to the avant-garde: that poetic imagination had to be rescued from the dulling effects of ordinary graphic and linguistic practices:

> Let us have no more of those successive, incessant, back and forth motions of our eyes, tracking from one line to the next and beginning all over again—otherwise we will miss that ecstasy in which we have become immortal for a brief hour, free of all reality, and raise our obsessions to the level of creation.[9]

This uncompromising criticism of the newspaper form was modified by Mallarmé's enthusiasm for its potential to produce surprise effects when folded, making unexpected juxtapositions from the conventional spatial ordering by which its reading was normally bound. Mallarmé's condemnation of the conventional book was no less severe:

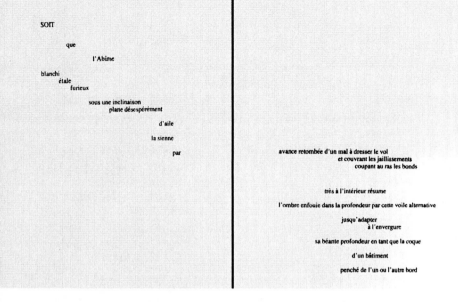

Figure 4. Page opening from *Un Coup de dés* showing both the use of spacing and the construction of axes of visual balance. (Stéphane Mallarmé, *Un Coup de dés*, Paris: 1914)

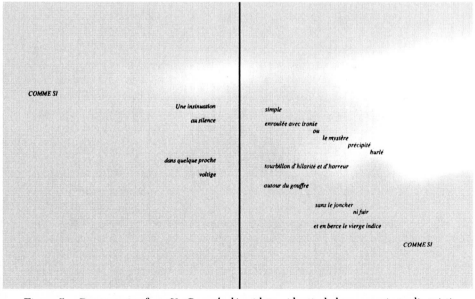

Figure 5. Page opening from *Un Coup de dés* with two identical phrases serving as linguistic and typographic poles of tension and balance on the page. (Stéphane Mallarmé, *Un Coup de dés*, Paris: 1914)

to the question of books which are read in the ordinary way I raise my
knife in protest, like the cook chopping off chickens' heads . . . [10]

Mallarmé's typographic plan for A *Throw of the Dice* emphatically un-
derscored the randomness and inadequacy of human thought and ac-
tion in the face of the Ideal. The constellation of phrases move into
figural relation to each other as the themes of shipwreck, chance, and
transcendence interweave. The shaped forms of the lines stand out
against the conspicuously marked white space of the page, activating
spatial and temporal relations outside the normal linear sequence of po-
etic lines. This complex format, as Penny Florence neatly states, "moves
thought toward the simultaneity of perception."[11] Designed as much as
an instance of the absolute, of the Idea, to be realized in poetic form for
refractive apprehension rather than reading in any conventional sense,
this work was designed to demonstrate Mallarmé's conviction that po-
etry was a serious instrument of ascesis through which a transition from
the daily world to the spiritual universe might be achieved.[12]

Mallarmé's dedication to the purity of the absolute and to the Idea
bequeathed a legacy to the early twentieth-century avant-garde that was
radically transformed, even among those Russian poets whose debt
to Symbolism remained so conspicuous. While rejecting the meta-
physics essential to Mallarmé, for instance, the poet and typographer
Zdanevich kept the conviction that there was an Ideal, a beyond-reason
and beyond-logic realm which was apprehendable through poetic expe-
rience. Poetry must, in Zdanevich's view, reject the habitual patterns of
ordinary speech, embody essences that are emotional, sexual, and uni-
versal in nature, and be presented in a visual form which reinforced the
effect of their verbal qualities. The concerns Zdanevich expressed the-
matically were of a different order altogether, as were the actual verbal
means he employed in the construction of his *zaum* verse. But impor-
tant aspects of the conceptual apparatus of Mallarmé's work are clearly
present: not the least of which is the conviction that through an inten-
sified attention to the material properties of poetic language a transcen-
dence from logic and the quotidian may be achieved. There are other
manifestations of the Symbolist legacy—the synaesthetic component of
Marinetti's work, for instance, vulgar though it is by contrast to Mal-
larmé's metaphysical poetics, is nonetheless derived from the Symbolist
aesthetic theory of correspondences, a theory which also depends upon
investigation of and recognition of the material forms of language.

Marinetti took up another aspect of Mallarmé's work, also trans-
forming it radically in both formal and conceptual ways—namely,

the repression of the lyrical subject which had been so essential to nineteenth-century poetics. The speaking author whose personal experience, inner life, was the source for poetic activity, is utterly absent from *A Throw of the Dice*. The metaphysical agenda precluded the personal; the realms of the absolute or the idea were without individual subjective inflection; they were beyond, outside, or so deeply interior to that subjective mode as to be without qualification by the experience of a mere poet whose humanity must necessarily pale in contrast to the enormity of the universal realm.[13] The absence of a lyrical subject within *A Throw of the Dice* is a marked one, and though, again, both motivations and manifestations were radically different, the conspicuous repression of the individual author as site of enunciation, as subjective source for the poetic experience, would be an important element of the early avant-garde, Marinetti and Tzara in particular, whose precedents are evident in Mallarmé.

The final feature of Mallarmé's work which demands recognition here is the use of a figural, visual, mode. This figuration is a kind of bringing forth, an appearance, that is radically antigrammatical. It does not derive from syntax or the tropes of speech which normally form a figure or image within language, but rather from the effect of language arranged to make a form independent of the grammatical order of the words. This arrangement is reinforced in the spatial distribution of the words on the page, but also, against the expectations of normative linguistic order. This concept of figuration belongs properly to the *presentational* rather than to the *representational*—to that order of visual and verbal manifestation which claims to bring something into being in its making, rather than to serve to represent an already extant idea, form, thought, or thing. A direct link is established through this between Mallarmé's poetics and the critical position developed on this point by Apollinaire, whose rejection of the representational mode depended upon the figural as its very foundation. This figure was not conceived of as something formed outside of language and then represented by it, but as something formed against and in spite of syntax— original, linguistic and/or visual, and nonmediate. While this formation in language works, for Mallarmé, as a means of access to the Ideal, it has no pre-existing referent and is not contained within the signifying structures of ordinary language.

Apollinaire had very different uses for this figurative notion than what is achieved in Mallarmé's work, where the concept of the figure was the very symbol of Symbolism—that elusive, hermetic, and ungraspable image which rejected the easy closure of meaning or gestalt. But

the concept of figure as that which subverts and problematizes the structure of representation and its ontological basis is apparent in the constellation of phrases which constitute the complex form of *A Throw of the Dice*. That the work had its first typographically complex appearance in print in 1914 makes its relation to the historical avant-garde all the more clear. It was published and received in the context of an experimental avant-garde poetics for which Mallarmé's own theoretical poetics had provided the fundamental framework.

Materiality and Modernism: The General Problem

Any attempt to deal with "modern art" or "modern literature" as if the phrases designated any single or unified area of activity would fall immediately prey to just criticism: the study of materiality within modern art and literature can only be sustained on the basis of individual artists. But in spite of the above caveat against just such activity, a few generalities will be sketched in here with respect to the attitudes toward visual and literary materiality in modern art practices.

The critical writing and texts produced in the early twentieth century served any number of modern artists and writers to articulate a metacritical understanding of their activity. The modern period may be characterized as much by the appearance of this superabundance of metacritical texts as by the innovative forms of its artistic productions. These critical articulations offer considerable insight into contemporary attitudes toward the conceptual premises of visual arts and literature.

In the early twentieth century, practitioners of both visual arts and literature paid unprecedented attention to the specificity and formal properties of their media. In literature this meant there was an increase in self-conscious attention to the role of the letter, the sound, the word, the sentence, the phrase, the form—in short, all of those elements identifiable as belonging to literature and to nothing else. Likewise, in the visual arts, there were systematic investigations of color, line, form, mass, surface, plane, composition, and spatial illusion or lack thereof. This investigation was not merely a concern with pure formality of means. Instead, both the artistic work and the critical writing function as a metacritical investigation of the structure of visual and literary arts as signifying practices. Underlying the queries into the nature of visual or literary form was an interrogation of what constituted visuality and literariness in aesthetic and, later, social terms. In addition, these partic-

60

ipated in an investigation of the terms of signification, of assumptions about the nature of presence and absence, of image and word, *imago* and *logos,* as different orders of symbolic activity. The materiality of presence associated with visual form, which comes to be dogmatically codified by mid-century, was considerably modified within the early twentieth century, as was the equally dogmatic concept of an absent signified within the structure of the linguistic sign. The early twentieth century investigations of materiality in arts practices refused such reductive oppositions, and the proliferation of the hybrid form of typographic experiment is a testimonial to this stance.

On further examination it becomes evident that formal investigation of signification within early twentieth-century art frequently focused upon an inquiry into the effect of the material properties of the signifier in its relation to the signified. Most specifically, this signals a shift of emphasis from the plane of reference, meaning or content, which had previously dominated representational art, to conspicuous and general attention to the plane of discourse. This new emphasis allowed, encouraged, and depended upon a focus on materiality, though within each artist's individual practice these relations were differently construed.

To chart the role of materiality within modern art practice requires an initial mapping of certain historical and conceptual territory, and an accompanying suggestion of alignments and similarities linked certain groups and individuals and differentiated others. The plurality of factions, voices, groups which surface in the splintering field of modern art practice with its proliferation of *isms* distinguish themselves on the surface by their variety of styles, approaches, and even manifest aesthetic propositions. Beneath these differences of surface are even more fundamentally different aesthetic convictions.[14] Making a rather gross model of the major aspects of modern art according to this general teleology will provide a framework for these individual practices.

Michael Levenson, in his *Genealogy of Modernism,* makes a useful distinction between two major strains of modern literary activity in England.[15] His distinction separates those modern writers, such as George Moore and Henri Gaudier-Brzeska (who insisted upon the autonomy of art as a scientific enterprise capable of discovering universal and absolute laws according to a rational logic and denied the ultimacy of the human subject) from those such as Ezra Pound, T. S. Eliot, and Ford Maddox Ford who focused upon the subjective vision of the individual experience as contingent, transient, and particular. These distinctions are operative within the visual arts as well, and betray strong traces

of inheritance from late nineteenth-century Symbolism, Realism, and Naturalism.[16] A third category should be appended to Levenson's model: artists primarily occupied with a political, interventionist agenda who focused upon the conventions of systems of representation as the site of their operation. Each of these strains is identified with particular attitudes toward materiality in its crucial role within signification, ranging from assumptions about the inherent value of form, to form as an expressive trace of individual consciousness, to an analysis of form as social, contextual, and historical.

The first of these categories depends upon a rational process legitimating what is essentially a spiritual teleology, grounded in a belief in transcendence. This was the most direct descendent of the aesthetic positions inherent in Symbolism, with its attention to the particular phonetic qualities of words, the almost obsessive attention during the decadent phase of Symbolist art to the surface of the image, to color for its own sake, jewelled, encrusted, brilliant, excessive—all of this was at the service of the revelatory potential of material.[17] The organization of material elements in such a practice was grounded upon their faith in a capacity to reveal, through a set of procedures which they termed rational and logical, absolute universal truths. The role of materiality in such an operation is its capacity to facilitate the revelation of and representation of that truth, even more, to *be* that truth, the manifest form and site in which a truth may be sought. The Russian artist Wassily Kandinsky articulated his evident concern with such formal values in the visual art: "Art, in giving birth to material effects, endlessly augments the reserve of spiritual values."[18] The recognition that the attempted codification of formal elements into a systematic understanding of their properties, capacities, and relations is linked to a belief that through such a visual or verbal algebra the corresponding logical organization of the universe was being understood, represented, made evident through material codes. This spiritual practice, dependent upon notions of transcendent truth, placed a striking emphasis upon the investigation itself. The almost obsessive engagement of Kandinsky, for instance, with the formal elements of visual art, is not the result of "purely visual" or "purely formal" concern, for the work was conceived of as an agenda of investigation of a spiritual plane. The rigor and thoroughness with which this motivates an enumeration of the formal elements of the art practice puts a conspicuous emphasis upon the material of art itself.

Nowhere within the Symbolist aesthetic is there evidence of the same degree of organized investigation. That logic and ration are employed as the mode of systematizing the investigation on the material

plane, in combination with a belief that this will lead to the revelation of truth on the spiritual plane, is the telling point. The link formed between the practice of art and the self-definition of art as a science in the early twentieth century displays an attempt to legitimize its enterprise in the same fashion as other humanistic endeavors had done in the course of the nineteenth century. The legitimating aspect of science was, of course, that it was irrefutably predicated upon a belief in absolutes, in truth. For all its invoking of the notions of "spirituality" as if that were some mystical realm of occulted or obfuscated knowledge, the fact is that the methods of logical science and the guarantee of spiritual value all depended upon this same central notion—truth. Truth, in this sense, is not a referential value; a signifying practice which guarantees its own authority by pointing to the link between material investigations and their correspondence with universal laws is not taking those laws merely as a referent external to the sign system in which the material representation takes place. The truth value is assumed to lie within the sign, in the sense so aptly and exhaustively demonstrated by Jacques Derrida in his critique of the inherent truth value of the linguistic sign.[19] This applies to both visual and verbal signs since the structure of those internal relations is the similar—though one could argue that the visual artists would insist that their "truth" was even more pure for needing less translation, for being self-evident. The visual representations of "energy," "forces," and "form" in such a teleology would be considered representations of these truths in themselves, rather than the mere naming of them or pointing to them.

In the second strain of modernism, identified as subjective, the construction of art as a signifying practice is completely different. According to the subjective mode there is no possibility of truth or absolute value since the emphasis is upon the representation of individual knowledge, perception, or experience. Rejection of ultimate law or of its guarantee by scientificized practices of art, does not entirely dispose of the procedures of rational logic, but formulates their application and effect very differently. The implicit "ultimate" of the subjective position is, naturally, that of the individual subject, that contingent and phenomenological entity with its emphasis upon the transient nature of existence and fleeting sensations of perception of a continually changing world.[20] In such a conception, the notion of any fixed absolute was ridiculous, and the individual experience coded into representation attempted accuracy in that activity in relation to the processes of knowing, experiencing, rather than to any assumed *essence*.[21]

This subjectively oriented modernism contained a split between

those who attempted to render the experience and sensation of perception with mimetic accuracy, using that experience as a reference point, and those who were interested in making the work an *actuality* capable of evoking sensation in accurate and effective ways. For the first group, the work of art still had a representative function, and the "objective correlative" of Pound, with his stress upon correctness (and all that such a notion is based upon in terms of categories necessary for such correspondence to occur), the direct treatment of the thing, and accuracy to one's own perceptions is the striking evidence of this position. "The sign still pointed, but to this world, not to any other."[22] There is a complete rejection of a "strain after the ineffable" in this struggle, a total denial of the necessity for or even the possibility of transcendent truth. There is a continuum here along which a slippage occurs in moving from the notion of an accurately designating sign, with its capacity to function, as Pound said himself, as "the adequate symbol," to the notion of a presentational, creative mode. In characterizing Vorticism, Pound wrote that it was "the creative faculty as opposed to the mimetic"[23] while May Sinclair, in her advocacy of the Imagist position, wrote: "The Image is not a substitute; it does not stand for anything but itself. Presentation not Representation is the watchword of the school."[24]

The parallels to the statements made by Cubist artists and the writers, such as Reverdy, making contemporary statements about its intentions, are unmistakable, and the implications of the notion of presentation will need to be addressed for its problematizing of signifying practices and the strong emphasis it placed upon the *effective* presence of material form.[25] For now, however, the point is to notice the importance that this places upon the accurate and well-regulated use of the materials of poetry and painting. No longer responsible to absolutes, not serving the cause of universal laws, the material means had no less a job to do in the service of accuracy and presentation. The bylaws of Imagism were as dogmatically severe as the tenets of Marinetti's Futurist Manifestos pretended to be. The regulated order of the material plane devolved from the belief in its existence as an order of *being* in itself, in the presentational mode, and as a way of *knowing* in the subjective mode—individual, personal, and inflected.

But there is a conflict in the rhetoric of the practitioners of this position. On the one hand, the ontological status of the work as *being* relieves it of designatory functions; it *is* and produces sensation in equal measure as the world. On the other hand, it is to be an accurate presentation of (individual and subjective) sensation, mimetic, though nonfigurative, nonimitative in the conventional sense. The extent to which

such a conflict could be held within a single position is evident in the paragraph below, where Maurice Raynal seems unaware of the contradictory content of his statement:

> But the true picture will constitute an individual object, which will possess an existence of its own apart from the subject that has inspired it. It will itself *surround* everything. In its combination of elements it will be a work of art, it will be an object, a piece of furniture if you like; better still, it will be a kind of formula, to put it more strongly, a word. In fact it will be, to the objects it represents, what a word is to the object it signifies.[26]

That something simultaneously is, in self-sufficiency, *and* represents, is clearly contradictory. In both cases, however, the materiality of the signifier, whether it be word or image, is linked to its capacity to either evoke or designate sensation as it is transformed into a perception and that it in no case has a guaranteed truth value, only the relative value of accuracy within the experience of an individual subject. The emphasis placed upon materiality in this conception is no less rigorous or formalized than that of the spiritually oriented modern artists, but there is an evident tendency to retain certain figurative or referential traces within the image or the word which becomes distilled out, for example, of the Russian painters as they move toward clearly defined formal visual language or of Mondrian as he moves into complete geometric abstraction. There is a referent operative within this construction, that of either sensation, perception, or the world, which constrains the activity of the sign from the freedom to be the element of free play which a really presentational and creative mode would seem to both allow and require. It is bound by rules of designatory accuracy, subject to judgments upon its efficacy. Materiality becomes important as the arena within which such activity actually occurs, and the subjective modern practice is predicated upon the belief that it is a direct engagement with the *matter* of word and image that is the central activity of art.

A third strain of modern art practice was concerned with opposing the established social order through subverting the dominant conventions of the rules of representation. There was very little clear theoretical articulation available in the period from 1909 to 1923 of such a social critique in these artistic practices as there would be with the emergence of Surrealism and the work of Breton or, in another realm altogether, in the positions articulated by the Prague School semioticians. The Russian Constructivists had the most developed theoretical stance with respect to the possibilities of formal innovation as a political tool, a position which comes close to that of certain of the activist Berlin Dadaists in

the 1920s. But the works produced by the Dadaists in both Germany and Switzerland between 1916 and 1921, as well as some of the Futurists in both Russia and Italy, gave evidence of these principles in aesthetic form. The identification of the symbolic orders of language, image production, etc. as the primary site for engagement with political critique was a unique development within the practice of art, even as a manifestation of the so-called avant-garde. The use of such an approach certainly belongs to those artists associated with oppositional positions, whose rhetoric formulated strategies of attack or intervention consistent with such a conception. Such an attitude maximizes attention to the material properties of the signifier as the first, if not primary, line of attack. The Dadaist perception of the *order* of language or image as the site of the production and reproduction of a social order led these artists to subvert the normative modes of syntax, of the unified (and unifying) use of paint, of any of the systems by which a comfortable relation with signifying practice could be assured through familiarity with its formal devices.

There is a subtle line to be drawn here between the Dadaist engagement with the conventional forms of symbolic representation in order to subvert them and the aggressive rejection of aesthetics as such. In particular, in the work of Heartfield, Tzara and Hausmann, the systematic interrogation of the material aspects of convention led to formal innovations which in another context could have been considered artistic first and foremost. The distinguishing characteristic of this approach, however, is that it has as its primary agenda a political and social critique rather than having a purely aesthetic motivation. Rethinking the formal properties of visual and literary modes so that the logics of syntax, signification, and symbolic form could be subverted required engagement with material and innovative solutions. The symbolic order was so complicit in the destructive absurdity of so-called rational culture that artistic practice remained the one effective instrument for disruption of its normative practices. Intervention in the symbolic order as such offered the only possibility for action which could operate both *within* and *against* representational modes. A fracturing, fragmenting atomization of elements so that they could be recombined in sound poems, collage, assemblage, and performance was the result. In all of these, obviously, attention was paid to signifying practices in an attempt to pry them loose from their conventional relations or easy recuperation as readily consumable modes. This evident engagement with materiality as the site in which resistance could be produced characterizes the Dada rejection of the transparent sign in a practice whose politics are more readily appar-

ent as an aspect of the stance toward representation than that of either Cubists or Russian and Italian Futurists. The Dada activity foregrounds the ways in which value (signification) should be considered a process, rather than a product, as an ongoing activity of relations rather than an achieved form, however innovative.

If in the case of the Dada artists this investigation was unrigorous and unsystematic (almost necessarily, by definition, to continue the rejection of systematization in its false representation of rational order), then nowhere was the realm of materiality more prominently engaged, more foregrounded by that engagement, than in this realm of politically motivated art practice.

What becomes clear even in this generalized discussion of these three conceptual categories, which delineate a certain configuring of modern art practice, is that none of them manifest a concern for formal values for their own sake. The concern for truth, for mimetic accuracy and effective presentation, for intervention into the symbolic order of representational norms—none of these divorces the formal investigation from a motivation which has content or substantive value. It is therefore all the more astonishing to realize the extent to which generalizations about modern art have been manufactured to support its engagement with a supposedly pure formalism.

> Modernism turned its back on the traditional idea of art as imitation and substituted the idea of art as autonomous activity. One of its most characteristic slogans was Walter Pater's assertion: "All art constantly aspires to the condition of music,"—music being, of all the arts, the most purely formal, the least referential, a system of signifiers without signifieds, one might say.[27]

Debunking these generalizations and reshifting the terms of the discussion into the structure of relations among elements of signification within these art practices puts the discussion of materiality into context. The elaboration of individual artists' characteristic relation to the questions of formal manipulation can only be fully appreciated in relation to the premise that not only were modern artists not concerned with form for its own sake, as either nonreferential or nonsignifying, but that they were fundamentally engaged with a persistent investigation of the process of signification such that the relations between formal manipulation and content could not be dissolved. This engagement was manifested very differently by literary and visual arts, largely because of the inherent differences in the two as symbolic systems. The materials of language, which even at the phonemic level retain some associative

properties, remain referential to some or to a great degree, even in the case of sound poetry or concrete visual works, while visual materials (color, line, strokes) are more readily freed from referential value and certainly capable of slipping away from figurative organization or linguistic correlations generally used to pin down their ambiguities.

Attitudes toward Materiality in Modern Literature

In their 1925 *Foundations of Aesthetics*, I. A. Richards, C. K. Ogden, and J. Wood, delimiting the domains to be attended to in aesthetic evaluations, discussed "The Medium."

> Every medium has as a material its own particular effect upon our impulses. Thus our feelings towards clay and iron, towards the organ and the piano, towards colloquial and ceremonial speech, are entirely different.[28]

This blanket assessment of material, with its characteristically unspecific attention to either its motivation or actual performance can be found throughout discussions of art and literature from the early 1900s. However, defining an attitude toward materiality as it is either implied or articulated in the practice of modern poetics against which to examine the use of typography presents several problems. The mainstream of modern poetry in English and American writing can be traced to Ezra Pound and T. S. Eliot and the modernist approach to both writing and interpretation which descends from them, but the range of typographic experiment among the pages of any of these moderns, even in the pages of *Blast,* is limited. This is not to say that there was *no* such experimentation within the anglo-american tradition, but simply to note that in the early twentieth century typographic innovation played a modest role among anglophone poets.[29] The more interesting uses of typography occur among the Dadaists, and Russian or Italian Futurists, where efforts to clearly articulate a *poetics* occur chiefly among the various Russian Futurists and Formalists, who, like the Italian Futurists and French poets were largely informed by a late Symbolist aesthetic.

There is a certain lack of symmetry, then, between the areas in which modern poetics are elaborated and in which a characteristically modern attitude toward materiality makes its impact felt in the use of typography. Materiality meant something other than typographic manipulation to the anglophone poets of the first part of the twentieth cen-

tury, acutely aware though they were of the visual structure and appearance of the work on the page, while among Italian and Russian Futurists, Cubist and Dada poets, typographic manipulation became widespread.

Literature of this period focused its attention upon formal elements of language at several different levels: among the poets of *zaum*, Futurism and Dada, phonetic, phonemic, and graphemic components were the atoms of composition; among the Imagists, Cubists, and some Futurists (Russian and Italian)[30] the primary focus was upon the word, upon assessing syntactic arrangements, making precise and highly adjudicated decisions in the structuring of their work; among the Dada writers and some Russian Futurists, the prime aim was to wrest language from its conventional usage, to disorient the reader by a confrontation with the specific characteristics of the language through tactics of disorientation, defamiliarization, etc. In each case, the relation between this attention to the formal elements and properties of language articulated a motivation to produce either truth, meaning, or effect; in no case was signification ignored.

For the *zaum* poets of the Russian Futurist movement, the attempt to understand language at the fundamental level of sound was motivated by a drive to subvert the possibility of conventional meaning and its pedestrian concerns in order to provide access either to the categories of universals or immediate emotional activity. In this they were much engaged with the legacy of symbolism and the concept of the self-valuable word.[31] "It was symbolism that propounded the self-valuableness and constructive nature of the poetic word." As in the semiotically influenced characterization of Pavel Medvedev and Mikhail Bakhtin from 1928:

> The symbolist word neither represents nor expresses. It signifies. Unlike representation and expression, which turn the word into a conventional signal for something external to itself, this "signification" preserves the concrete material fullness of the word, at the same time raising its semantic meaning to the highest degree.[32]

In two significant essays written in 1912 and 1913, "The Word as Such" and "The Letter as Such," Velimir Khlebnikov and Aleksander Kruchenyk outlined the program of their poetic concerns. For Khlebnikov in particular, the intention to derive *from* language and present *in* language his systematic understanding of what he took to be the total logic of the universe focused his attention on the prime syllables of the Rus-

sian language as the atoms of meaning in a kind of absolute linguistic arithmetic.[33]

> A work of art is the art of the word.[34]

> . . . wisdom may be broken down into truths contained in separate sounds: *sh, m, v,* etc. We do not yet understand these sounds. We confess that honestly. But there is no doubt that these sound sequences consti- tute a series of universal truths passing before the predawn of our soul.[35]

For Khlebnikov, Kruchenyk, and to a great extent Zdanevich, these "truths" relate to a state of pure emotion, freed from the constraints im- posed upon them by social forms, able to be accessed by "appeals over the head of the government straight to the population of feelings . . ."[36]

The end aim of this blend of subjective and universal "truths," how- ever, motivated the Russian poets to a direct engagement with the physicality of language and of its written forms. In "The Letter as Such," Khlebnikov and Kruchenyk emphatically declared the impact of the visual form upon its meaning: " . . . a word written in one particular handwriting or set in a particular typeface is totally distinct from the same word in different lettering."[37]

What is under discussion in these works, whose influence upon Russian Futurism finds its echo throughout the notes of men as di- verse in their intentions and practices as Mayakovsky, Kandinsky, and Shklovsky, is not a "free play of signifiers" but a calculated attempt at manipulation of material elements such as that which surfaces in the Shklovsky's theoretically articulate position as early as 1919:

> [An] attack against both the traditional critical school, with its empha- sis on content and social meaning in literature, and the new Symbolist school with its emphasis on philosophy, mysticism and musicality. The Formalists sought a reinterpretation of literature that would stress the im- portance of purely linguistic elements and artistic devices: sounds and words, structure and style.[38]

This Formalist approach, with its more clarified objectives, aims, and mechanistic procedures, moved beyond the messy, somewhat chaotic and jejune activities of the Futurists with their attempts to loosen the word from its "traditional subservience to meaning"[39] (really its subser- vience to traditional meaning) while simultaneously insisting upon the importance of a direct link between sound and sense beyond the limits of reason or convention, and, in Shklovsky's case, the importance of structures in prose. The codification of linguistic approaches which

characterized the Formalist method is more symptomatic of the transition toward a modernist critical stance than it is of the more hybrid and heterogeneous modern art practice from which it drew some of its inspiration and some of its practitioners. But in both cases what is brought to the forefront is the impossibility of separating the formal element from its signifying effect.[40] While this is a somewhat reductive description of the relations between Russian Futurism, *zaum*, and the strains of poetic, linguistic, and prose analysis leading to Formalism, it has the purpose of indicating the framework within which Zdanevich's *zaum* conceived of its material concerns. There was rapid evolution within the wing of the theoretical group most closely linked to the Moscow Linguistic Circle of awareness that any aesthetic investigation necessarily had implications within the *social* (if not expressly *political*) realm in which the symbolic discourse (language, image, film) under investigation was operating. The Russian linguists closer to Opajaz, meanwhile, remained more engaged with the linguistic activity for its own sake (so-called) and with language study as an instrument for understanding the critical complexities of signification (with the linguistic domain serving as a paradigmatic example of the conceptual basis of production).[41] Attention to materiality, therefore, is intimately related to the social critique and utopian agenda of various of the Russian poets.

A concern with materiality also evidences itself in English modernism among the Imagists, whose formulation of the terms of their poetics displays the conspicuous manifesto, in their concerns with tone as well as with the prescriptive rules for production so characteristic of the period. The overriding concern of the Imagists for *accuracy* caused them to focus on the *formal* structure of the work as primary: "Modern poetry [. . .] is groping for some principle of self-determination to be applied to the making of the poem—not lack of government, but government from within."[42]

The terms of formality are *literary*, poetry must be self-conscious about its *poetics* if it is to succeed in defining itself as a new form, and the terms of those poetics enumerate themselves according to the properties of poetic language and composition. Briefly paraphrased, these include: direct treatment, minimal use of adjectives, a quality of hardness as if cut of stone, individuality of rhythm, the use of the exact word, etc.[43] These are all attributes of a spare and reduced accuracy, motivated in reaction to what the Imagists considered the verbal excesses of their immediate nineteenth-century predecessors. It is not merely the substance of these poetic ordinances that is significant, but their *fact*, their existence as a self-conscious regulation of poetic activity drawing atten-

tion to its means and methods, of poetry defining itself in terms of poetics. In terms of substance, the Imagist doctrine presents certain problems. The requirement of accurate designation, over and over again, is a concept which implies a representational relation between the present poem and an absent value. This further assumes an indivisibly present form, based upon the assumption that signification constitutes the complete fact of the work. We can repeat May Sinclair's statement here: "The Image is not a substitute; it does not stand for anything but itself. Presentation, not Representation is the watchword of the school."[44] And beside it put these statements of Ezra Pound's, first, on modern poetry, then Vorticism: "It presents. It does not comment." "Vorticism is interested in the creative faculty as opposed to the mimetic."[45]

This confusion, conflict between a self-sufficient presentational mode for poetry and a well-regulated representational mode does not negate the overriding insistence upon the relation of linguistic material to its value: "The Image, I take it, is Form. But it is not pure form. It is form and substance."[46] The primacy of the medium is evident, though never at the expense of its capacity to produce meaning according to the terms of linguistic operation—the word as signifier is still linked to the absent signified even if both are remote from any mimetic relation to the *world*. In writing of works of art at an exhibition in 1914, Pound wrote, "These things are great art because they are sufficient in themselves."[47]

It was this insistence on autonomy, self-sufficiency, which allowed such emphasis on the poem as structure and form to be sustained; again this is a question of ontological status, the poem is to *be*, rather than to exist as a vessel of form conveying or holding a separate meaning. Its beingness therefore refers only to itself, its existence as a work must be poetical, and, in accordance with the rules, sufficient and necessary to define its operations. But this idea applies equally to other works of art in other media, which also, necessarily, find their own identity according to the specificity of their medium. In the well-known cliche of literary history, Pound was searching for immediately apprehendable linguistic value replete with the resonant associations of the ideogram. The apocryphal tale of his misguided enthusiasm for Fenellosa's misunderstanding of the Chinese character links Pound's sense of the presentational to his insistence upon the "self-evident" quality of form in his writings on the visual arts. The modernist position would exaggerate this to an extreme, reducing the poem to its structural features, which, arguably, is

at odds with the modern insistence that the work is the presentation of emotions, perceptions, psychic events.

As modern poetry came into its own among the poets of Russian Futurism and the English Imagists, the poets Apollinaire, Reverdy, and Marinetti, writing in France and Italy, had their formation within the aesthetic crucible of Symbolist poetry, and the influence of Mallarmé as both poet and theorist remained dominant through the first decades of the century.[48]

> He recommended the dismantling of traditional syntax, insisting that the means of poetry lay in the inherent magic of its concrete components. The word was to be liberated from the matrix of centuries of syntactical accretions.[49]

Among the modern writers, Apollinaire, arguably the most prominent figure of the early part of the century in France, dismissed the mystical sensibility and concentrated on the concrete aspects of this procedure.[50] Apollinaire and Reverdy, as poets involved with both the practice of their own art and the critical discussion of the visual arts, make a convenient point on which to link the discussion of literary and visual domains. Both served to articulate very distinctly the notion of the *presentational* on which Cubism claims its ultimate aesthetic legitimacy. That there could be such congruent overlap between visual and poetic aesthetics in this period is proof of the extent to which the definition of the identity of both visual and literary arts was dominated by the unifying attention to the signifying presence of material. Again, it was in the decades after 1930 that the division between disciplines was reinforced according to the specific qualities of the media under discussion, not in the decades of the 1910s and 1920s in which artistic experiment blurred these boundaries.

One of the bases for Apollinaire's new poetic language was its attention to both the sonoric and associative properties of language. Apollinaire was a poet employing the grammar of ordinary speech,[51] but according to methods of collage and combination, which appropriated the material from daily life to present it in the form of cut-up juxtaposition, echoing the mode of Cubist collage and Dada poetry. This presentation of language as material, its capacity to be operated upon in the same sense as the visual stuff of newspapers, wallpaper, or cloth, is central to Apollinaire's sensibility. His early criticisms of Marinetti's reactionary mode, correctly perceived as such by Apollinaire in spite of their apparent radicality, demonstrate dramatically his rejection of the tradi-

tional role of language as representational: "The 'Words In Liberty' of Marinetti lead to . . . an offensive return to description and in this they are didactic and anti-lyrical."[52]

Description subordinated the poem to a meaning-bearing role while presentation allowed it full status as extant. The importance of this position in Apollinaire's sensibility becomes even more evident as it recurs thematically in his works on the Cubist painters, where the terms of a presentational rhetoric are convincingly argued as *the* distinguishing feature of modern art. "Cubism differs from the old schools of painting in that it is not an art of imitation, but an art of conception which tends toward creation."[53]

In his poetic practice Apollinaire anticipates many of the stylistic features of the Dada poets whose first works, in 1916 and 1917, proceeded from the collage and cut-up techniques of which Apollinaire was already making use.

The Dada poetics of Tzara are not only never stated clearly as a program, but the resistance on his part to do so demonstrates Tzara's desire to subvert systematization and theoretical metalanguage as an authoritative gloss on practice. The poetics he engages in the period from 1916 to 1920, as they are evident in the work produced in the pages of *Dada,* are aggressively materialist in their continual use of found fragments of language, recombined in radical disregard for the crafts of a tradition he disdained for both its rational and romantic claims. Tzara's poetics is one of continual *negation,* in which even the logic of a premise must continually be held for question, reversed, undermined, and ridiculed.[54] Tzara's poetics take the materials of language as the very substance through which an attack on the symbolic order of representation may be launched. Interference in the simple production of meaning is a central tenet of Dada as Tzara practiced it, and material is one of the means by which such interference may be effected.[55]

Attention to material in language has a heightened quality in the poetic metalanguage of this period, one which forces the terms of poetic definition into self-referential vocabulary vis-à-vis the actual elaboration of a *poetics.* This attention finds itself paralleled in the visual arts, where the discussion of material elements takes place within the larger frame of the evolution of the notion of the "purely visual." The character of this investigation in the modern visual arts is curiously consistent with that taking place in literature and, not surprisingly, the typography which was a logical and evident link between the two domains presented no conflict to either discipline. This would emerge when the modernist revision of this activity insisted upon a more rigid distinction between dis-

ciplines and an exclusive identity dependent on specific qualities of formal elements of each rather than on an aesthetic investigation of the terms of signification.

Materiality and Modern Art

Art *is* the exploitation of the medium.[56]

This clear attitude toward the process of signification had become one of the prevailing features of early twentieth-century art practice. Articulated earlier by Maurice Denis, this notion cropped up frequently in paraphrase throughout the early 1900s, such as in the following example from an English critic in the *Egoist*.

> The important feature of a picture is not that it represents or reminds us of a given object, however strange this statement may sound, but that it is a group of very complicated lines and colors arranged rhythmically. A picture is first of all a pattern and not just the reproduction of a certain thing.[57]

The idea that an image's primary mode of *being* was in its means of expression was already an important implication of both nineteenth-century realism's notion of "retinal truth" and the Impressionist continuation of the "scientific" investigation of optical principles in the production of works of visual art. But the extent to which the form was freed from dependence on any mimetic or figurative value in the rhetoric defending modern art at the beginning of the century was unprecedented in the history of Western painting. There are two important aspects to this: first, the increased emphasis on the investigation of material; second, the problematic relation with language which accompanies the development of a visual art making claims for its formal purity and visual autonomy. Discussion of the first aspect continues the themes of the investigation of materiality in literature, though the important differences between the way *materiality* is conceived of operating in two such distinct domains needs clarification as well. Discussion of the second foregrounds the emergence of oppositional distinctions between visual arts and literature which are later entrenched in modernism and which result in the exclusion of typography from historical and critical consideration.

A determined attention to free formal elements from referential

and representational constraints first manifests itself among various abstract artists of the early twentieth century. The 1913–14 compositions of the Russian artists—the Abstractionist Kandinsky, the Suprematist Malevich, and the Rayonnist Larionov—were among the first nonfigurative works to attempt to exemplify an aesthetic position in which reference was called, very differently in each case, into question. Simultaneously, in the decade following 1912, concern with what was termed *concrete* painting became evident in the work of the Orphic Cubist Robert Delaunay while a complete discussion of materiality was formulated in Cubist painting and the accompanying critical rhetoric with its insistence on "the idea of the representational autonomy of the pictorial means."[58] The Italian Futurists canvases were less prone to the degree of nonrepresentational abstraction which was found among Russian painters and among the various Cubist groups, but the Futurist studies of rhythm and movement and the Futurist use of collage abstraction demonstrated a sympathetic engagement with formal and material means.

As in the field of literature, the motivations which stimulated this concentrated investigation of form were varied. For instance, to begin with, among the Cubists three themes entwined in the investigation of the materiality of visual form: an interest in the inherent properties of color, an exploration of nonillusionistic formal composition, and an appropriation of fragments of real material or stuff into collage paintings.[59] Of these, the interest in color gained intensity from the Symbolists Gustave Moreau and Odilon Redon, whose canvases, with their encrusted excrescence of paint, pushed the use of coloristic indulgence beyond any evident meaning-bearing value.

Among the Orphic Cubists, Delaunay stands out as an artist concerned to examine the properties of color within a sensibility toward the visual which he stated was painting's only true concern.[60] But while the display of color and investment in its properties evidently beg the question of the visual, the general Cubist involvement with a rhetoric struggling to define an autonomous activity of representation engages itself with other, more subtle, issues of *visuality* and its materialist specificity. For if among the Orphic Cubists the quasi-mystical discussion of color as "energy," "pure form" capable of universal harmonies etc. prevailed, the analytic and synthetic approaches to Cubism detailed the guiding intention which generated their painting according to very different principles, largely centered on questions of reference.

Cubism wrenched the pictorial firmly away from reference to any transcendent plane or, also nominally, to any natural one: that is, it negated the concerns of both spiritualism and mimeticism, but did not

negate the referential function of the image or reduce it to nonfigurative formality. From the point of its advent, with the 1907 paintings of Picasso, Cubism passed through successive stages as an analytic tool for the description of a perceptual reality to a synthetic mode of composition intended to "transform the object into an object of art."[61] For the Cubists, it was the nature of visual *experience* to which the realization in paint was to be accurately subject, thus substituting a phenomenological skepticism for the belief in the essential *thing* central to Orphic Cubism. Witness the influential essay written in 1912 by the two Cubist painters Albert Gleizes and Jean Metzinger:

> It therefore amazes us when well-meaning critics try to explain the remarkable difference between the forms attributed to nature and those of modern painting by a desire to represent things not as they appear, but as they are. As they are! How are they, what are they? According to them, the object possesses an absolute form, an essential form, and we should suppress chiaroscuro and traditional perspective in order to present it. What simplicity! An object has not one absolute form, it has many.[62]

This rejection of either universal absolutes or essential forms shifted the discussion of art practice into a focus onto what was repeatedly termed the "pictorial fact." Within the terms of this pictorial facticity, the emphasis upon a material manipulation held great sway, as is evident in this statement by Pierre Reverdy:

> We are at a period of creation in which people no longer tell stories more or less agreeably, but create works of art that, in detaching themselves from life, find their way back into it, because they have an existence of their own apart from the evocation or reproduction of the things of life. Because of that, the art of today is an art of great reality. But by this must be understood artistic reality, and not realism—which is the genre most opposed to us.[63]

The artistic reality of the work, its autonomous quality, was, in the case of Cubism, as in the case of Vorticism, grounded in granting to formal elements a clear ontological status. Again, while grounded in a different set of motivations, Vorticism shared this belief with the Cubists who had exercised at least nominal influence upon them. Not surprisingly, the substantive content of Ezra Pound's 1914 statement contains clear echoes of the writing on Cubism published in the years immediately preceding:

> The Vorticist can represent or not as he likes. He depends—depends for his artistic effect, upon the arrangement of spaces and line, on the pri-

mary media of his art. A resemblance to natural forms is of no conse-
quence one way or the other.[64]

The "arrangement of spaces and line," with very few exceptions, either
linked to the expression of universal absolutes or retained the figurative
traces of earlier modes of visual expression, simply removing them from
the pretense of serving a mimetic purpose, that is, supposedly relieving
the work from any order outside its own arrangement to which it could
be compared.[65] Even without "resemblance" visual art still "possesses a
substance of its own which is a feat which presupposes nothing less than
genius."[66]

This "substance" was exactly that which was constituted by the ma-
terial fact of its existence, its *pictoriality*. Insistence on the capacity of a
painting to *be* in its own terms was critical to all aspects of Cubism,
whether of the analytic, synthetic variety predicated on visual experi-
ence or the orphic exploration of supposedly pure form, as the following
series of statements, with their similarity of formulations, makes clear.
First, Apollinaire in 1913:

> Orphic cubism is the other important trend of the new art school. It is the
> art of painting new structures out of elements which have not been bor-
> rowed from the visual sphere, but have been created entirely by the artist
> himself, and been endowed by him with fullness of reality. The works of
> the orphic artist must simultaneously give a pure aesthetic pleasure, a
> subject. This is pure art.[67]

These ideas were echoed by Roger Fry in 1912: "not . . . to imitate form,
but to create form; not to imitate life, but to find an equivalent for life."[68]
Then Pierre Reverdy, 1917: "Cubism is an eminently plastic art; but an
art of creation, not of reproduction or interpretation."[69] And finally, Wal-
demar George, 1921: "Cubism is an end in itself, a constructive syn-
thesis, an artistic fact, a formal architecture independent of external
contingencies, an autonomous language and not a means of representa-
tion."[70]

Gleizes, Metzinger, Apollinaire, and the other prominent critics re-
sponsible for the influence of Cubist painting—André Salmon, Max
Jacob, and Maurice Raynal among others—continually reiterated the
stance so simply stated in Reverdy's formulation: "A work of art cannot
content itself with being a representation; it must be a presentation. A
child that is born is presented, he represents nothing."[71] The complexity
of this bald assertion, and the difficulties of taking the analogy into any
analysis of a work of visual and verbal art in terms of its signifying activity,

is not addressed by Reverdy, for whom the simple statement grants, by edict, full autonomy to an art object. Gleizes and Metzinger transform the vague rhetoric of these descriptive statements into prescriptive rules for the manipulation of the actual elements of pictorial composition and use of paint which they present as didactic formulae, using the linguistic coercives of "should" and "must": "We must also contrive to break up, by large restful surfaces, all regions in which activity is exaggerated by excessive contingencies" or "Taste immediately dictates a rule: we must paint so that no two portions of similar extent are to be found in the picture."

These insistent statements, couched in discussion of formal elements, make clear that the activity of the painter is prescribed. For the majority of Cubist painters (in distinction to the Russians and the Orphists) the source of this *law* is *not* a transcendent universal plane, which exists disembodied from the material world. Instead, Gleizes and Metzinger have a conviction that significant form, in Roger Fry's well-known sense, has its own absolute values: inherent, apparent, and apprehendable as well as stable and fixed. There is a rightness and wrongness to certain combinations, certain designs, certain arrangements of form to which we somehow, magically, instinctively respond:

> The diversity of the relations of line to line must be indefinite; on this condition it incorporates the quality, the unmeasurable sum, of the affinities perceived between what we discern and what pre-exists within us: on this condition a work of art moves us.[72]

The *preexisting* disposition is a response to an effective use of form, which remains linked to that material form, engaged with it, rather than transporting the individual to another plane; in this the influence of Roger Fry is evident:

> . . . the graphic arts arouse emotions in us by playing upon what one may call the overtones of some of our primary physical needs. They have, indeed, this great advantage over poetry, that they can appeal more directly and immediately to the emotional accompaniments of our bare physical existence.[73]

It will be necessary to return to the assumptions inherent in this statement in order to discuss the more subtle problem of presence and the myth of immediacy and accessibility of the visual mode within modern art practice, but for the moment it seems important to pose the question again of the relation between the evident concern with formal manipulation and the sense of the relation of such activity to signification. In

reading through Gleizes and Metzinger it is possible to imagine a mode of graphic composition derived from their prescriptions in which no human or natural figure would appear, no landscape, horizon, no organizing viewpoint in the perspectival sense. But in fact, and this is very important, the Cubist works which depart from the use of subject matter into utterly nonreferential domains are the *exception* rather than the rule.

Now it can be argued, and has been extensively, that the Cubist retention of recognizable imagery is *incidental,* that the subject matter was merely an *excuse* for the formal exercise.[74] The difficulty in sustaining this argument, in the face of the insistence of the Cubists themselves upon the pictorial *fact* of their work, is that the image remains one composed out of visual elements which carry recognizable meaning.[75] It is only within the context of the image's capacity to be recognized as a portrait, still life, etc., that the work's formal manipulations retain their value. This recognition allows the treatment to register in its specificity; the very *cubist* character of the work is significant insofar as the alteration of traditional graphic conventions may be perceived. The point is not to insist on the primacy of the subject matter, but to signal the discrepancy between apparent rhetoric and actual practice among the Cubists. This is important in main part because of the ways in which the modernist revision of this material emphasized the formal investigation as if there were no signifying trace left within the pictorial exercise.

Opposing the concept of a *pure formality* to the notion of a *signifying trace* leads back to the Cubist insistence on materiality in either case: the formalism of Gleizes, Metzinger, even Delaunay, is one obsessively investigating elements of pictoriality in a painterly manifestation. This is the sole mode of the image's existence, while the signifying practices of Braque, Picasso, the other mainstream Cubists following their innovative lead, make the material creation of the perceptual experience the legitimating fact of its existence. The tenets of this attention to materiality, as enunciated in Gleizes and Metzinger's essay, demonstrate their involvement with formal investigations of what they felt to be fundamental rules for understanding the graphic vocabulary of visual art. The discussion of materiality defined by such a practice cannot be dismissed as incidental, nor can it be contained as self-sufficient. Both of these claims will be asserted within the modernist rewriting of the Cubist and other modern art practices—initially evacuating content from the formal exercises, and, second, promoting their autonomy as *pure* visual works. The Cubist painters, like the Russian abstract formalists, were engaged in the more complex investigation of the ways a signifying practice, in elaborating its own means and mechanisms, could make

that material realm both an instrument of exploration and the manifest form of its practice, thereby increasing the resonance of signification through material form.

Among the Russians, there are also a number of divergent trends to account for in even a general discussion of artistic engagement with materiality. A concern with *faktura,* the making, production, of a work, be it literary or visual, continually informs the attitudes of artists and poets from the first Futurist stirrings of the group dominated by the Burliuk brothers, Mikhail Larionov, and Natalia Gontcharova. In their rapid evolution through Neo-Primitivism to Cubo-Futurism and Rayonnism, between 1908 and 1912, these artists' expression of their utopian expectations for the project of the arts engaged them in discussion of its modes of *production.*[76] Larionov developed, with the aid of Ilia Zdanevich, a theory of Rayonnism which had as its central tenet an interest in portraying objects through the depiction of the *rays* which emanate from their essential *being.*[77] While many of Larionov's compositions lose any capacity to be recognized as objects, there can be no doubt that an investigation of the so-called true nature of real things— their *essence*—was fundamental to Larionov's pictorial enterprise. This idiosyncratic direction splintered from the more general concern David Burliuk had defined when he identified *faktura* as the visual fact of painting and everything about its making—brushstrokes, color, texture, all of what resulted in its surface condition.[78]

This notion of *faktura* was equally evident in poetic activity— Zdanevich, Kruchenyk, Khlebnikov, Mayakovsky all use the term in their discussion of the linguistic construction of writing.[79] To make the implications of this interest for the visual arts specific requires introducing a distinction between the phenomenological orientation of the Cubo-Futurists, with their interest in the depiction of visual experience —and the nonrepresentational Suprematism of Malevich. A materiality put at the service of (even if it is the sole means of realizing) a *sensation* has, in the work of the Cubo-Futurist Burliuk, the instrumental task of facilitating this sensual, sensational, understanding. Malevich, however, moved beyond any representational function whatsoever in his Suprematist endeavor, in his efforts to define *nonobjectivity,* as Jean-Claude Marcade explains:

> It is absolute non-objectivity that the Suprematist pictorial action makes visible, and this absolute non- figuration does not represent, but very simply is—it presents the non-objective world, "puts it forth," makes it "vorstelling."[80]

Malevich, as Marcade goes on to say, was committed to the pictorial do-
main for its capacity to make a "negative revelation of *that which is,* that
manifestation of that which does not appear."[81] The concept of a single
living world, universal and nonrepresentable, underlies Malevich's su-
prematism. The contradiction in his position is that it is his engagement
with the unrepresentable, his desire to render its unrepresentability,
that compels him to "a revelation of the pictorial as such,"[82] where the
pictorial is defined as the "flat, colored surface" of "absolute planarity."
If Larionov's concern with materiality in the pursuit of his Rayonnist *es-
sences* was idiosyncratic and largely without influence, and Malevich's
Suprematism ineffable, sublime, and paradoxically negative in its en-
gagement with the pictorial facts whose rhetoric he articulated in terms
which anticipate the vocabulary of Clement Greenberg with a nearly
preternatural resemblance, the work of Kandinsky mainstreamed the
articulation of formal devices through both the tradition of painting and
also by affecting the tenets of design as developed in the Bauhaus.

In the Bauhaus curriculum the organized discourse of graphic vo-
cabulary became a systematic application without necessary attention
to spiritualist considerations, though that was a frequent and persistent
strain in the institutional curriculum. Kandinsky's well-known concern
with the spiritual dimension of his work was the motivation behind his
initial elaboration of the *rules* of graphic form he felt evidenced the exis-
tence of universal *laws* of pure form. For Kandinsky the new art re-
quired: "a composition, exclusively based on the discovery of law, of the
combination of movement, of consonance and dissonance of forms, a
composition of drawing and color."[83]

Kandinsky's position on this point was made very clear in his 1913
publication, *Concerning the Spiritual in Art.* He remained aligned with
this stance throughout his life, arguing for the "inner life behind the
external appearance of things" and for a study centered on the "fun-
damental characteristics of the material plane."[84] The rejection of fig-
urative value, of the mimetic subordination of image to the terms of the
"real" visual experience, did not necessarily imply a shift to a formality
for its own sake in the visual arts of this period. On the contrary, for
Kandinsky, all such investigation "expresses an inner, dramatic state of
mind," for he considered the basic principle of pictorial activity to be
"the purposeful stirring of the human soul."[85]

Kandinsky conceived of his painting as an investigation of universal
order, of a state of mind and consciousness. For Piet Mondrian, however,
a similarly executed process of reductivism and abstraction had a slightly
different conceptual base, drawing on theosophical beliefs in combina-

tion with a search for a genuinely pure plasticity. In Mondrian's work a distinctly rigorous and intellectualized rhetoric replaces the spiritual and emotive vocabulary of Kandinsky. While Mondrian works his investigations through similar attention to pictoriality as materiality, and similarly concentrates upon the investigation of universals, he believed that "the design and form in themselves create the reality in which universal harmony may be visually expressed."[86] Advocating this neoplasticism, he wrote in 1922, " . . . all arts are plastic, until now, all arts have been descriptive."[87]

Plasticity meant the specific character of elemental color and elemental form and an exhaustive atomization of the pictorial into its "fundamental" units, such that they could be elaborated as a systematic discourse. The result led Mondrian to "the conclusion that aesthetic harmony is fundamentally different from natural harmony . . ."[88]

Reaching this point by 1916–17, Mondrian had rendered the pictorial domain autonomous, had succeeded in allowing that an entire activity of signification resided in the manipulation of plasticity according to the rules of a nonreferential and nonobjective discourse. Such a discourse was not dependent on external rules of order, even if they were capable of revealing or expressing supposedly universal harmonies. At that point, nothing existed to support such an investigation, to be its arena of operations, except the materiality of the pictorial domain. Here the signifying practice engages itself most directly with a materiality which Cubism, Futurism, Rayonnism, and Suprematism also take into account, but now it is foregrounded in the potential which its recognition enables, for the production of signification it facilitates, even brings into being.[89]

So while the Russian abstract artists managed to eliminate figurative elements from their pictorial vocabulary, their investigation of formal elements remained bound up in a search for values whose transcendent qualities linked the graphic elements in a system of referential operations which belied the rhetoric of a simple, "pure" visuality for its own sake. Attention to form was not reduced to a formalism, but kept in the realm of a play between the apparent elements, their assumed essence: between the present materiality and an absent realm invoked as the universal. The French, on the other hand, continually returned their visual experiments to the plane of discourse, but retained figurative traces which invoke the habits of the more pedestrian sense of reference—such as "referring to" the elements depicted in a pictorial illusion. The materiality of elements of collage in the painted canvases which included them added a further dimension of play. Such an ele-

ment could not be merely or completely reduced to a surrogate, a stand-in, or sign for the referred-to context or object. The collaged element remained an object in-itself, present and replete, as well as serving in its capacity as a stand-in for an absent signified and an absent referent. Its undeniable material presence introduced considerable complexity into its signifying function.

Among the Italian Futurists, the themes of movement and dynamism, the study of speed, motivated the investigation of the pictorial means necessary to render these sensations or produce these effects. Constrained by their referential qualities, the mimetic effects of Severini, Boccioni, Carra have a visual dynamic in their frenetic shattering of pictorial unity. The work of Balla, in the studies of movement as a pattern of rhythm, escaped referential traces. While their formal, visual expression has its own characteristic look, the aesthetic propositions of the Futurist painters are poorly articulated with respect to either materiality or representation.

Before going on to the discussion of the problems of postulating a "purely visual" mode and its oppositional relation to language, it seems appropriate to make mention of collage with respect to this notion of materiality. The Cubist, Futurist, and Dada collage in the work of Schwitters, Hausmann, Carra, Heartfield, Picasso, Braque have in common the direct appropriation of materials into the fabrication of an image. This activity has been discussed frequently for its implications in the shift from a representational to a presentational mode among these artists, but in the Cubist use the subordination of such materials to their role within an image puts them at variance with the Dada use—particularly that of Schwitters—of these elements as material as such. This is not to imply that Schwitters was attempting to eliminate all meaning or image value from the elements; on the contrary, he seemed to be able to maximize their value. He insisted that every line, color, and form had a definite expression and impact, but he did not use these fragments within the more conventional still-life arrangements which bound the Cubists to their traditional artistic lineage.[90] The case of Hausmann parallels this (as does Tzara's use of typographic form to betray the source of origin of the phrases he clips together into poetry) for Hausmann uses material qualities to make the images resonate back into the social field in which they were produced. For the Dada artists materiality became one more leveragable element to bring to bear in the full force of their socially pointed critique. Grosz, Herzfelde, and Hausmann, writing in 1920, made a strong point of negating the conventional distinction between "tendency" art and "formalist," arguing that

the two could not be separated within a single work.[91] The implication is their recognition that all formal values carried a social force and that all social, thematic concerns must be worked out in appropriate formal terms. In addition, the use of "real" material was intended to grant the work the status of the real:

> The dadaists believed in all seriousness that only by their methods could they get closer to visible reality. Huelsenbeck wrote about their new material: "The sand pasted on, the pieces of wood, the wisps of hair lend it the same degree of reality as that possessed by an idol of a moloch, into whose red-hot arms infant victims were placed."[92]

The similarity to the Cubist position, stated here more modestly, is unmistakable, and once again the collapse of the notion of materiality with reality, with *stuff* as *being* rather than *representing* is apparent in Maurice Raynal. "But the true picture will constitute an individual object, which will possess an existence of its own, apart from the subject that has inspired it."[93] And Georges Braque,

> The *papiers collés*, the imitation wood—and other elements of the same nature—which I have used in certain drawings, also make their effect through the simplicity of the facts, and it is this that has led people to confuse them with *trompe l'oeil*, of which they are precisely the opposite.[94]

The Cubists, Dadaists, and even Suprematists—in a different way—granted to their works clear ontological status on the basis of material fact.

> . . . and all that we make, all that we construct, are realities. I call them *images*, not in Plato's sense (namely, that they are only reflections of reality), but I hold that these images are the reality itself and that there is no reality beyond this reality except when in our creative process we change the image: then we have new realities.[95]

The engagement with the material aspects of the visual domain was accompanied by an assertion of the *self-sufficiency* of the visual realm by which can be understood an independence from both referential domains in the natural world and any necessary relation to a linguistic equivalent. To understand the way in which this notion of a visual presence comes into its mythic stature in the modern period, it is necessary to inquire first into the terms by which the visual made its claim to autonomy and self-sufficiency, and why.

The desire of visual artists to determine an exclusive province of op-

erations, distinct from the colonizing imperialism of the literary do-
main, explains the development of such a stance. That the pictorial
realm had its own means was an ancient notion, but that it might be real-
izing its own *ends* was the novel feature of the conceptual base by which
early modern art articulated its practice. During that period from 1900
to 1920 which I have been discussing, no explicit use of the terms *pres-
ence* or *absence* or the implications of these concepts for signification in
general were expressed. And though the establishment of a *purely vi-
sual* category of existence was being advocated through the work of Kan-
dinsky, Mondrian, Metzinger, and others, many of the operations
engaging materiality slipped readily (as in the case of *faktura*) between
visual and verbal, literary, domains. However, as the concept of *visuality*
is purified and reified within a modernist stance, the concept of *pres-
ence* inherent to it will emerge from latent formulation into a fullblown
and determinative criterion. One of the changes symptomatic of the
shift from early twentieth-century modern art to midcentury modern-
ism is the rigidifying distinction between literary and visual practices
according to an exclusive and oppositional set of characterizations that
pit absence and presence against each other as conceptual operations
on which each of the literary and visual arts gain their identity as signify-
ing practices. Tracing the concept of the *purely visual* will establish the
historical foundation of the emergence of this antagonistic difference.
Metzinger's attitude in a 1910 "Notes on Painting," for example, already
outlines the oppositional program according to which the visual gains its
purity: "Rejecting every ornamental, anecdotal or symbolic intention,
he achieves a painterly purity hitherto unknown."[96]

The notion of "pure" visual, optical modes of either perception or
representation became a byword of modern art practices. While there
are demonstrable qualities specific to the visual domain whose replica-
tion in linguistic surrogates is inadequate at best and always a re-
representation dependent on finding approximate correlations between
two nonequivalent modes, the campaign to define and defend visual pu-
rity was intimately bound up in a motivation to separate the visual from
the linguistic and literary domain. This defensive tactic demonstrates
the extent to which the literary was seen as a threat to the identity of
visual art, and justifiably so given the history of the two domains. It is a
fact, for instance, that until the beginning of the twentieth century, the
visual arts had been deeply complicit with literary references, linguistic
titles, and the recognizable qualities of images and figures within the
works such that the identification of visual elements in terms of lan-
guage equivalents was hardly difficult. *Ut pictura poesis* designated ac-

tivity in which the ultimate reference was always the linguistic term. The possibility of a nonreferential, language-independent, pictorial mode changed this. The idea that images might slip out from the defining boundaries of linguistic reference opened the conceptual possibility that they might come into their own, that there might be an "own" to come into. Reverdy, writing in 1917, said:

> By the titles with which they were obliged to complete their works, they left the plastic domain and entered a literary symbolism which, in the field of painting, is absolutely worthless.[97]

The literary cannot be understood here in its most provincial definition as a body of texts, poems, allegories, etc. which serve as the source of subject matter for works. Instead, the literary extends to include all the activities of language such that they operate on and tend to dominate the visual with the claim of providing the "meaning" of a work, or even pointing to it. The modernist writers who reinscribed the position of modern art within these terms saw the activity of painting as a kind of manifest destiny of the visual, so that Michel Seuphor, for instance, could intone grandly the inevitability of such progression away from linguistic dependence to visual autonomy: "there had to be a painting wholly liberated from dependence on the figure, the object—a painting which like music does not illustrate anything, does not tell a story, and does not launch a myth."[98]

What becomes anathema in the modern period—to both literary and visual arts—is the idea of representation as a surrogate. Whether among the Russian Futurists, French Cubists or with Mondrian and his Neoplasticism, one prevailing theme is that the making, the very production, of a work is inseparable from its form and from the material in which the work is manifest. The heart of such anathema is the idea of substitution: there should be no "else," no "other" for the work. The terms of this are necessarily different in the visual arts than they are in literature. This is what allows the concept of *presence* to come into its mythic form, conceived of as a plenitude, full and replete, self-sufficient as a state of being in the visual realm. Simultaneously, this also allowed the notion of a pure *absence,* of an always-represented and never-present signified to be conceptualized as the fundamental basis of linguistic and *ergo* literary signification. The figurative, mimetic, and referential are all equated with the literary/linguistic in this conception. Huntley Carter, reviewing some "New Books in Art" for the *Egoist* in 1914 wrote of Kandinsky and Picasso that "both have achieved the final abandonment of all representative intention."[99]

Representation, the notion of a surrogate or substitute term for the actual fact of the work, was what was under attack in the formulation of a purely visual mode. The obvious surrogate, that which had sabotaged the painterly expression from time immemorial, was the word. To retreat beyond its reach, lay claim to a realm which was *unrepresentable,* completely resistant to access or definition or appropriation by language, was a supreme triumph. In its place was substituted the *presentational,* with all its assumed purity, visuality, and self-sufficient evident character. (Thus, red was red, a line was a line, a form a form and the redness, linearity, and formal arrangements were denied any assertive values or symbolic properties which might lead them to refer to anything other than their explicit presence.) Whether this is or is not possible is not what is at stake in this discussion; that the conceptualization of this difference manifested itself in small inklings among the modern artists is what provided the material for later codification of the visual in terms of this distinction by modernist critics and historians.

That the modern artists were concerned with the problem of presence is readily grasped in these discussions of material, and there is a curious but understandable link between this idea and the notion of the present as an immediate and graspable experience. "Everything absent, remote, requiring projection in the veiled weakness of the mind is sentimental. The new vortex . . . accordingly, plunges to the heart of the Present."[100] The banishing of representations, surrogates, and referents is perfectly consistent with the idea of immersion in the present. The fictions with which such ideas are sustained are evident and cliched—the "innocent eye," the "experience of the real," the "empirical validity of perception," etc.—but that they were operating to refute the authority of any medium but that in which a work was constructed was emblematic of the attitudes motivating the production of these works. There were evident problems with insisting on the self-sufficient autonomy of the visual, as Meyer Schapiro pointed out in retrospect: "What was thought to be a universal language of colors and forms was unintelligible to many when certain conventions were changed."[101]

But the idea of a readily intelligible and immediate art was a seductive one—and not only in the early period. "Whatever the language, the meaning is 'imminence'; and that 'nowness' is a precondition of the search for newness."[102] Newness, nowness, imminence—all depend on the notion of presence, on its existential possibility as both real and sufficient. The point is not to arbitrate between positions, but to describe their existence within the historical development of attitudes toward art and literature as signifying practices. The problem of presence and ab-

sence, and the characterizations of plenitude and surrogate with which they have been damned and distinguished, return a few decades later in the critical apprehension and historicization of early modern art and with the oppositional definition of literary and visual arts of high modernism at midcentury. For the moment, these concepts serve to contextualize the fundamentally problematic character of typographic experiment in early modernism.

Typography in this period was similarly concerned with its own specificity, its formal means and their investigation, the same language of *faktura*, of materiality, and of self-reflexive formal language. Because the lines of oppositional definition were only hinted at, just beginning to be formed in the discussion of material, typography could be included in a modern art practice. In addition, since materiality and formal elements were not used at the expense of content or subject value, but in relation to them, the identity of formal elements had not taken full precedence over the signifying function of those elements. Again, the insistence on such a distinction came later, in the modernist retrenched investment in an oppositional difference in which the terms of presence and absence were allowed to organize themselves into exclusionary positions, as if one could exist independent of the other and necessarily did so. The precise manner in which typographic experimentation challenged the division between literary absence and visual presence made it unsuited to the critical and historical categories used by midcentury modernists to describe the activities of early modern art. This typographic work embodied and manifested a complex attitude toward the materiality of visual and verbal aspects of signification—one in which there was a continual interplay of reading and seeing, linguistic referential functions and visual phenomenological apparence, as well as traces of social context and historical production evidenced in materiality.

Experimental Typography as a Modern Art Practice

The Typographic Context for Experimental Work

The early twentieth-century avant-garde found no medium more suitable for both production and promotion of their formal innovations and activist agenda than the printed page. And though print lacked the cachet of up-to-the-minute modernity associated with radio broadcast technology, it remained the mass medium par excellence of the decades of the teens and twenties. Print media were affordable, available, and effective means of communication and public visibility. From the first appearance of the Futurist Manifesto of F. T. Marinetti in the pages of *Figaro,* on 10 February 1909, through the profusion of independently published magazines, handbills, invitations, posters, and other printed ephemera—everywhere one looks across the broad spectrum of artistic activities from London, Berlin, Zurich, Milan, Moscow, Paris, and St. Petersburg—publications proliferate. The printed form existed not merely as an incidental record of the life and spirit of the times of avant-garde activity, but as one of the primary means of its realization.

Not surprisingly, many typical features of early avant-garde practices are manifest in these printed works: a strongly self-referential investigation of the formal properties of the medium; a blurring of the line between the forms and sites of so-called high art and the forms and

situations of mass media; a muddying of distinctions between image and language and a subversive attack on their fundamental properties as representation and an even more systematic attack on the conventions of literary and visual symbolic form.

The typographic experiments of the early avant-garde were created in a context in which the visuality of written forms of language had received significantly increased attention in several fields such as linguistics, poetics, and the visual arts. But it is also important to note the situation of typographic experimentation within the context of commercial and artistic publishing. The typographic distinction of the avant-garde only gains its specificity from its relation to this context, and the features which function to distinguish the experimental work from commercial or fine print productions are best understood by contrast—as a function of difference, rather than inherence.

For one thing, the late nineteenth century had witnessed the involvement of mainstream visual artists in the domain of graphic arts production. The lithographic productions of such artists as Toulouse-Lautrec, Theophile Steinlen, and Pierre Bonnard provided direct evidence of the effect of freehand drawing on the forms of written language. Mass production of lithography promoted freeform production, released from the comparative limitations of either letterpress type or engraved imagery. The effects lithography and its much expanded range of visual letterforms are not an integral part of the typographic experiments of avant-garde poets, who restricted themselves, by and large, to letterpress technology—though one major exception to this trend is found among the artists of the Russian avant-garde, who made frequent and skillful use of cheap means of lithographic reproduction for their handdrawn artists' books. It could be argued and demonstrated, however, that the development of poster design for artistic and commercial purposes in the late nineteenth century created a graphic presence in the urban environment which contributed to the cross-disciplinary sensibility in which the avant-garde attitude toward the materiality of visual forms of written language developed.

Another area in which a near fetishistic concern for the artisanal properties of letterpress technology emerged—and with it an insistence on the expressive content of visual form—was in the arts and crafts movement spearheaded by William Morris. Morris's influence on the book arts, and on the general look of journals and ephemeral publications associated with a certain segment of the avant-garde, is well known. His aesthetics were antithetical mainly to those of the early twentieth-century avant-gardists who made the retrogressive tenden-

cies of the arts and crafts movement a focal point for ridicule. But in spite of its *retardataire* stylistics and conservative promotion of anachronistic methods of production, Morris's work served to sensitize the eyes of the late nineteenth-century public to the visual appearance of the page as a significant feature of literary production. The force of his influence can be seen in the design of almost any literary or artistic publication of the late nineteenth and early twentieth centuries from San Francisco to Moscow—the intertwined borders, organic motifs, sinewy forms, and decorative patterns became the distinguishing hallmark of the artistic publication. Marinetti, Zdanevich, Tzara, and others would all decry these florid excesses in their call for a modern aesthetic in graphic design. But Morris's emphasis on the relationship between production techniques, graphic style, and categories of cultural activity contributed to developing the literary page as a distinct genre with a graphic style integral to, not incidental to, the literary text.

There are several other areas of activity, peripheral to the study of poetic experiment, to which one can look for evidence of the changed status of written language in the late nineteenth century. Some of these, such as developments in graphology and mediumist automatic writing, encouraged a typological vocabulary for codifying the visual forms of written language into categories to which significant value could be attached. They combined a pseudo-scientific discourse with the exhaustive categorization of visual forms and span the full spectrum from parlor game diversions to disciplines with implications for the legal adjudication of the authenticity of disputed autographic documents. Fascinating in its own right, this material makes a small contribution to this study by the peculiar emphasis it places on the relation between visible and invisible attributes of the written form and the terms on which the materiality of such production came to be codified within both psychological and legal discourses. The general topic of the reinvention of writing at the end of the nineteenth century is an area of inquiry unto itself, and to trace its various strains and themes would divert the discussion far from the mainstream of the arguments relevant to the work of Futurist and Dada poets.

But the most important context for typographic experimentation, the realm in which these printed artifacts gain their specificity, is in their relation to mainstream publications, including advertising graphics. The graphic arts witnessed the development of typographic forms to accommodate the burgeoning needs of the advertising industry. In tandem with the increased production of consumer goods resulting from industrial capitalism, the advertising industry provoked production of

an unprecedented variety of typographic means. These had been fully exploited by compositors stretching to invent ways of catching the attention of the reading public, and the forms of graphic design which would become hallmark elements of avant-garde typography were already fully in place in advertising and commercial work by the end of the nineteenth century.

At its broadest, the typographic field from which experimental artistic "inventions" are derived stretches across the spectrum of typographic printed matter from journals to advertisements through literary publishing and fine book work. Such work provides the norms against which the experimental typography takes on its cultural significance as transgressive, and it is therefore an essential underpinning to an evaluation of the effect of the avant-garde work.

The technology of letterpress typography was flourishing at the end of the nineteenth century. Highspeed presses had been invented, along with linotype and monotype machines for rapid setting and casting of large amounts of metal type. The advertising realm had burgeoned in response to the demands of the mass market strategies of industrial production. The result was an increased interest in graphics as an interface between producer and consumer to maximize the potential of a medium which had undergone, by contrast, comparatively little change in the three centuries since its invention. The graphic traditions established in the first decades of the existence of letterpress printing had undergone only slight modification.

Within the limited graphic vocabulary of early printing there were two distinct aspects to these traditions, each exemplifying a distinct mode of typographic enunciation. By this term I intend to designate those elements of typographic practice by which the speaker, recipient, and context of the text may be identified—and any other aspects of what is commonly recognized within linguistic analysis as the enunciative apparatus. The distinctive feature of this typographic enunciation is a distinction between *marked* and *unmarked* texts, with the additional possibility of distinguishing between public and private, personal language through their typographic treatment. In general, the split between marked and unmarked texts corresponds to the split between commercial and literary uses of typography, reflecting the distinction in linguistic modes of enunciation by which these domains are frequently distinguished from each other. These distinctions became increasingly operative in the nineteenth century with the increased possibility of entrenching the different domains through graphic means.

The basic distinction between marked and unmarked typography

occurred simultaneously with the invention of printing. Gutenberg printed two distinctly different kinds of documents, which embodied the characteristic features of what evolved into the two distinct traditions. On the one hand he printed bibles, with their perfectly uniform grey pages, their uninterrupted blocks of text, without headings or subheadings or any distraction beyond the occasional initial letter. These bibles are the archetype of the unmarked text, the text in which the words on the page "appear to speak themselves" without the visible intervention of author or printer. Such a text appears to possess an authority which transcends the mere material presence of words on a page, ink impressions on parchment. By contrast, the Indulgences which he printed displayed the embryonic features of a marked typography. Different sizes of type were used to hierarchize information, to create an order in the text so that different parts of it appear to "speak" differently, to address a reader whose presence was inscribed at the outset by an author in complicity with the graphic tools of a printer who recognized and utilized the capacity of typographic representation to manipulate the semantic value of the text through visual means.

That the tradition of the unmarked text was established with the printing of bibles is not incidental to the ways in which its mode of transcendent seeming authority comes to operate within the literary field which models itself upon that original presentation. Literary works, while they adopted certain modifications such as running heads and elaborate title pages, essentially adopted the unmarked mode of Gutenberg's biblical setting as their norm. The literary text is the single grey block of undisturbed text, seeming, in the graphic sense, to have appeared whole and complete. The literary text wants no visual interference or manipulation to disturb the linguistic enunciation of the verbal matter. All interference, resistance, must be minimized in order to allow the reader a smooth reading of the unfolding linear sequence. The aspirations of typographers serving the literary muse are to make the text as uniform, as neutral, as accessible and seamless as possible, and it remains the dominant model for works of literature, authoritative scholarly prose, and any other printed form in which seriousness of purpose collapses with the authority of the writer, effacing both behind the implicit truth value of the words themselves.

The marked text had its most vibrant spurt of development in the domain of advertising, where manipulation, practically for its own sake, motivated the development of a wide range of typefaces, styles, and conventions governing their use. Almost all the visual feats and virtuoso-seeming pyrotechnics of the late nineteenth-century advertisers'

practice had been a technical possibility since the invention of moveable type. The activity and variety of the nineteenth-century page, particularly advertising pages, was not the result of technical innovations surpassing those of Gutenberg, but of a changed attitude toward the application of extant technology. Putting type on a diagonal, mixing faces, sizes, styles all in one line or even one word, and any of the other apparently new inventions of nineteenth-century typography would have been possible at any moment after Gutenberg's first casting of moveable type. While the graphic vocabulary of metal type had been unlimited, the conventions which governed its use had established a very limited range of applications. What had been slow in developing was a sensibility to the medium which would investigate its potential to disturb the linear order by which the cast metal forms of type had embodied the normative linear text. An influence which had prevailed with increasing popularity in the nineteenth century was the graphic sensibility of lithography, which had none of the built-in restraints of cast metal to predispose the orientation of words and letterforms, but the promptings of a commercialized market eager for novelty and effect in the advertising of products can be assigned the greatest responsibility for generating innovation.

Without a doubt, however, the conventions governing the design of marked texts, typical advertising text, were broader, more open and varied, than those which restricted literary or unmarked production. While it would be a mistake to confound the domains of the unmarked and the literary, of the marked and the commercial, in typographic use, the boundary between the two domains does align with these distinctions. One effect of this division is a taboo against violating the literary page with any of the more obvious visual manipulations which typically characterize the commercial page. The way in which this taboo functioned became more obvious when it was intentionally violated by the Futurists and Dadaists.

By the end of the nineteenth century, the features of marked typography included: the use of a wide range of type faces, styles, and sizes with mixtures and juxtapositions of these proliferating within a single sheet; the breakup of the page into various zones of activity which received very distinct graphic treatments; the use of circular, shaped, or diagonal elements across the normal horizontal page; the use of vertical elements; and finally, the use of paragonnage—the incorporation of several different typefaces and/or sizes within a single line or word. Even without the incorporation of distinctly pictorial elements, the marked text became decidedly more visual, acting on the seductive methods and

shock effects that could be generated by graphic variety. In addition, the site of these works was public—the posted handbills, theater announcements, government notices, publicity circulars, and a myriad of other printed sheets came to be a feature of the urban landscape in the late nineteenth century.

Any text assumes a reader and marks that assumption to some extent. The texts which I am calling unmarked attempt to efface the traces of that assumption. The marked text, by contrast, aggressively situates the reader in relation to the various levels of enunciation in the text—reader, speaker, subject, author—though with manipulative utilization of the strategies of graphic design. Such inscription, obvious marking, of the assumed reader, forces the language into a public domain. All language is public to some degree by definition—it is the symbolic system which produces and reproduces the social order—but the language used in advertising has characteristic features designed to make it communicate more efficiently in accord with the purpose it necessarily serves. These characteristic features show up repeatedly in the Dada construction of its public stance. Such language, which I am calling public language, relies less upon syntax, and more upon rhetoric, than literary language. It emphasizes the use of nouns, of the imperative form of the verb, of prepositions rather than qualifying phrases, of verbs generally; and it tends toward direct address (meaning a form which names the audience, identifying it in the language used) rather than third and first person, underscoring the extent to which the assumption of a reader determines the structure of the text. The emphasis is on the *recipient* of the message rather than on the speaker.

The self-consciousness about design as a discourse which characterizes the twentieth century only began with the influence of the Arts and Crafts movement and became conspicuous in the Constructivist and later Bauhaus institutionalization of design. As mentioned above, the Arts and Crafts movement had strongly affected book design, calling attention to the craft and material qualities of printed works. The volumes of William Morris, for instance, transformed the book from a transparent vehicle for text into an art object, reviving the artisanal techniques of binding, illuminating, and so forth which had been part of the manuscript tradition. In the process, he made intense investigation of every element of the book as an object—type, ink, paper, threads, illustrations, etc. Evident influence of this work could be seen in the design of trade books, which attempted to reproduce the look of the decorative motifs which characterized the fine press productions. Another place where the influence of these works was conspicuous was on the covers

and title pages of literary journals, which broke out in a turn-of-the-century rash of floral borders, vines, and heavy chapter headings aping the initial-letter illuminations of more labor-intensive originals. This was precisely the aesthetic attack by the Futurist and Dada artists whose typography and design distinctly attempted a "modern" look—streamlined, reduced, nondecorative even when busy and collaged in quality. The first Futurist manifestos contained a violent assault on the floral, sinewy features of the remnants of the Arts and Crafts artisanal motifs as they had been processed through the Art Nouveau sensibility. The ultimate importance of the Arts and Crafts movement as an influence on early twentieth-century experimental typography was not stylistic influence, but its self-conscious attention to the visual form in which literary texts were represented and the demonstration that, even in their "unmarked" form, type gave text a distinctly visual form and character.

Self-conscious awareness of design as such was present in the commercial realm, but never clearly articulated as a separate, distinct aesthetic or intellectual program. A large number of trade volumes described the technical and mechanical processes of printing and typography, but volumes describing design choices or techniques barely existed. Most printers continued to learn their trade through the old apprentice system, working up to journeyman positions through direct experience, and trade schools for printers were virtually unheard of. There were a significant number of publications detailing various aspects of the printer's work written by experts willing to share the benefit of their expertise. None of these journals or manuals address design issues. The problems of layout, of typeface choice and compatibility, or any of the many aspects which must be dealt with in composing the complex and intricate pages which were the daily task of the compositor, simply did not merit explicit attention.[1] Discussion of design is limited to the suggestion that having a good layout artist make up schemes for the compositor would save the shop time and money by alleviating the need to rework designs. On the other hand, a new genre of journal, developed by the advertising trade for its own use, began to spotlight some of the graphics involved and to discuss both advertising copy language and to develop guidelines and strategies in a consistently formulaic manner.

The split between advertising and book design remained intact. The suggestions for one were considered so inappropriate for the other that there was never even a question of crossover. But the fact that advertising was developing its own language and graphic vocabulary is indicative of the degree to which it was developing a self-conscious sense of

itself as a practice several decades before being institutionalized in any academic or professional training programs.

A journal typical of those being published by and for the advertising trade in the early part of the twentieth century was *La Publicité*.[2] An article in a 1913 edition deals with typography and advertising, stressing the importance of basic graphic design considerations in advertising.

> Most advertisements would be improved by a better knowledge of typography, and by a sense of the appropriateness of a particular typeface to a particular kind of message. This would communicate the ideas, features and marks of individuality. The judicious use of the space available in an advertisement is just as important as the phrases themselves, because the logical placement and presentation determine how the sentences strike the eye.[3]

Few articles had even the degree of specificity evidenced by this one, which hardly contains detailed technical information or advice beyond alluding to its necessity. But the pages of *La Publicité* regularly contained a feature which reproduced advertisements and critiqued their design, layout, and typographic elements. A glance through these is instructive for two reasons: first, it demonstrates the kind of discussion which was considered useful or interesting to the trade as a proto-design sensibility; and, second, it strikingly demonstrates that many of the characteristic features associated with Dada typography can be pointed out in these advertisements as part of the common vocabulary of commercial printers. The following four examples, for instance, each give evidence of a specific graphic feature which will become part of the Dada vocabulary.

Referring to an advertisement which contained a whole sequence of paragonned words, the editors of *La Publicité* remarked, "This is the most bizarre advertisement imaginable."[4] While they were referring to the discrepancy between the content of the ad and the product to which it had no relation, they might just as well have been commenting upon the peculiarly arbitrary use of the uppercase letters inserted into the first two lines (figure 6). While the message is not segregated into two distinct linguistic registers—the sentence retains only one reading—it introduces a gratuitous graphic appearance to the text which, precisely because of its nonsensical and arbitrary quality, will be a popular feature with Francis Picabia and Tristan Tzara, in particular.

The advertisement for "La Dépêche de Lyon" uses a repeated line as a design element, a rhythmic recurrence which breaks up the space of the ad into three separate sections, each with its own subhierarchy. Of

Figure 6. Sample of advertising typography from *La Publicité*, 1913.

Figure 7. Sample of advertising typography from *La Publicité*, 1913.

Figure 8. Sample of advertising typography from *La Publicité*, 1913.

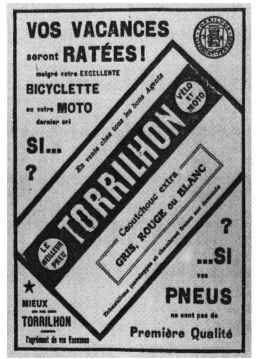

Figure 9. Sample of advertising typography from *La Publicité*, 1913.

these three, the last has distinct proto-Dada characteristics, with the confounding of the graphic and syntactic relation between the "est l'organe" and the three qualifying phrases which follow. Both features, the repetition and the subhierarchization will, again, become familiar elements in the Dada repertoire (figure 7).

Perhaps the simplest of these examples, the advertisement for "Crédit," takes advantage of basic size relations to put all of the elements on the left into the same relation to the element on the right, which, by its scale, brackets them all into a single reference point, the word "Crédit." The graphic relation is exploited to visually render a particular linguistic relation[5] (figure 8).

The last example, "Torrilhon," contains features that connect it to the pictorial influences that had seeped into graphic design through lithography, which provided much greater flexibility than metal type for the visual manipulation of the text (figure 9). In this case, an element inserted on the diagonal breaks up the horizontal linear text, creating an air of unsettledness.

> The arrangement is terrible. It is difficult to read, on account of the breaks in the main argument caused by the insertion of the central card.[6]

The suggestion of space created by the overlap of the card with the frame of the page is one of the elements of pictorial illusion which will play a role in Futurist typography and design. In this case, each element on the sheet continues to occupy a discrete space. There is no fragmentation or obscuring of any of the words or letters in the original, horizontal page. But this suggestion of a spatial dimension was not inherent to letterpress typography, since it represents a layering effect to which metal type, with its physical dependence on each space being occupied by one element in the form, does not readily accommodate. Again, the idea that this was possible was not coincident with the moment of its technical feasibility, which occurred several centuries earlier. The breakdown of this discrete letterpress space paved the way for very complex spatial illusions, which increase with the invention of photographic printing methods and a collage sensibility.

The idea that the Dada and Futurists artists were the inventors of a particular typographic vocabulary falters in the face of such graphic evidence. This does not discount the radicalness of their work, but the grounds on which that claim may be established cannot be supported merely on the basis of graphic innovations. The Dada and Futurist artists were aware of the place the particular visual properties of type, layout, and graphic design had in the social realm of public language and saw

that they had become sufficiently codified and organized so that they could be manipulated. They were also aware that the distinct separation of the two typographic domains, the public/commercial and the literary, made the appropriation of these publicity techniques to literary works an activity which was subversive to the visual codes on which the authority of the literary text had been established. But this notion of authority depends on an understanding of the way in which literature, as a signifying practice, obtains its definition in relation to certain fundamental critical terms. The literary mode of typographic representation, borrowing from the convention of the unmarked text, posited the existence of an absent author whose authority was reworked through the seemingly transparent, speaking-itself, character of the words on the page. The subversive disruption of this authority and its impact on the structure of subjectivity, ideology, and power in the text were effected through typographic manipulation.

The immediate and specific context for production of experimental typography was the realm of the so-called little magazine. Literary publications, independently produced and serving to showcase artwork and writing unpublishable in a commercial framework or in trade book form, were a well established genre by the turn of the century. English, German, Russian, and French artists, as well as Americans, had been in the business of producing small editions of journals from the scale of the minuscule pamphlet to the full-blown bound series since around 1850 when the Pre-Raphaelite *The Germ* initiated the genre with a run of four issues.[7] While such magazines flourished as a species, the individual journals themselves were often shortlived. Many of the Dada and Futurist publications ran for one issue only, and those which had some temporal extension, like *Dada,* were graphically transformed in the course of their development. Editorial and design responsibility for such publications generally resided with the sole editor, and the informality of collaborations which gave the works form was frequently the result of ongoing social contact as much as any institutionalized editorial board or policy. Few of the magazines associated with the Dada, Futurist, or Cubist/Nunist movements ever achieved either the degree of committee contentiousness of a publication like *The Masses* in New York, or professional regularity and relative homogeneity of *Les Soirées de Paris* or *L'Esprit Nouveau.* The absence of set rules or programmatic formats permitted these publications to function as the most inexpensive, immediate, and visible means of dissemination of work whose experimental character would not have found ready sponsorship among the staid editorial boards of established publishing houses. Risky and unreward-

ing ventures, most of these magazines existed by dint of the enthusiasm and economic advantage (often minimal) of their individual editors or sponsors. The cash flow of a journal like *Dada,* for instance, depended on donations, subscriptions, and whatever over-the-counter sales could be generated: advertising was minimal and, where it existed, consisted almost exclusively of notices of other literary publications. The circle of readers, the market, for these works was thus quite circumscribed by contrast to a magazine like *Sunset,* or *Harper's,* in which advertisers of household goods, patent drugs, manufactured clothing, bicycles, and other industrial products were well represented.

Between the period from 1917 to 1923 alone nearly three dozen journals associated with the writers of Dada, Cubist, and Nunist sensibility appeared (and many disappeared in the same period) just in Paris! This is a staggering outpouring of creative energy in independent publishing even for a cultural center. Add to this the publications of German Dadaists in Berlin and Zurich, Russian publications in Moscow, St. Petersburg and Tiflis, and the journals based in London, New York, Milan, Warsaw, Budapest, Brussels, and Amsterdam—to list only the most significant areas of activity—and the amount of printed surface available for experiment and innovation was considerable. The boundaries of these publications were well demarcated in aesthetic and cultural terms. The writers and artists, often many of the same in each of these various publications, were acquainted through personal and professional contact; in production and, to a more qualified degree, in reception these works formed a social sphere whose members might often be at odds over aesthetic particulars, but were bonded through their separation from the more traditional, conservative, or contemporary bourgeois realms from which they sought to distinguish themselves. The distinctiveness of these publications was to a very real degree an effect of their innovative typography, format, and design, which clearly manifest the aesthetic sensibility motivating the experimental literature and visual arts of the artists involved.

Poet Practitioners

If materiality were merely or purely a matter of plastic values, then the experimental typographic works of modern poets would be easily reduced to an instance of expressive form, an inflection glossing the literary value of the text, or, conversely, would be dismissible as poems and

appear as visual images. The dependence of the very activity of signification on the complex operations of materiality can be investigated through analysis of the particularities of typographic activity, which challenges the metaphysical premises underlying the oppositional concepts of visual presence and linguistic absence. The four poets whose work is featured here were all individually involved in the typographic design and production of their works or, at the very least, in making detailed mockups of the visual form for the printing houses in which they were produced. They were chosen for focus on that account: this direct involvement permits the analysis of these works to proceed without complex issues of authorship interfering and presupposes an aesthetic position rather than a complex of production processes, collaborations, or compromise decisions by committee. Each was also, to a greater or lesser extent, involved in writing critically or theoretically about typographic practice—in manifesto, review, or more extensive commentary. All were mainstream figures within the historical avant-garde whose contributions were primary, rather than imitative or derivative. Finally, they were chosen because each represents a strikingly different aesthetic position and each makes use of the materiality of typographic signification to very different ends.

■ **Marinetti: Materiality and Sensation: Mechanical Synaesthesia**

Poetics

Filippo Tomasso Marinetti's experimental typographic work was accompanied by systematic calls for revolutionizing the visual, literary, and graphic form.[8] The program of reform Marinetti called for was in some ways more radical than the work he achieved or brought forth in its name, but the implications of the positions he took are striking and mark clear breaks with the poetic positions in which he had been trained. Marinetti's well-documented infatuation with the concept of a modernity defined as speed, simultaneity, and sensation established the basis of his stylistics. The metaphysical premises on which these modes were fashioned leads to a paradox of major proportions when the temporally stable, static, and resolutely referential forms of printing on the page are used to invoke the immediacy and temporally ephemeral staging of phenomenal experience. The capacity of the materially present signifier to invoke the long-absent immediacy of sensation and, in fact, remake it, replay it as a sensation is at the center of this paradox.

Marinetti's connection to the Symbolist sensibility had begun with his education, a fact which merely underscores the domination of European poetics by the French movement in the late nineteenth century. In 1900, Marinetti, in his early twenties, ambitious and eager to promote his own career as a poet, went on tour declaiming the work of Baudelaire, Mallarmé, Rimbaud, and Verlaine. Marinetti retained many traces of this Symbolist tradition, most particularly an emphatic attachment to the expressiveness of plastic form and a synaesthetic disposition. He rejected the *recherché* language, private hermeticism, and metaphysical themes of, in particular, Mallarmé. Marinetti aimed for and achieved a readable public language, available to a wide public, communicative and consumable, streamlined and unburdened with arcane references and tropes. He also succeeded in constructing himself as a public spectacle, a personality whose identity was made through and processed by media attention. The switch in emphasis from revery to action was not merely a matter of poetic stylistics, but of lifestyle.

Certain terms and vocabulary which he inherited directly from the Symbolist tradition—such as *onomatopoeia*—however, were essential to his aesthetic stance, and the distinctions between his use of these terms and that of his Symbolist precedents is important to note. Marinetti was at pains to distinguish himself from Mallarmé and the Symbolist tradition, and he made this opposition explicit in manifestos and writings even as late as 1919. His poetics were not merely defined through opposition, but the extent of the protest demonstrates to some degree the profound influence of the tradition. Tristan Tzara, by contrast, was able to infuse his poetics with a freshness of approach which in the period from 1917 to 1923 was without any of the same debt.

One of the important legacies of Symbolism—though pushing the familial and genealogical metaphors should be done sparingly—in Marinetti's work was an attentive interest to all aspects of the arts. Marinetti's Futurist prescriptions would embrace theater, architecture, sculpture, music, painting, and poetry in the firm belief that they could all be equally *Futurist*. Such an approach engenders a disregard for material specificity in preference for a similarity of generalized aesthetic formulations: each mode was to free itself from its past, from tradition, and participate in the *simultanéiste* vision of modernity.

Marinetti's attitude toward materiality (which was never spelled out in metacritical terms in his own texts) must be teased out from an examination of his attitudes toward the two aspects which contribute to his typographic *Words in Liberty*—his theoretical propositions for and actual use of visual and verbal forms.

Marinetti employed a variety of visual elements in his typographic works, each of which was grounded in different assumptions about the character of visual images. First, he used graphic markings in a synaesthetic expression of sound, action, movement, effects as if their apparent form was immediately and unequivocally apprehendable. Second, he employed a pictorial strategy for mapping the relations of linguistic elements within his work, structuring specific poetic texts according to visual conventions for the representation of space—a technique which gives the semblance of an analogous relation to vision but is in fact utterly conventional and semiotically coded. Third, he introduced mathematical marks and diacritical marks into the sequence of alphabetic symbols as part of his attack on ordinary syntax, using these elements to give the linguistic forms an increasingly mechanized look, streamlining and modernizing it. In this last activity the distinction between visual and verbal becomes difficult to sustain, and yet the graphic effect of such introductions on the page called attention to the subversion of the normal syntactic activity. This infiltration of the symbolic order of language with visual symbols of another (visual) order has a subtly destructive effect. This latter gesture was also intimately intertwined with his project for destruction of the traditional (or at least, romantic) author. Marinetti's marked disdain for the psychological component of subjective experience was not least of all demonstrated by the manner in which his transformation of the written word works to repress the enunciative marks of that individual subject which had been so central to the lyrical tradition of nineteenth-century poetics.

The mechanics of Marinetti's Futurist enterprise ultimately self-destruct, the machinery becomes a demolition apparatus aimed first at convention and then at itself, which rigidifies with the inexorable deadening of sliding parts locked into immobility. But the evolution of Marinetti's Futurist aesthetic and its graphic formulations achieved a peak of explosive vitality in the works produced between 1914 and 1919. By the 1920s, though there were still many publications to follow which carried out the graphic propositions of the Futurist agenda, the innovation was complete. Aside from Marinetti, works by Cangiullo, Severini and, later, Depero made their contribution to Futurist typography. Depero was chiefly responsible for carrying the Futurist aesthetic into the realm of commercial and public application, in a manner which parallelled (almost parodied) the activity of Constructivists Rodchenko and Lissitzky. By the point that Futurist typography achieved its greatest visual effects, it seemed to have approached a limit past which it would merely have degenerated into noncommunicative, nonlinguistic visual chaos or re-

peated the schematic formulae developed within the battle poems of Marinetti.

In dealing with Marinetti's work, it is important to remember that he not only states and achieves certain aims, but that his stature as an international superstar of avant-gardism contributed to the influence of the aesthetics he proposed.[9] The term Futurism (like Dada a few years later) quickly became synonymous with avant-garde, to the point where it lost all specificity or value in identifying what were in fact distinctly different groups and individuals within the widespread arena of artistic activities throughout Europe, the United States, and Russia in this period.[10] If Marinetti had depended entirely on his printed work, he would not have achieved the widespread influence generated through the international tours, publicity stunts, and media visibility for which he used his considerable skill at making himself into a spectacle for public consumption.

"The Futurist Sensibility," "Words in Liberty," and "The Wireless Imagination"—under the banner of these three phrases the bulk of Marinetti's manifesto writings take on, in successive stages of definition, the reorganization of poetic language according to a radical aesthetic agenda.[11] The first manifesto of Futurism, written in Milan in February of 1909, contained few specific recommendations for linguistic reform or the pointed typographic and orthographic changes which would come to play a central part in his writings of 1912, 1913, and 1914. But the 1909 text did raise motifs of a Futurist sensibility like so many flags above a field of poetic activity which Marinetti would rapidly transform into an image of battle. Invoking the *passéiste* vocabulary of the Symbolists as the outmoded baggage to be jettisoned, with its penchant for revery, ecstasy, and somnambulance, Marinetti proposed as antidote a language of aggression, a punch in the face, and the ravings of a restless insomniac. He insisted on the motifs of speed, rapid movement, and, from the very outset, the image of the "wireless" as the model for the Futurist imagination. All of these participate in the disembodied ephemeral generation of sensation, rather than in the fixed form of aesthetic objects: the image of the "wireless" is dematerialized, immediate, and simultaneous.

In fact, Marinetti's agenda of transformation is not so much contained within thematic motifs as it is concerned with modes of communication. From the Symbolist's dreamy world of the psyche with its organic metaphors of smoke, ritualized transcendence, and esoteric alchemy, methods of communication bound into the fluid media of mind and flesh, Marinetti moves immediately into the world of transmission,

broadcast, and communications dependent on the new technology of electricity. The image of speed with which Marinetti and the Futurists are so clearly associated should be taken in this technological context, not as the mere vertiginous delight in rapid movement, but in a form of moving language, experience, and communications through and across spaces intraversable within the framework of old-fashioned media or modes of transport. Much of what Marinetti does in the transformation of syntax moves toward the effects of telegraphic language, condensed, mathematical, quantifiable. Marinetti's sensibility is nearly proto-electronic and cybernetic in orientation, informed by a sense that time and space were both malleable according to the manipulations representable through linguistic transformations. Embedded in the mechanisms of an industrial age, Marinetti's dynamic drive self-destructs. The rapidity with which he sought to dissolve the here and now of limited perception could not be sustained within the working parts of machines designed for industrial production, no matter how rapid fire their piston movements or interlocking motions of gears. Marinetti ran his poetry machine beyond top speed, and by 1919, when he collected the writings and samples of typographic work in the *Words in Liberty* mini-anthology, the thing had blown apart, spraying its fragments across the space of the page. Again there was a paradox within Marinetti's desire to achieve a spatial and temporal extension which allowed simultaneous communication and sensation, but he was struggling to do this within the technological limitations of industrial machinery. Photographs of him in 1917, 1918, 1919 firing rifles, standing with erect adoration in front of a beloved military tank, and of the machined parts of weapons and airplanes which he put into his private collection—all of these show him infatuated with the mechanics of the industrial apparatus at the same time that he is advocating a wireless, dematerialized aesthetic in communication.[12]

When he rejected the obvious thematic and stylistic mannerisms of his Symbolist forebears in 1909, Marinetti nonetheless retained the Symbolist concern for interrogation of what has been termed "the mechanisms of signification."[13] The Symbolist investigation of representation had "endowed the sign with unprecedented autonomy"[14] and, in the name of the pursuit of universal essences available through the correspondent resonance of visual, musical, or verbal signs, had invested heavily in the materiality of signification. This legacy, transformed according to Marinetti's sensibility, nonetheless had provided the precedent on which to establish the tenets of his Futurist sensibility. Marinetti's synaesthesia was to be mechanistic, industrial, military, and

immediate rather than reflective and organic, but it was still, emphatically, a synaesthesia.

The 1909 "Manifesto" appeared in print in the mass media, and not in just one place (the *Figaro* appearance is a famous instance), but in several. Translated into many languages, the piece used the journalistic press as stage, as an arena in which to make direct intervention, not merely by being the subject of reportage, but by making use of the popular press as a primary medium. Marinetti's strategic use of the publicity machine of mass media was in diametric opposition to the esoteric and reclusive sensibility of Mallarmé, for whom, as we have seen, the daily press represented linguistic anathema. Marinetti's ambitions were unbounded; his desire to unleash a poetic revolution, to thrust language into the modern age through innovation, gave him an impetus to perform these changes not merely in the public eye, but with a recognition of the role of mass media in forming the space of modern life.

Marinetti's detailed articulation of theoretical poetics came in three successive years: 1912, 1913, and 1914. The "Technical Manifesto of Futurist Literature" (1912), with its annexed "Response to Objections," contained the kernels of most of what would follow. It can be closely associated with the exemplary and exhaustive application of the principles discussed in the full-scale experiment, *Zang Tumb Tuuum,* all conceived in 1912 (though *Zang Tumb Tuuum* did not exist in book form until 1914). The "Technical Manifesto" outlined the rules for a radical reordering of language. Syntax was to be destroyed by employing verbs in the infinitive, nouns in the nominative, eliminating adverbs and adjectives and substituting for their qualifying effects a system of analogical doubles. These "doubles" were to be linked to the "substantive" terms of nouns without modification by the connective tissue of normal syntactic forms, consistent with the mechanical mode of construction Marinetti was attempting to apply throughout. Along with the concept of analogy, which needs elaboration, two other major features of Marinetti's poetics emerged in this tract: the call for demolition of the traditional "I" of poetry and an engagement with "matter" as a primary function of poetic descriptive activity. Matter, here, was defined as the physical stuff of the sensual world—odors, sights, sounds—which should be rendered in poetic form. The function of representation was evocative, but Marinetti glossed the distinction between mimetic imagery and autonomous form, not carefully distinguishing his premises in this tract. He continually calls for directness, but his tone has the severity of an officer enforcing a hygiene discipline rather than a liberation of imaginative activity.

In "The Technical Manifesto" Marinetti invokes the concept of analogy, radically rethinking the Symbolist doctrine of essences and correspondences. As characterized by various critics, Mallarmé's attitude toward the activity of the symbol was that it existed in relation to an ideal of which the sign was a pale shadow. Gabrielle Lehrman, for instance: "the symbol was an intermediary between the material world and the world of ideas."[15] and Michel Decaudin: "Things, and above all their exterior, yearn for a profound and mysterious reality of which they are only the ephemeral and changing signs."[16] Marinetti struggled to differentiate his analogical proposition from these metaphysical strictures. He rejected all faith in transcendence and in a realm of universal essences which existed somewhere other than in either the materialization of poetic language or the physical experience of material existence.[17] His emphatic insistence upon analogy, while mimetic in its predication upon a belief in the empirical nature of phenomena, to be approximated in linguistic terms, had nothing idealist about it. Marinetti was also at pains, within the supplement to the "Technical Manifesto" which he appended in August 1912, three months after publication of the first piece, to distinguish his concept of analogy from that of allegory. Analogy, he stated, was grounded in illogical relations, in the manifestation of a "powerful love which attracts distant things to each other," while allegory was based in and reinforced the conventional logic of poetic form.[18] The elements of the analogy operated with full autonomy, while the elements of an allegory were subject to the rules of reference. Marinetti's approach to analogy combined a mechanistic coupling device, direct linkage signaled by a hyphen, with a categorical and typological approach to linguistic elements conceived to be available, as from a catalog of combinable parts. The machine metaphor is obvious; Marinetti's attempt to modernize language depended on these mechanistic tropes which atomized and segmented linguistic elements and the apparatus of linguistic communication, then recombined the elements.

To link analogous elements in a text, Marinetti made use of the all-purpose hyphen and the basic elements of mathematical signage. The sixth point in the "Technical Manifesto" states succinctly that punctuation is to be replaced by the system of signs, plus, minus, multiplication and division, which so efficiently direct the relations among mathematical terms. That these are all marks of procedures, shorthand for operations to be performed rather than, again, mere substitutions for the organic connective tissue of conjunctions and complex vagaries of prepositions, is important. The insertion of the mathematical signage into the dense prose of the exemplary 1912 "Bataille Poids + Odeur" dem-

onstrated the radical distinction such a change could make in the appearance of the page. While no other typographic manipulation, of size, font, or layout occurs, the fragmenting, scattering, and atomization of the text is effectively marked by this single set of gestures. This will be described in greater depth in the following section, which explores Marinetti's typographic techniques. Marinetti had stated, in the "Supplement to the Technical Manifesto," that "words freed of punctuation shine on each other, interweaving their diverse magnetism, following the uninterrupted dynamism of thought."[19] Similarly, his account in "Bataille" works assiduously to approximate the sensations of the confused illogic of a perceptive sensibility immersed in the scene. This perceptive sensibility, to return to the two other points mentioned above, is not linked to the individual subject of the lyrical poem. Marinetti invokes the concept of the lyric imagination when, in the 1913 discussion of "Wireless Imagination" and "Words in Liberty," his use of the term is opposed to the concept of an individual psyche engaged with interior life. But the role of the lyric imagination is to plunge into and become one with the physical materiality of sensation provided by the world, not to situate an interior psyche at the center of poetic language.[20]

The influence of both Henry Bergson and William James on Marinetti's work during this period has been discussed by Giovanni Lista, among others, and Marinetti's model of consciousness as a continuous stream of ever changing and dynamic impressions derives directly from their work.[21] Marinetti mechanizes this model as he does with all forms he uses to express his aesthetic positions. In point #12 of the "Futurist Sensibility" (1913) he emphasizes the necessity to pattern human responses and perceptions after those of machines in a "perfect fusion of instinct with the productive efficiency of a motor."[22] This machine, motor, and its continuous dynamic are in no way affected by the interior life of the individual. The role of author is as reporter, though the paradox of this may be noted in the distance between Marinetti and the events which, for instance, separated him in time and space by several months and quite a few miles from the scenes of battle he aestheticizes in *Zang Tumb Tuuum*. Lista terms the concept of war with which Marinetti marks his poetic motifs an *idée fixe*, pointing out that it was very much the recalled sensation used to promote "poetic language in the face of an urban and technological modernity" rather than a direct reportage.[23]

It is also clear that another part of Marinetti's intention was to move poetic language toward the forms of transmission, toward forms whose physical materiality was at least temporarily imperceptible and which were characterized by their capacity to traverse space at tremendous

speed, rather than copying the encumberingly literal model of mechanical forms. In either case, however, the repression of the speaking I, of the authorial subject whose interior life had dominated, in radically different ways, Symbolist and Romantic poetic forms, is clear. This theme, first stated in 1912, is expanded in the 1913 and 1914 writings, as Marinetti continually emphasizes the perceptual apparatus as mechanistic and stresses material existence as the source of images rather than the psychic life or human drama of emotions. Whatever autobiographic intentions could be called in to account for this radical repression of individuality and interiority, the effect is a depersonalized voice within Marinetti's Futurist poetics. The site of the daily newspaper, in which his manifestos had appeared, had become a model for the depersonalized form of the voice. In spite of its thorough overturning of syntax and normative grammar, his poetic expression shares with the journalistic mode an attempt at clear reporting. Albeit that in this poetic version the forms are fragmentary and illogical, in juxtaposed relations, rather than copying the discursive and expository norms of journalistic writing. But the myth of a sensual, phenomenal physicality that can be rendered in linguistic material required the reduction of the "I" to a mediumistic transmitter of sensation. The "self" is merely the central site of response.

The notion of matter which accompanies this discussion of the "I" is literal, physical, and empirical. Matter consists of odors, colors, movements, and charges. The world, a landscape, for instance in the sample Marinetti provides, is to be described as if by a dog, a realm of pure sensation. The realization that language was in fact utterly distinct as a system from the world it proposed to be in relation to was a clear tenet of Marinetti's realization, and yet the realization did not carry to the logical extreme of releasing him from linguistic mimesis. Instead he condemned the old forms, believing that there were better linguistic means for approximating sensation, and the world, more adequately. Again, this was not the world of universal essences aspired to in Symbolist correspondence, but the world of empirical phenomena whose character and capacity to be represented Marinetti never questioned. As Luciano de Maria commented, "Under its revolutionary guise, 'Words in Liberty' hid a traditional, naturalistic and descriptive foundation."[24]

The 1913 manifestos, "The Futurist Sensibility," "Words in Liberty," and "Wireless Imagination," accompanied by a handful of brief appendices, "Semaphoric Adjectives," etc., expand the tenets of the "Technical Manifesto" without serious modification. Marinetti discourses in greater detail on the nature of the fragmented account, which is his model of a Futurist language, asyntactic and perceptual, and restates the

need for the poet to eliminate "conducting wires" so that words might be "absolutely in liberty."[25]

But in the "Typographic Revolution," another appendix to the 1913 "Futurist Sensibility," he outlines with more precision than ever before the elements of the practice he has already embodied to a great extent in the full-scale exploration of the 1912 production, *Zang Tumb Tuuum*.

> I call for a typographic revolution directed against the idiotic and nauseating concepts of the outdated and conventional book, with its handmade paper and seventeenth century ornamentation of garlands and goddesses, huge initials and mythological vegetation, its missal ribbons and epigraphs and roman numerals. The book must be the Futurist expression of our Futurist ideas. Even more: my revolution is directed against what is known as the typographic harmony of the page, which is contrary to the flux and movement of style. Therefore, we will employ three or four different colored inks and twenty different typefaces on the same page if necessary. For example: italic face for a series of similar and rapid sensations, boldface for violent onomatopoeia, etc., A new concept of the pictorial typographic page.[26]

A year later, in the 1914 "Geometric and Mechanical Splendor of Numerical Sensibility," Marinetti's commitment to a mechanical model for poetic language had been reduced to the most literal of conceptualizations. Copying mathematical notation had now become an obsession, a kind of hygienic purge for the otherwise excessive trivia which cluttered language. Streamlining the messy vagaries of syntax into the precision and brevity of numbers, poetic language could realize its true "splendour." Dangerously close, in some ways, to a cabalistic concept of mystic quantities, Marinetti remains pointedly committed to the material plane. Citing Bergson directly, he conceptualizes the very operations of knowing as those which include an immersion in the matter of physical existence. The jumble of rhetoric in the 1914 manifesto also includes the use of the term "animal magnetism" as natural force, and the influence of popular science versions of the concept of consciousness is obviously seeping into his attempts to universalize his theory of poetics into a philosophical system.

One peculiarly aberrant piece of theoretical writing by Marinetti, published in 1916, is his "Manifesto of the Surprise Alphabet." By the late 1910s, Marinetti, and even more so, a number of other Futurists, had, in a limited and tentative manner, begun exploring the techniques of automatism which would feature so prominently among the Surrealist approaches to writing. The 1916 essay contains a hierarchical progres-

sion of associations which can attach to the alphabet when it is rendered autographically. These begin with the notion of universal associations— the architectural structure of the "M" and so forth, which Marinetti conceives to be the condensation of centuries of human thought. He continues, with increasing degrees of personal association, to those which spring from the disposition of the writer—he mentions his own response to the "B" as an erotically charged form. At the next level, associations derive from the history of the writer, complex memories and connections, and finally, the letterforms become charged through their production as handmade and calligraphed images. This text is aberrant by its retrograde mystical character in every way but one—the attention to graphic character as expressive. The emphasis on the idiosyncracies of personal history and psychic life as well as the attention to the handmade quality of autographed forms is so out of keeping with Marinetti's other work that it seems necessary to attribute much of the thought in this piece to Francesco Cangiullo, as Lista does.[27]

Within Marinetti's Futurist texts, then, the premises on which visual and verbal elements function as signification is that of immediately expressive form. On closer inspection, this expressiveness turns out to be attributed to the apparency of visual form whose semiotic functions Marinetti ignores. His understanding of language as a system which is fundamentally mechanical, and capable of being atomized into elements available for recombination, attributes a functional efficacy to syntax as if its semantic properties were not linked to reference but entirely contained within the structure of the linguistic sign. But if, on these microlevels, Marinetti believes in the onomatopoeic apparency of linguistic form, and its capacity for immediacy and expression, on the macrolevel his themes depend on the conventions of mimesis with all of its referential relations and structures. Materiality, in this poetics, functions as the matter of sensual experience and the materiality of signification Marinetti assumes resides in its expressive form. But the paradoxes and conflicts between his emphasis on the immediacy of sensation and the thematics of reference are not resolved. The visible appearance of his work isn't only graphic mark-making, it is laden with semiotic functions. The typographic form Marinetti advocated as the most appropriate to his idea of the "Words in Liberty" puts the paradoxical relations between these elements into full play.

The 1919 publication of *Words in Liberty* contains almost no new material; it assembled the treatises Marinetti had written earlier and anthologized the experiments in typography in which he had embodied his poetic propositions. With this discussion of Marinetti's stated agenda

in place, it is possible to turn to close examination of his typographic work. Marinetti's realization that he needed a revised form of visual expression should not be taken for granted, and neither should its relation to the Mallarméan precedents to which it was, inevitably, compared— by Marinetti himself and by his contemporaries.

Typographics

Marinetti's typographic style, like his early poetry, was conceived within the aesthetic sensibility of late Symbolism. The covers and formats of his first publications, the *Le Papyrus* which he launched with Alessandria D'Egitto in 1894, *La Conquête des Etoiles,* his first long poem published in 1902, and the pages and cover of *Poesia* are all well within the conventions of established literary form. *Poesia* throughout its four years had the same cover—the allegorical image (nude, female, classical) of Poesia conquering a mythical beast with her silver arrows— and could not be more consistent with the *passéiste* sensibility Marinetti would decry in 1909.

Though the "Futurist Manifesto of 1909" broke the ground for aesthetic innovations, it was not, itself, typographically radical, nor, as per the above discussion, did it make specific propositions about the form of typographic experiment Marinetti envisioned as appropriate to the Futurist sensibility. The first radical typographic work appeared in the 1912 *Battle: Weight + Odor,* then a poetic account of Adrianapoli, October 1912, which was published as *Zang Tumb Tuuum* in 1914, and the sections of *DUNE* published the same year in *Lacerba.*

Marinetti's contemporaries responded to his typographic inventions by making the almost inevitable comparisons to the work of Mallarmé; these were, in fact, almost entirely unjustified, since the concrete expression of the sensations of battles, war, explosions, speed, movement were at odds with the fundamental sensibility—thematic and critical—of the Symbolist poet. The force of these comparisons is that they make clear, yet again, the extent to which Mallarmé was the single point of reference within the literary domain for such typographic experiment.

In many instances, the Futurists did not come off well in the comparison. For instance, in 1925, Pierre de Massot wrote descriptively of the typography for which Mallarmé's works had set a precedent:

A completely internal poetry, full of sensations, of sentiments, expressed without any links, by the sole means of assembling the vocables themselves without, on the one hand, this research into rare words which in-

vaded the speech of the parnassians and symbolists, especially presented by a typographic arrangement which could have been designed by a painter. This disposition, which owes its existence to Mallarmé, and his first attempt in *Un Coup de dés*, requires a bit of originality. Unfortunately, it has been abused. There isn't a single invention that the monkeys don't distort. The eye should play like the spirit. After all, apart from the emotion which the poem secures for itself, there is also the research of the design, the value of a typeface which is more or less thick, the choice of a line for a verse, the mystery of the blank space.[28]

Marinetti was in fact intent upon an explosion which positioned him against the occult style of the Symbolist generation and saw the role of typography as essential in making a revolutionary poetics.[29] Rosa Clough, in her 1944 discussion of Futurism, showed more understanding of Marinetti's typographic work in its relation to his other concerns:

> When critics accused him of copying the worst features of Mallarmé's poetic art, he answered, "This new array of type, this original use of characters, enable me to increase many times the expressive power of words. By this practice I combat the decorative and precious style of Mallarmé, his *recherché* language. I also combat Mallarmé's static ideal. My reformed typesetting allows me to treat words like torpedoes and hurl them forth at all speeds: at the velocity of stars, clouds, aeroplanes, trains, waves, explosives, molecules, atoms.[30]

Marinetti's poetics was predicated on a faith in the capacity of typography to produce adequate analogies. The plane of discourse was the realm in which the analogic potential of language must necessarily be realized. Marinetti's belief in a "true" phenomenal world was balanced by his engagement with representational means. In attempting to develop more appropriate means for representing the absent signified, he engaged in an exploration of the presentational elements of graphic effects available through manipulation of the signifier. Thus the specific interplay possible through emphasis on materiality—a faith in the effects of visual form coupled with the capacity of a visual or verbal signifier to invoke an absent signified—was foregrounded in his typographic treatment.

Marinetti's stated purpose was to use typography for its expressive potential. The means by which he set out to achieve that led him to inquire systematically into written forms at every level, from letter/symbol, to word, phrase, line and page, and even, occasionally, marks which had no identifiable linguistic component. He questioned the

symbol system, that set of notational devices which were familiarly used for written representation; used the page as both a picture plane and graphic field, alternately employing the illusionistic devices of conventional picture making and the purely graphic means of format design. His arrangements used the "lines" of the image as linguistic "lines" of a written text. Finally, he even broke down the traditional letterpress page, with its discrete spaces capable of being occupied by one and only one element at a time, and forced the two-dimensional plane to allow overlapping and layering, complicating the textual page in a way which was never permitted in literature until that point. It is arguable that the Futurist works *looked* more radical than they were poetically, given Marinetti's fundamentally descriptive bias. But in turn this argument supports the realization, by Marinetti, that the poem was the object of the look, of looking, and that recognition of its visuality was a significant feature of the radicality of the Futurist practice. Marinetti wanted the visual presence of marks on the page to function theatrically, phenomenologically, as the record of and the provocation of sensation. But he was also intent on creating a descriptive poetics and, at the same time, a language of simultaneity and telegraphic transmission. Highly invested in the material aspects of typographic practice on the one hand, he was equally invested in the dematerialization of language as transmission.

In the first extensive application of his expressive typography, the 1912 *Battle: Weight + Odor* (*Bataille: Poids + Odeur*), Marinetti demonstrated the pared down, streamlined version of language he felt embodied the Futurist aesthetic. The immediate visual impression given by this work is of a grey field of language broken only by occasional openings in the text and the slightly bolder marks of mathematical notation. The words follow each other with the blank solidity of facts, one after another, as items to encounter without preparation or modification. Their sequence fixes their relation to each other and to the reader. The linear form of prose text is preserved, though none of its discursive niceties are permitted to modify the blunt artillery fire of successively deployed terms. Elements and quantities, sounds, colors, and odors are equally enumerated, and their relation to each other resembles the suggestive effect of synaptic firings close enough to each other to create a full image in the mind. The sum effect is peculiarly neutralized, as if this were language received through telegraphic wires where the maximum efficiency in communications is merited by the means of transmission. The expressive potential of visual means has been pared down to the minimum, rather than expanded, since even the emphatic character of

majuscules, the differentiating tone of italic and bold versions of the type, have all been eliminated (figure 10).

The piece conforms to Marinetti's image of a "modern" language, a language designed for speed, unencumbered with the baggage of conjugations, declensions, qualifications, and descriptive excesses. This was a mechanical language with a few well-moving parts, put at the service of analogy and its full force. Marinetti also made the point that the force he envisioned in analogy was an illogical force, a language freed from the logic imposed by normal syntax, a "logic" which restricted the full potential of language to signify in the way in which words, disposed at random, or at least, freed from the linear confines of punctuation, might. The use of the mathematical notation at first glance suggests mere substitution of, for instance, the sign (=) for the word (equals). In fact, a different relation is actually posed by the sign than would have been posed by the word in the same position. The two terms on either side are balanced across a fulcrum point and their relationship is not, strictly speaking, linguistic, but rather, physical, even mathematical. Commenting on his procedure in this same work, Marinetti said,

treno express-express-expresssssssss press-press press-press-press-press-press-press-press-press-press-press-presssssssss punzecchiato dal sale marino aromatizzato dagli aranci cercare mare mare mare balzare balzare rotaie rott-tttaie balzare roooooottttaie roooooooottaie *(GOLOSO SALATO PURPUREO FALOTICO INE-VITABILE INCLINATO IMPONDERABILE FRA-GILE DANZANTE CALAMITATO)* spiegherò queste parole voglio dire che cielo mare montagne sono golosi salati purpurei ecc. e che io sono goloso salato purpureo ecc. tutto ciò fuori di me ma **anche in me** totalità simultaneità sintesi assoluta **=** superiorità della mia poesia su tutte le altre stop Villa San Giovanni cattura **+** pesca **+** ingoiamento del treno-pescecane immagliarlo spingerlo nel

ferry-boat-balena partenza della stazione galleggiante solidità del mare di quercia piallata indaco venti-lazione *(INSENSIBILE QUOTIDIANO METODICO SERICO IMBOTTITO METALLICO TREPIDANTE RITAGLIATO IMPACCHETTATO CESELLATO NUOVO)* accensione di un ve-liero **=** lampada a petrolio **+** 12 para-lumi bianchi **+** tappeto verde **+** cerchio di solitudine serenità famiglia metodo d'un secondo veliero prua lavorare al tornio il metallo del mare trucioli di schiuma abbassarsi della tempera-tura **=** 3 ventagli al disopra dei Monti Calabri *(AZZZZZZURRRRRRO LENTO INDUL-GENTE SCETTICO)* Macerie di Messina nello stretto

Figure 10. *Bataille: Poids + Odeur*, F. T. Marinetti (Milan: 1912).

The poet will hurl along parallel lines several chains of colors, sounds, odors, noises, weights, thicknesses, analogies. One of these lines can be the pictorial one, another the musical one, the third odorous. Let us suppose that the chain of pictorial analogies dominates all the others. It will then be printed in larger type than the second and third lines which contain, let us say, musical and odorous analogies.[31]

By using the conspicuous mathematical notation, Marinetti destroyed the visual habit of syntactic representation, the linearity in which certain structural relations, like (+) or (=), were buried within the semantic value of the words "and" or "equals" or "is." Arguably, the substitution was not simply that of a visual mark for a word which was its equal, but the substitution of a system in which relations were more propositional than prosodic. The elements on either side of an (=) or (+) sign separated into fully autonomous units, discrete units available for combination, opposition, or other nearly physical relations, while the elements linked by the word "and" or "is" would be contained within the linear sequence of which they were a part and which contained them within its ribbon of discourse. In Marinetti's terms, the "substantive" value of the elements linked by the mathematical signs increased since their definition as syntactic elements was decreased; all that remained to define them was their objectness, their individual identity as elements.

The works which follow this first rather restrained example of Futurist orthography are dazzling by contrast. The first of these is the small, concrete poem entitled, "Letter from a Pretty Woman to an Old-fashioned Man" (figure 11). (The term *passéiste* used to modify the word "man" is inadequately translated by the phrase "old-fashioned" since it carries a very pejorative outmoded and deliberately retro characterization unavailable to any single English word or phrase.) The two ends of the formal address, "Cher" have been pulled apart, revealing at their interior a message which transforms the "CH" and "R" which open and close the word into a frame in which the pun "chair" for "flesh" is given emphatic visual presence. The long strip of language, very much in the shape of a telegram, goes on to list the woman's requirements in cash, jewels, and shoes, per month. As a visual poem the work reduces to starkly efficient means the structure of a tendered contract, the doubling effect of the *cher/chair* doing much of the semantic work through simultaneous use of the typographic elements. The terms of exchange and contract are economic, are explicit, while the services are named as *kisses, caresses,* and *elegant beauty*—all in keeping with Marinetti's attempt, in the 1913 "Futurist Sensibility," to describe the terms on which

Figure 11. *Chair: Lettre à un monsieur passéiste*, F. T. Marinetti.

old-fashioned "love" had become involved with the notion of "luxury" in a manner Futurism aimed to destroy. In that text he had suggested that the liberation of women and their achievement of equal status would break the destructive link which associated women with luxury (the Baudelairean "luxe, calme et volupté" formula immediately comes to mind). The statement of terms in the form of this brief account demystifies the connection, even if it links feminine sexuality with male economic compensation.

But the synthesis of all of Marinetti's linguistic ideas, and his ideas about the visual representation of language, became fully developed in the 1912–14 productions of *Zang Tumb Tuuum* and "Dunes" (figures 12–16). It was in these works that his concepts of onomatopoeia and typographic representation manifest their first complete presentation. Marinetti's theoretical statements about this work have certain contradictions in them, however.

We will have a new orthography which I term free expression. This instinctive deformation of words will correspond to our natural penchant toward onomatopoeia. It doesn't matter if the words become ambiguous by this distortion. It will be in better accord with the onomatopoeic quali-

Dunes

Karazouc-zouc-zouc
Karazouc-zouc-zouc

nadI-nadI AAAAaaaaaa *(bis)* dunes
duuuuuuuuunes · soleil dunes dunes dunes
dunes dunes dunes dunes

douum douumm
derboukah ennuiblanc

précipité
aveuglant **doum** —+— laine du bruit
éternel **doum** de la pensée
aveuglant rembourrage sonore
mécanique **doum** du ciel
aveuglant **doum** bruit rotatif
consanguin du soleil souvenirs
aveuglant **doum** cotonneux tam-
ton majeur **doum** bours des moelles
aveuglant tunnel de sons noirs
dans les montagnes
incandescentes de la
lumière

Figure 12. From *Dunes*, F. T. Marinetti (*Lacerba*, Milan: 1914).

Ocre ✚ cuivre-jaune ✚ cannelle 18 Km.²

déchirant	**vvvvvvvrrrrriiiiiii**	
universel	**vluiiii**	violons chats grince-
fibreux	**vuulii**	ment de toutes les
ton mineur	**vuluit**	portes romantiques
	vuvu-	balles tympanums
	luit	tourbillons de neige
		dans les fils ,télégra-
		phiques
		cordes du vent ten-
		dues sur le nez du
très délicat		chauffeur sous l'archet
grimpant		toortuuUuUuUuUueux
étiré		de la route véhémente

JAUNE JAUNE

âcreté urine sueur cassie saleté jasmin
ventre de banquier pieds-laboureurs sable-
coussin se-coucher-soif-soif
bruit ✚ poids du soleil ✚ odeur orangée
du ciel ✚ 20 000 angles obtus ✚ 18 de-
micercles d'ombre ✚ minéralisations de
pieds nègres dans le sable de cristal

Figure 13. From *Dunes*, F. T. Marinetti (*Lacerba*, Milan: 1914).

distances

cadencé
navigant
moëlleux
maniable
minutieux distances
intestinal

dunes
s'étirer
ondulation
angles
angles modeler sables s'émous-
ser polir polir somnolence
du vent rond-de-cuirs
artères. écarlates joie de pa-
yer à un voleur le prix du
prurit comptabilité des
ongles 1/2 kilo de fro-

RAN

mage 226 kilos de
CHAIR DE FEMME spi-
rales d'une fumée bleue ─┼─
odeur de veau rôti GAR-
GOTE DE ROTHSCHILD
(ampleur 1000 km. carrés)

RAN

Figure 14. From *Dunes*, F. T. Marinetti (*Lacerba*, Milan: 1914).

négateur pa-
resse inertie ge-
ler tout par des
étoiles littéraires
deracinées de la
chair (NUIT LI-
VRESQUE) en-
terrer tout avec
odeur d'aisselles
matelas de par-
fums seins cuits
dans le plaisir
—|— 7000 raison-
nement sceptiques

affirmateur
optimisme force
repousser le vent-
pessimiste-chaud-
ou-froid
aller sans but
pour FAIRE VI-
VRE COURIR
ETRE

VENT

SANG

MOUVEMENT

DE

2 PISTONS

Karazouc-zouc-zouc-zouc-AAAaaaaaaaaaaaâ

Nadi-Nadi-

Figure 15. From *Dunes*, F. T. Marinetti (*Lacerba*, Milan: 1914).

terriiBLE SOLEEIL FÉROOCE

SENTIMENTAL

aveu-
glant
de
larmes

sur les jeunes ex-
plorateurs trompés
par leurs femmes
maîtresses
solennité d'un cocu
sur la ligne de l'é-
quateur

aveu-
glé
de
larmes
rouges

Figure 16. From *Dunes*, F. T. Marinetti (*Lacerba*, Milan: 1914).

Aéroplane Bulgare

INDIFFÉRENCE

DE 2 RONDEURS SUSPENDUES

SOLEIL + BALLON

CAPTIFS

flammes géantes colonnes ·e fumée spirales d'étincelles

villages turcs incendiés

grand *T*

rrrrronrrronnant d'un monoplan (pla-pla-
pla-pla-pla-pla) bulgare + neige lente de
petits manifestes

Figure 17. From *Zang Tumb Tuuum*, F. T. Marinetti (Milan: 1914).

ties of sound and permit us to achieve a psychic onomatopoeic accord, a
sonorous expression which is the abstract of an emotion or pure thought.[32]

Marinetti here confused the sounds of things and the look of things,
confused onomatopoeic language and its representation, confounding
the aural with the pictorial. Onomatopoeia became the means to "vi-
talize lyricism with the raw elements of reality" and to "express with
the greatest force and profundity, naturally transforming into self-
illustrations, by means of free, expressive orthography and typography
(e.g., the military balloon I designed typographically in my *Zang Tumb
Tuuum*)" (figure 17). Allowing words to become "ambiguous" forced the
emphasis on discourse rather than on reference, on signification as ac-
tivity rather than description grounded in a relation to a true empirical
reality.

Along with this exhortation toward onomatopoeia came a caution
against the pictorial, a caution which seemed almost contradictory:

> Sometimes we make synoptic tables of lyric values without words in free-
> dom which allow us as we read to follow many currents of intertwined or
> parallel sensations at the same time. These synoptic tables should not be
> a goal but a means of increasing the expressive force of the lyricism. One
> must therefore avoid any pictorial preoccupation, taking no satisfaction in
> a play of lines nor in curious typographic distortions.

And finally, he added this:

> Free expressive orthography and typography also serve to express the fa-
> cial mimicry and the gesticulation of the narrator.

> Despite the most skillful deformations, the syntactic sentence always
> contains a scientific and photographic perspective absolutely contrary to
> the rights of emotion. With words in freedom this photographic perspec-
> tive is destroyed and one arrives naturally at the multiform emotional per-
> spective.[33]

The pages of *Zang Tumb Tuuum,* many of which made their appearance
as excerpts in journals between 1912 and the 1914 publication of the
work in book form, and the pages of the shorter work, "Dunes," maxi-
mized the graphic potential of the page. The distribution of type into
split columns, horizontal and vertical elements disposed at right angles
to each other, the words fragmented into letters which amplify the ono-
matopoeic effect—these are all pressed into service.

A short piece, produced in October of 1912 to be distributed from a
Bulgarian airplane into pitched fields of battle, made literal use of the

pictorial distribution of elements (figure 18). "Aéroplane Bulgare" contains the schematic image of the indifferent orbs of the sun and the balloon, which carries its captives above a burning Turkish village which sends up columns of flame, smoke and sparks; true to his own propositions, Marinetti minimizes the human presence in the scene of battle and emphasizes the spectacle. The reverse side of the sheet carried, in a single column imitating the prose of a newspaper, a statement of the stance of the Bulgarians who waged war against the Turkish government. The image of a spectacle, to be redistributed through the air, its dissemination staged as a spectacle, this piece contained the publicity tactics and strategies so integral to Marinetti's Futurist aesthetics.

The pages in "Dunes," and later, *Zang Tumb Tuuum*, take these techniques further—both in the sense of exploring a wide range of spatialized relations as a means of hierarchically organizing the literary text, and also in the sense of playing with sequences of pages as part of the field of semantic production. "Dunes" represents, as Giovanni Lista states, "the mature state" of words in liberty. The nine pages contain a sequence of intense, sundrenched and scorching images, full of blinding light, and depictions of the sun, sky, sand as motorized, mechanized landscape. This is a relentless inscription of sensation, from the "toortuuUuUuUuUueux" image of the road to the wide void separating the words "distances" from each other, and of sounds, "rrrrrr sssssssss rrrrrr croucra croucra croucra" of the camels (see figures 13 and 14).

There is nothing pictorial about the organization. Columns of words in juxtaposition permit the simultaneous recording of sensations in various modes, the odor, sound, color strains of Marinetti's earlier propositions. The use of enlarged parenthetical devices permits a relationship which is largely temporal, emphasizing simultaneity, to be marked in what approaches an elaborate score of sensory phenomena. The two poles of optimism and pessimism are depicted as two pistons, "wind" and "blood," whose opposing movements drive the machine which is also the poem itself. Themes of tension between men and women, betrayal, lust, passion, and the diminishing force of sentiment below a "ferocious" sun—all of these wind through the work, inexplicit as a narrative, suggestive and evocative as a poem.

In *Zang Tumb Tuuum* Marinetti uses much of the same approach but for the elaborate scoring of a war epic. Here use of varying typographic emphasis, words standing out in full caps and larger size, the italic caps, streaking at what Marinetti must have felt was break-neck speed across the sheet, while they appeared to rely on the graphic value of the typography, on the assumption that there was an essential value to

imboscata di **T. S. F.** bulgari
vibbbrrrrrrarrrrrre
arrrrrrruffarrre comunicazioni turche
Sciukri Pascià - Costantinopoli

PALLONE
TURCO
FRENATO
vibbrrrrrrrrrrrare
vibbrr Tsarigraad
TSF
TSF
TSF
TSF

altezza
400 m.

SCOPRIRE
vibbbrrrrrrrarrre
CHE
vibbbrrrrrrrarrre

assalto contro Seyloglou mascherare assalto

Figure 18. From *Zang Tumb Tuuum*, F. T. Marinetti (Milan: 1914).

bold, italic or other type, play up the relations of elements within the page as a field, in turn used to depict the field of battle. There is a great deal of noise in this work and the creation of one chaotic scene after another. It is exhaustive and exhausting, a work which manipulates the verbal material into an imitation of both sound and image of the smoking, pounding realm of military struggle. At moments the words march and parade, at others, they disintegrate into mere vocables and letters.

Marinetti achieved an investigation in the way in which materiality served to establish a range of contrasts and values which simply, by the very form of their existence, could activate a literary work within the visual theater of the page, fluctuating between the effective presence of the graphic forms and the differential character of the linguistic elements. The evocative potential of the images to mimetically reproduce effects was achieved by the suggestive manipulation of visual materiality, which cannot be left out of the signification process. The representation did not duplicate redundantly something which was considered to already exist in some transcendent state of *being;* there is no pre-existing signified linguistic value to be represented. Rather, the actual rendering made the linguistic value through a particular form, gave it a material emphasis, within the structural limitations of the visual vocabulary, though the words continued to function through their differential linguistic operations. The physical, visual system, manipulated to linguistic ends, resulted in the full effect. Thus *anche in me* stands out (see figure 10) against the field of the page in which it occurs, just as *insensible quotidiano metodico* races away from the fragmented realms in which it is situated, and the vibrating lines which lead to the Turkish hot air balloon appear to shake themselves out of focus, the repeated "bbbb" and "rrrr" of word "vibrare" smearing the appearance of its visual image (see figure 17). Nothing in Mallarmé's spatial experiments, with their dramatic use of the white space, claimed the kind of theatrical value as did Marinetti's machines, which depended on a spatial relationship constructed by, as much as within, the edge of the page.

In the "Bataille à 9 Etages" (1916), Marinetti, without apparently, seeing any paradox in this whatsoever, made one of his most orderly typographic arrangements in order to depict the chaos of battle[34] (figure 19). The page was a flat picture plane against which the profile of the mountains appeared as series of peaks; the steep left/right slope of the line of condensed type echoed the movements of descent into the galleries of the mountain; the ascent in meters was marked out almost as precisely as in the cross-section of a geological map, so that the nine levels at which the battle took place were all given their own discrete

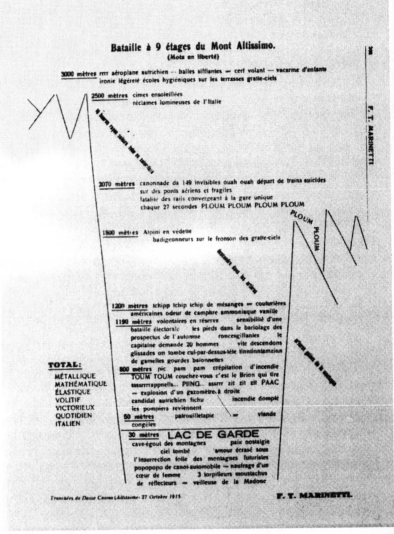

Figure 19.	*Bataille à neuf étages: Mont Altissimo*, F. T. Marinetti (Rome: 1916).

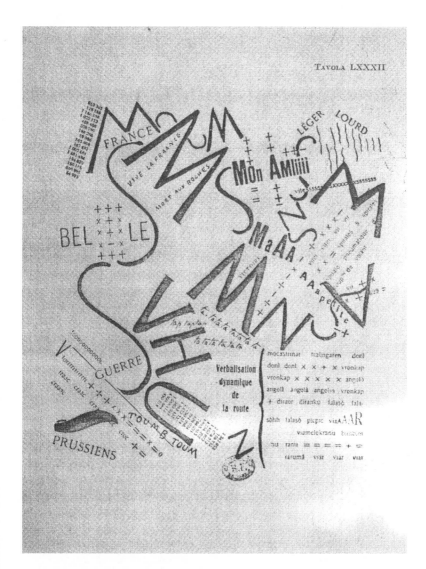

Figure 20. *Aprés la Marne, Joffre visita le front en auto* (originally titled
Montagnes + vallées + routes + Joffre) F. T. Marinetti, from *Mots en Liberté*
(Milan: 1919).

spot in the landscape. The work was a schematic diagram of the battle, an orderly diagram, a perversely systematic image of destruction.

The exaggerated stasis of this image contrasted radically with the rhetoric of Marinetti's manifesto and the dynamism of *Zang Tumb Tuuum*, which, by abandoning the conventional scheme of pictorial representations of space, had more fully freed the words to function in onomatopoeic liberty. Here the description of a battle in careful, horizontal, vertical and diagonal lines of type loses most of the organic force on which he had been so insistent. The pictorial qualities of the page were schematic, rather than dramatic. But pictorial qualities did exist, from the implied horizon line from which the sloping mountains rose, to the clarity of the section cut through without any implication of perspective or depth. There was no layering or fragmenting of the space represented. But the elements were locked into a pictorial relation with each other through the diagrammatic framework. The fixed edges of the page served as the lower and upper limits—in the case of the bottom margin, the implied ground line was coincident with the bottom line of the type, one of several very literal uses of the drawn space as it collapsed into the typographic rendering of the text. The edge becomes literal frame and graphic device in a reinforcement of material and pictorial functions. The graphic elements in the piece tended to belie the subtitle "Words in Liberty" since the composition was a rigid arrangement of typographic elements according to a fixed pictorial schema whose conceptual basis was one of the most rigidly codified of forms, the sectional diagram. To some extent, the visual and verbal elements duplicated each other. For instance, the placement of the elements in relative heights was redundantly restated by labelling those levels. Fixing the verbal elements in such a rigid hierarchical framework constrained their ability to resonate through the ambiguous layers of value available to linguistic elements; the visual relations restricted, rather than expanded, the possibilities. The pictorial relations fixed them in a diagrammatic syntax, that is, a single continuous space in which their relations might be read, even if they were free to a moderate degree from the linear configuration of conventional syntactic representation.

By contrast, a piece originally titled "Montagnes + vallées + routes + Joffre" makes a far more adventurous synthesis of the schematically pictorial with the onomatopoeically graphic (figure 20). The swirling path of the autoroute winds among the mountains and valleys of France, in and out of the scene of battle between French and Prussian forces. At the bottom right, a small square of type contains the "dynamic verbalisation of the route" with the usual onomatopoeic syllables. The map bears

no relation to either topographical schemes or pictorial landscapes: there is no horizon, no fixed coordinates, and no single orientation by which to navigate the churning field. The eye is drawn through the mass of activity by the dominant curves of the route, only to be distracted by the fields of crosses, tight passes between the high peaks of large, hand-drawn "M" forms, and then plunged into the fracas of sounds again. The compelling aspect of this work is that it refuses either pictoriality or literary form, sitting precisely between the two, requiring that one shift between the activities of reading for sense and looking for sensation.

The 1917 work which was titled by its caption, "At night, in her bed, she rereads the letter from her artillery man at the front," offered a contrast and further development of these pictorial strategies and pushed the question of the relation of the visual aspect to the linguistic even farther (figure 21). A voyeuristic charge is projected onto this piece, and structured into it, to amplify the sexual quality of the allusions. The image was dynamic, wildly so, and broke down the discrete space of the page that had constrained the "Bataille" in its space without implications of layering, intersection, or depth. "Letter" no longer functioned as a poem with a few visual features; it was a completely visual work, taking advantage of the graphic materials, for their pictorial properties. These properties worked to underscore the verbal content so that Marinetti's "expressive typography" was actively exemplified.

The change from the 1914 *Zang Tumb Tuuum* to the 1917 "Letter" was remarkable: in the 1917 work the full potential of the theatrical page was exploited. The typographic elements were no longer incidentally visual, but fully visual. The subject matter as well as its distribution on the page lent themselves to this dramatic treatment. The voyeuristic emphasis positions the reader to *look* into the situation. The object is the woman in her bed, her dark silhouette providing a certain amount of information, mainly, her identity as female, a privileged object of the voyeuristic drive. Her hunched buttocks and voluptuous form have a sensual, if not explicitly sexual, connotation, while the fireworks of the letter from her artillery man, a thinly disguised sexual metaphor, completes the text which the suggestivity of the image evokes. The point is that not only are the visual aspects of the representation of a text being fully explored, but the main subject of the work as a whole was the activity and structure of looking, of the visual impulse and concealment, of the activity of a particular moment of this woman's existence, played upon a visual field in which neither language nor the pictorial imagery could be excluded from the production of the signification as a whole. The visual distribution of linguistic elements, into a violent field of rev-

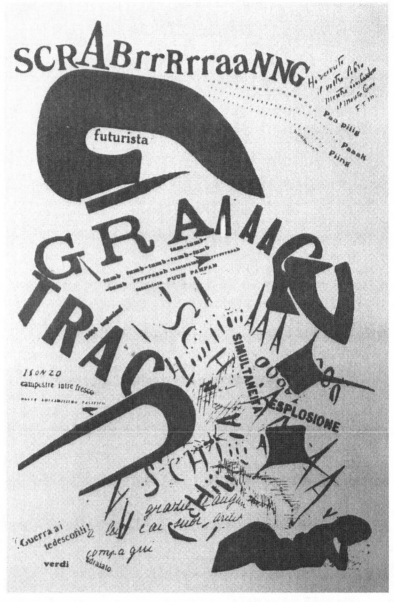

Figure 21. *At night, in her bed . . .*, F. T. Marinetti, from *Words in Liberty* (Milan: 1919).

ery which surrounds the dark figure of the woman, provided them with a signifying value already, a value in which the fragmentary, sound suggestive content of the words participate. As visual elements, the words make the page an image in which they function also as language, articulating a double subject position of the reader/voyeur. After this point, the line between the linguistic and visual aspects of representation in/of language demarcates two simultaneously occurring processes of signification within a single work. The meaning of the words derived as much from their position, their relation to each other as visual elements and their movement as a series of marks across the sheet, as from their semantic value. Their differential linguistic operation cannot be isolated from their phenomenological appearance on the page: both are at work in the production of signification.

The visual aspect was not superfluous in any way, even to the degree in which it could be so characterized in the "Bataille" piece. The graphic typography is inscriptional, fundamental to the making of the form in which the signification is produced. The linguistic component is overshadowed, overwhelmed by the visual effects, so that any attempt to unravel a sentence, a phrase, or even a fragment from the considerable chaos of the visual field would be considerably difficult, if not impossible. There was no simple verbal, linguistic presentation, in spite of the fact that with the exception of the female silhouette and a sprinkling of random visual marks, the bulk of the material which appeared on the page consisted of sequences of letters, fragments of words, sound imitations, etc. The two orders of representation cannot be separated from each other here, nor can the limits of one upon the other be identified, each contribute, simultaneously, to a piece in which the work of both occurs without cancellation, without redundance, without easy resolution. Image and language are neither reducible to nor separable from each other.

Marinetti's graphic and typographic manipulations in these works could not have been achieved with normal letterpress means. These works are collage pieces whose elements combine fragments of typographic text with calligraphic markings and this represents a condition of 'liberty' from technical constraints. In the final work to be considered here, the "Tumultuous Assembly," fragments of printed material have been cut, pasted, layered, drawn on, and rephotographed for reproduction. Letterforms have been violated and the discrete integrity of the letterpress shapes have been interlayered, creating a spatial confusion not possible in normal relief printing except through multiple printings.

This work consists, as do "The Letter" and "Joffre," of single printings, which must have been produced from photographically engraved plates.

The work of "Tumultuous Assembly" deploys Marinetti's techniques to a degree of chaotic expressiveness which verges on a disintegrated extreme. Here language is almost without meaning, and as much of the information is numeric, the work has the character of an exploded table of reported statistics. The machine of Marinetti's Futurism breaks down here, into a condition of 'explodity,' of malfunctioning tumult. The wires are jammed, the mechanisms locked into place as through an effort to force them too fast to surpass the limits of their parts. Within the metaphor of machine aesthetics, there was no way to keep poetics working with this approach; a dematerialized medium would have been required, an electronic mode, to transcend the limitations which Marinetti had reached with this project.

Finally, the successes of Marinetti's work lie in the depth of his onomatopoeic imagination and his capacity to force the matter of visual representation into its service. Marinetti struggled to develop a more accurate rapport between the representational system of language and its supposed referent. He did not question the relation between language and the field of reference, but foregrounded the material qualities of representation in his attempts to obtain a better correspondence. Typographic manipulation, in Marinetti's opinion, could contribute to this process by generating novel effects which aided in the destruction of normative syntax and the reinforcing effect of the linear mode in which literary language was conventionally constrained. While Marinetti's work was not informed by a specific acquaintance with the work of Saussure, his manipulation of the signifier offers a challenge to the distinctions articulated in the structural linguist's description of the sign. Most specifically, the determination of the signifier as an acoustic image breaks down in the face of a form of linguistic representation (fragmented typographic forms) in which that term would have no particular value. The concepts evoked in the image of the "Letter" would be difficult to isolate within the limited structure which Saussure envisioned for linguistic signification, and yet the elements in the visual field surrounding the woman's form were undeniably elements of language. They could easily be taken as a whole, as a group, as a mass of diverse elements, all of which could be described by a linguistic phrase, such as, "the noise of battle," which might suffice to describe what is on the sheet and the category of linguistic value to which it belongs. But as individual elements, the broken words and large letters, the curved and frag-

mented pieces whose curvature and fragmentation are an aspect of their signification, cannot have that signification adequately accounted for in a system which designates them as acoustic images. They are visual images of language whose complete value derives from aspects of their representation which are graphic in nature: form, position, relative direction and orientation within the page, etc. They present dramatic evidence that language may exist in visual form and that the visual form of language is available to manipulation through the signifier. It is not the signified which *determines* the visual form; rather, signification is achieved through the matter of expression which renders it available, extant. The typographic, visual, rendering of language is what corresponds, in this case, to the definition of the signifier as the "tangible part of the sign."[35]

These works stand emblematically to indicate how the final analysis of the relation of Marinetti's work to signifying practices must be understood: the image of war puts in place the figure of violence through which Marinetti focused his aesthetics: war as purge, war as hygiene, these are the features of a Nietzschean advocacy for violence as curative, necessary. Within the structure of his signifying practice, Marinetti not only embraced this necessity, but carried it out thematically and methodologically, insofar as he was able within the limits of his own creative practice. The requirement that he set for his work was that it launch an attack upon the norms of both ordinary language and poetic activity within the structure of the signifying process. The destructive aim of this project cannot be underestimated, for it was the motivating force of Marinetti's endeavor. His utopianism was based on an engagement with forces of destruction capable of devastating the infrastructure of social order, and his attack was made upon the linguistic structure of poetic discourse, not as a symbolic gesture, but as an arena of activity. This theme of destruction played out in the subject matter of the works and was completely integrated with the procedural sabotage of the order in which the works functioned. Marinetti's achievement was constrained by the basic mimetic quality which dominated his approach, so that even his attempts to destroy linguistic order were more *portrayals of destruction* than they were a disintegration of language as a functional system, though ultimately, his investigation disintegrated into a chaotic subversion of that which could be contained within the mechanistic bounds of linguistic order, exploding the machine of Futurism into widely scattered fragments.

As an attack, a subversion of the normative conventions, the Futurist "Words in Liberty" were successful instances of the language of rupture

so characteristic of the avant-garde.[36] Marinetti forged a strong link between his vision of a reformed state and the force of innovative, revolutionary aesthetics. The character of the Italian state did transform in the years in which Futurism flourished, and Marinetti participated in that transformation with all the influential force of his highly visible public personality. His politics were radical insofar as they were disruptive, and the rigid orthodoxy always apparent within his dogmatic rhetoric aligned readily and easily with a repressive, militaristic orthodoxy of fascist authority. Marinetti's avant-gardism is indisputable, and his call for the revolutionizing of everything in literature, art, and the world through a new Futurist aesthetic makes the clear case that formal innovation has no political allegiance.

Marinetti continued to produce "Words in Liberty" in typographic form until 1944—the last dated piece in this vein is from January of that year. But the impact of Futurism on the international scene diminished rapidly after the First World War, as the fascist agenda of Marinetti, the casualties to the movement, and the shift in aesthetic concerns within Paris, in particular, and Moscow and St. Petersburg as well, eclipsed the Futurist sensibility.

■ Apollinaire: Figuring the Vernacular

Apollinaire's work, no matter how tiny the scrap of poetry, must be understood within the context of his reputation. No other poet of the 1910s approached Apollinaire in stature and status within the milieu of Parisian intellectual and cultural life. The popularity of his work as a writer and critic combined, in the decade which followed, with his reputation as a war-hero to make him one of, if not the most, outstanding figures of the avant-garde. Through his critical formulations of the "new spirit" and his championing of the "modern" in painting and poetry, Apollinaire made major contributions to a platform to support his work and that of his generation. He exercised considerable influence over the discussions of the "new aesthetic" being articulated in the review pages of small magazines and independent publications, as well as in the cafes, studios and galleries of pre-war Paris.[37]

If Marinetti's approach to typographic experimentation can be characterized as a literal one, that is, literal every sense—manipulated at the level of the letter, manipulated with attention to the factual visual character of the graphics, and with a mechanistic insistence on the rapport between the look of a page with the sensation it recorded and thus

supposedly evoked, then Apollinaire, by contrast, in the works in which he experimented typographically, took his exploration into the realm of the figural. Unlike Marinetti, Apollinaire was not intimately engaged with a call for a new graphic order in poetic work: the calligrammes which make use of typographic manipulation do not represent the harbingers of a new aesthetic program, but rather, are the result of Apollinaire's interdisciplinary disposition. As a critic engaged with defining and defending the cutting edge of visual arts and a poet of innovative, new lyrical forms, Apollinaire produced his calligrammatic poems as an integral part of his wide-ranging work. Apollinaire's innovative sensibility was far more open—in its forms and its attitudes—than the doctrinaire aggressive militarism of Marinetti's avant-garde.

Apollinaire scholars were not always willing to extend their critical reach to include the calligrammes. An otherwise enthusiastic and respectful critic, such as Roger Shattuck, for instance, writing in 1950, characterized the pieces as "amusing, unpretentious poems" whose text is "meagre and shallow."[38] Apollinaire scholarship and criticism has long since seen fit to take seriously the poetic and semiotic aspects of Apollinaire's *Calligrammes*, however, and the volumes of exegesis on their import now counter any earlier dismissal.[39] Apollinaire had in common with Marinetti a strong interest in establishing critical and theoretical premises for the understanding of visual arts activities, as well as poetics, and brought to his poetry a sensibility nurtured by sources ranging far beyond the traditions of French poetry. He did draw heavily on these, and Baudelaire, in particular, remained an inspiring figure on account of the daring of his free verse and the reach of his language into realms of experience which had been kept out of the classical alexandrine. Apollinaire's early rejection of such structured poetic forms was accompanied by a coming to terms with the richness of spoken language and an infusion of vernacular, daily speech patterns into his poetry. Similarly, if Apollinaire took up the image of the ideograph as a contemporary hieroglyphic, a dense bearer of visual/verbal values, he did not make his calligrammes esoteric images, but simple, evident, even banal forms. His capacity to charge these with profundity, and to make them function through their structural integration of visual and verbal activities, is part of the daring and skill of his accomplishment.

Apollinaire was never a rigorous theorist of painterly craft.[40] Marcel Raymond observed that Apollinaire "perceived and saw" rather than "understood" painting, stressing the sensual leap to the work, rather than intellectual processing. The conceptual underpinnings of the framework within which sensuality is opposed to intellect should be ex-

amined to better understand Apollinaire's position vis-à-vis aesthetic experience. For instance, Apollinaire's early critique of the Futurist imagination was that it was "too intellectual," and in the work of the Cubist artists Braque and Picasso, he lauded the potential of what he termed the "presentational" mode.[41] The concept of the "presentational" was posed in contrast to the notion of "representational." Within the work of Braque and Picasso, and the writings of Apollinaire and Reverdy, the concept presumed the autonomous existence and self-sufficiency of an art object. To return to the earlier discussion, the phrase comes from Reverdy's succinct comment, "One does not represent a baby, one presents it." The work of art was assumed to have a similar status and, also, to be similarly available to sensual apprehension.

The *Calligrammes: Poems of War and Peace* are arguably Apollinaire's most mature and well-realized poetic work. Published in 1918, not long before his death from influenza at the age of thirty-eight, *Calligrammes* exemplifies Apollinaire's modern lyricism. In the succinct and minimal forms of the few visual poems it contains (about one-third of the works are treated as images), it also demonstrates his capacity to figure the vernacular.[42] The concept of figuration invoked here goes beyond the merely iconic representation of images and into the full spectrum of ramifications of what is achieved in the bringing forth of form within the presentational mode. The function of a figure in this aesthetic is not merely (or at all, actually) to represent an already extant value—be it linguistic, pictorial, or conceptual—but to bring a form into being for apprehension. In this concept, again, traces of the Mallarméan aesthetic enterprise are clearly visible: his concept of the constellation, the bringing forth of an idea in form, through form. But Apollinaire's concerns move far from the esoteric hermeticism of Mallarmé and into the quotidian linguistics of the vernacular. The visual forms of the *Calligrammes* are as evident, as simple, and as uncomplicated as can be. They also take up the old tradition of the pattern poem, which goes back to antiquity. Typical of Apollinaire in that respect as well, of his insistence that the "new" and the "modern" did not need to be created at the expense of or through the destruction of the past, these works, like the still-life collages of the Cubists done in the same years, are extraordinary in part because of their use of the most ordinary of objects and experiences as the basis of aesthetic productions.

With Apollinaire, as with Marinetti, there are two lines of inquiry to follow. The one leads through his critical writings and the other through the poetic works in which his typographic experiments achieve their form. As Apollinaire's writings on typography per se are minimal, at

best, the wider field of his writings on painting and aesthetics will be used as the basis on which to establish his critical stance vis-à-vis representational strategies.

Aesthetics

The new spirit is above all the enemy of aestheticism, of formulae, of cultism. It attacks no school whatever, for it does not wish to be a school, but rather one of the great currents of literature encompassing all schools since symbolism and naturalism.[43]

Apollinaire took over the editorship of *Les Soirées de Paris* in 1914, and the publication soon became "the organ of the avant-garde."[44] Apollinaire's essays on modern painting had already pushed him to the forefront, but the texts in *Les Soirées* earned him the reputation of having "revealed cubism to the cubists."[45] The indissoluble bond between Cubism and Apollinaire's poetic practice is rendered clearly by the fact that much of the critical rhetoric he devised for discussion of the painters' work can be applied to his own. In particular, attitudes toward appropriation, toward the use of ordinary materials, and toward the work as a process of construction, both materially and in terms of meaning. Succinctly articulating their processes, Apollinaire stated that the Cubist "creates new combinations with elements borrowed from visual reality."[46]

For Apollinaire, materials were already there; materials exist and the task of the artist was to put them into a new order which rendered them visible. Both the original elements and the act of ordering by which they gain significance were important in this process, but the task was of a completely different conceptual nature than that of Marinetti, for whom the invention of mimetically expressive forms required onomatopoeic innovation at every turn. Similarly, it is a far cry from the work of Ilia Zdanevich and other *zaum* poets, who claimed the very form of words, not merely the structure of syntax, was exhausted of poetic value through ordinary use. Apollinaire's work stresses, in a manner far more a prefiguration of Surrealism than it is a descendent of Symbolism or relation of Dadà, the mystery in the ordinary.

The break with aestheticism, comparable to Marinetti's blanket condemnation of the poetics of revery and interiority, became manifest in Apollinaire's poetry through his choice to employ forms of language which had systematically been excluded from the literary domain. The source materials for art were no longer to be sought simply among the

canonized categories of vocabulary and imagery traditionally associated with "art" but were assumed to be available within the context of daily life:

> Apollinaire never allowed his style to become involved in the complexities which are both a merit and a weakness of Mallarmé's and Valéry's verses. It is the grammar of ordinary speech which he writes, direct and unadorned.[47]

Neither the source nor the use of these elements was to be bound by the conventions of poetic tradition, though Marcel Raymond, speaking of Apollinaire, could write

> He reveals the mysterious affinities which exist between thought and language, increases the exchange between them, even by artificial means; he experiments with chance, the essentially arbitrary in poetics, the unforeseeable, free association, etc.[48]

Apollinaire's stated position of a presentational attitude pushed toward a continually made and renewed value grounded in the activity of poetry, which is in serious contradistinction from the symbolist notion of "revelation" and "mysterious affinities" cited by Raymond. Apollinaire's use of the notion of *affinity,* that which is borrowed by the Surrealists, is that unfamiliar combinations of language have the capacity to *make* a revelation, rather than serve as its representamen. The attitude that chance or random combinations were a useful mechanism would replace Symbolist craftsmanship with Dada and Surrealist chance and associative procedures, but in Apollinaire's work the idea of revelation links the Symbolist recognition of a distinction between the plane of discourse and that of reference with the undercutting of its mysticism by a modernist mechanics. Emphasis on process and *production* replaces the emphasis on the *produced,* thus simultaneously activating and relativizing the status of the poetic object within the context of its signifying practice. Apollinaire does not deny the "mysteries" of poetics, but his method is grounded in an appropriative collage tactic not constrained by the traditional rules of poetic order. In this he was inspired by the Cubist painters.[49]

The following statement, from his essay "On Painting," establishes the essential roles Apollinaire assigned to both the process of appropriation and the shift away from a traditional, representational, process of artmaking: "Cubism differs from the old schools of painting in that it aims, not at an art of imitation, but an art of conception, which tends to rise to the height of creation."[50] Neither subject matter nor recogni-

zability are undermined by this description, but *resemblance* is wished away: "Real resemblance no longer has any importance" (p. 12).

Shifting his emphasis to an analysis of process, particularly techniques for manipulating source material, Apollinaire characterizes various kinds of Cubism according to the manner in which each approaches the problem of fabrication: "scientific cubism" takes borrowed elements and recombines them according to a system of rational knowledge; "physical cubism" recombines them according to a visual sensibility; "instinctive cubism" assembles according to instinct and intuition; and the most important to Apollinaire, "orphic cubism": "the art of painting new structures out of elements which have been created entirely by the artist himself and have been endowed by him with the fullness of reality" (p. 18).

Apollinaire's categories are at odds with the art historical conventions which distinguished mainly analytic and synthetic modes as successive stylistic innovations; instead, he splinters the Cubist practice according to the various logics of recombination of elements. Nowhere does the notion of a "mimetic" Cubism arise, and the stress which Apollinaire places on Orphic Cubism indicates the degree to which he believed in the possibility of a creative process which does not participate in any act of reference. For Apollinaire, this problematizes the issue of truth in representation, undercutting its preexistence, if not its transcendent value, such that these works: "are clues to the truth, aside from which there is no reality we can know" (p. 12).

Going farther, Apollinaire makes clear that he locates the significance of aesthetic activity within the process rather than in any aspect of closure or signified value which might fix the signifying activity within a static resolution which could displace or replace the activity itself: "But reality will never be discovered once and for all. Truth is always new" (p. 11). Thus the power of the art object lies not only in its original formulation and in the processes of appropriation and presentation attendant to its creation, but in its capacity to promote invention in the experience of the viewer or reader. The original process by which the work is made becomes a model for the process by which the work functions, and in the typographic, calligraphic, works of Apollinaire, this attitude will become evident. There is an "originating" act rather than an "original" work and the play of signifying elements is put into motion rather than set into fixed place. In creating a critical basis for understanding Cubist painting, Apollinaire found the means of articulating a new aesthetic grounded in what would come to be recognized as characteristic of the modern position in these first decades of the twentieth century: a rheto-

ric of presentation rather than representation, one grounded in the material factuality of the work as the locus of its existence.

But a chief concern of Apollinaire's was to revitalize the spirit of *poetry,* responding to the decadent aestheticism he felt had enervated it. Forging a link between the visual aesthetics of the Cubist painters and the literary works of writers of the early years of the twentieth century in France, Apollinaire demonstrated his capacity to develop an aesthetic in which the features of a visual art practice might be applied to poetry in particular and to the development of an aesthetic practice in general. This capacity to actually look at visual work combined with the ability to extract from it an attitude, a method of working not specific to any medium (while respecting the specificity of that medium) was one of the features of his analysis which accounts for the extent of his influence. The substance of this method was to shift the emphasis of art activity onto the material activity and away from a traditional representational mode. His poetry is continually involved in resisting the apparent transparency of language, while his calligrammes and other visual experiments promoted a graphic manipulation of the plane of linguistic discourse.[51]

Apollinaire's attack on the poetic tradition, therefore, required both materials and methods. Fundamental to this destruction was an insistence on the ontological self-sufficiency of the object, its existence as an instance of presentational aesthetics rather than representational expression. "The canvas will exist, ineluctably."[52] Apollinaire's insistence on this aesthetic self-sufficiency marked his belief in the work's independence as a signifying system which was not standing in for anything, rather, was capable of a being-in-itself. The kernels of this insistence on being as a form of presence derive from struggling to find a critical vocabulary for Cubist collage work, with its evident materiality. The translation or transfer of the term into poetics posed other issues, and the manner in which Apollinaire plays with the calligrammatic features of his iconic works was part of his exploration of the means to make use of the obvious differences between visual and linguistic modes, as well as to position his poetics within existing language.

"He was content with the already existing treasures of the language. Interjections, curses, onomatopoeia, slang and barbarism all find a place in his work."[53] The act of appropriation, within Apollinaire's activity as well as within that of the Dadaists, rendered the materiality of the appropriated element substantive. The scrap of newspaper in a Cubist collage, in a manner similar to that of the fragment of conversation in an Apollinaire poem, refused to be neutralized into either mere presence

as stuff or the signifier of an absent value. Thus within the conceptual core of the method of appropriation lay the definition of a role for material as essential to Apollinaire's presentational mode. In such a definition, elements of language, phrases, words, were employed for their sensual texture, like printed papers in a collage, as well as for their textual value. Even at the extreme of his typographic experiments, the polysemous and visually complex "Lettre-Océan," Apollinaire was too acutely aware of the linguistic basis of poetic form to abandon the value of language to the form of image. But his unique manner of integrating the two, playing the dual aspects of signification, was rich in acknowledgment of the material features of both modes.

Another primary tenet of Apollinaire's aesthetics was his desire to forge a link between the domains of daily life and the work of poetics. Finding a superabundance of sources in his daily existence, Apollinaire staged the significant question of how the distinguishing boundaries of aesthetic activity may be recognized insofar as they function to identify a work of art as such. On the one hand, he was dedicated to the idea that poetry was found within the bounds of everyday life with all of its modern attributes: "Can poetry be forced to establish itself outside of what surrounds it, to ignore the magnificent exuberance of life which the activities of men are adding to nature and which allow the world to be mechanized in an incredible fashion?"[54]

But the requirement that there be some marked measure of distinction between the materials as found and the poem remains. This activity consists in the reframing, representation, shift of site from encounter into published form of the crafted work. The conceptual basis whereby such activity forced recognition of ordinary language through its inclusion in the framework of literary publications was one of Apollinaire's achievements. The boundaries which mark poetry are distinctly different from those marking the physical bounds of a painting or visual art object. Apollinaire's calligrammes in part attempted to mimic the ontological status of the canvas in their presentation on the page, approaching the form of objects by their visual format. In this way the works struggled toward the same presentational mode Apollinaire was articulating for visual works. The most obvious requirement for creating a poetics of presentation was to short-circuit the transparency of the linguistic signifier, to call attention to its materiality and to insist on this materiality as a primary element of the signifying process. The manner in which Apollinaire worked with this notion has not always been well received or understood. Witness the following characterization of his approach by Michel Decaudin: "Becoming a signifier without a refer-

ent, the word evolves . . . and allows all kinds of fooleries: the nearly exclusive attachment to its phonetic value is a source of semantic ambiguity."[55] And:

> The word ends up having a reality for him, its own reality, independent of its style or its content . . . which isn't concerned with the signification which the stroke adds to the painting, or, to put it a better way, which engages him in the same manner, on a level of function which is neither mechanical (syntactic) nor conceptual, but intensive. (p. 15)

> The word is only the sonoric or colored presence, something like an abstract decoration on a wall or a musical environment, a new dimension of linguistic space. In this way different associations are produced than those to which we are habituated. The word neither denotes nor connotes simply, it connects. (p. 16)

In fact, Apollinaire does not reduce the "word" to a mere sonoric presence. It is Decaudin who reduces Apollinaire's work here to the same contentless exploration of form which had been the casual characterization of Cubist work in the early stages of its historical assessment. Apollinaire's appropriative collages of language are substantive to the same degree as Cubist collages, though the process of signification is not the same. Scraps, remnants, identifiable elements of linguistic value find their way into the juxtapositions of the poem where they read, albeit suggestively, but nonetheless in recognition of their full function as linguistic elements of the poetic enterprise. To characterize the word as *sonoric* and as *colored* and as a *presence*—demonstrates an intense engagement with the materiality of signification symptomatic of the early modern art practice with which Apollinaire was engaged, a formalism self-conscious of its practices and yet very clearly not at the expense of content or subject matter. The integration, highly specific and very artfully articulated, of these domains can be detected in the attention to sonority within the poetic works of Apollinaire.

> What it comes to finally, is a constant interest in the linguistic mechanism defined in this case as the limits of a created language. And it is possible to demand whether, on a certain level, poetic language did not appear to him to be an organization of this sort. Because all of his uncertainty and his research from 1913, and especially in 1917–18, was concerned with the question of what a new poetic language could be, acknowledging his hypothesis of a "new language . . . about which no grammarian of any language will have anything to say." (p. 13)

Reconciling the discrepancy between the notion of appropriation of a vernacular language and the activity of creating a new form of poetic language beyond the rules of any "grammarian" depends on, first of all, realizing the extent to which the use of vernacular language was at odds with the French poetic tradition and, second, on realizing that what was at stake in the rejection of grammatical administration of poetics was a relation between the subjective latitude for invention in *parole* and the distance from the orthodoxies of *langue*. While Apollinaire had been critical of the excesses he perceived in Futurist work, he came to recognize that the "words in liberty" prescription of Marinetti was not unrelated to his own agenda. "The words in liberty can upset syntax, render it more supple, more direct, and popularize the use of a telegraphic style."[56]

By the 1913 publication of "L'Antitradition Futuriste," Apollinaire had come to see the usefulness of the Futurist radicality. As Shattuck noted, "In the manifesto, 'L'Antitradition Futuriste,' Apollinaire made an exaggeratedly destructive declaration of his position. It is virtually a rejection of the restraints of tradition and an affirmation of complete liberty."[57] The liberty which Apollinaire envisioned was less reactive, more expansive:

> We can hope then, in regard to what constitutes the material and the manner of art for a liberty of unimaginable opulence . . . In the realm of inspiration, their liberty can not be less than that of a daily newspaper which on a single sheet treats the most diverse matters and ranges over the most distant countries.[58]

By invoking the daily newspaper, Apollinaire was proposing that public language was a source for poetic activity, one which poses the issues of voice and the formation of authorial subjectivity. The enunciating subject of the daily press has a form completely distinct from that which was normally conceived within poetic practice. The leap Apollinaire is making is not merely toward a different source of poetic language, but toward a different concept of subjectivity, one more fully conscious of the social component of subject formation in even (especially) the realm of individuated articulation, poetics. Apollinaire is engaging himself with the *parole* of language use and, in this sense, decidedly obtaining distance from the *langue* of the grammarians.

The romanticized subject as author/poet traditionally considered the source of an interior discourse is implicitly challenged by the appropriation of language from "random" sources in "chance" combination

which themselves mimic the process of socialization through language acquisition and exposure to symbolic systems of representation of which the subject is an instance of specific intersection.[59] For Apollinaire this aspect of subjectivity works against the notion of a psychologized, individual subject which came again to the fore within the Surrealist mode of literary and artistic practice. The use of typographic means was meant to mark that site of origin of language as within the public domain, to recognize the necessarily social aspect of language as a symbolic system, and to reify that recognition through visual means. Tristan Tzara would do just that, but Apollinaire stops short of collapsing the visual form of his work with that of the daily press. His manipulations grant his work an ephemeral, consumable quality, a lightness which keeps them from esoteric difficulty or hermetic remoteness and within the lyrical tradition.

The playful visual means in Apollinaire's typographic calligrammes permit him to integrate the domains of a public discourse with that of individual literary expression in a manner which makes the distinction between a high or low art form impossible to sustain. The use of such cliche images as that of the heart, tie, smoking cigarette, and rain in his calligrammes also plays this opposition into an untenable dynamic where the esoterica of literature makes use of the banal force of recognition in ordinary, popular images.

The dynamicizing of the process of subject formation within the blurred boundaries of public and private uses of language indicates a characteristic dynamicizing of other issues relevant to the processes of signification within Apollinaire's work. The attempt to locate signifying activity within the plane of discourse, to render the relations between expression and content through the manipulation of graphic material such that the two become inseparable is another persistent feature of Apollinaire's attempt to make his poetic practice an example of the presentational mode he advocated in the visual arts. The activity of signification resides in a process, dynamic and active, rather than being a means of delivering a product which is disembodied meaning or value.

Ultimately, the manner in which Apollinaire brings the concept of the there and not there of the figure into play is achieved through the relation of the visualized image and the figurative language working against each other. The vernacular form of language is itself highly transparent—to give it a form as such, render it recognizable and apprehendable, not in its communicated substance, but *as* a form, is the undertaking so lightly dismissed by Apollinaire's critics as insignificant. It is the skill with which a play between the elements of image and language

present themselves, preventing any simple closure which would release the linguistic material into a signified value, which demonstrates the full dynamic of the activity with which Apollinaire is concerned. Rejecting the original as somehow other and elsewhere, insisting on the presence of the work in the form, as an ongoing process of signifying activity in which the reader/viewer participates, manifests the notion of a presentational rhetoric in the inscription of a figural form always *in* formation. The typographic component is no more a surplus to this than are the very "words" themselves. The calligrammatic activity is fundamentally at odds with a normative literary mode, and its deceptively facile visuality is in actuality the material site in which the activity of ongoing signification occurs.

Typographics

And I, too, am a painter.[60]

The portrait of Pablo Picasso written by Apollinaire and published in the pages of Pierre Albert-Birot's *SIC* magazine takes the above premises into the most concrete realization possible precisely because of the manner in which it plays with the signifying activity of visual and verbal means (figure 22). The text of the work describes the painter's work, listing its themes, images, colors and techniques, in poetically declaimed phrases laid out without the boundaries of a square form. The limits of this form visually suggest the limits of a canvas, thus the poem is framed as an image by echoing a visual convention readily readable—it signals that the work is a painting. While the descriptive force of the words invoke all of the absent qualities of visual means—color, form, composition, texture, and so forth—the visually present field of the words on the page has absent images dropped out of it. The blank spaces within the squared-off poem have the shapes of a bottle, pear, apples; in short, they are the absent phantoms of the elements of a still life. In this reversal, then, the visually present, phenomenally apparent elements of an image are represented only as an absence within the linguistic mode, whose visual presence belies its dependence on the absent signified. The signified itself, the image of a painting, is figured in the blank spaces of the work. Thus the visual presence of the painting referred to as the absent signified of the text is here made literally absent as a blank "presence" in the textual field. The absent signified is the replete image, here presented as a blank, visually and literally absent. The construction of inver-

PABLO PICASSO

Voyez ce peintre il prend les choses avec leur ombre aussi et d'un coup d'œil sublimatoire
Il se déchire en accords profonds et agréables à respirer tel l'orgue que j'aime entendre
Des Arlequines jouent dans le rose et bleus d'un beau-ciel Ce souvenir revit
les rêves et les actives mains Orient plein de glaciers L'hiver est rigoureux
Lustres or toile irisée or loi des stries de feu fond en murmurant.
Bleu flamme légère argent des ondes bleues après le grand cri
Tout en restant elles touchent cette sirène violon
Faons lourdes ailes l'incandesce quelques brasses encore
Bourdons femmes striées éclat de plongeon-diamant
Arlequins semblables à Dieu en variété Aussi distingués qu'un lac
Fleurs brillant comme deux perles monstres qui palpitent
Lys cerclés d'or, je n'étais pas seul! fais onduler les remords
Nouveau monde très matinal montant de l'énorme mer
L'aventure de ce vieux cheval en Amérique
Au soir de la pêche merveilleuse l'œil du masque
Air de petits violons au fond des anges rangés
Dans le couchant puis au bout de l'an des dieux
Regarde la tête géante et immense la main verte
L'argent sera vite remplacé par tout notre or
Morte pendue à l'hameçon... c'est la danse bleue
L'humide voix des acrobates des maisons
Grimace parmi les assauts du vent qui s'assoupit
Ouïs les vagues et le fracas d'une femme bleue
Enfin la grotte à l'atmosphère dorée par la vertu
Ce saphir veiné il faut rire!
Rois de phosphore sous les arbres les bottines entre des plumes bleues
La danse des dix mouches lui fait face quand il songe à toi
Le cadre bleu tandis que l'air agile s'ouvrait aussi
 Au milieu des regrets dans une vaste grotte.
 Prends les araignées roses à la nage
 Regrets d'invisibles pièges l'air
Paisible se souleva mais sur le clavier musiques
Guitare-tempête ô gai trémolo
O gai trémolo ô gai trémolo
Il ne rit pas l'artiste-peintre
Ton pauvre étincellement pâle
L'ombre agile d'un soir d'été qui meurt
Immense désir et l'aube émerge des eaux si lumineuses
Je vis nos yeux diamants enfermer le reflet du ciel vert et
J'entendis sa voix qui dorait les forêts tandis que vous pleuriez
L'acrobate à cheval le poète à moustaches un oiseau mort et tant d'enfants sans larmes
Choses cassées des livres déchirés des couches de poussière et des aurores déferlant!
GUILLAUME APOLLINAIRE

Figure 22. "Pablo Picasso," G. Apollinaire, *SIC* (Paris: 1916).

sions, and relations, between the play of linguistic absence and visual presence, could not be presented in theoretical terms with more sophistication than that which appears in this typographically complex work.

The structure of materiality demonstrated in such a piece does not, evidently, depend on a simplistic reduction of material to the plastic values of the image in opposition to those of language. The construction of signification in the work proceeds according to the capacity of image and language to function differentially with respect to each other, and for each of these modes to make use of their apprehendable, phenomenal aspects (the articulation of the linguistic phrases, the inscribed image of the still life) as well as their differentiating, semiotic activities (the absent referent of language made present as the inscribed space within the piece, the values attendant on the categorical identification of still life as a kind of image, the play of plane surface and empty, evacuated space, and so forth). Materiality, in this instance, operates through the full spectrum of signifying operations.

But it is the *Calligrammes* which provide the main corpus for studying Apollinaire's approach to typographic enunciation. The typographic manipulation of "L'Antitradition Futuriste" was not Apollinaire's doing, apparently, but Marinetti's.[61] Not surprisingly, it bears no relation graphically to any other piece of Apollinaire's work, while it does conspicuously resemble the columnar divisions and vertical/horizontal relations of the publications produced by Marinetti in the same year, 1913.

In his reviews of painters' work, Apollinaire revealed his meticulous capacity for attention to visual detail. This short excerpt describing the writing of Cézanne demonstrates such attention, here transferred into his critical observations of letterforms:

> In the handwriting of Cézanne, the *t*'s are crossed with a very long bar, he uses the double *s* which Restif de la Bretonne wanted to suppress from typography, and which was finally eliminated by the Didots. He often uses the accent grave for the accent aigu. The signature of Cézanne is decorated with swashes which surround the *P* on the left and underline and surround the entire name.[62]

Apollinaire's autograph versions of calligrammes evidence the expressive potential of written language generally suppressed by the regularity of printed forms. The observations made by Michel Butor on Apollinaire's interests in the history of written language, and on the calligraphed forms of Chinese as well as the ever popular (and misunderstood) hieroglyphic, show the poet's active pursuit of precedents in this domain. The calligrammatic tradition is as old as written forms of language, far older

than printing. Apollinaire's reinvention of the pattern poem was quite self-consciously participating in and commenting on that tradition. But in place of the funerary monuments, the dreary odes in the form of urns, or the elaborate twisted strands of a love knot entangling the eye as the sentiments had entangled the heart, Apollinaire disposed his words in the casual shapes of forms readily scribbled on the napkin from a café— a cigar, a tie, a watch, a heart, the rain. These easy, open forms, when recognizable, are sketches, lightly delineating an icon, not building it with cookie-cutter regularity or monumental solidity. Their very accessibility to the eye is reinforced by this illusion of the tossed-off, casual sketch whose contract with the viewer is tendered on simple terms.

There are several kinds of works in *Calligrammes,* a volume whose six sections were produced over the period from 1913 through 1916. There are works in free verse whose format ranges from recognizable stanza patterns to simple line-by-line progressions structured according to the internal requisite of the language and thoughts. While attentive to the modality of visual form, they do not break with the norms of poetic representation and so will not be given particular attention here. Then there are various kinds of figurative works. These include works whose form is clearly iconic, those which use the page as a field of action to force spatial relations into the reading of the work, and then, finally, works whose construction of a field, not strictly with an iconic referent, free the language from syntactic restraints through typographic means. It is in these last works that the concept of the *figural* becomes most dynamic since the language of the poem cannot be contained within the image, but renders the linguistic elements in a figural mode which itself eludes any specific identity except that which is granted through the reading of the work, seeing of the work, as a thing in itself. To appreciate the typographic subtlety of these works almost requires an initial confrontation with the difficulty they cause to literary critics.

Apollinaire wrote of this work:

> As for *Calligrammes,* it is the idealization of the poetry of free-verse and of a typographic precision at the moment when typography was brilliantly terminating its career, in the dawn of the era of new means of reproduction: the cinema and the phonograph.[63]

Michel Butor would point out that this notion was misconceived; typography indeed was at a peak, but hardly at the end of a career which, in fact, even at the end of the twentieth century seems unlikely to suffer a demise at any point soon. But Butor's introduction to the works goes on to be brutally unsympathetic to the more visual of the poems, claiming

that their "figuration is often at the expense of their readability." Struggling to come to terms with the works, Butor evidences the prejudices of the literary critic toward the visual aspect which is in many ways a mere annoyance as far as he is concerned, since for him the "image" of poetry is that which is constructed through sense, not sensation. He even suggests it might have been better had Apollinaire not "disposed the text along the schematic lines of his image" but had merely drawn the picture and left the text a separate entity.[64] Of course, the calligrammes are not composed of two different things, two separate entities, and it is precisely the degree to which Apollinaire is successful in demonstrating the integrative play of visual and verbal materials which is measured by the degree of discomfiture caused in his more literary-minded readers. Subsequent readings and critical studies have recuperated the visual complexity and poetic richness of the typographic calligrammes in full appreciation of Apollinaire's subtle and complex vision. The poet himself stated:

> Typographical artifices worked out with great audacity have the advantage of bringing to life a visual lyricism which was almost unknown before our age. These artifices can still go much further and achieve a synthesis of the arts, of music, painting and literature.[65]

The simplest of the typographic modes used in *Calligrammes* is the employment of an iconic form; there are about ten such works within the book. A representative example like *La cravate et la montre* serves, however, to demonstrate that there are many not so obvious features in these works (figure 23). There is, for example, no simple relation between the words which mark the hours around the face of the watch and the positions which they occupy, each enumeration depends on a conceptualized pun—the singularity of the heart, the duality of eyes, the seven days of the week, twelve hours etc. The diversionary tactic of disposition allows their relation to be a spatial one, rather than a linear, syntactic one. Putting the words into the figurative relation forces a communally shared field of meaning into being where in fact there is none evident in the words, even in the most extreme of free verse at the time. The daring of this, to synthesize out of scraps, fragments, each one in itself a pun through an image conjured out of the words, has correspondence with the visual assemblage of Cubist collage works. The watchface works with the reassuring familiarity of the café table motif in Cubist imagery to orient the reader/viewer and provide a safe place to encounter what is in fact a disjunctive field of verbal information. The phrase which runs around the right side of the watch face, in a style rem-

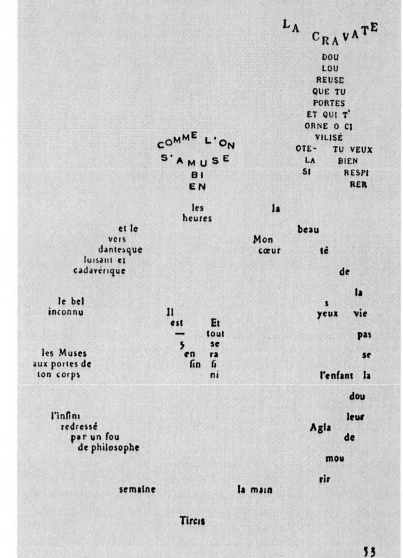

Figure 23. "La Cravate et La Montre," G. Apollinaire, *Calligrammes* (Paris: 1916).

iniscent of the moral lessons about time inscribed with regularity upon the faces of sundials, reads, "The beauty of life exceeds the sadness of death." One amuses oneself, and well, in this space of time, but it is a time without clear logic, whose image, banal and familiar on the one hand, is riddled with surprises, games, and the unexpected on the other.

Above the watch hangs the "mournful" tie which "you wear and which decorates you, o civilized man—take it off if you really want to breathe." While this text may be safely read against the image of the tie, as a comment in keeping with its iconic value, there is nothing which predetermines this reading. Reinforcing the referential value of the image through the iconic form forces the reading to return to that dominant term, but there is nothing in the image which requires the text. A relationship is forged in the process by which the two interplay. Is the shape of the tie the fact, its closed and final meaning, or is it a qualification of the linguistic value, socially resonant and interactive with the field of references against which its image is interpreted? Both, in fact, and the insistent, even reductive, visuality of the image reinforces that. This is the point at which the play with materiality of image, and language, becomes skillfully used to position the signifying process in some intermediate zone between that of the image and that of the language.

The effect of the pictorial form of these poems (which are the extension of a tradition which goes back to Greek calligraphic works) is to make an apparently redundant duplication of linguistic theme and iconic form. On the one hand, these works have a one-liner quality to them, the visual image supplying a gestalt punchline to the text. But there is considerable tension to be derived from the relation in which an overdetermined referent, that of the icon, works with the signifying value of the text, and this collapses the planes of reference and discourse. In another example, from "Heart, Crown and Mirror," the notion of "heart" and the image of heart, as well as the text all indicate the referential value of heart as love as symbol (figure 24). "Mon coeur appareil a une flamme renversée" ("My heart like a flame turned upside down") reads the text, shaped like an imperfect heart and inverted flame.[66] If the text is reduced to a signified "heart" as the iconic form suggests, then the emotional impact of the text is diminished; if the referent of love/passion/flame is inscribed within the form, then the signifying activity of the work is constantly at odds with this reductive formulation as well. The image and text must be read as visually punning so that the heart/flame inversion is marked in the form as well as in the text.

Thus the figurative quality of the image works on the possibilities

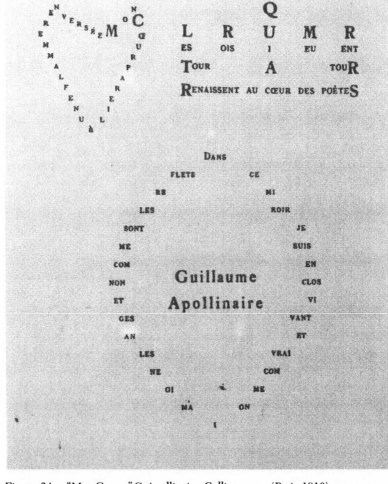

Figure 24. "Mon Coeur," G. Apollinaire, *Calligrammes* (Paris: 1916).

inherent in the language by causing the linguistic value to be continually evaluated in relation to that pictorial form. Language cannot *be* the object it represents, but by referring to itself through the icon, the poem loops back on itself in the signifying process. The effect is to literalize the metaphoric content of the work, as, for instance in the phrase, "a cigar, lit, smoking . . ." which might mean more than the denotative description of a physical event, but whose resonance is constrained by the bounds of the image into which it is inscribed. Reinforcing the literal value provokes a necessity to get beyond that reductive reading while at the same time the overriding image makes it difficult, almost impossible, to free the phrases from their relation to the iconic form.

Before finishing the discussion of these works, the issue of the vernacular and of the concept of figuration returns. The relatively easy look of these works and their suggestive but hardly esoteric language puts them into the realm of a popular communication at the level of, almost, scrawls and graffiti. Which is to say, they function with terrific immediacy and are readily assimilated as recognizable images of everyday life. The degree to which they serve to figure that everyday-ness, give it a recognizable form and value, should not be undermined by their effectiveness in doing so. To give the vernacular a recognizable form as poetry was to wrest from the ordinary a gestalt on its character and form which had been taken for granted, passed over, in the same manner as the material form of language had been taken for granted in the continual enterprise of poetics engaged with transcendent imagery. The plane of discourse of language and the domain of the quotidian are in no way the same, but the activity of calling attention to the overlooked and seeing in it the adequate, sufficient, and even rich, material for poetic work is what links these two.

In "Lettre-Océan," there are relations formed among the verbal elements through their visual manipulation which are not strictly pictorial—that is, they do not depend on or duplicate the conventions of pictorial arrangements in the manner of, for instance, Marinetti's "Bataille."[67] The value of this work is irreducible to either absent signified meaning and reference or to immediately apprehendable effect. It is a highly condensed image and lends itself to a dense, layered reading of its elements as well as their spatially deployed relations to each other (figures 25 and 26).

From the first, the use of materiality, that combination of differential play and substantive apparence, is as conspicuous as is the work's distinctly innovative form. While "Lettre-Océan" participates in the long tradition of pattern poems, its complexities are such that Apollinaire

Lettre-Océan

Je traverse la ville la tête en avant
et je la coupe en **2**

J'étais au bord du Rhin quand tu partis pour le Mexique
Ta voix me parvient malgré l'énorme distance
Gens de mauvaise mine sur le quai à la Vera Cruz

Les voyageurs de *l'Espagne* devant faire
le voyage de Coatzacoalcos pour s'embarquer
je t'envoie cette carte aujourd'hui au lieu

Juan Aldama

Correos
Mexico
4 centavos

TSPERANÇA

REPUBLICA MEXICANA
TARJETA POSTAL

de profiter du courrier de Vera Cruz qui n'est pas sûr
Tout est calme ici et nous sommes dans l'attente
des événements.

U. S. Postage
2 cents 2

Vive
la
Ré
pu
bli
que

Zut
pour
M.
Zun
que

Hoo le croquant

Sur la
rive
gauche
devant
le pont
d'Iéna

Des clefs j'en ai vu mille et mille

Envia il Papa

Jac
ques
c'é
tait
si
beau

La
Tu
ni
sie
tu
fondes
un
jour
sai

non
si
vous
avez
une
mou
stache

T

S

F

Bonjour ANOMO TU NE CONNAITRAS JAMAIS BIEN

ANORA

LES

Mayas

Figure 25. "Lettre-Océan," G. Apollinaire, *Calligrammes* (Paris: 1916).

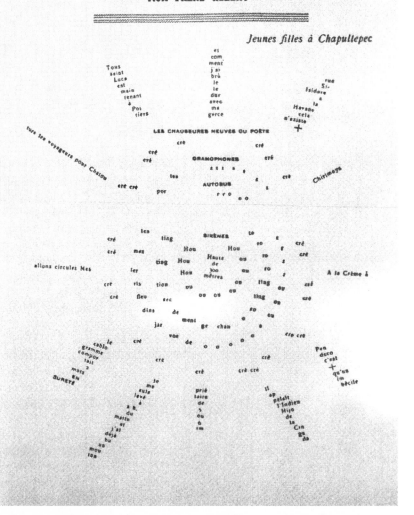

Figure 26. "Lettre-Océan," G. Apollinaire, *Calligrammes* (Paris: 1916).

himself claimed, in placing it within such a tradition, that it had surpassed the icons of pattern poetry to the same degree as the "modern racing car" surpassed "the toy of the 16th century powered by a clockwork spring device." Invoking Futurism, echoing Marinetti, in this phrase, Apollinaire indicates that he is flirting with the Italian movement's principles. The TSF—Telegraphie Sans Fils—which in manuscript was placed in the center of the image, the connecting device of transmission—is a clear quote of the "Wireless Imagination," "Words in Liberty" of Marinetti's Futurist manifestos. Indeed, this was the period of Apollinaire's poetic career in which he was most involved with Futurism, especially through his personal proximity to Carlo Carra.

What the poem is "about"—and the spatial metaphor is apt here, since a continual play of movement through space by language is a central thematic of the work—is an exchange of communication between Apollinaire in Paris and his younger brother, Albert, in Mexico. The title, "Lettre-Océan," refers to a specific type of correspondence—that exchanged between ships at sea.[68] But the work can't be read as a simple mimetic image of a single card. The work is a collage, and the fragments of language are organized as much through visual arrangement as through any linear sequence or logic. For instance, the work bears two postage stamps (a two-cent American and a four-centavos Mexican one) and the postmark—dated 29 May 1914—is from Rue Batignolles (Paris). This could mark the place of receipt—but, as it turns out, the language in the work does not originate from a single place, nor does it have a single "speaker." It offers several points of view recorded simultaneously for (again) "condensation" of a rather complex narrative—or maybe it would be better to say—set of circumstances.

At first glance, the pages (and this was published, in *Les Soirées de Paris*, as a double-page spread in June 1914) are dominated by the two large wheel-like forms, spacious, open, expansive, and the linear elements which bind and confine them to the postcard format. Title and signature, "Lettre-Océan" and "Apollinaire," function as opening and closing frames, and the parallel waving lines serve to separate the "message" of linear communication from the "image" of the spatialized forms. The most visually striking verbal elements are the greeting to Albert on the upper right and the word "Mayas" on the lower left, along with the vertically arranged TSF. Thus the hierarchically dominant elements of type emphasize Mexico, further indicated by a caption "the young women of Chapultepec" and the "exotic" character of those "Mayas" whom "you will never know." But the visual wheels actually describe the events of a parade in Paris—events being broadcast as news

transmission from the top of the Eiffel Tower. The connection of the two spaces will also connect histories of the current European power with its colonial past in the engagement with events replaying those still unstabilized international relations.

The spaces of this poem, its rhetorical and visual topoi, include, on the one hand, a clear inscription of Apollinaire's lyrical subjectivity, replete with his ear for and use of vernacular language—though produced before the *Calligrammes*, this work shares their popular, *populaire*, attitude toward language and image—and, on the other, a record of current events. Apollinaire is present as a person, subject, speaker, here, but is historically specific as well—for the events are the events of Spring 1914 in Vera Cruz. This is not yet in the period of the war, Ferdinand's assassination hasn't occurred, but the anxieties about the instability of Mexico, with its ongoing revolution, and the international situation, are in evidence. By splitting the spaces of Paris and Mexico, Apollinaire allows himself to describe events in two hemispheres where there are signs of political tensions. A nod toward this activity of splitting is already indicated by the first line of the poem "I cross the city, nose first, and I cut it in 2"—a line in which the figure "2" also sketches the profile of a nose, though it is linked to the Paris part of the thematic.

"I was on the Rhine when you left for Mexico Your voice comes to me in spite of the long distance Unpleasant types on the quai at Vera Cruz." Immediately below this, sandwiched between the stamps and postmark, is the word "Ypiranga"—the name of a German cargo ship bringing arms supplies to a faction of the Mexican government of then-President Huerta to use in the ongoing (endless) hostilities of the Mexican revolution. The port was seized and blockaded on 12 April 1914, and the boat went to Coatzacoalcos. Thus references to the unsureness of correspondence, and to the "types" on the quai at Vera Cruz record American presence and intervention in Mexico. These political events are played out merely in terms of Apollinaire's concern for his brother's safety, but Albert's reassuring words "the cablegramme carried two words, In Safety" permit another mode of transmission, communication to be recorded. Radio transmission, cablegrams, telegraph and postcard, "ocean letter" and exchange—all means by which language crosses space have been condensed here, giving evidence of the communications' connections. The two large circular fields of fragments, however, are both located in Paris. The center of the one, the Eiffel tower, anchors two sets of elements: the onomatopoeically recorded sounds of sirens "Hou ou ou ou ou" and Autobus and Gramophone and Poet's shoes in rings which move outward like the waves of transmission. The ele-

ments which surround these rings hang like keys on a chain—as per the statement on the left-hand circle, farthest left "I have seen thousands and thousands of keys." All these elements are fragments of conversation, observation, noise, which describe the busyness of an urban scene generically, but also, with specific reference to a parade. "Long live the Pope," and "down with the clergy," "Long live the republic," and "Long live the King" are all cries heard in the crowd. Apollinaire records them all—but in the process, any clear "position" with respect to such advocacy disappears.

These details hardly exhaust the polysemous quality of the poem's capacity to produce readings—but they should demonstrate that the work can neither be read by assigning its elements value within a mimetic image, nor through the normal modes of linear textuality. The work is very much a hieroglyphic dense, condensed, and composed in accord with collage techniques of analytic cubism—with which Apollinaire was intimately familiar and which was fully developed by 1914.

Locating himself in the events of a drama from which he is an ocean distant, Apollinaire participates in the romanticization of collapsed space and time which the "moderns" linked to the developments of new communications technology, which provided, as well, the basis for the image of the radiating waves. Now while Apollinaire's work is undeniably radical in its formal innovations, the politics of the work and of his stance vis-à-vis the role of formal innovation in the normative mode of the symbolic is less clearly so. A description provided by Raymond Williams of the progressive stages in the development of the avant-garde provides a context for this part of the discussion. His scheme sketches the following: (1) formal innovation as a means of becoming distinct from academic conventions; (2) seeking control of modes of production and seeking independent distribution and publicity; and (3) becoming fully oppositional by attacking institutions and the social order.

It's interesting to consider whether Apollinaire's work ever achieves or even aims at fulfilling this schematic plan for the avant-garde. For instance, Apollinaire's rupturing of the norms of syntactic language is perfectly consistent with Julia Kristeva's criteria for the transgressive activity of revolutionary language. But to support its revolutionary quality, we must at least look for some kind of effect—or at least, aim to effect. Apollinaire, however, was hardly to become the poet of revolution—not Mayakovsky by a long shot, Apollinaire instead became a hero of a nationalistic war fought for the sake of readjusting the boundaries of power among the European capitalist power structures. Apollinaire, the foreigner of uncertain parentage, gained validity and popularity as the

wounded soldier who served his adopted country and was valorized—
that is, "legitimized." Apollinaire is the least likely poet on whom to pin
the hopes of bringing down—or changing—the French state. For Apol-
linaire the limits of the avant-garde are well within the bounds of aes-
thetics. To construct a model of the avant-garde with Apollinaire as its
basis would be to defuse any political purpose from that designation. To
construct a model of the avant-garde which leaves him out is to beg the
question of the relation between formal innovation and radical cultural
effect. And as Williams points out in the *Politics of Modernism*, the over-
lap between social revolution and revolution of the word was always pre-
carious.

This work was followed, in the issue of *Les Soirées de Paris* in which
it appeared, by a sympathetic review by the critic Gabriel Arbouin, in
which he described the work as an "ideogram":

> The objection has been raised that a pure ideogram is a pure design and
> that it has nothing to do with written language. My response is that in
> "Lettre-Océan," what carries the most weight is the typographic aspect,
> which makes the image, the drawing. The fact that this image is com-
> posed of fragments of spoken language doesn't matter at all, psycho-
> logically speaking, because the link among these fragments has nothing
> to do with the logic of grammar, but an ideographic logic leading to a
> spatial order of distribution completely at odds with that of normal dis-
> cursive order . . . A revolution: because it requires all our intelligence to
> get used to the idea of a synthetic ideogram instead of analytic dis-
> course.[69]

The term "ideographic" is misleading, since it assumes a fixed relation
between form and idea, while this work seemed intent on opening both
to investigation. The questions which both the poem and the suggestive
remarks of Arbouin posed seem to be fundamental ones about whether
the typographic treatment of a text could actually undermine the norms
of syntactic logic, and, if so, at what point did typography enter into the
production of linguistic value? The phrases of "Lettre-Océan," like
those of "L'Antitradition Futuriste," did not violate the rules of grammar,
they only undermined syntax by eliminating the normal connectors
through which the relations of words are determined and fixed. The fig-
urative form, immediate, recognizable, familiar, works against the nor-
mative presentation of grammar as transparent. Rendering the language
in visually conspicuous form, calling attention to its materiality, disturbs
the casual function of the grammatical norm. Syntax was undermined by
a subversive ambiguity, and the role of the reader is rendered more ac-

tive by forcing a continual reformulation of the relations of meaning among the elements of the work. The disruptive force of this effect on the normative modes of reading necessarily causes the work to be synthetic, rather than discursive, in character, thus relating it again to the work of Cubist painters.

One final work to be considered here, "Visée," makes use of a device of movement and shifting as an optical effect[70] (figure 27). An analogy is made between the activity of looking and the activity of reading the work, which, in "Visée," reinforces the theme of aiming or sighting. The lines shift downward, as if searching for their object. On the one hand, this poem is distinctly linear, the sequence undisturbed by the disposition; on the other hand, the movement, shift, within the work resists the habitual patterns of linear reading, slowing and disorienting the eye with the emphatic distortion of sightlines. The procedure of scoring actually *makes* the work; the two are one. The movement of the attitudes within the work is not duplicated by the form, not indicated, but inscribed. This process of inscription is precisely what places Apollinaire's work in the presentational mode—it is no longer acting to reiterate the pre-existing relations of elements of semantic value, so assumed in the literary disposition, but to make them.[71] The dominant visual property made use of in "Visée" is the convention of a *reading sequence,* in spite of the dramatization of that sequence through its arrangement. Readily identifiable as a *poem* by its format, "Visée" has been warped out of its contextual restraints to open that normal form to investigation, call attention to even the materiality of that conventional arrangement. Line after line was displaced across the page, following a gradual displacement from the horizontal. Fixed into sequence, neither syntactic nor poetic logic was completely abandoned, but neither was the regularity of normal relations left undisturbed. The extent to which the deviations registered from the original position, literally drifted from the usual horizon line, worked its definite but subtle disturbance through the text. Even as a subliminal undermining of the habitual reassurance of reading, the effect of this manipulation would escape notice in an oral delivery unless some attempt were made to either mimic or transpose its effect; the effect resides in the visual domain and depends on graphic manipulation. Here again is an effect which depends on visual properties and could not be duplicated in the realm of speech.

The source material of "Lettre-Océan," with its Paris/Mexico sites and telegraphic links signaled between them in partially mimetic form, is not what determines either the shape or effect of the work, which is produced through the effective function of the visual domain. The

Visée

A Madame René Berthier.

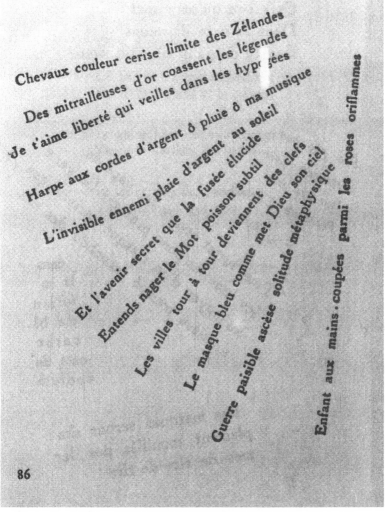

Chevaux couleur cerise limite des Zélandes
Des mitrailleuses d'or coassent les légendes
Je t'aime liberté qui veilles dans les hypogées
Harpe aux cordes d'argent ô pluie ô ma musique
L'invisible ennemi plaie d'argent au soleil
Et l'avenir secret que la fusée élucide
Entends nager le Mot poisson subtil
Les villes tour à tour deviennent des clefs
Le masque bleu comme met Dieu son ciel
Guerre paisible ascèse solitude métaphysique
Enfant aux mains · coupées parmi les roses oriflammes

86

Figure 27. "La Visée," G. Apollinaire, *Calligrammes* (Paris: 1916).

boundaries of signification allow the full activity of "Lettre-Océan" to work within the limits of the text, without external reference; the plane of discourse *is* the realm in which signification is produced.

The impossibility of separating the elements of image from the elements of language in these works does not merely reinforce or over-determine a reading in relation to the single iconic image suggested by the form. The seemingly easy connection and the near immediate recognizability permit Apollinaire to make the most deft sleight-of-hand achievement—the figuring of familiar speech into form. The minimal point on which the language, so apparently casual, is distinguished from that of quotidian use, is precisely the skillful element. Apollinaire brings into being, as if from passing whim, a recognition that vernacular language has a form and that the poet's work is the foregrounding of that *parole* against the general field of *langue* through techniques of recognition and figuration. While Apollinaire's aesthetic of presentation cannot do away with the dependence of language on the invoked and always absent signified, it goes a long way toward demonstrating the activity of the signifier, with its evident visual presence, in the process of signification.

■ Zdanevich: Inachievable Essentialism and Zaum Typography

The range of purposes to which typographic experiment was applied during the experimental phase of early avant-garde activity becomes strikingly clear in moving from a discussion of the accessible figures and language of Apollinaire to the hermetic esotericism of Ilia Zdanevich, or from the radically militant politics of Marinetti to the revolutionary language and relative apoliticism of Zdanevich. Zdanevich belonged to that generation of Russian artists and writers whose early formation, like that of Marinetti, had been within a Symbolist aesthetic. They had grown up reading the works of Mallarmé, Baudelaire, and Verlaine and had absorbed the forms and tenets of that sensibility. For Zdanevich, just slightly younger than the group of radical practitioners who had already broken ground ahead of him in the experiments which would come to be known as Russian Futurism, the turning point in his orientation occurred as a result of his exposure to the manifestos of Marinetti. But the lessons of the Italian became intertwined with the investigations of Zdanevich's Russian peers, and the synaesthetic sensibility inherited

from Symbolism transformed into a proto-formalism in which the *factura* of works, their physical, material production, was as central to their conception and execution as any thematic concern. Russian Futurism, that heterogenous array of activities which emerged with tremendous vigor and dynamism in the decade of the 1910s, contained both the conservative nationalistic investigation of folkloric conventions in the search for an aesthetic identity which would differentiate the Russian avant-garde from that of the Europeans, whose influence had so long dominated the artistic circles of St. Petersburg and Moscow, and contained the most sophisticated and adventurous of formalist investigations in the work of poets and painters. Zdanevich's work in *zaum* poetry and typography, between 1916 and 1923, contains elements of both of these mainstream investigations.

Zdanevich's pursuit of typographic means was motivated primarily by the drive to represent the *zaum* works he had been writing in a manner appropriate to their structural innovation. Between 1916 and 1923 he produced a series of five *zaum* plays in a related cycle. The typographic sophistication which emerges over the course of these five works culminates in the dazzling *Ledentu* of 1923, produced the same year as Lissitzky's imaginatively conceived version of Mayakovsky's *For the Voice*. Both works made exhaustive use of the elements of the typographer's case, but Zdanevich restricted his inventions to supporting the linguistic matter of his *zaum*. Nothing in *Ledentu* is merely visual, and there are none of the more playful, decorative passages typical of the work designed by Lissitzky.

Zdanevich's typography participates in the Futurist activities in which the innovations which characterize his work had already begun to make their appearance several years before his engagement with typographic form. But Zdanevich is a thorough and systematic user of these inventions, and the truly exhaustive character of his productions appropriates every possible typographic manipulation, and always at the service of the linguistic material. Like Marinetti and Apollinaire, Zdanevich wrote theoretically about his practice, though these writings have a tone that moves between absurdity and self-serious play, which is far from the strident manifestos of the Italian or the critical, sharp focus of Apollinaire. If Zdanevich was not the most clear-thinking theorist of the Russian avant-gardists, he was the one most engaged with typographic means as an integral part of his writing practice. He was also the only one among the poets studied here to think extensively in terms of the space of the book as a physical object rather than merely in terms of pages which incidentally amounted to a whole tome.

Poetics

Zdanevich was by no means the only poet to conceive of *zaum* or practice it: the two other writers extensively involved in *zaum* experiments were Khlebnikov and Kruchenyk, both of whom exerted significant influence over Zdanevich's work, though he quickly defined his own mode and area of investigation, as we shall soon see.[72] For Zdanevich typography was more than a means, it was the substance of his expression. In terms of the linguistic and poetic theories informing his work, Zdanevich had much in common with various poets and the emerging Formalists: Khlebnikov, Kruchenyk, Jakobson (who also experimented with *zaum*) and Shklovsky were all figures whose positions, vocabulary, and concerns overlapped with Zdanevich's.

Zdanevich's work contains most of the major themes of concern to the Russian poets of his generation, with one important exception. His interest in the intense interiority of emotional life was at the expense, even was the means of blocking attention to, any recognition of the political context in which language functioned. In spite of the extent to which his rejection of the normative symbolic order of language functioned through games of identity, power, and sexual formation, to which he attempted to give form in the *zaum* dramas, and their implicit relation to external structures of power, he refused any overt inscription of historical or political context. In this sense, he was more remote from a sense of responsibility to the affairs of his day than any of the other poets under consideration here. He invested in the project of an essentialist *zaum*, with a faith in the capacity of linguistic material to communicate directly, without recourse to linguistic meaning in the conventional sense (that is, in the sense in which it is dependent on conventions).

Zdanevich's attitude toward language was irrational and antirational at the same time, involving a deliberate subversion of its organized logics and the assertion of an emotional basis, universal and interior, for effective meaning production. *Zaum*, and its typographic presentation, were conceived in the curious combination of Futurist-inspired rejection of quotidian language as enervated and depleted, and a deeply focused investigation of interior life as somatic, emotional, and universal. The essentialism underlying Zdanevich's project, predicated on the capacity of morphemes, phonemes, and graphemes to *mean* through their very *being* was a rejection of the fundamental concept of linguistic value as the production of difference. It was also a rejection, one might almost say a denial in the Freudian sense, of social context as site of linguistic activity.

The earliest theoretical writings of Zdanevich of which any trace

170

remains were written in 1917, with the bulk of writing dating from the conferences he wrote and delivered in Paris in the early 1920s. Again, Zdanevich's interests in *zaum* and in a typographic manipulation suitable to its forms, echoed the interests of Khlebnikov, Kruchenyk, and Jakobson from the period of 1912 to 1916. For instance, in a letter to Velimir Khlebnikov, Roman Jakobson wrote of the problems in finding a visual means of scoring *zaum* work:

> The question of the interplay between speech sounds and letters and the possibility to utilize these interplays in verbal art, particularly on its supraconscious (*zaum*) level, vividly preoccupied me in 1912–14, and they were intensely discussed in my correspondence of 1914 with Krutchenyk and Khlebnikov. The selection of those elements of phonetic transcriptions which could and should be utilized for the printing of various poetic experiments was touched upon next to the daring problems of poetic experimentation with diverse combinations of sounds and letters and even numbers.[73]

Jakobson never realized this potential for transcription, nor did Khlebnikov or Kruchenyk, though the original formulation for a graphic representation capable of maximizing the expressive potential of language had been presented in their 1912 "The Word as Such" and "The Letter as Such" where they had affirmed "the pictorial principle claiming that the symbol should look like the object it represents."[74]

One of the unique aspects of Zdanevich's achievement in the typographic presentation of his *zaum* plays is his exploration of the graphic potential of language, but the issue of the relation between verbal and visual modes needs further clarification and it did not follow the prescriptive line advocated by Khlebnikov and Kruchenyk, whose positions also diverged sharply after 1912. Khlebnikov's *zaum* was constructed according to a mystical interest in understanding (really *revealing*) the order of the universe through a nearly Pythagorean understanding of the morphemic units of language as reflections of fundamental vibrations, frequencies, and quantitative reflections of universal qualities. He was not interested in the contents of the individual psyche, but in himself as a priestly figure working in the service of profound truth.

> Khlebnikov "dislocated" the words and phrases of his poems. He segmented and rearranged the parts of language, inventing plausible prefixes and suffixes for existing roots or building new meanings with real beginnings, endings, added to imaginary roots. He did this to give a fuller meaning to poetry, to break language free of time-worn convention.[75]

While this process led Khlebnikov to combine familiar elements in an unfamiliar usage in a manner methodologically like that of other writers who, from Mallarmé through Mayakovsky and Shklovsky, were intent upon finding a poetic language distinct from the journalistic norm of quotidian communication, his mystical orientation distinguished his work by its underlying purpose. The influence, however, of this experimentation, was that it promoted an attitude which had a historical root in the work of Pushkin, who had urged poets to listen to the peasants as a means of revitalizing the Russian language. These two aims, the search for vitality and the search for universal truth, had as their point of intersection a faith that a source for poetic strength and invention lay in the material of language rather than its (mere) content, in its sounds and rhythmic structures, rather than in borrowed motifs and themes imported from the Decadents and Symbolists.

Zdanevich's *zaum* differed from Khlebnikov's both structurally and in its primary motivation. Zdanevich atomized language below the level of the morpheme, not respecting the integrity of the existing roots, prefixes and suffixes, nor feeling that a sufficient investigation could be carried out merely through their recombination into words whose suggestivity derived largely through association with existing vocabulary. The transmental *zaum* conceived by Zdanevich was rooted in the investigation of sound and the properties of those sound values:

> It was not the sense of words, the inherited monopoly of sense, which must be respected. Primary attention should be given to the sounds . . . independent of rational schemes, the burning projections of the being. This sign, by which the very least articulation of emotion takes hold, this break which cuts space and time in letting go the audible jet of their interruption, that is, the letter, is treated by him not as a notation in a system coded in advance, but more in the expectation of the phenomena of reception, of rejection, of accord, which amasses around it . . . [76]

Zdanevich was motivated by the desire to create an expressive language capable of generating direct effect, of bypassing the normal routes of language practice with their dependence on communicated meaning. His concerns were intensely personal, and the substance of the plays he wrote in *zaum*, to be discussed below, is the interrelation of language, power, identity, and sexuality through representational modes. Language was both the substantive and methodological subject of Zdanevich's work, and the contents of his unconscious, with all the libidinal drives and impulses, worked its way directly into the scatological and sexual imagery and tone. Again, politics exist in Zdanevich's work

only to the extent that it contains a clear attitude toward established language as a symbolic system of law, and that *zaum* is the means of subverting and transgressing that law. Zdanevich's positioning of himself in relation to language played itself out, both thematically and methodologically, through the *zaum* plays by his repeated distinction between a semiotic language of the infantile body and a symbolic language of the name of father. Zdanevich, however, never articulated his poetics in these terms. In the series of lectures he delivered in 1922 and 1923, just after his arrival in Paris, he described his relation to the traditions of Russian poetry and, in particular, his place within what he called "The New Schools of Russian Poetry."

From the outset of these lectures, Zdanevich was at pains to differentiate the poets who used *zaum* from those who did not. This distinction allowed him to structure his objections to Mayakovsky's domination of the field of poetic activity through an aesthetic point, while he aligned himself with Khlebnikov, Kruchenyk, and Terentiev. He defined the central goal of the new poetics as follows: "[I]t's the ancient idea of the language of the gods, sacred and enchanted, with words that break the doors of the unknown, demolish villages, build mountains."[77]

Stressing the aesthetic content of the poetic program, he further distinguished himself from those Formalists whose interest in language stemmed from an overtly social concern:

> In Russia there exist a number of Schools of poetry which, in spite of the Revolution and the War, have not abandoned the study of pure art. Politics has not touched them. During the last few years, they have made such a huge leap forward, such tremendous progress, such a quantity of discoveries and inventions, and so completely changed our attitudes towards poetry, that all the theories of the Symbolists have been completely surpassed; and I am proud to belong to one of these Schools.[78]

Of the *zaum* poets, Khlebnikov was the one most closely associated with the Moscow Linguistic Circle, formed in 1915, whose interests were defined by a logocentrism in which the search for meaning in its purest form had motivated the investigation of language. Characteristic of this position is the work of Roman Jakobson, who demonstrated that the poetic and communicative aspects of language were one and the same and that form was the means by which meaning was achieved. Zdanevich was closer to the work of the St. Petersburg group Opayaz, or the Society for the Study of Poetic Language, who stressed the existence of a noncognitive side to consciousness. Osip Brik, for instance, had exhaustively studied linguistic sounds, motivated by a belief in "direct apprehen-

sion," or the bypassing of referential values, for the sake of producing emotional effect. Zdanevich had no formal linguistic training, and his theorizing often reflects this. He tends to generalize poetics without regard for a clearly articulated understanding of linguistics.

For Zdanevich, again, typically, the major task of poetry, *zaum* poetry in particular, was to "emancipate poetry from ordinary language."[79] In order to do this it must proceed from an understanding of the fundamental dual character of language:

> . . . the word is always dualistic. In the word, the universe is known and understood rationally by logical knowledge, by sense. Sense limits the birth of the word in a practice. At the same time, sense indicates the place of fact, its position. The phonetics of a word indicate the substance of the object in its transordinary sense. The world which is found beyond the frontiers of reason and rationality, the world of instincts, the world of intuition, that is what the sounds talk to us about. Each sound has its quality, its character, its nature. For this reason, ordinarily, the sense of words can be different whether the words are made of the same sounds or not, and words of similar sense can be made of different sounds. The world of sound and the world of sense are the two poles of our life, the two roads on which we travel. This is eternal dualism, the earth and the sky, day and night, body and soul, reason and intuition, thought and emotion.[80]

For Zdanevich the utopian aspect of his work was in its potential to get beyond the limits of discursive language in a way which avoided the social dimensions in favor of the psychic. It was both metaphysical and meta-psychical in character. The realm in which liberation from the rational might be addressed and achieved was that of the psyche, and the exhaustive mechanics in which he engaged for the sake of his *zaum* experiments led him into typographic experiments designed to short-circuit the control of reason on language and unleash its emotive, expressive potential.

In so doing, Zdanevich reinforced the opposition between sound and writing, defining the specificity of a typographic practice grounded in a materiality, which identified the qualities of inscription and distinguished the visual from the verbal in the domain of language. Paradoxically, his route to this was through exhaustive examination of the sounds of the Russian language, which he was atomizing in his search for the roots of a transrational language, *zaum*, which led him to similarly approach the notational elements of the alphabet, and, in his search for correspondence between the two, discover their irreconcilable non-equivalence.

Zdanevich's investigation of language as a signifying practice centered on his *zaum* works; these were characteristically Russian in both thematic and linguistic terms, as well as being sterling examples of the intersection of investigation of poetic language with the production of poetic work—the unique achievement of the Russian writers of the teens and twenties. But this *zaum* work, produced between 1916 and 1923, also demonstrates a relation between the visual representation of language and the production of linguistic value, which supports the general premise that the engagement with materiality was fundamental to the investigation of the processes of signification as they were conceived within modern art practice in general and in typography insofar as it constitutes an aspect of modern art.

The primary principles Zdanevich invoked in his discussion of *zaum* were *sdvig*, with its attendant notion of *verbal mass; faktura, global itinerary*, and *orchestral verse*. These are concepts which circulated widely among the Russian avant-garde writers and artists, and Zdanevich's particular formulations show the earmarks of synthesis rather than completely original thought. That these were common notions, rather than original ones, makes Zdanevich's work all the more useful as representative, however, in spite of its personal idiosyncrasies with regard to subject matter. The concept of *sdvig*, or "shift," allowed one to act upon the *verbal mass* of a word, treating its sound independent of its conventional sense. By transforming the word slightly a new sense could be evoked, largely through association of the new work with other words with which it had homophonic connection.

> *Sdvig* is the deformation, the demolition of the word, voluntary or involuntary, achieved by displacing a part of the verbal mass into another position. *Sdvig* can be etymologic, syntactic, phonetic, morphologic, or orthographic, etc. If a phrase becomes a double-entendre, that is *sdvig*. If the words become confused with each other (by *verbal magnetism*) or if a word detaches itself and joins up with another, that is also *sdvig*.[81]

The verbal mass and *sdvig* both relied on the imposition of the notion of *faktura*, attention to the making of a work of art, especially to the resultant qualities of its surface, onto verbal material. It is easy to see how this process would focus attention on sound patterns and values, on rhythmic and other formal properties of language rather than on conventional meaning. But the *sdvig* of Zdanevich and Kruchenyk never achieved the social force or thrust of Shklovsky's *ostrananie;* the effect of *sdvig* was not to alienate or defamiliarize, but rather to evoke emotive response, with

emphasis upon the sexual ("double sense is merely the synonym of hidden impropriety").[82]

With *global itinerary* Zdanevich justified the circumlocutionary indirectness of poetry, explaining that while prose and quotidian language moved by the shortest route to achieve a particular end, poetry necessarily went in the opposite direction, going completely around the globe, for instance, to get from the back of the head to the front of the face. There were no examples of this provided by Zdanevich, who left explicit demonstrations of his principles to the imagination, except insofar as they are carried out in his works. The final concept central to his *zaum* plays, *orchestral verse*, involved the scoring of a text for multiple voices, a technique which was a persistent feature of all the five *dras*.

Zdanevich began his cycle of *zaum* plays in 1916 in St. Petersburg with the writing and performance of *Yanko, King of the Albanians*. He finished with the printing/publication of the fifth play, *Ledentu as Beacon*, in Paris in 1923. There is considerable typographic evolution in the course of the five works (*Yanko* was first published in Tiflis in 1919 after Zdanevich had apprenticed himself to a printer there and began publishing the editions of 41 Degrees). The first works are more modest typographically, while all of the elements present within the early plays are included in some form in the visually extravagant *Ledentu*, which will serve as the focus of my analysis. By 1923, Zdanevich would have been exposed to the bulk of what was produced by Tzara, Kamensky, Hausman, Arp, Schwitters, Picabia, Albert-Birot, Marinetti, among others—in short, all of what constituted the typographic experimentation of the Dada and Futurist era in Europe and Russia. But even if it had contained no unique features (which it does), the typography of Zdanevich would deserve attention on the basis of the precision with which he worked out his typographic vocabulary. More than any other poet under discussion here, he understood typography as a printer and compositor, with a strong sense of the physical and technical qualities of the medium: that it was metal, rectangular, made of pieces inclined to certain combinations and not others. Unlike Marinetti, for instance, Zdanevich never broke through the discrete space of the page, never piled typographic elements on top of each other, never broke words or destroyed letters. Instead he manipulated the letterforms, created them out of other typographic pieces and printing elements (such as borders or dingbats), with a careful understanding of the actual processes of typographic composition, that is, the actual ordinary assembling of letters in a composing stick. The selection and combination of the elements he used permitted his *zaum* inventions to be registered through a highly

structured typographic mode in which its visual character was not merely represented, but manufactured.

Typographics

Zdanevich's attitude toward *Ledentu* justifies selection of the work as the primary example of his *zaum* typography:

> The idea of the book, of the typographical characters of *zaum*, have attained in this book their highest development and perfection. This is not the extinction of the work, it is its summit. This book is the synthesis and overture, seen in regard to *zaum*, of everything that has happened during the last ten years in the radical Russian avant-garde.[83]

This personal assessment has been confirmed elsewhere, as in these remarks by Susan Compton:

> In the final publication of the book he outstripped most Western European typographical invention while anticipating surrealism by continuing the Russian Futurist tradition which he and Krutchenyk had pushed further in Tiflis. Beyond the reach of the censor they had developed the double meanings of words to a degree of obscenity which was unthinkable earlier.[84]

Ledentu was the culmination of the *zaum* cycle of plays, or *dras* as Zdanevich called them. He used the term *vertep* to designate the cycle, a term which describes a theatrical mode characterized by a certain eclecticism:

> Vertep was a form of puppet folk theater of Ukrainian origin, which mixed episodes from the Bible with comic scenes of everyday life . . . Also in the tradition of folk theater is the figure of the Master [. . .] who begins each play with a short talk with the audience, providing hints as to the possible meaning of the play.[85]

Zdanevich similarly combined the religious image of the donkey, associated with Christ in Russian folklore, with autobiographical materials in order to forge the central figure of his farcical plays. The title of the series, *Aslaablitchia*, serves as an example of the linguistic complexities of Zdanevich's *zaum*. The word "donkey" was at its core:

> . . . which one can decompose into "as'el" (the donkey, the central theme of Ilia Zdanevich), and the "oblica" (the *traits*, the physiognomy), and also into "slab" (*weakness*) and into "oblicen'ja" (*accusations*) according to the system of phrases and double-sense words.[86]

Other interpretations of this title include: "the author putting the asinine pranks of his youth on trial"[87]; and, "the effect of disguising human traits under those of an animal in a manner which 'signifies the blindness caused by love.'"[88]

The range of imagery layered into this title includes love, of both sacred and profane varieties, and the foibles and weaknesses of a young "ass." Zdanevich identified himself with the ass, bearer of burdens, a stubborn and intractable beast, and a martyr to long suffering, but also with another figure, that which serves as his feminized double, the figure of Lilia.[89] In the first of the *dras* Lilia is portrayed as a mute creature, excluded from language, while Yanko is a sexless little flea captured by bandits and glued to a throne against his will. This gendered opposition is typical of the thematic construction of sexual identity in relation to language, which continues throughout the cycle of five plays. The character Lilia grows from child to courted young woman to mature lover while the various roles into which the male leading figure transforms include a donkey, a suitor, a lover, and an artist. A combination of playful and serious tones, of the themes of resurrection, death, anal eroticism and infantile sexuality, mature love, and the role of representation all filter through the plays. But in character and quality the final play, *Ledentu*, is more mature and subtle than the others. While there were still elements of the ridiculous and childish, the problem of representation, mimesis, and realism came to the fore, and the play was dedicated to the memory of Zdanevich's friend, the painter Michel Ledentu.[90]

Ledentu begins with Zdanevich's descent into Hell to bury Lilith, the woman in him, evolved from the infant Lilia. But he finds the woman guarded by five stinking cadavers and a nauseating Spirit who greeted him in the name of "god the donkey," invoking the sacrilegious figure of the ass. Meanwhile a realist painter has made a portrait of the dead woman, and it is admired by the cadavers for its conventional properties. Ledentu appears and makes a second portrait, called "Non-Likeness," which has a resuscitative effect upon the woman. The woman and the new portrait make love, and once revived, the woman attacks the realistic portrait and initiates a series of murders: Non-Likeness kills Likeness, the five cadavers assault the revived woman, the spirit attacks the cadavers, the realist painter kills the Spirit, Ledentu kills the realist painter, and in the end, Ledentu, as beacon, leads the woman and Non-Likeness out of the abyss.[91] The aesthetic message of this play was abundantly clear: the life of the spirit was not served by the conventions of mimetic realism.

The *zaum* of *Ledentu* is also more sophisticated than that of the ear-

lier *dras;* no longer simply piecing together various absurdities and random fragments of language, as in the earlier works, characterized by Markov as a "rich melange," Zdanevich had made a thorough investigation (albeit idiosyncratic by definition) of the phonemic structure of the Russian language. He made use of this investigation to construct distinctly different voices out of these sounds:

> Each person in the play is characterized phonetically. The Holy Ghost speaks in a language composed entirely of consonants and a single vowel "i" (*ijitza*) borrowed from church slavoni, in order to indicate both a certain closedness and also a degree of solemnity. The five cadavers each have their own manner of speaking: one is soft, liquid, and employs only vowels, the second uses all dentals, the third is brutal and speaks in sharp commands, brusque outbursts of the tongue and lips. Ledentu speaks a language which has a particularly Russian sonority, the hobby painter salivates and uses diminutives, the living portrait speaks in a tongue close to Russian. The Non-Likeness is virile, hard, with lots of "j," "ch," and "k" which recalls the "chacadam" of the sorcerers invented by Khlebnikov.[92]

As Markov emphasized, Zdanevich was a "classicist" of *zaum,* thorough and systematic, not dependent on the "aleatory theories of his colleagues."[93] Having established the phonetic character of these voices, Zdanevich explored the possibilities of rendering them in typographic terms. A brief survey of his typographic explorations to this point will put the graphic effects of *Ledentu* into perspective.

In the setting of his first play, *Yanko,* Zdanevich had restrained himself to the use of boldface to indicate vocal emphasis (figure 28). A connection between pronunciation and visual representation was intended as Zdanevich, from the outset, was interested in scoring these works for eventual performance. But an additional intention was to render *zaum* comprehensible to the *eye,* in reading, and to make the performance of the works one which occurred upon the page. These two operations do not duplicate each other, and by the time Zdanevich had arrived at the typographic extremes of *Ledentu,* the visual presentation had practically taken over the vocal dimension. *Yanko* also contained the first attempts at orchestral scoring in which simultaneous voices spoke in unison or independently in relation to each other according to the placement of their lines on the page.

In the second play, *Donkey for Rent,* Zdanevich achieved a higher degree of graphic organization, and the relations of the voices to each other in the polyphonic passages were indicated either by the place of the voice in the line or else in juxtaposition of voices side by side (figure

албаниц брешкабришкофскай
двои разбойникаф из гусыни
немиц ырентꙗль
блаха
свабодныи шкипидары шкипидараф ы
грают зритили слушаца клаки
дела в албании па ниде
начꙗла
реф мелких чисоф

разбойники
ривут за сценай
хорам

аб бевегбевиг ге де е
аб бевегбевиг ге де е
жꙗи какал какал мио
о о о о о о прстуеф
ха чешыщчешыщ щэ ю ꙗ
ха чешыщчешыщ щэ ю ꙗ
ь ьь ьь ы

ы ы ы ы ы ы о

вбигают

хазꙗин

разбойники из гусыни

первай разбойник

абвг дижзий клмно прсту фхцчш
щеъь ы ыюꙗ ижыца аб вгд жзик

фтарой

лмн? оп рст? уф хцчшщ? ъ? ь? ь?

первай

ы ыюꙗ ѳ v абвгд еж эйкл мно
рстуфх цчшщ ыыю ꙗжыцаа

Figure 28. *Yanko, King of the Albanians,* I. Zdanevich (Tiflis: 1918). (Photo courtesy of Hélène Zdanevich, Fonds Iliazd.) This is the opening page of the drama. The cast of characters is listed, beginning with the main character, *the albanian,* whose name is spelled phonetically to suggest an association with the famous revolutionary klan, *Breshko breshkovsky.* The next characters are *two thieves: born from a she-goose,* and finally, *the roar of a tiny clock.* The second paragraph indicates the scene, differentiated typographically from direct speech by the absence of bold character stresses. The bottom paragraph is a recitation by the thieves of the names of the characters of the Russian alphabet. In this first *zaum* drama Zdanevich used the bold letters in accord with the established convention of indicating intonational stress. However, once this pattern is established, he breaks the expectations of the reader by using the bold characters to stress elements which are, literally, unpronounceable, as in the last line of the left-hand page. Here letters used to indicate palatalization or lack thereof are given stressed emphasis though they cannot be pronounced. On the right-hand page the action continues with nonsensical roaring. Then *the owner* runs in, followed by *the thieves from a she-goose* who continue to roar out the names of the alphabet. In the last few lines these alphabetic names are posed as questions. There is a blend of old and new orthography (pre- and post-revolutionary) as there will be in subsequent dramas as well. (Caption with the help of Olga Meerson.)

29). The chorus sections of the third and fourth plays embellish these techniques, including more voices. Produced in 1918 and 1920 these last works did not represent the forefront of typographic experiment in the period (figures 30, 31, and 32). Kamensky's *Tango with Cows*, printed in 1914, already contained far more daring typographic work. But in constructing the pages of *Ledentu*, the final play in the cycle, Zdanevich put all of his typographic resources and imagination into play (figures 33 and 34). Governing this construction, present throughout and in all sorts of variations, is the concept of the *letter*. Whatever phonemic or phonetic investigations had prompted the writing of the text, its imprinted form manifests an obsessive interest in the manufacture, use, placement, and attention to the letters which compose it— made of smaller units of type, juxtaposed in radical contrast of scale, mixed within a single word or scattered across the lines of an orchestral score, the letters are inviolate and discrete. The isolation of elements and emphasis upon their place in the graphic hierarchy of the page had no strict relation to the value of phonemic elements in the same words. The distinction between verbal and visual domains of language was made clear, and Zdanevich's capacity to manipulate them independently had been demonstrated by *Ledentu*. Viktor Shklovsky wrote in 1923:

> The typographic side of Zdanevich's work is one of the most curious successes in contemporary art. Zdanevich uses typographic composition not merely as a means of noting the words, but as an artistic material. Every writer knows that writing provokes specific and particular responses. On Egyptian papyruses the scribe ends with an incantation, but I think that this is read in the form of enormous characters which do not have a happy appearance. Zdanevich gives typographic composition the power of expression and calligraphic beauty of a manuscript of the Koran. The visual side of the page provides new sensations, and coming into contact with different meanings gives birth to new forms.[94]

As Janacek pointed out, since *zaum* was an invention, there could be no way of determining what the relation between the representation and its sound should be: no one spoke in *zaum*, it was a literary invention, and even if concerned with phonetic structures and forms, it was only insofar as those could be adequately *notated* that they could come into being in any stable form, unless Zdanevich had availed himself of primitive recording techniques. Though it was intended, at least at the outset of Zdanevich's work, for recitation, it was the existence on the page

зохна

бабазОбинькай

убигант вприпрышку
жыних а
асел
вскакьвают

Н. ГОНЧАРОВА
(карандаш)

жыних а жыних б

аркестрам

вЫмухала	лисянЯфы хАни
гАп вытАп мяжнЫ	
ааргЯн	Обжыч
гУка зОвана	жыянЕлин Ть—нь
зашагОвана	
мАгуясь	‚Обжыч
гАжыта хУпка булУ	лажыпЯры иры-
нупарЕ хАх пагубО	рЕбжыч

Figure 29. *Donkey for Rent*, I. Zdanevich (Tiflis: 1919). (Photo courtesy of Hélène Zdanevich, Fonds Iliazd). Taken from the midst of the play, this page makes little sense until the third paragraph, which describes the action in the play where someone *runs in, leaping.* Following this are mentioned (without specific tie to the action) the *bridegroom* and the *donkey,* major characters in the story, and in the fourth line of this paragraph the phrase *jumps up.* The page then splits into frames A and B, designated as being like *an orchestra.* The lines which follow are, again, largely nonsense, though the themes which emerge on the left are *learned, stepped around, to make something perish* while the right side suggests patronymics and pseudonymous naming patterns. Given the theme of the play, with its doubles and masquerades of identity, these plays on the theme of naming are fitting, if obscure by virtue of their nonsensical form. (Caption with the help of Olga Meerson.)

which made it available for and determined the form of that representation.

> Imprecision in the correspondence between written and oral language would be highlighted were it not for the absence of an *a priori* oral correspondent, making the issue of imprecision immaterial. The *zaum* word is a precise visual representation of itself. A reader looking at a *zaum* text may wish to verbalize it, and is probably expected to do so, but he does so at his own risk, since the intentional relationship is lacking.[95]

Janacek further argues that this complex visual scoring would have made an actor's work more difficult, creating a task of decipherment by the visual complexity of the page. But the visual effect of Zdanevich's pages are clear to the *eye*, with well-articulated emphasis of relations of voices in both rhythm and tone. It can be argued that, by the time of *Ledentu's* publication, Zdanevich no longer considered a verbal *performance* obligatory, but he was concerned with constructing a performance on the page. On the other hand, in *Ledentu* he also included a pronunciation key for recitation, "a fully developed system which included not only stress, but vowel reduction, consonantal elisions and so forth, as well as (on paper if not in print) tempo, pitch, volume."[96] To score the work, Zdanevich relied on both selection and arrangement of type: the place of the type on the page, mainly in the lines of his orchestral verse, and the use of a variety of sizes and styles of type to indicate "character." In *Ledentu* the orchestral versification contains five voices, which act as a chorus, and the coincidence of sounds on which they were to synchronize was apparent in the vertical alignment at points along the five horizontal lines, aping the effect of a musical score. Zdanevich's attention to the page as a matrix, with each place within it assigned a specific value according to the graphic division of the whole, prefigures his later work in the production of luxurious *livres de peintres* after 1940 in which the theatrical quality of the whole work is played out in graphic and material terms.

The orchestral scoring in *Ledentu* was relatively tame compared to the more aggressive visual features of the rest of the work, where Zdanevich experimented with what he later termed "the construction of the page by the variable volumes of letters, typographic tableaux."[97] Letters were selected to maximize the visual contrasts they imposed upon the eye. On one sheet a gigantic, full-page cry of the corpse is set off against the orchestral score to the left, and the huge, domineering screech of a vowel stretches out to the full height of the page. This attention to letters indicates Zdanevich's acute sensitivity to typography: he

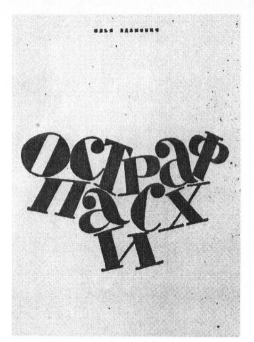

Figure 30. *Easter Island*, I. Zdanevich (Tiflis: 1919), cover. (Photo courtesy of Hélène Zdanevich, Fonds Iliazd.) The title of the play is spelled out here in letters whose form has been distorted as well as their arrangement. Even if put back into linear order, they would have odd slants, curves, and bends in their shape. Though morphologically correct, the spelling of the title is phonetic—the stressed syllable, which is the key morphemic unit, is respected, but the unstressed elements are given a distorted phonetic treatment. By contrast, Zdanevich's name, as author, is spelled correctly and set according to the conventions of the new, revolutionary orthography. (Caption with the help of Olga Meerson.)

Figure 31. *Easter Island*, I. Zdanevich (Tiflis: 1919). (Photo courtesy of Hélène Zdanevich, Fonds Iliazd.) Both the typography and orthography of this drama are considerably more complex than that of *Yanko*. One may read any line, for instance, through the path of letters these dense groups, but only occasional glimmers of sense appear. Beginning at the upper left, one reads a word suggesting *birdhouses*, or, reading diagonally from the same spot, *clarity*, while in the second large group, on the first line the word *tabac* is spelled out orthography suggesting the form of a shop sign. There is, however, no linear reading which makes sense, and many of the letters fill in around morphemic units which then, as with these first examples, flicker at the reader suggestively. The effect is as in the recognition elements of a foreign language, which, to an outsider, might accurately suggest associations with roots in one's own tongue, or might simply have a coincidence of sounds—as to an English speaker the French word *mer* might be mistaken for the word for a female horse, *mare*. These lines cannot, therefore, be either read or translated, though occasional words cohere in the field—as *cat* and *look there* in the second line, or the word *Spring* repeated in the final line. (Caption with the help of Olga Meerson.)

Figure 32. *As though Zga*, I. Zdanevich (Tiflis: 1920). (Photo courtesy of Hélène Zdanevich, Fonds Iliazd.) The structure of these pages, typographically and linguistically, is very close to that used in *Easter Island*. While there are suggestions of morphemes and meaningful units, the language is almost entirely nonsensical. The term *Zga* has a highly colloquial meaning, however, which provides some insight. A *zga* is a bell fitted into a bowed metal element hanging above the harness on a troika, and the term is used in an expression "so dark one can't see a single *zga*." By association, the word comes to suggest the glimpse of something seen when there is the merest glimpse of light. Thus the term suggests the relation between meaning and sense and the elements which flicker through the nonsensical groups of letters. (Caption with the help of Olga Meerson.)

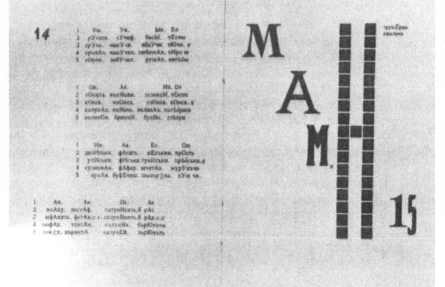

Figure 33 *Ledentu as Beacon*, I. Zdanevich (Paris: 1923). (Photo courtesy of Hélène Zdanevich, Fonds Iliazd.) This page shows a split between the so-called orchestral verse and the speech of a single character, the corpse (on the right). The orchestral verse is, again, largely nonsensical, and the simultaneous reading aloud would have complicated this even further. The glossolalia simply rambles, as the utterance of a chorus of voices, in which, as in the previous plays, there are glimpses of sense. The huge, emphatic utterance on the right is the cry "Mom's"—the cry of a child looking for its mother in a moment of crisis and making a claim on that association, implying, at least, that one has one's mother, one belongs somewhere. The large-sized final character was made up out of elements in the typecase normally used for decorative purposes and the graphic effect is to unify the page, putting the orchestral elements on the left into a visual bracket. They become the visual pattern of verbal patter against which the distressed cry registers its bold simplicity. (Caption with the help of Olga Meerson.)

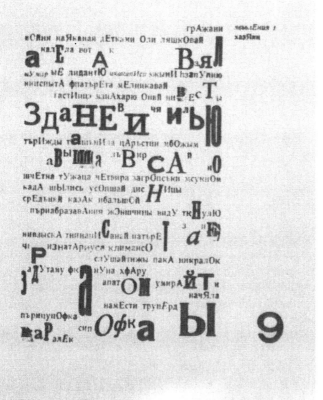

Figure 34 *Ledentu as Beacon*, I. Zdanevich (Paris: 1923). (Photo courtesy of Hélène Zdanevich, Fonds Iliazd.) This is the first page of the play and describes the initial situation. There is a cast of characters, an owner, as well as citydwellers, and women indicated in slang innuendo-laden terminology, and the painter Ledentu has already died. There is a fiance described as having no experience of the portrait of Melnikova, as well as an expert (presumably a connoisseur of painting). Zdanevich, indicated as *Iliou*, is dragged along with help provided by divine sources and when he comes out, it is at *Versailles* (spelled very phonetically). There are four characters who make use of a shroudlike cloth, binding themselves with it and into it, and the action revolves around a portrait. The typographic variation is arbitrary, not even signaling stressed syllables as in the earlier plays. In the melange of forms, the name *Zdanevich Iliou*, more or less the sixth line, stands out with striking coherence. *Ledentu* is readable in a way which neither *Zga* nor *Easter Island* were, and the course of the action may be followed in the text, not just from descriptions of the scene. The language contains Church Slavonic and a full range of Russian from proper forms to indecent slang. The morphological distortions multiply the associative potential of the text. (Caption with the help of Olga Meerson.)

composed the large "H" out of decorative elements, engaging himself with the physicality as well as the visuality of the typecase. The aesthetic qualities of these pages depends on the sense of rhythm and timing, of opening and closing, the design of the spaces as they created dramatic relations among the visual elements. It would be a mistake to see this as an arbitrary or whimsical indulgence; Zdanevich's typography was a poetic practice in a visual domain: "[I]n reality, nothing is left to chance, everything, down to the last minor detail, has a tight, mathematical precision."[98]

This detailed, almost obsessive, precision with regard to the visual image of the letter raises questions about the definition of the signifier as an acoustic image. On these pages, the interrelation between the phonetic structure of language and its representation in visual form was complicated by the amount of attention paid to the visual material of the letters. On the one hand, this would seem to have been the means of making the phonetic structures more precise; but since these phonetic forms were not in the conventional form of words the easily established relation of signifier/signified of the conventional sign is lacking. The signified brought into being through an association with those aberrant signifiers, whether considered phonetic forms or visual forms, was already problematic. The conceptual category to which the association should be made was a novel one, and it broke the Saussurean rule that the division of the signifying chain into matched sets of signifiers and signifieds was what guaranteed communication. For the phonemic elements and the visual forms were both linguistic elements, and in both cases their deviation from a norm, from the conventions of use and form, altered the structure of the signifying system. The emphasis on the process of signification in Zdanevich's work was definitely placed on the signifier, and the effect of that was to produce a signified lacking clear semantic value. The signifier evoked something other than *meaning;* the signified became a visceral, physical experience of the effect of a material signifier rather than a clear mental concept neatly aligned to an acoustic image.

While it is clear Zdanevich was investigating the phonemic structure of the Russian language, teasing out its effective particles and using them at the limits of verifiable communicative value, he left the letterforms intact, adding a few letters from the Greek alphabet to notate additional sounds. But the manipulation of the letterforms is often independent of the investigation into phonemic investigations; they made a form which a verbal rendering might interpret, but did not precisely du-

plicate phonemic elements. Thus it becomes even more difficult to sustain the notion of a purely acoustic signifier, since in many cases the signifier is a letter whose value is determined by a graphic relation to another letter because of its scale, or typeface, or weight.

The concept of *sdvig* provides insight into Zdanevich's own understanding of these processes:

> *Sdvig* is not just the useless result of the decomposition of language. It is a means of poetic expression. Poetry has a tendency towards the transmental, towards emotions, among which the foremost is a sexual emotion and the expression of this emotion by means of sdvig is quite frequent. Double meaning is only the synonym of hidden impropriety.[99]

The force of linguistic manipulation in Zdanevich's cosmology must not be underestimated: "No, language is not a lie, not a mirror, not a phantom without force, it is complete power."[100] The emphatic embracing of the material plane was important because it was not a surrogate representation; *zaum* was the thing itself, it was the force, it did not embody, surround, clothe, or reflect an energy—it *was* the energy. The concept of *sdvig* based the power of language in the material force of words and in their ability to use, displace, recover, borrow that force to the end of making a direct, extreme effect. This was not sound symbolism or letter symbolism, as in the case of Khlebnikov's "localized expression" of universal order; this was not a case of an absence invoked by a presence, it was a primitive and powerful sense of the capacity of sound and image to produce effect by virtue of material qualities.

Paradoxically, then, although *zaum* was concerned with the elements of sound in language, Zdanevich's involvement led him to consider the letters as independent, thus intensifying the contrast between written and spoken forms of language. A poster produced by Zdanevich in Paris in 1923 demonstrates this contradiction, while also dramatizing the distinction between Zdanevich's typography and that of other Dada and Futurist poets.

The outstanding feature of this poster for the "Soirée du Coeur à Barbe" is what is technically termed paragonnage: the assortment of various sizes of type within a single word (figure 35). This had been a feature of Zdanevich's typography from the very beginning of his work in Tiflis, but the degree to which it had developed by the time he was in Paris forced the separation of the word into single letters, the smallest atomized units of the visual word. No other artist using typography was so relentlessly insistent upon the isolation of one letter from another.

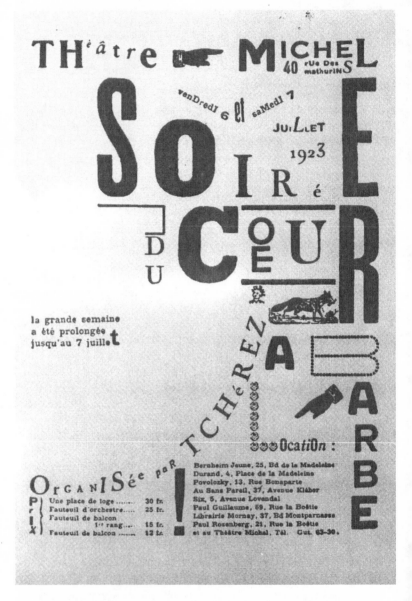

Figure 35. *Soirée du Cœur à Barbe*, I. Zdanevich (Paris: 1923). (Photo courtesy of Hélène Zdanevich, Fonds Iliazd.)

Looking at this piece in a catalog of other Dada ephemera, one is struck by its uniqueness in this respect.

This insistence affirmed more clearly than any manifesto or pros-elytizing statement Zdanevich's belief in the autonomy of written lan-guage and the value of its specificity. Letter by letter the poster fragmented the work into a graphic arrangement that literally danced before the eyes, even distorting the letters out of any habitual vertical or horizontal alignment. With the single exception of the doubling up of the letters which form the diphthong into a single space, there is little to indicate a sound/letter/space relationship as the basis of the visual ma-nipulations. Volume, weight, size, density: the use of large letters as a frame on an open space, into which the small elements enter, combined with the arrangement of the not more than two dozen words of the main text to create a nearly sculptural composition. All this amounts to a sin-gle conclusion: Zdanevich manipulated the word as a series of letters in a graphic field, insisting on the visual properties of written language. Zdanevich demonstrated that the materiality of the signifier, in this case, that of the letters, was what grounded the distinction between written and spoken language in an actual specificity so that the two could not be confused or mistaken for each other.

In concluding this discussion of the work of Zdanevich, one further point needs to be made. The thematic disposition of elements within the *zaum* plays of the *Aslaablitchia* cycle consistently situate the ele-ments of language within structures of power. The voice of the Spirit, for instance, in the final *Ledentu* is almost unpronounceable; the voice of the infant *Yanko* in the first play is all vowels, that of the bandits who enforce a repellent power structure and role on him is the repeated se-quence of the Russian alphabet. Conventional authority and repressive power structures are everywhere associated with the norms of language or the sign of those norms (that is, the alphabetic sequence) while the infantile, anally eroticized characters mouth sound which resists any possibility of sense. This opposition, which in many cases also engages with the structuring of sexual identity in relation to those figures of au-thority, clearly establishes the domain of sound as liberated, as escaping from the bounds of an order which is made in the linguistic norm. Sound, as Zdanevich conceived it, was visceral, physical, direct; it was possessed of those qualities Julia Kristeva associates with the semiotic, the domain which resists and provides escape from the patriarchal au-thority of the established order of language.[101] Sense, on the other hand, Zdanevich aligns with Kristeva's order of the symbolic, and Zdanevich's

characters are frequently engaged in the rejection or refusal of authority as it appears in the specter of the male figure (the throne which little Yanko rejects while the bandits hold him on it, torturing him with the order of the alphabet).

Such an opposition works well in the analysis of the psychoanalytic issues in Zdanevich's *dras* and his own relation to established language. While the alignment of materiality with the semiotic would undermine the premise of my overall argument, which is that there is no easy opposition to be made and maintained in signifying practices between orders of form and meaning, presence and absence, stuff and sense, etc., Zdanevich's thematic embrace of this opposition situates his *zaum* project within a social context in which his engagement with materiality serves a function beyond the engagement with imaginative work for its own sake. The escape which poetry provided, the liberation of the poetic form, was essential to Zdanevich as the utopian dream of poetic potential.

Zdanevich's politics were relatively unformed, he never aligned himself with any particular position and considered his writing to be radical, though not political. The naivete of this situation, of a faith in the power of poetry to provide an escape from the normative forms of social order, does not belie his adherence to it. His work was an esoteric practice, but intended as a liberating force; escapist as this position is, Zdanevich was certainly not alone in believing that the attack on the symbolic order is the single socially significant poetic act. But Zdanevich conceived of this activity only in terms of his individual relation to language rather than in any political frame. Liberation of the imagination into unknown, unfamiliar activity was the sole aim of this project, and the use of materiality to forge an arena in which such experience would be produced engaged Zdanevich with an attack on the normative principles of signification. Inventing a new language, his own language, one grounded in the faith in a direct somatic apprehension of the expressive potential of either sound or image, clearly inscribed Zdanevich within a rejection of the symbolic order of language and its instrumental controls, but at the risk of engagement with an interiority so idiosyncratic it communicated only in code. Yet this also disposed Zdanevich to engage fully in what he considered the liberating force of the materiality of that expression. The authority under attack remains an abstraction and the structure of power which is subverted, engaged with, and used for a struggle of psychic definition, remains disconnected from anything except the symbolic order of language.

■ **Tzara: Advertising Language of Commodity Culture**

Dada is not a doctrine to be put into practice: Dada—it's a lie if you
want—is a prosperous business venture.—Dada runs up debts and will
not stick to its mattress.[102]

The intense interiority of Zdanevich's *zaum* could not be farther from
the work of Tristan Tzara, which is engaged at every level with the pro-
duction of language within the sites and rhetorical structures of com-
modity culture. Tzara begins his poetic activity in full recognition of the
circulation of linguistic signs within the domains of advertising and pub-
licity. His sense of a public language is more cynical than that of Apol-
linaire, whose project was to open the closed realm of poetics to the rich
potential of spoken language, while preserving the possibility of individ-
ual authorship and subjectivity. Tzara's work attacks the existence of the
authorial subject more dramatically than any of the other poets I have
discussed, his method for composition dissolving any trace of inten-
tionality except that which surfaces by default in the act of inadvertently
directing chance processes.

Between 1916 and 1920, Tzara's language was selected from the
already produced discourse of the newspaper, advertisement, published
train schedule, etc., so that the subject of his poetics is the already enun-
ciated subject of a very publicly produced articulation. And the typo-
graphics which come onto the pages of his Dada work are all evidence of
that discourse: they bear the material traces of their original sites in their
typographic form. The visual form of language here reveals the context,
history, origin of the phrases within the public sphere of printed matter.
Linguistic phrases have already been stamped in the mold of publicity,
been given the form of commodities to circulate in the production of a
rhetoric which splits the signifier from signified in order to have it func-
tion as *image* within a society moving rapidly to the condition of spec-
tacle. Tzara's concerns were not with the creation of art as original act, as
an individually inspired construction of form, expression, or subjective
articulation, but rather with defining the boundaries of art as an aesthetic
negotiation, as that which is continually to be negotiated—namely,
the defining terms on which the practice of art comes into being and
exists as a cultural category. In this commodity form, the value of art is
neither essential nor lyrical, but develops as a use value gained through
circulation.

If Zdanevich is the poet who uses material form, visual character in

typography, with a faith in its essential character, Tzara is the poet who conceives of linguistic elements at their most contextual, their most relational and relative. For Tzara neither poetry nor the speaking/writing subject may be conceived in isolation from cultural context. Linguistic signs circulate in a commodity culture that is that context, and poetics is not other than, but participates in, that domain. True, Tzara works to subvert the consumability of language as it is used in advertising and commercial enterprise, but with full recognition of the power of the rhetoric of advertising and by making full use of its techniques in typographic terms.

Tzara's work is subversive because it erodes the defining boundaries of artistic genres, making poetic work indistinguishable in form and linguistic content from that of advertising language. In addition, it is subversive by fact of its continually shifting strategies of production, rejecting the logic of the rules of linguistic or poetic order. Dada is a game whose rules change constantly in order to avoid either the appearance of rules or a systematic resistance through simple opposition. Finally, Dada is subversive by virtue of its embrace of what Nietzsche termed "aesthetic amoralism." Tzara's Dada project is without the utopian agenda of even Marinetti's negative, destructive drive, or Zdanevich's naive essentialism, or, in fact, the dedicated visionary character of Hugo Ball and Richard Huelsenbeck. Tzara is personally ambitious and uses the maneuvers of Dada for his own ends. His writings in the 1910s are peppered with statements confessing his desire for attention or simply making a bid for the audience to notice him. But there is no other moral commitment or position underlying his strategies. In fact, Tzara's Dada is predicated on the negation of morals, on a deeply founded belief in amoralism as politically necessary subversion. Tzara attempted, in a primitive and aggressively original manner, to put into his work the continually resistant practices which would come to be articulated as a necessary antidote to the seemingly inevitable path of enlightenment progress. Such resistance could not be achieved through anti-rational means and required the alogical procedures which came to be synonymous with the very term Dada.

Tzara's work is filled with apparent contradictions, the aim of which is to render any systematic position impossible. In "The Seven Dada Manifestos," the "Second" contains a sequence of paired terms, linked as equivalents, as "order = nonorder," "ego = nonego" and "affirmation = negation." These support his prior statements distrusting unity and any kind of theory which attempts unification. His stand against

principles and common sense prevents his stating any clear manifesto, since:

> To put out a manifesto you must want ABC to fulminate against 1, 2, 3, to fly into a rage and sharpen your wings to conquer. To impose your ABC is a natural thing—hence, deplorable. Everybody does it in the form of crystalbluffmadonna, monetary system, pharmaceutical product, or a bare leg advertising the ardent sterile spring.

Tzara's resistance to systematic thought extends to a proclamation against meaning. "Dada means nothing" is a slogan phrase he used repeatedly whose evident contradictions are emblematic of his manifestly absurd articulations. But this absurdity is crafted against the simplified closure of meaning essential to the deceptive language of commodification in which the value of the signifier is presented *as if* it *were* the signified. In the "Second Manifesto," the statement that "words that are forever beyond understanding"[103] compels the refusal of final closure. This follows fast on the heels of the sequence of statements in which Tzara situates aesthetic manifestos among the other types of advertising and publicity language, disdaining their techniques while signaling the participation of his own aesthetic/poetic activity in that sphere: the sphere of language as cultural practice engaged with a society of consumption.

Tzara was acutely aware, therefore, not merely of poetic traditions and norms, but of the institutional and cultural frameworks within which aesthetic activities were sustained and given their identity. He was self-consciously and continually calling these frameworks to attention in his writings and this became as much the thematic focus of his work as any other matter. In a manner which far exceeds the transgressive acts of the other poets here, he pushed his work toward the limits of the norms which could be defined as poetry. Tzara demonstrated astutely his understanding of the role of representational systems in the continual reification and reproduction of those very norms, and the attack which he launched in his work was not so much on poetics as on language as an unquestioned system and its normalizing potential. To rethink poetics would have placed Tzara's project too clearly (and too limitedly) within the tradition of poetics itself. But the questioning of language as a system carrying cultural value in its transparency as well as its communicative substance permitted Tzara to attack ideology through the activity of a subversive poetics. The role of materiality was central to this subversion, since calling attention to the nontransparency of linguistic produc-

tion served to demonstrate the way in which materiality necessarily embodied the semiological as well as the economic and political aspects of production.

Tzara did not claim, in the 1916–17 period in which he produced his first Dada typographic works, that these pieces were poetry; in fact, the general tenor of his protest against genres and literary categories at the time precluded any such prerogative. A conspicuous interest of Tzara's, however, was his investigation of *poésie nègre* during the mid-1910s, at which time he "translated" a number of works from African languages, becoming particularly involved in the sound and rhythmic patterns, ignoring the semantic value of the works. This was parodic of the typical education of linguists of the period: Jean Paulhan, for instance, had cut his linguistic milkteeth on the study of "primitive" languages, and of course the interest in things African in the visual arts had become so widespread that *primitivism* was to the early twentieth century what *orientalism* had been to the nineteenth. But Tzara's undertaking had neither anthropological nor linguistic authenticity to it. Instead, his was an exercise in the investigation of the otherness of these works purely in material terms. The influence of these studies on Tzara's work manifested itself in the use of syllables without linguistic sense for the manufacture of rhythmic patterns, somewhat in the manner of Hugo Ball and Kurt Schwitters' sound poetry. But Tzara was too bound up in the critique of cultural context to linger long in the realms of the pseudo-primitive; mystical or nostalgic romanticization of the "other" did not provide sufficient means for his purposes.

In terms of typography, Tzara lacked the technical background of Zdanevich. Nor did he have the pictorial orientation of Marinetti or Apollinaire, whose visual sensibilities were attuned not only to the properties of the page through their dialogue with painter peers and contemporaries, but to the visible properties of type. Rather, and this is important, Tzara proceeded with his manipulations in typography with the kind of information available to any sensitive reader of the daily press, recognizing and making use of the conventions of typography as it appeared in the public media. The crucial feature of Tzara's work is that he was able to make use of the expectations and habits of the public in the ways which were already coded into the typographic and linguistic vocabulary of the press. The strength of the Dada platform was its dependence on conventions and habits which were sufficiently familiar that their subversive use could be immediately recognized; this deviation registered against the familiar norm, rather than occurring in the more rarified domains of poetic or highly aestheticized activity. Certainly

his contemporaries were well aware of the tactics Tzara put into use, as the following statement by Georges Hughet will testify:

> It should be noted that the artistic methods which seem, by their nature, to be strictly defined, lose their specific value little by little. The methods are interchangeable, they can be applied to any form of art, and, by extension, appeal to all kinds of heteroclite elements, despised or noble materials, verbal cliches or the cliches of old magazines, public places and publicity slogans, bits of trash thrown on the garbage heap, etc. all the miscellaneous elements whose assemblage transforms itself into an unforseen homogenous coherence, in which the elements take their place in the newly created composition. . . .Dada also made use of advertisement, but not as an alibi, and allusion, but as a utilisable material with aesthetic and suggestive ends. . . .It used the very reality of advertising in the service of its own publicity needs.[104]

Tzara was thus able, in the circulars, posters, and pages of Dada publications, to undermine the apparent authority of the printed page according to the very terms generally used to support its literary authority: that is, its visual appearance. And he did, in fact, actively promote use of leaflets, ephemera, tracts, as was also noted by Hughet, who witnessed the "aggressive derailing" undertaken by Tzara in the "insults" and "nonsense" these works contained.[105] "Language and form fell beneath their blows like so many houses of cards."[106] The development of Tzara's attitude toward materiality in artistic practice begins with some of his earliest published writings (not including his early work in Rumanian, which he himself discounted) and continues throughout the years of the publication of *Dada*. In 1914, the date he assigned to the work "Realitiés Cosmiques," Tzara had already developed many of the major procedural approaches and attitudes which would form the core of his Dada activities. This work was first published in 1916, which associates it chronologically with the beginning of the Cabaret Voltaire.[107] Tzara was immediately involved with the performance and other activities of the Cabaret, including the publication of the ephemera and journals in which his influence was to have such a conspicuous impact.[108] But the central issue in Dada which makes Tzara so useful a figure through which to investigate the Dada use of typography was the investigation of the social and cultural functions served by language and its operation as a domain in which subversion might be effectively produced.

In a passage from *Dada* #3, 1918, Tzara prescribes the task of the Dada artist in terms reminiscent of Apollinaire's insistence on the material fact of art making as the prime locus of art activity:

The new painter creates a world, of which the elements are also the means, a sober and definite work, without argument. The new artist protests: he does not paint a symbolic and illusionistic reproduction, he creates directly in stone and wood, iron, clay, rock, living organisms, which can be turned in any direction by the limpid wind of momentary sensation.[109]

Tzara translated this notion of materiality into a conviction that the words and even the letters of language were equally available for such creative work; "used for its intrinsic value, the letter detached from words to live its own life, a word as its elements, not its usual stereotype."[110] But Tzara's enthusiasm was not merely for materials, as he made clear in distinguishing between his attitude and that of the French Cubists with whom Apollinaire was aligned:

If it is evident that the Cubists believed in the use of different materials . . . it was not for the same reasons that the Dadaists believed in such use for literary or plastic works. It was the sense of a polemic attached to the process which was most important, and this was neither for descriptive nor explicative reasons.[111]

Tzara extended this polemical eclecticism until it became a method, a technique, a process of appropriation which Apollinaire had also practiced: "In 1916 I tried to destroy literary genres, I introduced into the poems elements which would ordinarily be judged unsuitable, such as sentences from the newspaper, sounds and noises."[112] Thus Tzara began his "art" activity at the border of the distinction between what constituted art and what lay beyond it: "A will to the word, a being on its feet, an image, a unique construction, fervent, of a deep color, intensity and communion with life."[113]

The cliched notion of the attempt of the avant-garde to dissolve the boundaries between art and life, a frequently untenable position given the genuinely identifiable domains of high art in which the work of most painters and poets remained sequestered, has its strongest base in such claims. For Tzara, as for the cubist collagists, the appropriation into their work, itself clearly defined as literary/fine art, of materials from beyond the traditional realm, was the simple basis on which this concept acquired currency. From a sociological perspective, that is, from the position in which the defining terms of the condition of art practice, the works which appeared as bounded visual pieces and the works which appeared published in the pages of small journals, literary magazines, and other organs of avant-garde activity never lost the least edge of defi-

nition in this regard. Still, the permeation of the boundaries of literary discourse by the polluting elements of commercial speech, linguistic forms which were vulgarly associated with advertising practices, was an outrage against the literary establishment. The arguments of avant-garde poetics, in this sense, are with literature, not with popular arts. On the other hand, the Dadaists (and the Futurists to some extent—in Italy by virtue of their extensive leafletting programs, in Russia by their public performances and tours) explored new sites for their work within the broad cultural sphere of early twentieth-century cities. Berlin Dada is notorious for its activist engagement with workers, strikers, and revolutionary groups while the Zurich Dadaists made early attempts to involve the tradespeople of the quarter in which the Cabaret Voltaire was established as participatory audience to their activities. The Dadaists encountered resistance on all sides—from the wider audience, which was baffled beyond belief, to the readership of Sylvia Beach's Shakespeare & Co. Ms. Beach found the first issues of *Dada* she received so aberrant and uncategorizable that she kept them in her back room, away from the view of even the supposedly adventurous audience which frequented her establishment.

Aside from his direct engagement with materiality, which will become immediately evident in his typographic works, Tzara also played upon conventions themselves—poetic and linguistic—as a kind of *material*. For instance, Tzara had a clear sense of where public language was located in the conventions of both discourse and its representation. In spite of the idiosyncracy of his writing, it served as effective publicity because that was the realm from which its tactics and rhetoric and vocabulary had been borrowed. To the extent that all of this activity worked from the assumption that language could be manipulated without regard to the conventional assumption that it must make *sense*, it forced the value of language to reside in its materiality. This led Tzara to an exaggerated insistence on the autonomy of Dada practices.

> Dada had no meaning outside its own world of words, which begins with the opening word of the poem and fades with the last, but has no link with any world beneath or above, before or beyond it.[114]

This position is in some ways contradictory to the observable links between publicly produced language and Dada poetics—subverting the conventions of advertising or newspaper phraseology required quoting these sources, often more or less directly, and certainly copying their rhetorical stances. Much of what Tzara effects in his typographic work depends on the extent to which the material form of the poem provides

an indexical link to the referential fields of journalistic language. True, his work, by its improbable sequences, fragments, and juxtapositions, subverts the normative order of consumable commercial language. But this subversion depends on direct reference. Dada, in Tzara's work, *does* resist the normative mode of meaning production, creating a field of chance encounters composed of linguistic elements who make meaning only by accident and incident.

> Dada language . . . renounces all interferences of meaning and aspires to an autonomous existence which produces a confused and illogical pleasure, as though language had escaped its own gravity.[115]

This "autonomy" declared a liberation from normative syntax and grammar, but not the kind of esoteric isolation characteristic of Zdanevich's *zaum*. Tzara's work was profoundly antilyrical, but not antihistorical. It's very engagement with materiality demonstrates, again, the function of materiality to link poetics through the traces of production to the sites and moments and contexts in which it comes into existence, or, to use Tzara's phrase, "falls into place."

Typographics

One of Tzara's most effective strategies for typographic work was his use of the apparent look of appropriation as a means of subversive negation. Tzara's work gets its characteristic visual distinctiveness by its flagrantly conspicuous appropriation of commercial, mainly advertising, techniques, which he used to undermine many of the fundamental conventions according to which literary and linguistic value were traditionally determined. This appropriation takes place at two levels: the visual and the verbal. As François Caradec has demonstrated, Tzara's typographic techniques were consistent with those of contemporary advertising in terms of their technical approach and achievement. François Sullerot has carefully shown exactly how Tzara borrowed from commercial language.[116]

Tzara's work has more relation to poetic conventions in terms of form, for instance, than do the works of Schwitters or Baader or Hartfield and Hausmann, all of whom developed characteristic "dada" styles using fragments of language in a graphic mode. Tzara's way of working virtually formed the visible profile of Dada as it proliferated distribution of *Dada* magazine.

The earliest work of Tzara's demonstrating an interest in typography was produced in 1914. "Realités Cosmiques Vanille Tabac Eveillés" contained about a dozen instances of typographic manipulation, rang-

ing from the use of all upper-case letters within a word or line to the insertion of a word or words in a different size of face into a line (figure 36). The work contains a total of three different typefaces, one of which was used in several different sizes. The first use of this typographic manipulation implied emphasis, the words "sur les poteaux de prière . . ." stood out in contrast to the rest of the lines as emphatic, bold, intense in their presence, as did the words "Trop, trop fort" and "comme le sang" further on. But in the tenth verse there is a further invention: a words which spans three lines of type was used to terminate all three of the final lines of the verse. The pun on the word "grace," which is made by the word used here, "glacé," is reinforced by the visual juxtaposition to three lines of conventional prayerlike supplication. The semantic relation is typical of Tzara's work of the period: irreverent, mocking, forged through the combined use of expectations and their frustration, and rendered more obvious through the graphic mode of their presentation.

The full force of Tzara's interest in typography began to make itself felt in the Cabaret Voltaire, most specifically, with the publication of *Dada*, especially after *Dada 3*. The argument that it was Tzara's influence which determined the appearance of *Dada* can be supported by the fact that it was at the moment when he came into contact with Tzara that Francis Picabia violently changed the appearance of *391*, taking on the look which had been so characteristic of *Dada*.

> Every page should explode, either because of its profound gravity or its vortex, vertigo, newness, eternity, or because of its staggering absurdity, the enthusiasm of its principles, or its typography.[117]

The features of this style were fairly simple: each page had one or two lines of type set on a diagonal; large type was used for isolated words; a wide range of typefaces was used rather gratuitously; bits of illustrational material floated around the equally drifting blocks of type so that the magazine as a whole looked like an assemblage of bits and pieces which made a visually dynamic sheet (figure 37).

This *Dada* "look" became the characteristic style of the ephemera: handbills and announcements, some produced under Tzara's direction, others in imitation or correspondence with his style, were graphically and typographically eclectic. The pages had the appearance of having been assembled with pieces from different sources. Each piece in the publications, especially in the fourth and fifth numbers of *Dada*, was set in a different typeface and placed so that it occupied a discrete place on the page determined by its graphic rendering rather than by any preestablished layout used consistently throughout. There is a definite pro-

n'étais pas ma sœur

IX.
en acier de gel
sonne
dors-tu lorsqu'il pleut ?

X.
les serviteurs de la ferme lavent les chiens de
chasse
et le roi se promène suivi par les juges qui ressem-
blent aux colombes
j'ai vu aussi au bord de la mer la tour bandagée
avec son triste **PRISONNIER**
dans les fosses ouvrez l'électricité
par conséquent
seigneur seigneur **DE GLACE**
pardonnez-moi

XI.
GRANDES LARMES glissent le long des
draperies
tête de chevaux sur le basalte, comme
des jouets de verre cassent entre les étoiles avec
des chaînes pour les animaux
et dans les glaciers j'aimerais suivre
avec racine
avec ma maladie
avec le sable qui fourmille dans mon **CERVEAU**
car je suis très intelligent
et avec l'obscurité

Figure 36. *Realités Cosmiques Tabac Eveillés*, T. Tzara (Paris: 1914).

PROCLAMATION

sans prétention

DADA 1919

L'art s'endort pour la naissance du monde nouveau. "Art" — mot cacadou — remplacé par DADA

Plésiausaure

ou mouchoir. Le talent qu'on peut apprendre fait du poète un droguiste.

Aujourd'hui la critique balance ne lance plus des ressemblances. Hypertrophiques peintres hyperesthésiés et hypnotysés par les hyacints des muezzins d'apparence hypocrite,

consolidez la recolte des calculations exactes.

Hypodrome des garanties immortelles:

Il n'y a aucune importance il n'y ą pas de transparence ni d'apparence.

Musiciens cassez vos instruments aveugles sur la scène.

En ce moment je hais l'homme qui chuchote avant l'entr'acte — eau de cologne — théâtre aigre. Le vent allègre. Si chacun dit le contraire c'est qu'il a raison.

La seringue n'est que pour mon entendement. J'écris parce que c'est naturel comme je pisse comme je suis malade. Cela n'a pas d'importance que pour moi et relativement.

L'art a besoin d'une opération.

L'art est une prétention chauffée à la timidité du bassin urinaire. L'hystérie née dans l'atelier

Nous cherchons la force droite

PURE SOBRE UNIQUE

nous ne cherchons RIEN nous affirmons la VITALITE de chaque INSTANT l'anti-philosophie des acrobaties spontanées. Préparex l'action du geyser de notre sang — formation sous-marine d'avions transchromatiqueč métaux cellulaires et chiffrés dans le saut des images

au-dessus des règlements du "BEAU" et de son contrôle.

Ce n'est pas pour les avortons qui adorent encore leur nombril

TRISTAN TZARA.

Figure 37. *Proclamation*, T. Tzara, *Dada* (Zurich: 1919).

gression in the course of these several issues of *Dada*, and each one in turn introduced more variation into the structure of the pages. They demonstrated a steady undermining of any of the graphic devices which might have maintained a residual influence from the literary journals of their epoch—where the main typographic feature was a distinction between text and titling type. Other elements which entered into this Dada style were: marginalia, random pieces of copy which acted as editorial commentary, the interplay of vertical and horizontal elements within the page. The result was a scrapbook sense of order, typical of the busy pages of nineteenth-century gazettes and of the many ads tucked alongside the editorial features of daily papers, though most conspicuously filling the back pages. It is important to remember, in all of this, that the look of literary journals had been more austerely homogenous, with the floral chapter headings or decorative marks to terminate pieces, and dark, even blackletter (in Germany), solid blocks of uninterrupted type. Literary journals carried few if any advertisements, except in their back pages, where other literary journals or publications might be allowed a modest advertisement. Thus from the very outset, Tzara moved the graphic appearance of Dada publications away from "art" and toward "life"—in other words, from literature to press:

> Art is not the most precious manifestation of life. Art has not the celestial and universal value that people like to attribute to it. Life is far more interesting. Dada knows the correct measure that should be given to art: with subtle, perfidious methods, Dada introduces it into daily life.[118]

The visual features of these pages had their greatest impact in the force with which they distracted their readers from any simple clue as to the organization and hierarchy of elements on the pages. The material presented escaped genre recognition as well: it could be poetry, an announcement for an event, a bit of nonsensical random language. All of these were slid together into the form which made up the sheet, printed together to diffuse the focus of the page, distracting the eye which had to struggle to decode the unconventional order. Many of the scraps of language which appeared in the pages of *Dada* remained uncategorizable, thus successfully disintegrating the criteria on which literary forms had been guaranteed by undermining both the actual "forms," that is *shapes,* of literary works, and the context which had supported them. The five issues of *Dada* track a general, subversive undoing of those conventions which had kept intact the visual identity of literary genres.

In addition, the pages of *Dada* reveal no single unified editorial position or voice. The reader is continually adrift within the shifting posi-

tions of enunciation marked out by the radical changes in graphic treatment from one part of the page to the next. United only by the material fact of their appearance on the same page, the elements of *Dada* make an *ad hoc* unity only by association and synthetic effort. But the very *gratuitous* quality which Tzara managed to effect in these pages has another aspect to it, namely, that it successfully separated the elements of signification from each other. The sensation of gratuitousness is itself produced by the interference in the regular transparent operation of the sign. The impossibility of slipping easily from signifier to signified returns the reader to the signifying operation, calling attention to the materiality of the signifier itself, which is thus termed *gratuitous* because it insists on its own participation in the process.

There is strong evidence to support Tzara's direct involvement in the typographic production, at least at the design level, of his works. There are at least two handdrawn mockups among his papers, one for "Bilan" and one for "Une Nuit d'Echecs," which prescribe not only the layout of the work but attempt to render the typefaces to be used. The result was something like a calligraphed version of typography, and it is clear Tzara was working from specific typographic samples, not merely manufacturing differences arbitrarily and then asking a compositor to fill in at random with any suitable face.

Further evidence of Tzara's direct interest in typography can be found in an exchange of letters he had with Pierre Albert-Birot in the period between 1917 and 1919.[119] Tzara was still in Zurich at the time, and the two men had become aware of each other through an exchange of publications. They began to send material to be published and in almost every piece of correspondence mentioned the graphic format of the works in question, pointing out the necessity of preserving the typographic features of the texts:

> I send you two poems, very different from each other, and I ask simply that you scrupulously respect the typographic form of them.

> Here are two poems. I ask you to note carefully their typographic form, one should resemble a mathematical rectangle, the other is arranged to note a vocal trio.

> I ask you to pay attention to the outside curves on both sides and put much white space around them, to use as much as possible small, complex and very dark characters.[120]

The shared understanding clearly articulated here was a concern with the specific qualities of typographic representation:

all the miscellaneous elements whose assemblage transforms itself into an unforseen, homogenous coherence, in which the elements take their place in a newly created composition.[121]

Tzara continually worked to shift the frames in which the domains of commercial and literary language were contained, polluting the one with the other to belie the myth of individual, authorial subjectivity as it had been supported within the canon of literary activity. That is, he negates the production of language as an original act deriving from an interior psychic domain and places poetics squarely in the realm of the social. The subject of production here is a socially produced linguistic subject, one whose poetics demonstrate the continual circulation of already spoken language through the very intimate, supposedly private, realm of the (therefore mooted) personal voice. The role of typography is in part to mark the undigested (indigestible?) character of such language. It remains other than the personal, marked as derivative and signed as already itself participating in the domain of commodities. It is itself, this language, an object, with material properties, a life, a history, and a semiotic and economic function to perform in the cultural context of linguistic operations.

Characteristic of Tzara's well-achieved individual pieces are the poems in the vein of "Bulletin"—of which "Boxe," "Bilan" (in at least two versions), and "Proclamation" are also representative examples (figures 38 and 39). In these works, taking "Bulletin" (see figure 40) as the sample, the typeface changed line by line, exemplifying the method of composition which Tzara had advocated in his famous prescription for a chance composition.[122] Roughly paraphrased, this was: take a newspaper article the length of a poem you wish to write, cut it in strips, put the strips in a hat, pull them out one at a time, write them as they appear in the sequence, and that is your poem. The strips in "Bulletin" followed this logic a step further, they seemed to have been cut from a number of articles rather than just one and the typographic treatment of each was preserved, phrase to phrase. The simple effect was that of disjunction, an emphasized and underscored disjunction, which continually posed the problem of the relation of the elements within the "poem" line to line:

> As for the absolute dadaist poem, needless to say, it gives the reader a most striking impression of incoherence—"words at liberty," shreds of sentences, disintegrated syntax, and occasionally phrases borrowed from contemporary advertisements.[123]

Both the eclectic typographic sensibility, a catchall approach of a job shop printer using the means at hand to diversify the copy for the sake of generating visual interest in a client's project, and the language of advertising, forms of address and language, which assaulted the reader in a manner totally distinct from that of the literary form were in use here. These visual and linguistic aspects of commercial printing, as used in the discursive strategies of advertising, have been pointed out by François Sullerot, in "Des Mots sur le Marché," where he noted the various features of advertising language appropriated by Tzara: the language which took the part of the reader, assumed a dialogue, called the reader to action, used repetition, used words almost decoratively in a sloganlike capacity, and implied both distance and complicity by the use of a familiar tone.[124] It is easy enough to identify these elements in Tzara's work, but more problematic to understand the effect of these devices in the interplay between them and the typographic treatment which was so conspicuously part of the page.

Tzara's phrase for this enterprise, "Language is made in the mouth," can be recast as "language made on the page," that is, language inseparable from its actual, physical, material production. Tzara's gaming has often been misunderstood, even by his peers, because it was out of synch with the positions of other Dadaists. Georges Hughet, for instance, wrote that

> The aspiration of Dada towards an indisputable truth which was that of man expressing himself outside the limits of formulas learnt from or imposed by the community, by logic, language, art or science.[125]

But Tzara was not in search of any truth value, rather in search of its negation, of the act of the inevitable logic of discourse itself, making language, poetry in the mouth and on the page in an activity which pointed out all too clearly the parameters of the social domain as they inscribed themselves in these representational systems. The desire to put formulas aside is not accompanied by a desire to replace them with a new and better formula, but rather, to make an invention in poetics which will continue to invent itself on ever-renewed terms of alogical innovation. Dada cannot be written off as a mere parody of advertising. Instead, Dada, in the hands of Tzara, was a method of proceeding which did not observe the expected norms of either commercial or literary sensibility.

This method, as embodied in "Bulletin," used some of the expectations and strategies of advertising for visual effect (figure 40). As each

BILAN

virement, *crustacée long* bleu règlement

soigne *la parodie* et touche *A BAS*

étais lentement la taille paradis *A BAS* **cataphalque**

étalon *sur les rails* à travers hypocrisie *ressorts ressemblants*

sur mes dents *sur tes dents* j'écoute sentis dans les os

qui baille extasié extraction de hameçons ou corridor tricolore

hamac perfore *et les insectes* du vide (soude) **ZZ**

des nombres *on réveille* le nombril (sonde)

fini le paragraphe *et la seringue* pour phosphore

Voisinage du fer bravoure gymnastique balustrade

les chiffres astronomiques acclimatisées

SUR BILLARD A TOUS LES VENTS

gratuitement

drogue halucination transcaspienne sacristie

AVANCE LA COULEUR EN LANGUE DIFFÉRENTE

vivisection

EX-CATAPLASME PLAIT AUX AMOUREUX

à 3 fr. 50 ou 3 h. 20 invincible martyrologiste

ton cible et tes cils rappellent la naissance du scorpion en cire

syphilis blanchissant sur les bancs des glaciers

joli TAMBOUR crépuscule

auto gris autopsie cataracte

ô nécrologues prophylactiques des entr'actes antarctiques régions

$t^{Ri}s^{tA}n \; T^zaR_a$

Figure 38. *Bilan*, T. Tzara, *Dada* #4–5 (Zurich: 1919).

BILAN

arc voltaïque de ces deux nerfs qui ne se touchent pas

près du cœur

on constate le frisson noir sous une lentille

est-ce sentiment ce blanc jaillissement

et l'amour méthodique

partage en rayons mon corps

pâte dentrifice

billets

transatlantique

la foule casse la colonne couchée du vent

évantail de fusées

sur ma tête

la revanche sanglante du two-step libéré

répertoire de prétentions à prix fixe

folie à 3 heures 20

ou 3 Frs. 50

la cocaïne ronge pour son plaisir lentement les murs

horoscope satanique se dilate sous ta vigueur

VIGILANCE DE VIRGILE VÉRIFIE LE VENT VIRIL

des yeux tombent encore

 TRISTAN TZARA

Figure 39. *Bilan*, T. Tzara, *SIC* (Paris: 1919).

M. Janco

TRISTAN TZARA:

BULLETIN

à Francis Picabia qui saute avec
de grandes et de petites idées de New-York à Bex
A. B — spectacle
POUR L'ANÉANTISSEMENT DE L'ANCIENNE BEAUTÉ & Co
sur le sommet de cet irradiateur inévitable
La Nuit Est Amère — 32 HP de sentiments isomères

Sons aigus à Montevidéo âme dégonflée dans les annonces offerte
Le vent parmi les télescopes a remplacé les arbres des boulevards

nuit étiquetée à travers les gradations du vitriol *vient de paraître :*

à l'odeur de cendre froide vanille sueur ménagerie
craquement des arcs
on tapisse les parcs avec des cartes géographiques
l'étendard **cravatte**
perce les vallées de gutta percha
54 83 14:4 formule la réflexion
renferme le pouls laboratoire du courage à toute heure
santé stilisée au sang inanimé de cigarette étiolée
cavalcade de miracles à surpasser tout langage
de Bornéo on communique le bilan des étoiles
à ton profit
morne cortège ♭ mécanique du calendrier
où tombent les photos synthétique des journées
„*La poupée dans le le tombeau*" (Jon Vinea œil de chlorophylle)
5ᵉᵐᵉ crime à l'horizon 2 accidents chanson pour violon
le viol sous l'eau
et les traits de la dernière création de l'être
fouettent le cri

tristan tzara - 25 poèmes
h arp - 10 gravures sur bois
collection dada - 3 fr.
édition numérotée - 15 fr.
édition sur hollande - 60 fr.

Figure 40. *Bulletin*, T. Tzara, *Dada #3* (Zurich: 1918).

line had the appearance of having been removed from a particular context, it had also the possibility of referring back to it. Each individual line implied a different world, a different graphic and linguistic context. In juxtaposition this marking became more apparent than if any single element had been permitted to dominate.

The title of the work is a non-title, a naming of a type, category, of language production, the bulletin, rapid-fire announcement, which recalls Tzara's statement that "A manifesto is a communication addressed to the whole world." The "bulletin" is no less a publicly addressed series of statements. Following this, sharing the lines by division into smaller typeface, is a dedication to Francis Picabia. The immediate collapse of poetic/aesthetic and commercial language is made clear here, as Tzara notes that this work is dedicated to the "Destruction of Bygone Beauty, & Co." What follows are a series of phrases which at first appear as snippets cuts from previously existing pages. The substance of their text indicates that in most cases the phrase itself already contains at least two contradictory types of language—reportage and advertising. This supports the idea that whatever technique Tzara used for writing, collage or chance combination, he had the sentence/phrases he produced in that manner set in type according to his own instructions (this, again, is supported by the manuscript pieces in which he sketched the typographic character of the lines).

Thus, the "sharp sounds at Montevideo" and the "deflated soul offered in the advertisements" run together in the first line with no modifying connection. This line is followed by: "The wind in the telescopes has replaced the trees on the boulevards," followed in turn by an image of the "ticketed night" and "gradations of vitriol." This melange of phrases, some descriptive and many grabbed straight off the placards of store windows "for your benefit" or headlines "fifth crime, second accident," creates a linguistic texture inassimilable into either poetic or commercial norms. The words cry out for attention, using the techniques of direct address—the second person, short phrase, catchy slogan—which belong to the world of advertising. The use of hard-edged images, sharply defined, inserted into this field makes them the objects being offered up in this marketplace of "the underwater rape" and the "cracking of bows." Throughout, the language of commerce and commodity, of guarantee of quality and inflated claims to value: "sterlized" "at any hour" etc. And at the edge of the poem, inserted at right angles, a genuine advertisement for a book of Tzara's poems accompanied by Arp's woodcuts, "Just appeared!" Nor should it go unmentioned that the form of this edition, with its three-tiered price struc-

ture, includes not just the modestly priced "Edition dada" but also a numbered series and a series on "holland" fine printing paper which sold for twenty times the price of the "dada" edition. Whatever Tzara's profit from this enterprise, he had not hesitated to participate in its production, thus playing the fine art production of books against the adversarial mocking of his "Bulletin." The registers slip so easily, one to the other, that the advertisement becomes part of the poem which is itself continually crossing the boundaries between the language of commodity promotion and that of poetic imagery.

The use of the typographic marking of difference line to line within this work cannot be underestimated. The re-rendering of this work into a single typeface would grant the impact of the sequence an effect closer to that achieved within Tzara's manifesto writings, where a similar linguistic eclecticism characterizes the texture of the work. But those texts have the quality of a churned-out paste of language unified by their visual homogeneity; they are all of the same voice, a voice of the ranting, chattering person who is almost randomly expelling the range of language produced through daily contact with the world. But the "world" has vanished from its visual form, all the language having been put into a single medium, single suit, its marked differences retained only in the traces of linguistic genre. By contrast, the lines in "Bulletin" (in "Boxe" and the "Bilan" pieces as well) refuse to give up their visual discrepancies. That they have originated in very different places in terms of their appearance, each designed for an appearance and then lifted from it (fictively, as, again, it seems clear that Tzara directed the setting of this work after its composition) from a context whose traces are clearly, visibly, materially marked by its typographic form. The concept of difference with which Tzara worked here is a socially constructed one, achieved through use and the relations among elements on the page which established and inscribed these differences.

> . . . after having disjointed the words, one from another, in the manner of
> typographers who redistribute type before resetting it, in order to disso-
> ciate it from its history, its past, which weighs on it like dead facts, each
> island vocable must, on the page, present abrupt contours. They are
> placed here or there (just as well) like a pure tone, and nearly vibrate
> other pure tones, but with such an absence of relation that they do not
> legitimate any association of thought/ideas. In this way the word is liber-
> ated from any prior signification, and, at last, from the evocation of the
> past.[126]

In freeing the language from "the past" Tzara did not divorce it from the very specific relation to the present, to a contemporary context and ongoing history. One other piece produced by Tzara deserves attention here, and that is a full page of advertisements for Dada publications which Tzara designed (the handdrawn mockup for this exists as well). "Une Nuit d'Echecs Gras"—"A Night of Heavy Blows," designed or "composed by Tristan Tzara" is an unabashed sheet of promotion (figure 41). Borrowing, again, directly from the world of advertising, this page contains nothing which is technically innovative or beyond the daily work of the job shop compositor. The works are by Picabia, Arp, Ernst, Baargeld, and of course, Tzara, who demonstrates here his contradictory attitude toward the concept of the "self," his own "self" in particular. The continual synthesis of publicly produced and commodity oriented language in his work on the one hand tends to cancel, or at least level, the possibility of an authorial voice as original, interior and individual in the romantic sense. But in his manifestos, and in particular, the 1922 "Lecture on Dada" an organized subject, self, capable of being "represented" in language even (maybe especially) through the accidents of Dada method seems to hover behind Tzara's rhetoric.

> What interests me is the intensity of a personality transposed directly, clearly into the work; the man and his vitality; the angle from which he regards the elements and in what manner he knows how to gather sensation, emotion, into a lacework of words and sentiments.[127]

On the one hand, language, "words" have a life in the world, a social use value, and a character, "a weight of their own" which has nothing to do with "grammar" but with "representation," their material form and the activity of using this language almost without intention, "that which issues freely from ourselves, without the intervention of speculative ideas" is that which is most central to Tzara's practice as well as, he claims, that which "represents us." The "us" here is both an individuated self and the socially produced subject of language. In creating the "Nuit d'Echecs" page Tzara organized the self as the source of production, selling the commodities of poetry with the same techniques as those used for patent drugs and supportive braces.

> Dada also made use of the advertisement, but not as an alibi, an allusion, but as a utilisable material with aesthetic and suggestive ends . . . It used the very reality of advertising in the service of its own publicity needs.[128]

UNE NUIT D'ÉCHECS GRAS

PagE composée par Tristan TZara *

Réclame pour la

VENTE DE PUᵦLICᴀtIONS dada

du 10 au 25 Décembre 1920

chez PovoloZKY, 13, rue Bonaparte, Paris

391 N° 6 2 Frs New-York

mettez le Broadway à Besançon et un petit parfum dans New-York Sabots, le timbre poste

391 N° 8 2 Frₛ ZURICH rose

feu économique

rose

l'art est mort

Picabia Gabrielle Buffet Arp Tzara Alice Bailly, Pharampsau

PAGES MYSTIQUE

les 25 poèmes de Tristan Tzara sont épuisés

il en reste que quelques exemplaires aux bariolures à 150 Fr.

Vient de paraître : HÉLAS

DA DA DADALINE DA DADASTE PICABIA PARAIT AUCHOUY PAR FRANCIS DAPHNOME DA DA CHROME DA VA DODOMA CHBIST RASTAQOUÈRE PAR FRANCIS

Francis PICABIA

UNIQUE EUNUQUE

Préface par Tr. TZARA

COLLECTION DADA

Au Sans-Pareil Paris : 2 fr. 50

FRANCIS PICABIA :

La Fille née sans Mère 4 fr.

Pensées sans langage 3 Fr. 50

IL Y A DaDa ET daDa..........

La livre de GEORGES RIBEMONT-DESSAIGNES est sous presse. Lequel ? As !

L'AMOUR dans le Cœur

Parlez-lui de moi *

N° 1 N° 2 1 Fr Directeur : Francis PICABIA

La Revue

BLEU

L'YOPSYCHE

CANNIBALE

PICABIA

MATCH

391 13

PROVERBE

DIE SCHAMMADE

par Francis ARP MAX ERNST

ALMANACH SABA

DERNIER DÉRANGEMENT

Semer :

DADAPHONE

CINÉMA CALENDRIER DU CŒUR ABSTRAIT

par TRISTAN TZARA

19 Bois par ARP

Collection Dada

tirage limité

DADA 3 Fr. 1.50 Édition de Luxe 20 Fr.

ARP La Pompe à nuages

J. EVOLA ARTA ASTRATTA Collection DADA ROMA 5 Frs

FRENCH CANCAN RIO TINTO

MERCI

Figure 41. *Une Nuit d'Echecs Gras*, T. Tzara, *391* (Paris: 1920).

The result was a page most succinctly summarized into one small box at the bottom center, "Réclame pour moi" ("Advertisement for myself") signed by Tzara. Self-advertisement in this case had to be understood not only as an exploitation of publicity techniques for the sake of gathering attention to the case of Dada, not simply the first set of publicity stunts used to promote a movement whose actual substance might, in the final evaluation, prove to consist in large part of those moments of public assault. No, this should be understood as the confusion of publicity with the product. The two were not only interchangeable, they were inseparable, in a way which, figuratively, duplicated the confusion of the materially present signifier with its meaning. The publicity did not sell anything but itself, as the word did not stand for anything but what it could, immediately, produce. Thus the commodity of publicity reifies the activity of production to which it is calling attention and becomes, in a sense, a commodity without substance, though not without value, as Dada language is operating here as language without meaning, but not without value. If the words in "Une Nuit d'Echecs" actually were advertisements, they were for the most part advertisements for journals which themselves looked like publicity, so that a continual chain of signifying elements was established which never led to any particular or final commodity. The publicity was the poetry and the signifying chain of commodification could not be closed. That which was materially present could not be wished away by obtaining an absent value, object, or meaning.

Typographic Activity in the Broader Field

The complex links between formal experiment, modernity, and the aims and agendas of the avant-garde are nowhere more diverse than in the range of positions manifest in experimental typography. The four artists whose work has been discussed above provide examples of the diversity of such positions, but do not exhaust the range of either the formal innovations or aesthetic and political agendas. Futurism in both Russia and Italy fostered a tremendous variety and quantity of experiments, and the independent efforts in the English context of Vorticism, the American publication 291 associated with Alfred Stieglitz's group, Francis Picabia's unique innovations, and in Germany, the efforts of Raoul Hausmann, Johannes Baader, and Kurt Schwitters were all contemporary with the works which have been discussed. Before closing the chapter on the

poet practitioners and artists engaged with typography, at least a few words on figures whose contributions should be incorporated into the larger discussion follow.

But first, a few general comments. Attention to the material properties of the word within modern art and literature was not limited to efforts at typographic experimentation. The invention of a genre of sound poetry attentive to the vocables of language, independent of morphemic value, or larger semantic and syntactic structures, called attention to the material qualities of sound, laying the groundwork for twentieth-century sound poetry. The visual appearance of language spans a spectrum of activities which stretch from the investment of artists in the painted word, from Paul Klee and Stuart Davis through Picasso and Braque, while the artistic practice which most acutely foregrounded the visuality of written language, collage, flourished in the American, Russian, and European avant-garde. While many aspects of the role materiality played in typographic experiment are featured in these collaged images as well, the deliberate choice to exclude them from consideration here was determined by the focus on works whose literary properties force the visuality of language without the possibility of their being returned merely or only to the realm of the pictorial. But collage reinforces the properties of materiality and its attentive concern with linguistic value as well as visual form is an important complement to the literary work which circulated in printed form in the years of radical experimentation.

Within the realm of Futurism the contributions of Ardengo Soffici and Francesco Cangiullo, both as theoretical writers and practitioners, deserve discussion. Cangiullo, as mentioned in connection to the "Surprise Alphabet" manifesto of 1916, had a more essentialist position with respect to the form of letters than did Marinetti. His poetic works are more clearly marked as musical scores, and the Symbolist legacy of the musical analogy comes through unmodified except that he carries it to an extreme of more or less pure sonority in pieces like the "Canzone Pirotecnica."[129] This work was accompanied by a supporting statement authored by Fortunato Depero which had the word "Onomalangue" in it. This term was designed to suggest the entirety of an "abstract language" which was "universal" in character and incapable of being translated. Paolo Buzzi, Soffici, Cangiullo, and Depero all made typographic compositions between 1914 and 1919 in which they experimented with onomatopoeic representation.

The work of Carlo Carra moved more explicitly into the realm of painterly collage. The substrate of visual language, scraps and touched-

up, repainted words layered onto a surface dense with newsprint scraps, served as the material base for the depiction of a dynamic whirlpool of motion in his "Manifestation interventionniste," its themes of war splintering through in vivid fragments.[130] Carra's fundamentally visual sensibility displays itself through the overall designs, graphic forms, which organize the images in which his typographic forms appear. The visual language does not appear, as it does for the most part in Marinetti's work, without visual images in accompaniment. Carra's works effect so complete an integration of image with fragments of language, however, as to make the distinction between the two domains in pieces like *Angle pénétrant de Joffre sur la Marne* (1914) merely academic. The spatial relationship of forms within the work is made through the graphic means, which in turn form the basis for the literal relation of linguistic elements. The topography and typography so clearly intermingle as to be one articulation of the *espace* of the signifying field.

In the Parisian scene an influential figure, now much eclipsed in spite of the role he played in the 1910s as publisher, editor, and promoter/producer of performances and works, was Pierre Albert-Birot. In the pages of *SIC*, a magazine whose very title betrays its synaesthetic roots (*Sons, Idées, Couleurs*), Albert-Birot both exhibited his own typographic works and called vehemently for experimentation in this realm on the part of other poets. His own works, such as the *Poème-Paysage*, have a literal pictorial character which is childishly naive. The words are redundantly reinforced by their position within the picture, and the placement of lines of verse which both state and depict their imagery becomes reductive. But the sheer range of his efforts in typographic work led him to experiment with conversation and graphic dialogue, the articulation of voice in contrasting forms, and both complex and simple shaped poems. *SIC* was a popular and influential publication at the time, however, and the continual appearance of these and other examples of typographic manipulation within its pages merely reinforces the ubiquitous character of such work in the period. Rather than existing as an anomaly, it became more or less the norm. The poems which stand in conservative stanzas are the works which seem oddly out of place in the graphic variety and diversity of the pages of *SIC*.

Among the Russian avant-garde the role of small, independently produced books had been central from the very start of the 1910s when the roughly printed neo-primitive volumes of Kruchenyk, Stepanova, Gontcharova, and others proliferated. The visual inventiveness of this work depended in part on the strong influence of indigenous peasant sources, the *lubok* books with their woodcarved images, as well as on the

cheapness and availability of their means of production. Some of these works were made on simple duplicating machines, some produced by hand, others with blocks and handcut type, others lithographically. Almost all were produced in direct contrast to the tradition of either fine print or industrially mass-produced works. There is clear attention to material sensibility as a measure and marker of economic status of the poetic text as an object in these works which often used wallpaper, scrap paper, and other unconventional stuffs in their production.

The ferro-concrete poems of Vassily Kamensky stand out in the realm of typographic inventions. Much influenced by Marinetti's schemes for onomatopoeic representation of language through visual manipulation, they are unique among the Russian works for their complete disregard of the linear conventions of poetic form. The more common typographic play among the Russian poets, including Terentiev, Mayakovsky, and others, was to use, again, the common practice of visual scoring. The premise that the page could function as a musical or performance score made use of graphic relations describing (and prescribing) temporal relations among the elements as well as simultaneous patterns for vocal rendering.[131]

Among the Dada artists the uses of collage practice are widely varied. The use of collage as a means of constructing strongly pointed political critique for mass production in magazines and journals became a trademark of those artists, like Hausmann and Heartfield, who had begun their work in Dada context in Berlin but put their efforts in the service of a more focused political agenda. In these works the ransom-note visual character helps carry the threatening impact of current events into the visual image, while the recirculation of elements of printed matter also serves to demonstrate the necessity to rethink the elements of contemporary experience through radical recombinations and juxtapositions. Here the plane of discourse is manipulated in order to call attention to that which has been obscured in the plane of reference by the circulation of images designed to hide, rather than reveal, the realities of the political and social condition. This work is pointedly at odds with that of Tzara, which refused any programmatic allegiances or principles, but makes use of many of the same techniques.

The list of other artists who made use of typographic manipulation in interesting ways is a long one, but a few more need particular mention: Marius de Zayas, Francis Picabia, and Wyndham Lewis. De Zayas was the director of the review *291* and in its pages introduced several instances of typographic poetry. His compositions were more abstract than those of Apollinaire, though vaguely iconic in form, as for instance

the portrait "Elle," which mirrors the schematic caricature by Picabia on the page which faces it. The tone of the text is misogynist, at once condemning and celebrating "her" engagement in pleasure while the type disposes itself in an arrangement which mimics the mechanistic portrait sketched by Picabia. The machine, which is the "she" of the poem, is already an abstraction and de Zayas's reduplication of its articulated parts would hardly read as the image of a woman without the visual referent of Picabia's work beside it. The piece is unique and has most in common with the mecanomorph drawings of Picabia, whose degree of abstraction also removes them a great distance from the literal, figurative, or essential works of other artists.

Picabia's typographic experience ranged from design of his own *391* journal, which underwent its most dramatic transformation after Picabia had been exposed to Tzara and his publications, to the design of the unique example of *La Pomme de Pins* in 1922, and the production of his mecanomorphs. In neither of the first two did Picabia do anything beyond imitating and carrying to an extreme the techniques already stylistically associated with Dada. The 1922 work in particular simply makes use of each and every trick of eclectic combination to produce a work whose visual character is well in keeping with the nonsensical tone of its verbal elements: "Our heads are round in order to let our thoughts turn around."[132] The piece, a four-page pamphlet, is filled with the noise and clatter of advertising language, real events and publications mentioned along with the smattering of quotes, random insults—"Cubism is the cathedral of shit"—and contradictions—"Picasso is the only painter I love," so symptomatic of the Dada style established by Tzara.

But in his mecanomorph works Picabia achieves, in calligraphic form, schematic and spatialized relations among elements of language which cannot be reduced from their abstraction to any more specific referent or figure. The portrait of Tristan Tzara, for instance, serves to illustrate this point. A solid circle grounds the whole arrangement, and, beneath it, the name Tristan Tzara identifies the image. Just above a horizon line composed of two other vectors are the opposing poles, here marked as if the poles of an electromagnetic current, the "illusions" and "certainties." The realms which rise above this, along the line of a single, simple vector, are increasingly idealized, as if in imitation of some medieval cosmological scheme: "the magic spectacle of ideas," "vaporised words," "a flower," and then "perfumes." The hierarchicization of the linguistic elements depends on their spatial relationship. Nothing in "a flower" per se grants it a higher place in the conceptual scheme here except its position. Neither does the image *mean* anything beyond its

capacity to organize the relations of elements into a schematic order, itself suggestive by its putting into relation the linguistic terms and by the schematic suggestion of dynamic interaction it achieves in the process. Linguistic elements are successfully removed from syntax, as visual elements are distanced from pictorial referents or conventions.

Of another order altogether, but indicative, again, of the extent to which typographic form was consciously attended to across the full spectrum of avant-garde activities in the 1910s, is the work of Wyndham Lewis. The first pages of *Blast* announce their aggressive modernity with a starkness of design quite in contradiction to the complex acrobatics of Marinetti's pages or, by contrast, the baroque and seemingly mannered excesses of the Dada journals. Here is a modernism devoid of decorative distractions—clean, streamlined, direct and assaultive to the eye in the same striking tone as its language. The visual character is closer to that of the handbills placed by unionists and activists on the walls of the city streets than it is to any advertisement or diversionary eye-catching poster for an entertainment. The work was produced, after all, in Lewis's "socialist" phase, and its anti-Classicism is an important feature of its anti-establishment stance. Here, again, the material form of typographic production is used to signal the place of the work within its contemporary context, to force associations and alliances in the eye of the reader, as an effect of that visual form even as it works on and through and with the verbal text.

The enumeration of typographic works and concern with the play of visual and verbal relations within avant-garde poetics and visual arts could go on considerably longer but would not make significant contributions to the issues involved. The extent to which the synaesthetic sensibility of Symbolism transformed in the early modern period to flourish as a cross-fertilization, blurring the lines of verbal and visual practices, should be evident. With that blurring came a complex theorization of the nature of signification and of the role of materiality within its operation.

It should be clear by now that the role of typographic manipulation in the presentation of poetic language in the 1910s was more than a diversionary tactic or trifling surplus of decorative excesses. The attention to materiality which characterizes these works is available to a range of interpretive analyses which link these pieces to their contemporary context in terms of aesthetic and political issues. That they have and demonstrate a material form which is itself replete with associations, references, and indexical links to other cultural sites and practices was reinforced, in some instances, by the distribution of these works onto

the walls and into the streets of the contemporary urban world. Thus the boundaries of high art practice in the very literal sense of its site were frequently eroded by such activities, and the typographic character of Dada and Futurist ephemera was an essential feature of such work.

Other boundaries are also challenged by these methods of distribution and production. The distinction between high and low art becomes highly problematic in works whose forms are borrowed from the culture industry activity of advertising, then reified in fine art practices and then returned, via the development of design disciplines, to the domain of commerce and business. This is not the simple formula of appropriation of mass-produced modes and materials symptomatic of the high art Cubist works which violate the old terms of methods and materials but never challenge the sites, modes, and production methods of either their own work and its reception or have any substantial effect on the realms which served as sources for their innovative efforts. Far more than Cubism, Futurism, or even Suprematism, Dada resisted historical assessment by its very nature—which may now be accounted a sign of its success on its own terms.

In the end, this typographic work participates in the rejection of classical aesthetics, of the terms of form and beauty, and in the investment of modern art practices in the negotiation of boundaries which define art in cultural terms. In addition, they are clearly involved in the curious restructuring of the concept of authorial subjectivity, the momentary break with the notion of originality as interior and individual, and the recognition of the dialectical character of subject production within the context of the social order. The two characteristics which distinguished modernism in the arts—a concern with formal innovation and the utopian, activist agendas of the avant-garde—were well served by the printed page. But if modernism generally considered can be characterized by its self-conscious attention to innovative form, the avant-garde can be distinguished from modernism by its claims for the effectiveness of radical form in effecting social change. The activist agenda of the avant-garde was generally utopian, based on a romantic belief in revolution and the power of radical form to help facilitate a change in the social order. The obvious fact that radical form and radical politics need not go together, and that the subversion of the norms of the symbolic order do not necessarily engender a utopian social order, is all too painfully clear to need repeated emphasis. The founding myths of modernism and the avant-garde have not withstood the critical retrospective regard of history, but the force and influence of the formal innovations is still felt through the mainstream of twentieth-century Western

culture in literature, visual arts, and applied graphic design. Belief in the capacity of radical form to bring about a change in the structure of society remains highly circumscribed within the very limited domain of demonstrable effect. The typographic forms of the period of innovation have now come to stand for—to represent in stylistic terms—the naive utopianism of this belief. It is only through attentive critical investigation that the specifics of the relations between interventions in the order of the symbolic (verbal or visual) and the circumstances of enunciation and production of signification can be made meaningful. The politics of materiality remain as varied as its forms; intervention and resistance are shown, through such study, to be processes and activities, not formal means; all the rest is style.

■ 4

Critical History: The Demise of
Typographic Experiment

The year 1923 saw the publication of several landmarks in typographic
experimentation: Zdanevich's *Ledentu,* El Lissitzky and Mayakovsky's
For the Voice, and Marinetti's "The Torture of St. Unique by Speed and
Simultaneity." That year also witnessed the commonly considered mo-
ment of the "death" of Dada in the July production of Tzara's *Gas Oper-
ated Heart* at the Théâtre Michel in Paris.[1] Apollinaire was dead, as was
Khlebnikov; in the wake of changes brought about by the Revolution,
Russian artists were testing the application of radical aesthetics to a new
society; and in post-war Paris artistic activities such as Futurism or Dada,
which were associated with the War, rapidly fell from favor. André
Breton's 1922 publication "Enter the Mediums" and the appearance of
the "First Surrealist Manifesto" gave the group of poets forming around
the journal *Littérature* a new focus.[2] In the course of the next two dec-
ades typographic experimentation would be transformed in mainstream
art, in commercial application, and in the critical assessment of its place
within the early modern art movements in a way which reveals far more
about the development of visual art and literary theory in those years
than about typography. Each of these developments is summarized
here, briefly, so that the demise of typographic experimentation within
the mainstream of visual arts and literature can be understood.

From Surrealism to Lettrism: 1924 to 1950

Told as a narrative account, the fate of typographic experimentation in Surrealist practice is brief. Having cut his aesthetic milkteeth on the chance techniques and poetics of Dada, André Breton, in asserting his own and the Surrealists' hegemony, would declare against the conspicuous visual forms of the experimental typographic page. Breton had created a number of the "ransom-note" typographical poetic works which were visually modeled on the "Bulletin" and "Bilan" of Tzara ("Corset-Mystère," for example). In establishing an editorial look for the earliest Surrealist publications, Breton reverted to a severe bareness for textual presentation. The diagonally placed lines of type, varied typefaces, sizes and styles, the gewgaws and cliches, printers' marks and devices, were banished. Images became bounded and discrete elements carefully placed within the columns of type. Content, not form or formal visual experiment, became the focus of the Surrealist text.

In very concrete, visual terms Breton, Aragon, Soupault, Eluard et al. distinguished their publications from those of the Dadaists and Futurists who had dominated the printed media of experimental art for the previous decade and a half. The chaotic busy-ness of those publications, with their disregard for clear presentation, their upset of the hierarchies of literary and advertising texts, and their subversive attacks on the norms of reading, seeing, viewing—all these were banished in the well-ordered pages of the Surrealist publications. The transition happened relatively quickly; between 1923 and 1925, a somber, sedate, and well-behaved literary page re-establishes itself in the publications associated with the Surrealist group.

"Breton didn't want to use these conspicuous innovations, of which he retained only the most superficial elements. He felt that these juvenile typographics only served to distract the reader from what was important."[3] André Breton believed unequivocally that the authority of the text relied on acknowledging the materiality of the typographic signifier as little as possible. The role played in the demise of experimental typography was thus twofold: his influence allowed the prejudice to have a strong effect, and his prejudice was not original or unique to him, but symptomatic of the widespread refusal to acknowledge the materiality of written forms of language in the literary tradition. This aversion to typography can be explained succinctly as an aversion to anything which interferes with the text. A distinction between Dada and Surrealism could be grounded on this attitude and all that it implies about the transparency of modes of production versus the obsessive concern with at-

tention to them which had been so fundamental to Dada. Surrealism did not shatter or fragment the structure of signification, but worked to rearrange, reconfigure the relations of elements within that structure in figurative terms. This is especially true of the writing practices which followed the structure of automatism or dreams in using highly condensed and tropic images. The painting practices are more complex, with those of Dali, Magritte, Varos following this in a visual parallel, as much as that is possible, while the work of Masson, Tanguy, and to some extent Ernst actually used frottage or suggestive organic gestures to dissolve the conventional limits of the visual sign.

But in literary terms, the distinction between the communicative sign system of Surrealism and the subverted symbolic order of Dada is marked by the repression of typographic enunciation. Dada had attempted to disrupt, subvert, and call attention to the very mechanisms of production used in signification as a socially and culturally bound system of order. Breton rightfully saw this as a threat to the authority of logocentric discourse. He feared the material pollution of writing, fearing that its voluptuous appeal might interfere with the purity of language. In fact, he understood that the material form would threaten the relation between signifier and signified, threatening that economical and transparent unity. Breton wished the voice of the author, the site of enunciation, historical and cultural, to go unmarked in the totalizing tendency of his exploration of the unconscious as a universal entity, at least in these early phases before his Communist conversion. He wanted the voice of the text to be omniscient and unmarked. Thus he banished typography from the literary page, condemning the reader to the gray tone of literary authority in order to assure his own, insisting that literature "speak itself" without interference. In so doing he also banished all consideration of language as making a generative contribution to the signifying practice.

Dada and Futurist typographers had demonstrated that the literary convention in which marks of production and enunciation were repressed was a complicitous fiction, one in which the constructs of language might readily pass for truths, concealing the arbitrary and specific behind the mask of the absolute and universal. Disclosing the grounds on which language grounded its authority, Dada attempted to render problematic a linguistics in which an "absent" signified might be construed to exist independent of its relation to a material signifier. It is hardly surprising, therefore, that Dada typography and the visual representation of language in general have received so little attention and have been the object of so much negative bias in the context of logo-

centric discourse. Similarly, however, typography posed problems to the modernist insistence on a concept of the "purely visual," one which would be without the polluting effects of literary or linguistic associations.

Surrealism's success as a literary and artistic movement in the 1920s and 1930s granted it a prime place among the experimental artists of those decades. The literary avant-garde in France in particular became homogenous, francophilic, and conservative by contrast to the hodge-podge milieu of foreign influences and splinter factions of radicality which had characterized the capital between 1910 and the early 1920s. And, as stated above, Breton's sensibility with respect to the authority and self-seriousness of the literary text simply brooked no dabbling or distracting play with the visual materiality of the linguistic signifier. The ongoing activities of various strains of abstraction, formalism, and figuration within School of Paris remained without a typographic component of any significant dimension, though it did surface in the pages of *De Stijl, LEF* and *NovyLEF, AIZ* and other journals which continued some of the radical rhetoric of the late 1910s into focused projects in the 1920s. Another contributing factor to the transformation of the literary use of typographic experiment is the growth and codification of the discipline of graphic design, which received an unprecedented boost in professional identity and activity in these decades, as per the discussion below. As the techniques which had been themselves transformed from the miscellany of commercial practices had been subject to systematic exploration in the crucible of artistic experimentation, they had developed some of the characteristics which would make them attractive to the burgeoning industry of commercial design.

Experimental typography within a literary context went underground or, at least, lay dormant, until after 1945, when this area was reopened with a vengeance by the work of Isidore Isou and the Lettrists and by the work of the Concrete poets of Germany and Brazil. The issues raised by their work do not conform to the parameters set out in the interpretation of the early modern typographic experiments. The aim of Isou, in particular, was to atomize signifying elements past the point of communicative signification, to pulverize the sign, subjecting it to the discipline of a complexly conceived *écriture* whose play across surface and page was more in keeping with a deconstructive *différance* than any linguistic activity. The Concrete poets, whether the Noigrandes group established by the De Campos brothers in Brazil and the various groups around Diter Rot or Eugen Gomringer and Oyvind Fahlstrom in Europe, returned in some ways to the concepts of constellation and icon

reminiscent of Mallarmé. In general, this concrete work was more readily available for closure in interpretive practice than was the work of the Symbolist poet and less integrated into the mainstream of literature. In fact, concrete poetry, and its sibling, sound poetry, become specialized domains of literary activity, ghettoized by their distinguishing characteristics and encountering significant prejudice on that account. They are the "other" of post-war writing, treated as a curiosity and a novelty.

One interesting note vis-à-vis the work of Zdanevich. Of the writers who have been studied in depth here, he was the only one (a fact in part attributable to biographical circumstances but more significantly attributable to aesthetic conviction) to continue to work systematically with typographic design as a conceptual category. These concerns framed his artistic practice throughout his life, and the investigation of the book as an artist's medium, rather than an editor's or publisher's domain, is uniquely achieved in his work in midcentury. One of the more remarkable productions of book arts and literary history in the 1940s was his publication, in 1949, of the *Poetry of Unknown Words*, the first exhaustive anthology of concrete and experimental typography and sound poetry. Produced in part as a response to the claims of Isou to sole invention of the genre, this work contained pieces by the dozens of artists and poets, all of whom Iliazd had known from the 1910s onward, whose work had contributed to the development of the genre. Printed in a fine, limited edition, the work has not had the historical recognition it deserves as a landmark piece of anthologizing or for the actual substance of material it contains.[4]

An *écriture* of sorts develops in the visual arts as well, with the work of such people as Cy Twombly, Henri Michaux and André Masson, whose quasi-automatic graphismes function as visual images with occasional reference to the activity of linguistic or figurative signification. With the advent of Pop art, the use of language as a visible form resurfaces in the visual arts, but the challenge to the boundaries of signifying practice are overwhelmed by other issues in its consideration. In large part, the distinction between visual and verbal modes, between the visual arts and literary practice, has become so distinct that there is no question of confusion in these works. So-called serious literature returned to the convention of the unmarked page, the curiosities of concretism are safely identifiable as a marginal discourse, and the pictures of language within visual art through the 1960s were distinctly identifiable as images and icons, not functioning to confuse the issues of plentitude and surrogate meaning. This changed radically with the advent of

conceptual art, which took as its point of departure the investigation of the premises on which structures of representation functioned.

Critical History: From Form to Formalism in High Modernism and New Criticism

Early twentieth-century modern art began to be assessed in critical and historical terms by the 1930s. Early pioneers in such attempts, Pierre de Massot and Leonce Rosenberg, for instance, were replaced in the visual arts with figures like Alfred Barr, Michel Seuphor, and Meyer Schapiro. Between the 1930s and the peak of high modernism in the visual arts with the work of post-war abstraction in the United States and Europe, a modern paradigm came to be defined in both literary and visual arts according to the terms of critical practice. Though this paradigm has subsequently been as systematically dismantled as it was established, the relation between this paradigm in literary and visual arts critical discourses to the fate of typography needs some discussion.[5]

The conceptual structure of the modernist assessments of literature become apparent with the work of the New Critics, Cleanth Brooks and W. K. Wimsatt, and in the visual arts with the work of the modernist critics cited above, but very particularly in the writing of Clement Greenberg and Michael Fried, who serve as representative figures of high modernism in the visual arts. In its critical reinvestigation of the terms of modern art practice, modernism invested seriously and intractably in the distinction between literary and visual arts practices. By inscribing each realm in the specificity of its own medium as the basis of its essential identity, the visual and the verbal necessarily excluded each other in all and every possible manner in order to assure the *pure* definition of their own activity. It is also possible to trace the manner in which the anglo-american critical practice, having separated from that of French poetics and the legacy of Symbolism, especially Surrealism, established its own directions and definitions for both modernism and literariness and remained separate and distinct for several decades.[6]

In critical writing the stress on investigation of the medium as the major site of activity within art practice became more and more dependent on that medium's distinction from any other media, to its independence from any referent outside its own operations, and to the insistence on the formal value of a work as its primary, even sole, significance. The production of *works* of modern art was replaced with the

production of modern art *as an object of modernist criticism*. In the 1930s the visual arts in Europe were largely dominated by the innovative force of Surrealism. Simultaneously, the trajectory of early modern art followed the careers of the major figures who had established themselves within the innovative period of Cubism, Fauvism, etc., such as Picasso, Matisse, Chagall, etc.[7] The formal experiments which had established these figures had long exhausted themselves, but the concept of modern art came to be institutionalized as these figures were canonized within museum walls and historicizing texts.

While Surrealism dominated the French landscape, in anglophone poetics the figures of Pound and Eliot maintained central place and influence. But the focus here is not with tracing the fate of modern poetics or its legacy in terms of poetic production. Rather, it is the investigation of the difference between an earlier modern art practice and a later critical/historical practice and the ways in which the latter attempts to produce the former through its own reductive, retrospective definitions.

The critical position which emerged in the 1930s as the foremost trend in interpretation in the anglophone community (exerting, incidentally, a dominant influence in the canonizing process) was American Formalism and New Criticism. Other critical trends on the continent which took their influence from Russian Formalism, Prague School linguistics, and later, Structuralist criticism, all have their place in the discussion of the definition which accrues to the term *modernism* as it comes to designate a poetic practice. The primary factor of modernist literary criticism on which the exclusion of typography was based, however, was the privileged attention to the *signified*. This attention, in turn, contributes to defining the oppositional boundaries between visual arts and literature in the period following 1930 in which the historical canonization of the early twentieth-century work in both disciplines was occurring. I will limit my discussion of criticism in the 1930s to the single example of anglo-american New Criticism, in large part because of the way it interacted with and reinforced the tenets of High Modernist criticism. The paradigm thus established had its greatest influence in the academic circles of American universities until it was challenged by French structuralism and poststructuralism in the late 1960s.

The critical work of T. S. Eliot, along with that of Ezra Pound, T. E. Hulme, and others had been committed to the revitalization of language by a rigorous attention to its use: an attention focused on every level of language from its atomized particulars of words and sounds to the invention of new forms of versification and structure. A link between the English and American practitioners of criticism was established by I. A.

Richards, cited above.[8] Richards's symptomatic emphasis on the medium could be detected as an influence surfacing repeatedly in the writings of critics of the 1930s and 1940s. As an example, this citation of W. W. Urban in Cleanth Brooks, with its nearly verbatim reiteration of Ogden and Richards's formulation serves as representative: "The artist does not first intuit his object and then find the appropriate medium. It is rather in and through his medium that he intuits the object."[9]

However, the distinguishing feature of New Criticism, which differentiated it in intention and procedure from earlier practices, was its objective to divorce the poem from any context beyond itself and propose a critical method sufficient to understanding its full value from a study of the object. There are evident similarities between this approach and that of those Russian Formalists who facilitated their political agenda with linguistic critical analysis, but the rigor of the Formalist method derived from its greater dependence on linguistic analysis and was also much embroiled with questions of social, if not explicitly political, context.[10] Terry Eagleton summarized the spirit of New Criticism as follows:

> "close reading" also held at bay a good deal else: it encouraged the illusion that any piece of language, "literary" or not, can be adequately studied or even understood in isolation. It was the beginnings of a "reification" of the literary work, the treatment of it as an object in itself, which was to be triumphantly consummated in the American New Criticism.[11]

While it is relatively simple to see the connection between attention to the formal devices of composition which motivated modern poetry and attention to formal devices as the basis of interpretative inquiry, there is a subtle distortion which occurs in the process of equating the production of a work with the production of its meaning in interpretive inquiry. The attention to material properties of language which had come to the fore in what was for the European and Russian a linguistically sensitized and largely Symbolist influenced environment, bore the imprint of Stephen Mallarmé's formulations, here summarized by Claude Abastado: "the function of literature, he felt, was to show language producing meaning and establishing truths; poetic writing represents no more than its own functioning and operations."[12]

But a radical shift in emphasis occurred as the formalist principles of interpretation came to focus on the production of meaning within the self-contained autonomy of the work. New Criticism functions as a bridge between modern poetics and the activity of later Structuralist critics who divided the elements of signification, reasserting the power of the *signified* in a model of analysis grounded in the transcendental

practices of an orthodox semiotics. New Criticism, isolated the poetic object from any context—what remains is a mythic sense, purely fictional, of the autonomy of the *poem* as a work. (This is a very similar operation to the establishment of an autotelic painting.) Witness Cleanth Brooks: "We had better begin with it, by making the closest possible examination of what the poem says as a poem."[13]

One of the features of New Criticism was an emphasis on the boundaries of the field of meaning of a poem. Very peculiar vocabulary attendant to the definition of what was relevant to interpretation defined an "interior" and "exterior" to the work, delimiting the boundaries of what was relevant, reducing the poem more and more to its "linguistic fact." The emphasis on formality became extreme in American Formalism; for W. K. Wimsatt and M. C. Beardsley, poetry was to *be,* in some absolute and unquestionable sense, bearing its meaning as a product of its form without mutation from external influences.[14] From the Imagist prescription of a work produced according to a "government from within" to the work reduced *to* that government is indeed enormous. No longer concerned with what was legislated, but with the principles of legislation, criticism attacked its object with full authority.

> To call for close reading, in fact, is to do more than insist on due attentiveness to the text. It inescapably suggests an attention to *this* rather than to something else: to the "words on the page" rather than to the contexts which produced and surround them.[15]

> The same impulse which stirred them to insist on the "objective" status of the work also led them to promote a strictly "objective" way of analysing it. A typical New Critical account of a poem offers a stringent investigation of its various "tensions," "paradoxes" and "ambivalences," showing how these are resolved and integrated by its solid structure.[16]

The crux of the issue in determining the transformation to a New Critical stance was this shift from a relation between formal values and their communicative effect to an attention on the formal values for their own sake. The effect of this is a reduction in the substantive content of the work to nearly nil, it becomes of less and less consequence while the terms of *literariness* become more and more distinct as that which the poem works to define. "The criticism of Eliot displays an extraordinary lack of interest in what literary works actually *say*: its attention is almost entirely confined to qualities of language, styles of feeling, the relations of image and experience."[17] The aim of the poem is increasingly to support *poetics* rather than poetry, and in fact, what is meant by poetics is a

critical practice as much as a literary one. The early attempts of the modern arts to legitimize themselves through scientific-looking procedures was now being echoed by the critical approaches, which were attempting to accrue to themselves the same sort of legitimacy:

> New Criticism, moreover, evolved in the years when literary criticism in North America was struggling to become "professionalized," acceptable as a respectable academic discipline. Its battery of critical instruments was a way of competing with the hard sciences on their own terms, in a society where such science was the dominant criterion of knowledge.[18]

The guise of pseudo-scientificization taken on by art returned to reproach it through the monster of modernist criticism in terms of a relentless orthodoxy defining literariness. What is important in the definition of this literariness, which became operative under the influence of New Criticism, is its dependence on the assumed nature of the linguistic sign. Such an analysis of literature was deliberately divorced from intention, biography, or history. Insofar as it could "say" anything, it spoke a "meaning" divorced from context in the social and historical sense. Such an interpretive method led only to an analysis of words, words in their reduced semantic and syntactic sense, with barely a hint of pragmatism to redeem the sterile functionality of their existence. This autonomy of the word, of language, placed it into a relation to meaning absolutely predicated on a faith in the link between signifier and signified. The search for the one through the other was the sole purpose of the analytic endeavor, and perhaps never, outside of the analyses of New Critics, has the sense of linguistic authority based on the absent signified as presented by the signifier been so religiously professed as fact. Closure was the order of the interpretive practice, and the meaning value of the poem was assured precisely insofar as its formal properties could be apprehended and fixed through critical analysis. What was at stake was *meaning,* pure and absolute (though resonant and proliferating), and in spite of all of the supposed attention to form, that attention was actually designed to bypass its existence for its own sake and legislate its existence for service to the signified value.

Signified value, within such a linguistic frame, meant *absent* value, and the structural linguistics on which Formalist criticism of any variety was based, is predicated on one principle more than any other—that the presence of the signifier serves only as the indication of the *absent* signified. The function of the signifier is immaterial, dematerialized. And necessarily so. The material properties of a manipulated typography would only violate the production of the truth of the signified by rela-

tivizing it, subjecting it to a regime of contextualization, returning it to a domain in which there was no possibility for the transparent production of meaning.

The political implications of a position in which the means of production are effaced, attempt to be eradicated, are obvious—and the conservatism of American Formalism is hardly incidental. In concluding this section, suffice to say that formalist literary criticism had no use for a typographic practice whose material properties, if acknowledged and accounted for, would have prevented any possibility of linguistic closure on the work. The principles of autonomy which characterize the poem as it is scrutinized by the modernist critic are echoed in the establishment of similar principles for the interpretation (and, again, canonization) of modern painting.

In the visual arts, the term modernism had, with respect to its midcentury form, only one equivalent: it meant whatever "Greenberg meant by it."[19] While this hegemony has long since been shattered, the terms of the Greenbergian paradigm established themselves as highly influential elements of midcentury art critical vocabulary, and even if they have been questioned more recently, they remain significant historically. In an important way, the work of Greenberg, and that of other early narrativizers of the course of modern art such as Seuphor and Barr, came to stand for the point at which modern art became defined through modernism. Greenberg's 1939 "Avant-Garde and Kitsch" began the formulation of a position which he fully articulated in the 1961 "Modernist Painting." While the works of art for which Greenberg was developing a critical justification were those of the Abstract Expressionist painters, he managed to project his vision back through the twentieth century and discuss the works of Braque, Picasso, etc. according to the same terms. As a result, a lineage was established retrospectively which distorted the activities of, especially, the Cubist painters. The terms of Greenberg's discussion, it is well known, were strictly formal. It was Greenberg who stressed the concept of a formality which was only about itself, a self-referential, self-critical elaboration of the elements of a medium. "It quickly emerged that the unique and proper area of competence of each art coincided with all that was unique to the nature of the medium."[20]

This statement has been quoted so frequently that it emerges as the founding cliche of modernist criticism, and it is easy to read Greenberg too reductively through its lens. However, this reductive process had a powerful effect; Greenberg's formulation of the modernist position was reinscribed repeatedly to serve as the basis of modernist criticism and historical analysis. While the many conflicting resonances of Green-

berg's work can't be reduced to a single reading, he was, frequently, so reduced that he became equated with a single instance of his own writing and then was repeatedly invoked as the authoritative spokesman of the extreme formalist position. In the context of the argument about the shift from modern to modernist definition of an earlier art practice, this cliched reduction of Greenberg functioned to define a rhetoric of visuality and modernity.

> The task of self-criticism became to eliminate from the effects of each art any and every effect that might conceivably be borrowed from or by the medium of any other art. Thereby each art would be rendered "pure," and in its "purity" find the guarantee of its standards of quality as well as of its independence. "Purity" meant self-definition, and the enterprise of self-criticism in the arts became one of self-definition with a vengeance.
>
> Realistic, illusionistic art had dissembled the medium, using art to conceal art. Modernism used art to call attention to art.
>
> It was the stressing, however, of the ineluctable flatness of the support that remained most fundamental in the processes by which pictorial art criticized and defined itself under Modernism.[21]

Briefly, the basis of Greenberg's midcentury definition of modernism was a self-critical purity through which art might achieve its self-definition. The one thing most fundamentally threatening to the possibility of this purity was a literal, readable, illusionistic value to the image. However the elements appeared on the canvas, they were absolutely not to refer to or suggest the possibility of an illusion. This extreme repression of the figure, and of its very possibility, was an attempt to guarantee that the visual properties of painting (in this case, sculpture having other properties, of course) *be visual*.[22] Here was the kernel of the exclusive definition of the visual arts, of painting in particular, as decidedly *not* literary or language related. The links between Greenberg and the earlier generation of formalist oriented critics, such as Clive Bell and Roger Fry, was readily apparent (and has of course also been pointed out repeatedly).[23] But it seems worth recalling the position of Roger Fry was qualified as he grappled with the problem of visual experience by its relation to language. Fry pointed out the difficulty of *having* a visual experience since the visual domain was essentially excluded by the linguistic labels with which works of art were *noted* rather than really *looked at*, and indeed, people did not so much *look* at life, as *recognize* it. And by "recognize" he meant, identify it with the appropriate linguistic category.[24]

The contentious position taken by Fry was amplified (though never

directly stated) in Greenberg; Fry's rejection of the linguistic label antic-
ipated Greenberg's rejection of the figure, the referent, and the illusion-
istic value—that is, any of the elements according to which an image
might be reduced to something *other* than itself, represented by a word,
title, or name functioning as dominating surrogate for the work of visual
art. Greenberg, in his efforts to empty visual art of all extraneous ele-
ments, bolstered his argument on what he took to be evidence of this
process's having been begun by the artists themselves, most particularly,
those formalist pyrotechnic practitioners of cubism, Picasso and Bra-
que: "By the end of 1911, both masters had pretty well turned tradi-
tional illusionistic paintings inside out. The fictive depths of the picture
had been drained to a level very close to the actual paint surface."[25]

This statement was simply incorrect. For all their attention to the
formal aspects of their approach, neither Picasso nor Braque were in-
tent on denying the existence of depth or illusion in their work: they
were in fact assiduously attending to the interplay of surface with illusion
and with calling attention to both aspects of the plane of discourse
simultaneously—the surface and the suggested illusion, or, in semiotic
terms, signifier of paint and signified of image. The point is not to deter-
mine *why* this transformation occurs with Greenberg, but rather to
stress *that* it happens and that it had strong implications for the defini-
tion of modern art practice through modernist criticism. This redefini-
tion of modern art practices by modernist revision in part made it
necessary to exclude typography from the canon of modern art.

In his effort to purify painting, Greenberg reduced it to absolute
formality. For Greenberg, what did not represent formality does not *rep-
resent* at all, does not even *signify.* Traces of this position appear in the
writings of various critics, though none of them are as unqualifiedly
extreme as Greenberg. By contrast, consider Meyer Schapiro's con-
temporaneous statement: "In abstract art, however, the pretended au-
tonomy and absoluteness of the aesthetic emerged in a concrete form.
Here, finally, was an act of painting in which only aesthetic elements
seemed to be present."[26] The word "pretended" says a great deal in this
statement. Schapiro was always intent on revealing both historical and
cultural circumstances of a work's production, including the mythic
frames of conceptualization within which they are constructed. His dis-
cussion of the emphasis on formal elements in modern art therefore
took on certain qualities which distinguished his position from that of
Greenberg, while appearing to stress some of the same conspicuous fea-
tures of the work. Schapiro:

Hence the great importance of the mark, the stroke, the brush, the drip, the quality of the substance of the paint itself, and the surface of the canvas as a texture and field of operation—all signs of the artist's active presence. The work of art is an ordered world of its own kind in which we are aware, at every point, of its becoming.[27]

The fact that Schapiro inserted the "artist's active presence" as a central reference made his assessment of the work (he was speaking in this essay of "Recent Abstract Painting" and it was written in 1957) less constricted by terms of purity. Herbert Read, in his 1954 discussion of Juan Gris, while stressing the significance of formal values as an emerging focus of attention for the Cubist painters, made a rather ambivalent statement about the production of image value: "form has a meaning, but it is meaning entirely its own, a personal and specific value that must not be confused with the attributes we impose upon it."[28] A "meaning entirely its own" was a phrase so problematic that without significant gloss from Read himself it is impossible to unravel, however, it bore a familial resemblance to the characterization of modern art borrowed by Greenberg from another early critic and artist, Wyndham Lewis, when he wrote on nonobjective art in the 1910s: "Such an artwork need not be interpreted, because it contains 'within itself all that is relevant to itself.'"[29]

 The work of visual art in these modernist, midcentury formulations, was not only formal, but replete, fulfilled, in terms which put forth the notion of "presence" as a sufficient grounds for being, as the basis of an artwork's definition in aesthetic and critical terms. That this was a fallacy is not the point, because it was mythically considered to be true and allowed to stand within the rhetoric of art criticism as convincingly and definitively true of modern art in these critically historicizing years. It is possible to read Read as including the notion of signification, of the interplay between signifying material and signified value, at one with each other in spite of the conceptual possibility of discussing them separately: "The idea is the form, the form the idea. The composition is conceived, *ab initio*, in plastic terms. It cannot be translated into any other language and is not itself a translation from any other language."[30]

 But the notion of plasticity as presence, as an irrefutable fact and a given, accessible, immediate, and nonlinguistic, was lurking fairly close to the surface of this statement. Even Schapiro could not help slipping into this embrace of formality as presence, as in writing of the works in the Armory Show: "Among the arts, painting (and to a smaller degree,

sculpture) have the unique quality of combining in a permanent state the immediately given or tangible."[31]

This fictive fetishizing of a full presence became the high modernist's fundamental grounds for definition of the operation and identity of works of visual art. In conclusion, a brief reiteration of the ways in which this slippage from discussion of formal elements to the prioritizing of formality for its own sake occurred. Michael Fried, in his discussion of the evolution of cubist art, wrote that the development from Manet to synthetic Cubism and Matisse "may be characterized in terms of the gradual withdrawal of painting from the task of representing reality—or of reality from the power of painting to represent it, in favor of an increasing preoccupation with the problems intrinsic to painting itself."[32]

Schapiro, aptly describing this same phenomenon, stressed: "Much was said about purity or form in itself, but in practice this meant a particular economy and rigor in employing the new means."[33] And indeed, this was the crux of the issue. Where the modern painters were concerned with the manipulation of the material aspects of the painting practice, with calling attention to them, they were not engaged in doing this to the point of exclusive insistence on the negation of content. It is simple enough to claim that the subject matter of cubist works was merely an excuse for formal investigation; the fact remains that the image value continues to exist, function, and to communicate through that formal language, calling attention to it, in fact, all the more, because it is an effect and renders the art practice acutely self-conscious. The formality of the modern artist was *not* the formalism of Clement Greenberg, especially not Greenberg as he came to stand for the cause of a "pure" formality. In his search for the pure and irrefutable nature of painting as a universal category, Greenberg merely participated in a historical moment of discussion in which the identity of painting was being established on the terms of a formality which belonged to it in a supposed entirety, complete, insular, and absolute. That this was necessary as a gesture to insure that identity and grant it a full autonomy from the literary mode might be supported; that it is either possible to achieve such a definition or to ignore the implications it bears with it, cannot.

Modern art practice and its critical definition within high modernism were substantively different. Modern art was concerned with an attentive investigation of the effect of materiality on the practice of signification. Modernist practices generated an exclusive and oppositional definition of the literary and visual arts. The terms of the modernist critic had at stake defining the bases of their own existence and

practice while the activities of modern art allowed for much greater am-
biguity, complexity, and heterogeneity, plus recognition of the potential
for materiality to play a part in politicizing the activity of signification.
Once modernist critics established the territory of their own domination
they produced an object more purified, more suited to the development
of their own critical identity. Literature, i.e., poetry, became the func-
tion of poetics; the visual arts, i.e., painting in this case, became the
purified self-referential domain of a formal investigation. Obviously, ty-
pography, as the image of language, the messy, boundary-blurring prac-
tice which included both formality and reference, image and language,
present signifier and absent signified, while not in conflict with modern
art practices, was distinctly at odds with modernist definitions of those
practices and was therefore excluded from their consideration, histori-
cal or critical.[34]

Turning the Page on the Hard Edge of Modernism: Codification of Typographic Design Practices

Introducing elements of display traditionally reserved for advertising
into the pages of journals which were integral elements of mainstream
art, the avant-garde artists of the 1910s shattered the conventions which
distinguished the two domains in visual terms. As the form of literary
publishing reasserted its repressive, unmarked presentation with the as-
cendancy of Surrealism and Breton's conservative graphic aesthetic, the
look of advertising and commercial printing would be seriously trans-
formed not only by the influence of these avant-garde publications, but
by the direct involvement of the very same practitioners in a reformed
version of their own practices.

The avant-garde poets of the 1910s became the graphic designers,
teachers, and systematic theorists of the 1920s and 1930s while another
generation emerged to follow their directives in the codification of
design. There is perhaps no more perverse (and successful) transforma-
tion of the formal radicality of early modernism into the seamless in-
strument of corporate capitalist enterprise than this progression from
radical graphic aesthetics into Swiss-style modern design. The process
by which the very elements which marked the radicality of the early
work and its utopian agenda of intervention through the means of mass
production print media become ordered and codified into a system
which enunciated an insidiously complicit and instrumentally enabling

corporate style is duplicated by no other aspect of the early avant-garde. Nowhere else in the history of modernism, except, perhaps, in the applied arts of architecture and industrial design, does this peculiar transformation occur.

The claims of avant-garde modernity as resistant, and of high modernism defining itself according to a difference grounded in the binaristic distinction it maintains in relation to low or mass culture (largely through modes of production, but also, through significant elements of style) is belied here. As the avant-garde loses its identity in becoming the instrumental means of constructing the very image of the corporate institution, it becomes more and more involved in the very mechanics of mass production as a form. The visual stages by which this transformation can be noted and marked are therefore all the more significant for not being the signs of the transformation, but the very means by which this transformation is itself effected, brought about. For the graphic media to function efficiently as the repressive face of a corporate capitalism required the repression of all manner of deviant elements. The clean, hard-edged character of design served as both the instrument of and the image of a smooth, unmarked process of enunciation. What had begun, in the 1910s, as a vivid and exuberant exploration of the materiality of signification, became, by the end of the 1920s, in the hands of Herbert Bayer and Jan Tschichold, an ordering of visual graphics which caused that very materiality to efface itself, to disappear, under the style of a graphics whose very adjectival character—elegant, clean, streamlined, balanced, correct—betray its repressive force.

Tracing the formal changes by which this transformation occurs allows the construction of a discussion of the signs of a discourse engaged in its own metamorphosis into a sterile instrument of efficient production. From an exciting formal invention with its disorienting diagonals and eclectic typography to a formalism of authoritarian strictness, and further, from the evident self-conscious grid structure to the invisible and implied and all the more insidious grid of Swiss design whose efficiency at serving, internationally, corporate style with a unifying graphic base, this history marks, in visual terms, a loss of identity for the avant-garde, a mutation of the stylistic elements of high modernism into the mainstream of mass production, a permeation of boundaries which destroys the distinguishing binarism, and rather than returning the mass to the high as raw material, consumes the avant-garde and effectively destroys it through absorption. Thus the very elements used by Alexander Rodchenko to signal a radical program of change can be observed in their gradual, barely perceptible stages of transformation into the famil-

iar, the consumable, the absolutely undisturbing elements of a design practice guaranteed to help promote and reproduce the very order which it was originally conceived to subvert.

Looking to the early twentieth-century avant-garde for the roots of modern advertising, several centers of activity emerge as interrelated through contact among principle figures. These are enumerable, finite, and are largely to be found in the post-war early 1920s in Germany, Russia, and Holland, with a later nexus of significant activity developing in Switzerland as the "neutrality" of that nation once again offered a sterile and safe haven in a period of increasing conflict and physical danger. In Soviet Russia the Russian constructivists engaged with mass production and graphic design through the work of Alexei Gan, Alexander Rodchenko, and others (including Klutsis and Stepanova). In the German Bauhaus in its later incarnation at Dessau the typographic workshop was under the guiding influence of Herbert Bayer and Joost Schmidt, with peripheral influence from Theo van Doesburg—whose centrality to the activities of Dutch DeStijl, as well as his mobility as an international figure, linked him to the various centers of emerging design activity.[35]

One point which seems significant to underscore is that even where typographic experimentation continued as an artistic activity in its own right in the 1920s, it changed character. If one were, for instance, to examine the works of Piet Zwart, who did not begin to produce typographic designs until the mid 1920s, it would become clear that Zwart orders his pages formally to make them readable when they form part of an advertising or corporate image campaign and to make them visually engaging without the baggage of literary or poetic meaning when they are part of his typographic catalog showpieces. It is not incidental to either poetics or design that the visual codes of earlier avant-garde activity became subsumed under the well-ordered behaviors of advertising display. Once coded in this manner, they were returned to literary practice only much later, in concrete poetry, and then with new poetic strategies designed to rework the relations of visual form and verbal meaning. This is not to say that there was no typographically experimental work done in the 1920s, but that it was done in a distinctly different historical, aesthetic, and poetic context than that of the radical experiments of the 1910s.

The stages by which the practitioners of graphic design transformed the visual characteristics of experimental typography so that what began in the avant-garde ended up as the basis of corporate ad campaigns stretch through the decades of the 1920s and 1930s and across Western Europe, from the newly emerging Soviet Union to the

ever-widening circles of emigration patterns which accompanied the rise of fascism in the 1930s. The careers of El Lissitzky, of Jan Tschichold and of Herbert Bayer are exemplary in both the graphic transformations of experimental techniques which occur in their work and in the shifts of client base and attitudes toward their aesthetic choices.

The situation in which these individuals, and their students and imitators, worked had several distinct characteristics determining its form: the look of printed matter had been radically influenced by the mainstream literary and publishing activities of Futurists and Dadaists of the 1910s. Their appropriation of mass publishing techniques, the ransacking of display cases, dingbat cases, and eclectic assembling of innumerable visual elements chosen expressly to dispel the ennui of the tradition of literary printing had effectively blasted the aesthetics of the "grey page" of fine print wide open.

Every typographic designer from Tschichold to Bayer, Rodchenko and Lissitzky, knew about and mentioned the legacy of that experimental era. But the profile of the individuals who would become practitioners of graphic design, a discipline whose very existence is synonymous with the period of the 1920s and 1930s, were not, by and large, avant-garde poets. Though the continued activity of Schwitters, of Zdanevich, of Hausmann, and of Lissitzky to a measured and limited degree, remained linked to the production of avant-garde poetry and editions suited to its formal exigencies, the generation which came to the fore in the 1920s tended, in a general sense, to conceive their work within very different parameters. Their motivation was conceived, as were the tools and stylistics of their endeavors, within the already accepted existence of mass audience, mass production, and advertisement. This was the generation which developed techniques of visual display within print mass media which would catapult the funky naive quality of product announcements (which had littered the back pages and margins of late nineteenth-century publications with a rash of earnest language and typographic fussiness) into a major industry and a major instrument of cultural change. By the end of the 1930s, even before the explosion of consumer culture which followed the geared-up techno-industry of the Second World War, the development of graphic design into a means of production separate from products or their characteristics, use, or origins, had become fully established. The use of graphics as the means to make and perpetuate the image of the corporation, and through it, the virtuous projection of themes of progress, industry, and capitalist consumption, was essential to the development of the public fantasmatic notion of modern life. In that culture, images and

signs circulate without relation to their mode of production, and they sign the existence of a spectacle designed expressly for consumption, not productive necessity, but its surplus. Graphic design is not only the sign par excellence of this surplus, but is the very site in which it comes into being and is itself consumed as spectacle through the formal mechanics of display.

The invention of graphic design as both a professional discipline and a curricular category within academic institutions which had formerly considered visual arts only in their beaux arts forms occurred within the institutional framework of schools in the Soviet Union and Germany to which the leading figures of Bauhaus and Constructivism (and, even more so, Productivism) gave initiative. The revolutionary restructuring of these institutions combined with the increased need perceived by both industry and government for the mass media campaign to promote an ideological program of advanced industry. That this took place within both the developing infrastructure of a Soviet communist economy and a Western industrial economy is not so surprising, especially as both were gearing up as military industrial powers in anticipation of the coming war. That the production of military *matériel* would fuel the economies of both Soviet and Western powers to the advantage of the ruling "class" and the disastrous sacrifice of the disadvantaged (and increasingly economically disenfranchised) sectors of the population goes, of course, hand in glove with the advanced consolidation of the image of unity provided by multinational corporate control of capital across national boundaries.[36]

The legacy of the avant-garde was a radical formal language, visually and verbally considered. The invention of design as a profession and as a discipline within the changed form of arts academies—Vhkutemas and Bauhaus in particular—permitted the formal aspects of the avant-garde experiments a setting designated by the conspicuously suggestive term "laboratory" for investigation, codification, and transformation. The pseudo-scientific attitude signaled by this term was echoed in some of the Bauhaus rhetoric of formal functionalism, most apparent in the youthful Bayer's articulation of a program of what he took to be a minimalized economy of graphic means.

The changing aims of the Bauhaus through the 1920s chart its shift from an arts and crafts orientation, with a theosophical component, to an increasingly industrialized aesthetic. As Gropius redefined the Bauhaus goals, the change in personnel signaled clearly the sublimation of earlier utopian agendas under an embrace of a mass production technology—the change from the sensibility of Johannes Itten to that of

Lazslo Moholy-Nagy. Always within the stated apolitical and nonpartisan frame of the Bauhaus's operation, these shifts insured that the functional, instrumental aspects of the early avant-garde would not move toward greater applied engagement, but toward increasing aestheticization, formalism, and a materialism which put itself happily at the service of corporate communications. Bayer's capacity to produce such seamless designs made his work highly assimilable into the corporate world. The very featureless elements of his "universal" type were designed to be absorbed, made use of, without calling attention to themselves. Bayer's designs for rationalized design in type, in page layout, format, and above all, in the systematic design of a corporate "look" were tremendously successful. The letterforms themselves resembled machined parts, fabricated without interference of a human hand.[37]

By contrast, the work of Rodchenko retained a certain handmade quality. Though he included photographs, photo-engraving, and printing in the designs he made in the 1920s, the colors of his posters were produced in flat areas which resembled lithographic or silkscreen technology rather than the slick products of four-color separations and high-speed, high-volume printing. His letterforms had a blocky handdrawn style to them which stopped far short of Bayer's fabricated technographics. But Bayer would, like many of the designers of his generation, end up working for the affluent (and at that point, forward looking in terms of design) clients like the Container Corporation of America. The influence of such highly funded, high-visibility campaigns won out in influencing the development of graphic design through the postwar boom over the remote and old-fashioned seeming graphics of the Russians—whose products were in any case not widely circulated in the West in those decades. Bayer shared with Rodchenko and Lissitzky a deep conviction about the social effect of graphic design and knew that "typographic revolution was not an isolated event but went hand in hand with a new social and political consciousness and consequently with the building of new cultural foundations."[38]

Bayer, Rodchenko, Lissitzky, Moholy-Nagy—these are significant figures in the development of modern graphic design. Not least significant is that they all felt compelled, to some degree, to write about the principles of their work as designers and to create a metacritical discussion about it which had not existed previously. This, also, was one of the legacies of the self-conscious productions of the early twentieth-century modern artists. El Lissitzky, who chose to devote his design skills to the project of building the new Soviet Union, asserted the role of design as an element of construction in what was "not world visions, but world

reality." Rejecting the emotional, individualistic aspects of creative art, and the mystical tendencies of Russian abstract artists like Kandinsky, he proposed an objective creative activity as an effective, constructive instrument.

Tschichold was particularly articulate with respect to the political and social components of design aesthetics. His youthful book, *Die Neue Typographie* (published in 1928) had established both tenets and legitimacy for the clean lines of what became classic Swiss design. In that work he asserted the basis of a "modern" typography, countering the chaotic disorder which he saw as rampant in commercial practices. The typographic manuals and the printed evidence of commercial printing in the early twentieth century—which has all of the shortcomings and none of the virtues of the more artistic forms of typographic experiment—bear him out on this point. The particular habit of centering type on the page, hanging all the miscellaneous fragments of ad copy, or title page, or editorial offerings on a central axis (sometimes several on a single sheet) without any regard for the overall design and shape of the page came under particular attack.

Tschichold effectively changed this approach through his work, publications, and lecturing on the topic of asymmetrical typography. The premise of this approach was that a document, page, section were a whole and should have the balances and counterbalances of the textual blocks worked out rather than left to the hazards of space and the chance combinations of display faces. Opting for simpler, less decorative faces, for fewer faces in a more selective range of sizes, Tschichold streamlined the look of the pieces he designed.

By 1933, however, Tschichold found himself accused of being anti-German and degenerate by the emerging forces of the Social Democrats. At that point he left Germany for Basle and gradually began to consider the rigidity and orthodoxy of his "New Typography" as unconscionable, complicit with the attitudes of National Socialism. He renounced the "efficiency" he had touted so enthusiastically in his earlier work and took a strong stand against the rhetoric of a techno-efficiency which was seeming increasingly antihumanistic and totalitarian. He became convinced that the "unity" of style could be used to mask, shield, and conceal many contradictions in texts, images, and communication more generally.

Tschichold's justifiable horror at the ways in which a technics of efficiency articulated as an aesthetic could be deformed in the service of a Nazi regime of an all-too-smoothly functioning apparatus of destruction had caused him to rethink the orthodoxy of his youthful statements in

Die Neue Typographie. But the link between the militarism of the National Socialists and the rigidity of rules of order laid out in his original plan for typographic reform would not hold as the defining characteristic of strict typographic practice in the post-war period. The forms of repression according to which the structuring of power began to reformulate in the period following World War II would not have the conspicuous appearance or readily identifiable hallmarks of a military regime. Rather, the face of power, the image by which it would work its force in the world, would become the international corporate image of seamlessness and synthetic, technologically perfect, production. The daring diagonals, graphic manipulations, and experimental attention to the material features of visual language which had been given such slapdash nurturing in the experiments of Dada, Futurism, and Cubism had become well-behaved elements of the corporate machine, and the advertising profession became a most efficient partner in the business of promoting consumption as an effect of seamless images and a smoothly functioning ideological apparatus. The devices so conspicuously laid bare in the experimental work of the (albeit politically disparate) early twentieth-century artists became, within two decades, the most efficient means of concealing not only the marks of artistic and literary enunciation, but of the structures of economic power in corporate, state, and military production as well.

Summary Note

Typography renders apparent the relative, rather than the absolute, value of symbolic systems. No easy closure on signification is available in typographically experimental work. The surplus of information provided by the expressive manifestation of the written form cannot be fixed, as Saussure had wished to fix the values of linguistic terms, within a finite order of a closed set of elements. All of the various activities which typography can engage in in the production of value—pictorial analogy, emotional expression, formal iconic imagery, the freeing of linguistic elements from traditional syntactic relations and placing them into fieldlike arrangements—demonstrate its capacity to participate in the production of signified value. Material specificity enters into the final sum of semantic and symbolic value which collapses the planes of *imago* and *logos* in an uncomfortable and disturbing blend of presentational and referential modes which displace the fictive categories of

presence and absence. Rather than acting as subservient signifiers standing in for fully extant (and criticizable in Derridian terms as such) categories of the signified, the typographic operations make manifest the unsustainable aspect this old distinction.

Saussure's sign, in its metaphoric image as recto and verso of a sheet of paper, is shown to be hopelessly enmeshed in the very fibers of that sheet so that the illusion of distinction is destroyed by the material support which *makes* both sides of the sheet available for that fictive differentiation. It is *in* material that the activity of signification is produced, and the works here investigated simply make the extreme case for what is the norm: "Lettre-Océan" would cease to exist as such were it rendered in different form, its being depends on its material existence in specific terms. Other works suffer to lesser or greater degrees depending on the extent to which material concerns have been exploited in the construction of the work. But for the period of modern art practice, this concern with material was one of the major activities of both literary and visual arts. The generalization that the focus of art in the twentieth century has been to free the trace from referential value, taken as a truism in the critical examination of work of the modern mainstream through the mid-1970s, can be readily criticized by a realization that it was instead a self-conscious concern with the manipulation of the various elements of signification in both art and literary discourses which was central to modern art practice.

In summary, then, the "truth" value which was to be grounded in a linguistic sign, incorruptible by the influence of the relativizing effects of materiality *within* that sign as the material aspect of the signifier, was important to the grounding of a scientifically sound linguistics as Saussure conceived of it as well as an authoritative literary mode of production, while the purity of a visual sign immune to literary or linguistic influence was essential to the founding of a visual arts discourse infatuated with the myth of its autonomous universality. Since neither of these were features of the period of early modern art practice, whose investigations into the relations of elements of signification within the production of literary and visual arts carried both political and aesthetic implications, the integration of experimental typography in the activities of this period comes as no surprise. It was only in the course of the reductive and purifying critical enterprise of the modernist position, with its attachment to a deeply entrenched tradition which opposed *logos* and *imago* as distinct orders of representation, that typography raised issues by its very operation which were problematic on conceptual, critical, and historical grounds.

The presence of experimental typography within modern art practice is not only not incidental, but symptomatic of the tenor of the bulk of experiments of the period. Further, the investigation of typography points out an important implication for the critical investigation of signifying practices: that attention to materiality which is so repugnant to logocentrism (and which positions the visual arts as oppositional to this, as the realm of indulgent sensuality, and leads to all the systematic oppositional pairings of symbolic/semiotic, spiritual/material, etc. etc.) suffers an exile into inadmissability. The attitude of repugnance comes from a sense that materiality escapes the control of logocentric discourse, leading again to the reverse of this which is the imagined freedom of the visual domain from any such constraints. Recognition of materiality in its operative function, however, allows for an opening in the discourse of *logos* whose prejudices and biases depend on its claim to a closure which it names as truth, while it also allows for an escape from the reductive claim of *imago* to a purity to which any associative, referential cultural value would be repellent. Both categories are destabilized by the signifying function of materiality, both lose their reassuring capacity for closure—for the transcendent presence of the signified to be guaranteed by being, for the fully present signifier to be guaranteed by another form of being, both equally vulnerable to the contingent values of materiality. Relativizing both of these absolute values, tying them to specific historical and cultural contexts, the attention to materiality which the Dada, Cubist and Futurist poets elaborated in their typographic experiments was investigative and even momentarily subversive.

Introduction

1. This discrepancy still exists—the number of works which treat typography seriously in a theoretical manner constitute a limited, if increasing, bibliography while works on literature and visual arts of the early twentieth century are innumerable by contrast.

2. See the work of Carole Anne Taylor, *The Poetics of Seeing* (New York: Garland Publishing Co., 1985); Henry Sayre, *The Visual Text of William Carlos Williams* (Urbana: University of Illinois, 1983); Jerome McGann, *The Textual Condition* (Princeton: Princeton University Press, 1991); Marjorie Perloff, *Radical Artifice* (Chicago: University of Chicago Press, 1991); and the issue of *Harvard Library Bulletin* edited by Roland Greene, "The Material Poetry of the Renaissance/The Renaissance of Material Poetry" (Summer 1992), vol. 3, no. 2, for some of the work in this area. My thanks to Charles Bernstein for many of these references.

3. Obviously, I am introducing a rather polemic distinction here, and this will be part of the first chapter's discussion.

4. In this instance I am adhering to the work of Raymond Williams, particularly in the posthumously published *Politics of Modernism,* edited by Tony Pinkney (London: Verso, 1989).

Chapter 1

1. See Victor Burgin, *The End of Art Theory* (Atlantic Highlands, NJ: Humanities Press International, 1986), and Wendy Steiner, *The Colors of Rhetoric* (Chicago: University of Chicago Press, 1982) for two differently oriented discussions of semiotics in relation to literary and visual art in the twentieth century.

2. For the uninitiated, Terry Eagleton's *Literary Theory* (Minneapolis: University of Minnesota Press, 1983), and Terence Hawkes, *Semiotics and Structuralism* (Berkeley and Los Angeles: University of California Press, 1977) offer useful introductions to this topic.

3. Ferdinand de Saussure, *Cours de linguistique générale*, edited by Charles Bally and Albert Sechehaye (Paris: Payout, 1949), was the posthumous publication of lectures given between 1906 and 1911; Edmund Husserl's "Philosophy as a Rigorous Science," was first published in 1911 and *Ideen I* in 1913; the former is characterized by Quentin Lauer as a link between earlier pretranscendental work and later transcendental work. See the "Introduction" by Quentin Lauer to Edmund Husserl, *Phenomenology and the Crisis of Philosophy* (New York, Evanston and London: Harper Torchbooks, 1965).

4. Jacques Derrida, *Of Grammatology* (Baltimore and London: Johns Hopkins University Press, 1976) and *Speech and Phenomena and Other Essays on Husserl's Theory of Signs* (Evanston: Northwestern University Press, 1973).

5. Again, see Wendy Steiner, *The Colors*, particularly pp. xii and xiii of the "Preface," and then throughout.

6. An elaborate discussion of the conceptualization of these two terms within early modern art practice forms the basis of the following chapter.

7. See below, but also, in addition to Derrida, see Rosalind Coward and John Ellis, *Language and Materialism* (London, Henley and Boston: Routledge and Kegan Paul, 1977).

8. Roland Barthes, Frederic Jameson, and Julia Kristeva, as per below, but also see Kaja Silverman, *The Subject of Semiotics* (Oxford: Oxford University Press, 1983), for a general introduction.

9. See E. F. K. Koerner, *Ferdinand de Saussure: Origin and Development of His Linguistic Thought in Western Studies of Language* (Vieweg, Schriften sur Linguistik, 1973).

10. Maurice Pope, *The Story of Decipherment* (London: Thames and Hudson, 1975), provides a nontechnical and nontheoretical background.

11. Linguistics in the nineteenth century was largely concerned with the study of morphology and phonology, with the evolution of language forms and their use. It was one of Saussure's more genial points that he institutionalized the distinction between the synchronic and traditional diachronic approaches to the study of language.

12. Holger Pedersen, *The Discovery of Language: Linguistic Science in the 19th century*, translated by John Spargo (Bloomington: Indiana University Press, 1959).

13. See Pope, *Decipherment*, but also, Cyrus Gordon, *Forgotten Scripts* (New York: Basic Books, 1982).

14. With hieroglyphics this repressive function is particularly problematic since many of the specific linguistic values of the text depend on a reading of visual features such as spatial arrangement or determinatives. It can be pointed

out, however, that this is essentially no different than reading punctuation, paragraph indentation, or capitalization in an alphabetic code and that in both cases the net effect is to get the linguistic value and forget the written form. See also Erik Iversen, *The Myth of Egypt and Its Hieroglyphs* (Copenhagen and London: Gad, 1961).

15. It was also during the nineteenth century that the theory of the origin of the alphabet wandered toward a pictorial form. The idea that the nonfigurative, nonmimetic letters had had their origin in pictorial images was a product of this period's historical imagination—as if in some desperate search for a pictorial validity for writing, some original truth in the letters whose arbitrary form is in fact guaranteed by their Semitic origins. See Isaac Taylor, *The Alphabet, An Account of the Origin and Development* (London: Kegan Paul Tranch and Co., 1883).

16. See also, R. H. Robins, *A Short History of Linguistics* (London: Longman's Green and Co., 1967).

17. Theodore Rosset, *Recherches Experimentales pour l'Inscription de la Voix Parlée* (Paris: Armand Colin, 1911). For a more extensive list of references, see the bibliography.

18. See Roy Harris, *Reading Saussure* (London: Duckworth, 1987), and Jonathan Culler, *Ferdinand de Saussure* (London: Penguin, 1976) for overviews.

19. The most direct connection was between Russian experimental writers and the linguistic circles in Moscow and St. Petersburg; in France, Jean Paulhan was the writer most directly engaged with the study of linguistics and semiotics, see particularly, Jean Paulhan, *Jacob Cow, le Pirate: Ou si les mots sont des signes* (Paris, 1921) and early essays in *Oeuvres Complètes* (Paris: Circle du Livre Précieux, 1966); in terms of the anglophone poetry community, Ezra Pound, Hilda Doolittle, and Gertrude Stein most immediately come to mind as self-conscious practitioners.

20. Roland Barthes, *Image Music Text* (New York: Hill and Wang, 1977), especially the essays "The Photographic Message" and "The Rhetoric of the Image" are groundbreaking in this regard, as are a number of Meyer Schapiro's essays on semiotics. Other writers, mainly French, such as Louis Marin, Hubert Damisch, and Jean-Louis Schefer were particularly concerned with developing a semiotic model for the investigation of visual arts and in noting its problems.

21. All my references to Saussure will be to the *Cours de linguistique générale,* edited by Charles Bally and Albert Sechehaye (Paris: Payot, 1949), which is their transcription of Saussure's 1906–7, 1908–9, and 1910–11 lectures; some citations are from *The Course in General Linguistics,* English translation by Wade Baskin (New York: McGraw-Hill Book Company, 1966); I have also frequently used my own translation and referred to the pages of the French original.

22. Saussure, *Cours,* p. 45; *Course,* p. 23.

23. Saussure, *Cours,* p. 46; *Course,* p. 24.

24. Throughout chapter 6 of the *Cours* these "negative" words exist, and

their presence forms the basis of Derrida's attack on Saussure, thus it is important to realize what the object of Saussure's negativity is: the confusion of writing with spoken language rather than writing per se.

25. Saussure, *Course*, p. 23, and then p. 30.

26. Saussure, *Cours*, p. 51; *Course*, p. 30.

27. Saussure, *Course*, p. 30. Also, on p. 31, "The pronunciation of a word is determined, not by its spelling, but by its history."

28. Saussure, *Cours*, p. 53; *Course*, p. 30.

29. David Holdercroft, *Signs, System and Arbitrariness* (Cambridge: Cambridge University Press, 1981), has a useful discussion of the nature of Saussure's assessment of language; see also Raffaele Simon, "The Body of Language," in *Presence de Saussure* (Geneva: Droz, 1990), pp. 121–41.

30. Saussure, *Course*, p. 66.

31. Saussure, *Cours*, p. 144; *Course*, p. 103.

32. Saussure, *Cours*, p. 145; *Course*, p. 103.

33. Saussure, *Cours*, p. 146; *Course*, p. 104.

34. Saussure, *Cours*, p. 164; *Course*, pp. 117–18.

35. Saussure, *Cours*, p. 36; *Course*, p. 18.

36. Saussure, *Cours*, p. 37; *Course*, p. 18.

37. Charles W. Morris, *Writings on the General Theory of Signs* (The Hague: Mouton, 1971).

38. Saussure, *Cours*, p. 121; *Course*, p. 168.

39. Jean Starobinski, *Words Upon Words*, translated by Olivia Emmet (New Haven and London: Yale University Press, 1979), p. 14.

40. Starobinski, *Words*, p. 15.

41. Saussure, *Cours*, p. 25; *Course*, p. 9.

42. Saussure, *Cours*, p. 30; *Course*, p. 13.

43. Robert Strozier, *Saussure, Derrida and the Metaphysics of Subjectivity* (Berlin, New York and Amsterdam: Mouton de Gruyter, 1988), elaborates on these issues, taking another approach.

44. The influence of Charles Peirce and his work on semiotics should be factored in a full account of the twentieth-century developments of semiotic analysis.

45. For one brief historical survey of the development of the Prague School, see Ladislav Matejka, "Postscript: Prague School Semiotics," in *Semiotics of Art*, edited by Ladislav Matejka and Irwin R. Titunik (Cambridge, MA, and London: Cambridge University Press, 1976), pp. 265–90.

46. See Terence Hawkes, *Structuralism and Semiotics* (Berkeley: University of California Press, 1977), for an introductory overview. Also, Charles Morris should be mentioned here because of the major contributions he made, espe-

cially in expanding Saussure's syntactic and semantic categories of linguistic activity to include the all-important domain of pragmatics. Morris's addition in some ways complements that of the Prague School writers, such as Petyr Bogatyrev and Jan Mukarovsky, who placed major emphasis on the social function and operation of signs, but the aims of the two are distinctly different.

47. Matejka, "Postscript," p. 267.

48. Lee T. Lemon and Marion J. Reis, *Russian Formalism* (Lincoln, NB: University of Nebraska Press, 1965), and George Gibian and H. W. Tjalsma, *Russian Modernism* (Ithaca, NY: Cornell University Press, 1971).

49. Roman Jakobson, cited in Tzvetan Todorov, *Theories of the Symbol* (Ithaca, NY: Cornell University Press, 1982; originally published in Paris, Editions du Seuil, 1977), p. 271.

50. Roman Jakobson, *Language in Literature* (Cambridge, MA: Harvard University Press, 1987), and "Responses," an interview between Jakobson and Tzvetan Todorov, in *Poetique* 3 (February 1984).

51. Cited in Tzvetan Todorov, *Theories of the Symbol*, p. 271.

52. Roman Jakobson, *Questions de poétique* (Paris: Editions du Seuil, 1973).

53. Roman Jakobson, "What Is Poetry?" (1933–34), in *Semiotics of Art*, edited by Matejka and Titunik, p. 174.

54. Peter Steiner, *Russian Formalism: A Metapoetics* (Ithaca, NY: Cornell University Press, 1984), and Victor Erlich, *Russian Formalism* (New Haven and London: Yale University Press, 1955 and subsequent editions).

55. Mikhail Bakhtin and Pavel Medvedev, *The Formal Method in Literary Scholarship* (Cambridge, MA: Harvard University Press, 1985; first published 1928).

56. Petyr Bogatyrev, "Costume as Sign" (1936), in *Semiotics of Art*, edited by Matejka and Titunik, pp. 13–19.

57. Mukarovsky, "Art as Semiotic Fact," in *Semiotics of Art*, edited by Matejka and Titunik, p. 6.

58. Mukarovsky, "The Essence of the Visual Arts," in *Semiotics of Art*, p. 241.

59. Ibid., p. 243.

60. Again, my intention here is not to map French intellectual history in the 1960s but to trace the sources for the concept of materiality of the signifier, very briefly, to fill the gap between Saussure and Derrida.

61. Josette Rey-Debove, *Lexique Semiotique* (Paris: Presses Universitaires de France, 1979), p. 135.

62. Bogatyrev, "Costume as Sign," in *Semiotics of Art*, edited by Matejka and Titunik, p. 14.

63. Roland Barthes, "Myth Today," in *Mythologies* (New York: Hill and Wang, 1980), p. 113.

64. Louis Hjelmslev, *Prolegomena to a Theory of Language* (Madison: Uni-

versity of Wisconsin Press, 1963); also this point is made by L. Matejka, "Post-script," p. 282.

65. Husserl, *Phenomenology and the Crisis of Philosophy* (New York: Harper and Row, 1965), pp. 71–147.

66. This is convoluted. I am proposing that the subject of interpretation has to be factored into a formalist position such as that of Clive Bell even when it is unacknowledged. This is a somewhat heretical statement, since it negates the possible objectivity of the positivist position. What is consistent here, and will be throughout, is my insistence on the role of the individual, historical, and culturally specific subject in the production of signification.

67. Charles Peirce, *Philosophical Writings* (New York: Dover, 1955, reprint of the 1940 edition); p. xii, "Introduction" by Justus Buchler: "In Peirce's labours toward a scientific philosophy, his empirical phenomenology is an essential factor." The "Logic as Semiotic" was first published in 1897.

68. Heidegger made several attempts to incorporate history into his philosophical method; assessment of his success depends on the disposition of the reader—Terry Eagleton, for instance, is dismissive in *Literary Theory* (Minneapolis: University of Minnesota Press, 1983), pp. 62–67, where he also discusses the late work of Husserl in regard to the project of historicization and/or the theory of history in phenomenological method.

69. I say supposedly and qualify this because the relation between signifier and signified has always been linked, in my understanding, to basic problems of speech and cognition—thinking to uttering or uttering to understanding—for either speaker or addressee—there is a lag, a space, between signified and signifier, or signifier and signified—as concept and utterance or as utterance and comprehension.

70. Derrida, *Grammatology*, and his *Speech and Phenomena*.

71. Derrida, *Speech and Phenomena*.

72. See Peter Dews, *The Logics of Disintegration* (London and New York: Verso, 1987).

73. This summary is reductive to the point of simplisticness and leaves me open to considerable criticism, but while Derrida's criticisms and insights are significant here, I don't wish to make his work the sole object of my study, which, to do it justice, would be necessary. There are plenty of other critics who have done this, from Stephen Heath through Barbara Johnson; Jonathan Culler's *On Deconstruction* (Ithaca, NY: Cornell University Press, 1983) provides a useful bibliography for this topic.

74. Coward and Ellis, *Language and Materialism*.

75. Frederic Jameson, *The Prison House of Language* (Princeton, NJ: Princeton University Press, 1972); *Marxism and Form* (Princeton, NJ: Princeton University Press, 1974); *The Political Unconscious* (Ithaca, NY: Cornell University Press, 1981); Louis Althusser, *Lenin and Philosophy* (New York: The

Monthly Review Press, 1971); and Roland Barthes, *Image Music Text* and *S/Z* (New York: Hill and Wang, 1974); in addition, the pages of *Screen* magazine, *Discourse, m/f,* and so forth.

76. Norman Bryson, in *Vision and Painting: The Logic of the Gaze* (New Haven and London: Yale University Press, 1983), discusses Barthes's development in an interesting way; but again, Kaja Silverman, *The Subject of Semiotics,* for all its problems, offers a good introductory overview.

77. These are Husserl's terms.

78. This argument privileges the status of the original document unduly, but the principle is important, since any physical document provides the matter on which links to historical conditions of production can be established.

79. I am paraphrasing Peter Dews's analysis of Husserl and Derrida, *Logic,* p. 9.

80. Kristeva's work of the 1970s: *Semiotiké: Recherches pur une semanalyse* (Paris: Seuil, 1969); *La Revolution du Langage Poetique* (Paris: Seuil, 1974); and the two very important essays: "The Semiotic Activity," *Screen* 14, nos. 1 & 2 (Spring and Summer 1973); and "The System and the Speaking Subject," *Times Literary Supplement,* October 1973 (London); see also, Toril Moi, ed., *The Kristeva Reader* (New York: Columbia University Press, 1986).

81. Moi, *Kristeva Reader,* introduction, p. 32.

82. Ibid., p. 17.

83. She extends this to a discussion of the semiotic as that which is associated with the unconscious, and, in turn, with the mother and body of the mother; all aspects of her work which I find extremely problematic, binaristic, and essentialist.

84. In this respect, Kristeva assigns to the unconscious and to the somatic drives a romantic power of disruption. Contrast this with Foucault's discussions in the *History of Sexuality,* which describe the unconscious and its drives as also subject to historical and cultural constraints in their formation and their perceived force as expression.

85. This is obviously the tiniest tip of the gigantic iceberg on which the semiotic project founders with respect to the visual arts. That images are a symbolic system, culturally coded, psychically motivated, and ideological, is inarguable, but any simplistic, facile projection of semiotic terminology onto the field of the image is readily shown up as a misguided venture.

Chapter 2

1. Rosa Trillo Clough, *Looking Back at Futurism* (New York: Cocce Press, 1942); Graziella Lehrman, *De Marinetti à Maiakovski, Destins d'un Movement Littéraire occidental en Russe* (Fribourg: Université de Fribourg, 1942); and more recently, such works as Alan Robinson, *Symbol to Vortex* (New York: St. Martin's, 1985), and Marjorie Perloff, *The Futurist Moment* (Chicago: Univer-

sity of Chicago Press, 1986), and Gerald Janacek, *The Look of Russian Literature* (Princeton, NJ: Princeton University Press, 1984) for some discussion of the legacy of Futurism.

2. It would be patently absurd to claim that Symbolism was the major force in anglophone poetics, especially in turn-of-the-century American writing, and similarly, in German poetics other influences temper the Symbolist legacy. But the work which is the focus here will largely be within the francophone tradition in which both Symbolism and Mallarmé were significant elements—even in the transformed version of Symbolism, which is represented in Russia by V. Ivanov, K. Balmont, early Briusov, and A. Bely.

3. See Dick Higgins, *Pattern Poetry: Guide to an Unknown Literature* (Albany: State University of New York Press, 1987), as a useful compendium and historical survey.

4. Suzanne Bernard, "Le Coup de dés de Mallarmé replacé dans la perspective historique," *Revue d'histoire littéraire de la France* 52, no. 2 (avril–juin 1951): 184–86, suggests that Mallarmé was intrigued by the possibilities of advertising typography.

5. Janine D. Langan, *Hegel and Mallarmé* (London and New York: University Press of America, 1986), p. 12.

6. Robert Greer Cohn, *Mallarmé's Un Coup de Dés: An Exegesis* (New York: Yale French Studies, AMS Press, 1949), p. 3.

7. Robinson, *Symbol to Vortex*, p. 13.

8. David Seaman, *Concrete Poetry in France* (Ann Arbor: University of Michigan Press, 1982), pp. 117–150, has a discussion of Mallarmé's poem and various interpretations which have been offered, some of which are more arcane than the original.

9. Stéphane Mallarmé, "The Book: A Spiritual Instrument," *Selected Poetry and Prose*, edited by Mary Ann Caws (New York: New Directions, 1982), p. 82.

10. Mallarmé, "The Book: A Spiritual Instrument," p. 84.

11. Penny Florence, *Mallarmé, Manet and Redon* (Cambridge: Cambridge University Press, 1986), p. 116.

12. Guy Michaud, *Mallarmé* (New York: New York University Press, 1965), p. 138.

13. Langan, *Hegel and Mallarmé*, p. 12.

14. See Andreas Huyssen, *After the Great Divide* (Bloomington and Indianapolis: Indiana University Press, 1986), for a recent discussion of the heterogeneity of modern art. An older, standard discussion occurs in the James Bradbury and Malcolm McFarlane, *The Name and Nature of Modernism* (New York: Penguin, 1976), chapter entitled "The Name and Nature of Modernism."

15. Michael Levenson, *A Genealogy of Modernism* (Cambridge: Cambridge University Press, 1984).

16. As with any and all of these terms, there is a difference between what they

designate as a body of work and also as an aesthetic position when they are used in visual arts versus the literary domain. Obviously, Impressionism must also be included in speaking of late nineteenth-century movements whose influence is inescapable in the early twentieth century, but since my discussion is not on this inheritance and its transformation (though I will give that some attention within the analysis of each individual artist), it seems pointless to dwell on the difficult issue of distilling and distinguishing the aesthetic positions among these groups; I will assume a conventional understanding of their definition and its attendant properties.

17. Laura Riding and Robert Graves, in their *Survey of Modern Poetry* (London: William Heineman, Ltd., 1927), wrote, "Modern French poetic theory lays a great deal of emphasis on the phonetic sense of words; and has done so increasingly since the Symbolists" (p. 35).

18. Wassily Kandinsky, "A propos de la grande utopie" (1919), in *Art et Poésies Russes*, edited by Troels Andersen and Ksenia Grigorieva (Paris: Pompidou, 1979), p. 123.

19. Jacques Derrida, *Of Grammatology* (Baltimore: Johns Hopkins University Press, 1974).

20. The evident influence of Bergsonian philosophy on this attitude has been pointed out: Michael Levenson's *A Genealogy of Modernism* (Cambridge: Cambridge University Press, 1984) is the immediate source within my discussion, but the reference is a common one in, for instance, Edward Fry, *Cubism* (New York: McGraw Hill Book Co., 1968).

21. These "categories" are somewhat unstable since, for instance, the "essence" of Rayonnism is bound up with the examination of subjective, phenomenological experience and the phenomenology of Cubism often engages itself with absolute categories of existence, etc. This initial discussion, however, allows certain distinct attitudes toward materiality to be clarified in relation to one another.

22. Levenson, *Genealogy*, p. 110.

23. Cited by Levenson, in *Genealogy*, p. 126.

24. *Egoist* (1 June 1915), p. 88.

25. There are many issues which could be raised to counter or support the generalized arguments I am making here, since each point would vary depending upon *whose* work was being talked about *when* and *which* of their works was under discussion. It does seem important, for instance, to see the influence of the retinal argument of the Realist painters, its links to Impressionism, and the resurfacing of this in the subjective modern attempt to find an accuracy in their own materials.

26. Maurice Raynal, in Edward Fry, *Cubism*, p. 151.

27. David Lodge, "Modernism, Anti-Modernism and Post-Modernism," in *Working with Structuralism* (London: Routledge and Kegan Paul, 1981), pp. 3–16; originally a talk at the University of Birmingham in 1977.

28. C. K. Ogden, I. A. Richards, J. Wood, *Foundations of Aesthetics* (New York: Lear Publishers, 1925), p. 28.

29. See Milton Klonsky, *Speaking Pictures* (New York: Harmony Books, Crown Publishers, Inc., 1975), for a survey of these materials, as well as Dick Higgins, *Pattern Poetry: Guide to an Unknown Literature* (Albany: State University of New York Press, 1987).

30. I am thinking in particular of Pound, H.D., Apollinaire, Reverdy, Mayakovsky, and Marinetti here; of Zdanevich, Ball, Arp, Schwitters, Marinetti above; of Tzara, Shklovsky below. But these are as *examples* and my characterization is in no way intended to define these poets' work by such categorization. For a discussion of visual poetics in English modernism, see Jerome McGann, *Black Riders: The Visible Language of Modernism* (Princeton, NJ: Princeton University Press, 1993).

31. For one treatment of this topic, see P. Medvedev and M. Bakhtin, *The Formal Method in Literary Scholarship* (Cambridge, MA: Harvard University Press, 1985; first published 1928), p. 57.

32. Ibid.

33. I do not mean this phrase to be taken metaphorically, but literally, as a look at Khlebnikov's "A Checklist: The Alphabet of the Mind" would quickly demonstrate (in Velimir Khlebnikov, *Collected Writings* [Cambridge, MA: Harvard University Press, 1987], vol. 5, pp. 314–17).

34. Khlebnikov, "The Word as Such," *Collected Works*, vol. 5, p. 255.

35. Khlebnikov, "On Poetry," *Collected Works*, vol. 5, p. 370.

36. Khlebnikov,"The Word as Such," *Collected Works*, vol. 5, p. 257.

37. Khlebnikov, "The Word as Such," *Collected Works*, vol. 5, p. 257.

38. Lily Feiler, preface to *Mayakovksy and His Circle*, by Viktor Shklovsky (London: Pluto Press, 1972), p. xv.

39. Victor Erlich, *Russian Formalism* (New Haven, CT: Yale University Press, 1981), p. 45, paraphrasing Kruchenyk.

40. Roman Jakobson, manifesting his poetic and linguistic dispositions, speaks of phonemes as "auditory representations capable of association with semantic representations" and the thrust of his analytic method is its emphasis on the interrelation of linguistic form and poetic message, an interrelation carried to the point of inseparableness. See Roman Jakobson, the 1919 essay "La Nouvelle Poésie Russe," in *Questions de Poétique* (Paris: Editions du Seuil, 1973), p. 21.

41. Peter Steiner, *Russian Formalism: A Metapoetics* (Ithaca, NY: Cornell University Press, 1984), references in Chapter I.

42. Riding and Graves, *Survey of Modern Poetry*, p. 47.

43. This is from Richard Aldington's list of attributes in *Egoist* 1, no. 11 (1 June 1914).

44. May Sinclair, *Egoist* (1 June 1915), p. 88.

45. Cited in Levenson, *Genealogy,* p. 126.

46. May Sinclair, *Egoist,* p. 88.

47. Ezra Pound, *Egoist* (16 March 1914).

48. See Marcel Raymond, *De Baudelaire au Surréalisme* (Paris: Jose Corti, 1940), tracing this from Baudelaire; also, on p. 217, Raymond refers to Apollinaire's "materialist" poetry.

49. Dore Ashton, "The Other Symbolist Inheritance in Painting," in *The Symbolist Movement,* edited by Anna Balakian (Budapest: Akadémiai Kiadó, 1982), p. 513.

50. Raymond, *De Baudelaire au Surréalisme,* p. 229, makes the point that Apollinaire was *the major* influence on French poetry from 1909 to 1920.

51. Guillaume Apollinaire, *Selected Writings,* edited by Roger Shattuck (New York: New Directions, 1948), p. 27.

52. *Les Soirées de Paris,* no. 21 (15 February 1914), p. 78.

53. Apollinaire on "Modern Painting," from Edward Fry, *Cubism,* p. 116.

54. It is interesting to see how Raymond struggles to define Tzara; the best he can do is to compare him to Jarry—but this misses the point, as Jarry's absurdity is clearly parodic, with the French bourgeoisie as its actual referent, while Tzara's poetics are aimed at any and all systematic terms of logic and language as Symbolic order—an entirely different project.

55. Dada, as described by Marcel Raymond (*De Baudelaire au Surréalisme,* p. 267) has three axes—that of Duchamp/Picabia, that of Apollinaire/Albert-Birot, and that of Tzara. Certainly a discussion of Duchamp's attitudes toward language and material would be consistent with Tzara's, though Duchamp's attack is aimed at art institutions while Tzara's is aimed at symbolic order/social order on a larger scale. Apollinaire, it seems to me, cannot be included among the Dada poets as his personal politics and poetic intentions, while they may, by their collage approach, have stylistic relations to Tzara's, are distinct from the Dada position in every other way. Apollinaire does not share the attitude of *negation* which is central to Tzara's approach, nor does Albert-Birot.

56. Ogden, Richards, and Wood, *Foundations of Aesthetics,* p. 28.

57. Honor M. Pulley, Letter to the Editor, *Egoist* (15 August 1914), p. 318.

58. See Werner Haftmann, *Painting in the Twentieth Century* (New York: Praeger, 1965), vol. 2, pp. 147–49.

59. Haftmann is typically *modernist* in his discussion of what he terms concrete painting—reducing it to formal exercises without attention to or belief in their capacity to engage with content.

60. Also, Franz Kupka and the American Synchromists (Stanton MacDonald Wright and Morgan Russell) deserve mention here. Robert Delaunay, "Letter to August Macke," pp. 317–18, "Letter to Wassily Kandinsky," pp. 318–19, and "Light," pp. 319–20, in Herschell B. Chipp, *Theories of Modern Art* (Berkeley: University of California Press, 1968).

61. Haftmann, *Painting*, citing Georges Braque, p. 79.

62. Gleizes and Metzinger, "On Cubism," from Fry, *Cubism*, p. 110.

63. Pierre Reverdy, in Fry, *Cubism*, p. 145.

64. Ezra Pound, "On the Vorticist Art of Edward Wadsworth," in *Egoist* 1, no. 16 (15 August 1914).

65. Remember that for Pound the artwork is "a formal structure whose components nevertheless are essentially psychological constituents: energy, emotion, idea" (in Levenson, *Genealogy*, p. 135).

66. José Ortega y Gasset, *The Dehumanization of Art* (Princeton, NJ: Princeton University Press, 1968), p. 14.

67. Apollinaire, "On Painting," *The Cubist Painters: Aesthetic Meditations*, translated by Lionel Abel (New York: Wittenborn Schulz, 1944), pp. 17–18.

68. Roger Fry, cited by Peter Faulkner, in *Modernism Reader* (London: Batsford, Ltd., 1986), p. 19; Fry in 1912.

69. Reverdy, "On Cubism," in Fry, *Cubism*, p. 144.

70. Waldemar George, "Introduction" to a 1921 Exhibition, in Fry, *Cubism*, p. 161.

71. Reverdy, "On Cubism," in Fry, *Cubism*, and he goes on to stress that it is *not* emotion or some intangible which is being represented either, it is really and actually the work in itself.

72. Gleizes and Metzinger, in Fry, *Cubism*, p. 109.

73. Roger Fry, "An Essay in Aesthetics," in Francis Frascina, *Modern Art and Modernism* (New York: Harper and Row, 1982), p. 86.

74. Roger Allard, for instance, writing in 1912: "The subject of the picture, the external object, is merely a pretext: the subject of the equation" (in Fry, *Cubism*, p. 71).

75. One of the most extreme arguments about the interpretability of Cubist collage is Patricia Leighten's *Re-Ordering the Universe* (Princeton, NJ: Princeton University Press, 1989).

76. 1912 is the date of the Donkey's Tail exhibition, which is considered the culminating event of Neo-Primitivism; see John Bowlt, "Neo-Primitivism and Russian Painting," *Burlington Magazine* 116 (March 1974): 133–40.

77. Mikhail Larionov, *Une Avant-Garde Explosive*, edited by Michel Hoog and Solina de Vigneral (Lausanne: L'Age d'Homme, 1978).

78. David Burliuk, "Cubism," in *Art et Poésie Russes*, p. 57.

79. See Benjamin Buchloch's "From Faktura to Factography," *October*, no. 30 (Fall 1984): 83–126.

80. Jean-Claude Marcade, "Malevich," in *The Avant-Garde in Russia, 1910–1930*, edited by Stephanie Barron and Maurice Tuchman (Los Angeles: Los Angeles County Museum of Art, 1980), p. 25.

81. Ibid., p. 22.

82. Ibid., p. 20.

83. W. Kandinsky, *From Point to Line to Plane* (London: Dover, 1979), reprint of 1947 book, p. 21.

84. Ibid.

85. Ibid., p. 22.

86. Piet Mondrian, *Le Neoplasticisme* (Paris: Editions de L'Effort Moderne, 1920), p. 4.

87. Ibid., p. 5.

88. Haftmann, *Painting*, p. 45.

89. The use and investigation of these formal elements for their own sake, as a so-called "purely visual" set of compositional elements, occurred *not* in this early innovative period, but in the second generation appropriation of their means for very different ends. The work of Bourgogyne Diller, for instance, in America was almost exclusively formal in its presuppositions and its execution, a denuded neo-plasticism which was effective in its visual forms, but void of the complex of factors involved in Mondrian's theoretical and artistic work. One sees a similar, though more perverse transformation, evacuation of meaning in the work of Nicolas Pevsner and Naum Gabo as they shift from the context of Russian Constructivism into the domain of American formalism. See Benjamin Buchloh's insightful and highly detailed discussion in "Cold War Constructivism," *Reconstructing Modernism*, edited by Serge Guilbaut (Cambridge, MA, and London: The MIT Press, 1990), pp. 85–112.

90. Schwitters, "Merz," in Robert Motherwell, *Dada Painters and Poets* (New York: Wittenborn Schulz, 1951), p. 59.

91. G. Grosz, J. Heartfield, W. Herzfelde, *Art Is in Danger* (Willimantic, CT: Curbstone Press, 1987), the essay "Art Scab."

92. Hans Kreitler, "The Psychology of Dadaism," in *Dada, Monograph of a Movement*, edited by Willy Verkauf and Arthur Niggli (New York: Wittenborn Schultz, 1957), p. 74.

93. Maurice Raynal, in Fry, *Cubism*, p. 152.

94. Georges Braque, "Thoughts on Painting," 1917, in Fry, *Cubism*, p. 147.

95. Naum Gabo, "Philosophy of Constructive Realism," cited by Herbert Read in *The Philosophy of Modern Art* (New York: Meridian Books, 1954), p. 97.

96. Metzinger, "Note on Painting" (1910), in Fry, *Cubism*, p. 59.

97. Reverdy, in Fry, *Cubism*, p. 144. And Michael Levenson notes: "Whistler and Kandinsky and some cubists were set to getting extraneous matter out of their art; they were ousting literary values" (Levenson, *Genealogy*, p. 130).

98. Michel Seuphor, *Abstract Painting* (New York: Abrams, 1964, Dell reprint), pp. 157–58, here betraying his own Symbolist predilection.

99. Huntley Carter, "Some New Books in Art," *Egoist* 1, no. 12 (15 June 1914), p. 235.

100. Levenson, citing Wyndham Lewis in *BLAST*, in *Genealogy*, p. 78.

101. Meyer Schapiro, *Modern Art* (New York: George Braziller, 1978), p. 167.

102. Harry Levin, "What Was Modernism?" in *Refractions* (Oxford: Oxford University Press, 1966), p. 286.

Chapter 3

1. Of the many sources I drew on for this section, I list the following examples: extract from the journal *L'Imprimerie* (Paris: Libraries Reunis); L. Toureaux, *Typographie, Grammaire de la Composition* (Paris: Champion Librarie, 1884); Emile Mermet, *La Publicité en France* (Paris: 1880).

2. *La Publicité*, first published 15 August 1903, in Paris.

3. "Typographie des Annonces," *La Publicité*, no. 17 (August 1904), Deuxième Année, p. 8 (Paris: P. Raveau et Cie., editors).

4. *La Publicité*, no. 114 (January 1913), p. 261.

5. *La Publicité*'s editors succinctly commented, "We think this is a good advertisement" (p. 260).

6. *La Publicité*, p. 262.

7. James Campbell, "Littleness in Literature," *Times Literary Supplement* (12–18 October 1990): 1098.

8. Gerard-Georges Lemaire's *Les Mots en Liberté Futuristes* (Paris: Jacques Damase, 1986) is the most recently published survey of the typographic work of the Italian Futurists.

9. Carol Vanni Menichi, *Marinetti, Il Futurista* (Florence: Tellini, Studio Kronos, 1988), and Giovanni Lista, *Marinetti* (Paris: Seghers, 1976), offer biographical information surveying Marinetti's activities. In addition, Marinetti's own *Marfaka, Le Futurista* provides its own insights.

10. This was particularly true in Russia, as per the accounts of Vladimir Markov, *Russian Futurism* (Berkeley and Los Angeles: University of California Press, 1968), and others.

11. See Marjorie Perloff, *The Futurist Moment* (Chicago: The University of Chicago Press, 1986), especially the chapter "Violence and Precision: The Manifesto as Art Form," pp. 80–115, for a discussion of the rhetoric of Marinetti's manifestos.

12. Claudia Salaris, Maurizio Calvesi, and Luce Marinetti, *Filippo Tomasso Marinetti* (Florence: La Nuova Italia Editrice, 1988) has extensive photographic documentation of Marinetti's activities.

13. Jaroslav Andel, *The Avant-Garde Book 1900–1945* (New York: Franklin Furnace, 1989), p. 6.

14. Ibid., p. 6.

15. Gabriella Lehrman, *De Marinetti à Maiakovski* (Fribourg: Université de Fribourg, Imprimerie de la Gare, 1942), here citing V. Hoffman, p. 42.

16. Michel Decaudin, *La Crise des Valeurs Symboliste* (Toulouse: Privat, 1960), p. 23, citing Firmin Roz in *L'Hermitage*, 15 April 1982.

17. This statement was made by Rosa Trillo Clough in her study, *Looking Back at Futurism* (New York: Cocce Press, 1942), p. 55: "Analogical discovery in Futurist criticism was that inspired vision which penetrates to the essence of reality and discloses the communion of all things by indicating the identity of their source." This can be considered correct only insofar as Marinetti was convinced of the dynamism of all things and a kind of essentialism in language itself.

18. F. T. Marinetti, "Technical Manifesto of Futurist Literature," in *Futurisme*, edited by Giovanni Lista (Lausanne: L'Age d'Homme, 1973), p. 133.

19. F. T. Marinetti, "Supplement to the Technical Manifesto," in Lista, *Futurisme*, p. 140.

20. Jeffrey Schnapp's "Politics and Poetics in Marinetti's *Zang Tumb Tuuum*," *Stanford Italian Review* (Spring 1985): 75–92, contains a suggestive discussion of the public aspects of Marinetti's poetics and language analyzed in terms of the attack on the conventional speaking subject.

21. Giovanni Lista, introduction to *Mots en Liberté* (Lausanne: L'Age d'Homme, 1987), p. viii.

22. F. T. Marinetti, "Sensibilite Futuriste," in Lista, *Futurisme*, p. 142.

23. Giovanni Lista, "Introduction," *Futurisme*, p. xii.

24. Luciano de Maria, "Futurisme Littéraire," in *Le Futurisme 1909–1916* (Paris: Musée Nationale d'Art Moderne, 1973), p. 44.

25. F. T. Marinetti, *Mots en Liberté Futuristes*, edited by Giovanni Lista (Lausanne: L'Age d'Homme, 1987), p. 144.

26. Marinetti, "Mots en Liberté" and "Imagination sans Fils," both in Lista, *Mots en Liberté Futuristes*, p. 153.

27. Lista, *Futurisme*, n.p. 154.

28. Pierre de Massot, *De Mallarmé à 291* (St. Raphael: Au Bel Exemplaire, 1922), p. 21.

29. De Massot was not the only writer to find the Futurist use of typography a distortion of Mallarmé's more respected efforts, and the denigration of Marinetti's work has continued, for example: "The typographic composition which Mallarmé says is the attendant to a rite had no other end but to be the handmaiden to an explosion that would demystify all aesthetics, going against all received habits, including those of current practice." This comes from Dora Vallier, "L'avant garde russe et le livre éclaté," *Revue de L'Art*, no. 44 (Paris: 1979), p. 60.

30. Rosa Trillo Clough, *Looking Back at Futurism*, p. 63.

31. Ibid.

32. Marinetti, "Imagination sans Fils," in Lista, *Futurisme*, p. 147.

33. Marinetti, "Splendeur," in Lista, *Futurisme*, pp. 146, 150, and 149.

34. By contrast, think of Tzara, and his reasons for feeling aghast at the "rational" use of representational conventions for such depictions.

35. Josette Rey-Debove, *Lexique Semiotique* (Paris: Presses Universitaires de France, 1979), p. 135.

36. The phrase "language of rupture" is taken from Perloff.

37. André Billy's *Apollinaire vivant* (Paris: Ed. de la Sirene, 1923) and Marcel Adema's *Apollinaire le mal-aimé* (Paris: 1952) provide highly personal biographical studies.

38. Roger Shattuck, "Introduction," in Guillaume Apollinaire, *Selected Writings* (New York: New Directions, 1950), p. 20.

39. The work of J. P. Goldstein and I. Lockerbie (both in articles in *Que Vlo Ve?*, 29–30, 1981) has contributed to the analysis of the calligrammes in semiotic terms, and the study by Willard Bohn, *The Aesthetics of Visual Poetry* (Cambridge: Cambridge University Press, 1986), established a serious basis for the integration of visual factors into the analysis of the calligrammatic poems.

40. Even Marcel Adema makes this point several times in the course of his text, citing "Three Plastic Virtues" and other important art critical writings in terms of their nontechnical method.

41. G. Apollinaire, *Les Soirées de Paris*, no. 21 (15 February 1914).

42. Timothy Mathews, *Reading Apollinaire* (Manchester: Manchester University Press, 1987), make a very different argument. Mathews intently opposes the concept of the figure, which he sees as closed, and as an outmoded poetic trope, with Apollinaire's free verse openness. The concept of the figure invoked here is not meant to hark back to those tight images of romantic or classical poetry, but to suggest an image, as a resolvable and apparent form in the visual poems published in *Calligrammes*.

43. Apollinaire, "The New Spirit and the Poets," pp. 227–37 in *Selected Writings*, p. 237.

44. Guillaume Apollinaire, *Les Peintres Cubistes*, edited by L. C. Bruenig and J. C. Chevalier (Paris: Collection Savoir, Herman, 1980), p. 16. See Adema, *Apollinaire*, pp. 178–80, for the details of Serge Ferat's backing of *Les Soirées*, which he supported in part in order to promote his sister's painting (Baroness d'Oettingen, Roch Grey).

45. Apollinaire, *Les Peintres Cubistes*, edited by Bruenig and Chevalier, p. 34, citing Georges Lemaître.

46. G. Apollinaire, "Modern Painting," pp. 267–70 in *Apollinaire on Art* (New York: The Viking Press, 1972), p. 269. This citation is from a discussion of what Apollinaire termed "physical" Cubism, which he, in turn, characterized as a "minor" aspect.

47. Shattuck, "Introduction," in Apollinaire, *Selected Writings*, p. 27.

48. Marcel Raymond, *De Baudelaire au Surréalisme* (Paris: Jose Corti, 1940), p. 232.

49. For a discussion of Apollinaire's relation to Futurist painting and his shift to emphasis on Robert Delaunay and Orphic Cubism, see Mathews, chapter 2, "Poetry, Painting, Theory," pp. 86–126 in *Reading Apollinaire.*

50. Guillaume Apollinaire, "On Painting," in *The Cubist Painters* (New York: Wittenborn Schultz, 1949), p. 17. Further page references are cited in the text.

51. See Claude Dubon, *Guillaume Apollinaire après Alcools* (Paris: Minard, 1987), for a highly detailed linguistic analysis of the structures of Apollinaire's works.

52. Apollinaire, "On Painting," p. 11.

53. Shattuck, "Introduction," in Apollinaire, *Selected Writings,* p. 28.

54. G. Apollinaire, "The New Spirit," in *Selected Writings,* p. 237.

55. Michel Decaudin, "Apollinaire et les langues," in *Apollinaire, inventeur des langages* (Paris: Menard, 1973), p. 16. Further page references are cited in the text.

56. Apollinaire, *Les Soirées de Paris,* no. 21 (15 February 1914), p. 78.

57. Shattuck, "Introduction," *Selected Writings,* p. 15.

58. Apollinaire, "The New Spirit," *Selected Writings,* p. 229.

59. Again, see Timothy Mathews, *Reading Apollinaire,* pp. 177–82, for a discussion of identity and anxiety in Apollinaire.

60. Shattuck's "Introduction" to G. Apollinaire's *Selected Writings* notes that this was to be the subtitle of one section of *Calligrammes.*

61. Lista, *Futurisme,* p. 125.

62. Guillaume Apollinaire, "Quatres Lettres sur la Peinture," *Les Soirées de Paris,* no. 2 (March 1912, Paris), pp. 42–43.

63. Apollinaire, cited by Shattuck, *Selected Writings,* pp. 20–21.

64. Guillaume Apollinaire, *Calligrammes,* edited by Michel Butor (Paris: Editions Gallimard, 1966), p. 14.

65. Apollinaire, "The New Spirit," *Selected Writings,* p. 228.

66. Mathews, *Reading Apollinaire,* p. 178.

67. Once again, the response of Shattuck reflects the prejudices of the literary critic toward the visual manipulation of the text: "The words are arranged in a very complicated fashion—around central points, running up and down the page, broken into separate syllables or letters, and in many sizes of type. From this poem one does receive a certain impression of the distribution of the world in space, of distances which at the same time separate and link together remote places. But the lines are unreadable; thus sprinkled about the page, it is not a poem" (Shattuck, "Introduction," *Apollinaire,* pp. 19–20).

68. Bohn, *The Aesthetics,* pp. 18–24, provides many of the research details employed in this discussion.

69. Gabriel Arbouin, "Devant L'Ideogramme d'Apollinaire," *Les Soirées de Paris*, no. 26–27 (July/August 1914), p. 383.

70. This poem met with warmer reception even in Shattuck's critical discussion: ". . . where the variations in position of the lines correspond to the shifting attitude of the poet . . . the gradual transition was very similar to the sensibility Apollinaire generally displayed, slowly turning his attention across the world and speaking of each object as it entered his field of vision" (Shattuck, "Introduction," *Apollinaire*, p. 20).

71. My intention is not to disparage Shattuck, but to demonstrate the extent to which his problems with these works are indicative of a literary prejudice against the visual format so essential to Apollinaire's project.

72. See Perloff, *Futurist Moment,* chapter 4, "The Word Set Free: Text and Image in the Russian Futurist Book," pp. 116–60, for a discussion of the wider context for Zdanevich's work.

73. Gerald Janacek, *The Look of Russian Literature* (Princeton, NJ: Princeton University Press, 1984), p. 181.

74. Velimir Khlebnikov and Alexander Kruchenyk, "The Word as Such," in Khlebnikov, *Collected Writings* (Cambridge, MA: Harvard University Press, 1986), p. 257.

75. Susan Compton, *World Backwards: Russian Futurist Books 1912–1916* (London: British Museum Publications, 1978), p. 20; also see Khlebnikov's *Collected Writings* to get the full scope of his mystical orientation.

76. François Chapon, "Itinéraire d'Ilia Zdanevich de Tiflis à la rue Mazarine," *Iliazd* (Paris: Centre Georges Pompidou, 1976), p. 36.

77. "New Schools of Russian Poetry," unpublished mss. of Ilia Zdanevich, cited in Regis Gayraud's thesis, *Il'ja Zdanevič, Theoricien et Promoteur au Zaum dan ses Conferences Parisiennes, 1921–1923,* Memoire de D. E. A. sous la Direction de M. Michel Aucouturier, 1984, Université de Paris-Sorbonne, p. 58.

78. Ibid., p. 60.

79. Zdanevich, "For Berlin," *Iliazd* (1976), Appendix V, p. 94, delivered October 1922.

80. Zdanevich, "New Schools of Russian Poetry," *Iliazd* (1976), pp. 93–94.

81. Ibid., p. 93. These concepts are also active in the work of Khlebnikov and Kruchenyk, among others.

82. Ibid., p. 93.

83. Janacek, *The Look of Russian Literature,* citing Zdanevich, p. 22.

84. Compton, *World Backwards,* p. 65.

85. Vladimir Markov, *Russian Futurism* (Berkeley: University of California Press, 1968), p. 350.

86. Regis Gayraud, "Iliazd et le Degre 41," pp. 9–16 of *Iliazd: Maitrê*

d'oeuvre du livre moderne (Montreal: Université du Quebec à Montreal, 1984), p. 14.

87. Olga Djordjadze, "Ilia Zdanevich et le Futurisme Russe," *Iliazd* (1976), p. 16.

88. Françoise Le Gris-Bergmann, "Iliazd, ou d'une ouevre en forme de constellation," in *Iliazd* (1984), p. 75, citing Rifaterre, in her note 144.

89. The substance of the two preceding sentences were provided by André Markowicz, in conversation, Spring 1986.

90. Ledentu had been killed in an accident in 1917. Also, a much more detailed discussion of the thematic construction of all five plays is included in both my article, "The Futurist Work of Ilia Zdanevich," and my biography of *Iliazd*, still in mss.

91. This description is synthesized from the descriptions in Markov, Djordjadze, and Gayraud, as well as from discussion with André Markowicz.

92. Djordjadze, *Iliazd* (1976), p. 22.

93. Markov, *Russian Futurism*, p. 357.

94. Manuscript letter in Zdanevich Archive, courtesy of Hélène Zdanevich.

95. Janacek, *The Look of Russian Literature*, p. 164.

96. Ibid., p. 180.

97. Zdanevich, "New Schools" *Iliazd* (1984), p. 94.

98. Djordjadze, *Iliazd* (1976), p. 22.

99. Zdanevich, "New Schools," *Iliazd* (1984), p. 93.

100. Djordjadze, *Iliazd* (1984), p. 22.

101. Julia Kristeva, *Desire and Language*, edited by Leon S. Roudiez (Oxford: Blackwell/ New York: Columbia, 1980).

102. Tristan Tzara, "Seven Dada Manifestos," "#5," in *Dada Painters and Poets*, edited by Robert Motherwell (New York: Wittenborn Schultz, 1959; Cambridge, MA: Harvard, 1979), p. 95.

103. Tzara, "Second Manifesto," Motherwell, *Dada*, p. 80.

104. Georges Hughnet, *L'Aventure Dada* (Paris: Galerie de l'Institut, 1957), p. 8.

105. Ibid., p. 16.

106. Motherwell, *Dada*, citing Ribemont-Dessaignes, "History of Dada," p. 102.

107. Tristan Tzara, *Oeuvres Completes*, Tome i., 1912–14, edited by Henri Behar (Paris: Flammarion, 1975).

108. Yves Poupard-Lieussou and Michel Sanouillet, *Documents Dada* (Geneva: Weber, 1974), p. 7.

109. *Dada* #3 (December 1918), p. 54 (Zurich) (Paris: Jean-Michel Place, Paris 1976).

110. Poupard-Lieussou, *Documents*, p. 11.

111. *Da Dada*, Kunsthaus (Zurich), (Paris, Musée Nationale d'Art Modern, 1967), pp. 23–24.

112. Mary Ann Caws, *The Poetry of Dada and Surrealism* (Princeton, NJ: Princeton University Press, 1970), p. 41.

113. Ibid., p. 95.

114. Harriet Watts, *Chance: Perspective on Dada*, University Studies on the Fine Arts, Avant-Garde, #7 (Ann Arbor: University of Michigan Press, 1975/80), p. 118.

115. Raymond Federman, "The Language of Dada: Intermedia of Words," in *Dada and Surrealism* (New York: Queens College Press, 1972), p. 20.

116. Both in *Cahiers Dada et Surréalisme* #3 (1969). Sullerot's article is discussed in detail below.

117. Tristan Tzara, *Seven Dada Manifestos and Lampisteries*, translated by Barbara Wright (London: John Calder, 1977), p. 6.

118. Tristan Tzara, "Lecture on Dada" (1922), in Motherwell, *Dada*, p. 248.

119. In Doucet collection.

120. Letters, Doucet collection.

121. Hughnet, *L'Aventure*, p. 8.

122. Tzara, Section VIII of #5 "Manifesto on feeble love and bitter love," in Motherwell, *Dada*, p. 92.

123. Motherwell, *Dada*, excerpt from Marcel Raymond, *From Baudelaire to Surrealism*, p. xxxv. Original: Marcel Raymond, *De Baudelaire au Surréalisme* (Paris: Corti, 1933).

124. François Sullerot, "Des Mots sur le Marché," *Cahiers Dada et Surréalisme*, #3 (1969), Association Internationale Pour L'Etude de Dada et Surréalisme, France, p. 63.

125. Hughnet, *L'Aventure*, p. 20.

126. André Gide, "Dada," *Nouvelle Revue Française* (Paris), April 1920, p. 77.

127. Tzara, 1922, in Motherwell, *Dada*, p. 248.

128. Hughnet, *L'Aventure*, p. 8.

129. See Giovanni Lista, *Futurisme*, pp. 152–53.

130. See Marjorie Perloff, *The Futurist Moment* (Chicago: University of Chicago Press, 1986).

131. See Janacek, *The Look of Russian Literature*, and Compton, *World Backwards*.

132. Francis Picabia, *La Pomme de Pins* (Saint Raphael: 25 February 1922).

Chapter 4

1. Elmer Petersen, *Tristan Tzara* (Rutgers, NJ: Rutgers University Press, 1971), p. 77.

2. See Michel Sanouillet, *Dada à Paris* (Nice: Centre du XXième Siècle, 1980 reprint of 1965 edition), chapter XXII, "L'Option Surréaliste," pp. 366–90, for one account of this transition.

3. Yves Poupard-Lieussou, *Documents* (Paris), p. 11.

4. François LeGris (Bergmann) is currently working on a study of this work which will no doubt go beyond my own treatment of it in the biographical *Iliazd: Ilia Zdanevich and the Modern Art of the Book.*

5. This dismantling takes place in the work of feminist theorists (such as Carol Duncan, Carol Armstrong, Linda Nochlin, Griselda Pollock, Mary Kelley) and in the work of critical art historians (such as Francis Frascina, Lisa Tickner, Victor Burgin, John Tagg, Nicole Dubreuil Blondin, Tom Crow, and not least of all, Tim Clark).

6. Arguable, poetics itself has remained distinct with a very different genealogy than that of contemporary French or Russian poetry.

7. My point here is that whatever innovation there was in this period is largely restricted to Surrealism, and that in other areas the aesthetic positions formulated between 1900 and 1920 had established the groundwork for most of what is termed modern art until the Second World War.

8. Terry Eagleton, *Literary Theory* (Minneapolis: Minnesota University Press, 1983), p. 44.

9. Cleanth Brooks, *The Well Wrought Urn* (London: Dennis Dobson, 1947), p. 160.

10. The split in Russian Formalism, which is a reflection of very early established differences between the Moscow and St. Petersburg groups, placed Medvedev and Shklovsky on the side of the necessity to see language and poetry and indeed all cultural practices within the political frame and Jakobson, Bogatyrev, etc. on the side of embracing aesthetic issues without feeling compelled to entertain such considerations. See Peter Steiner, *Russian Formalism* (Ithaca, NY: Cornell University Press, 1984).

11. Eagleton, *Literary Theory,* p. 44.

12. Claude Abastado, "The Language of Symbolism," in *The Symbolist Movement,* edited by Anna Balakian (Budapest: Akadémiai Kiadó, 1982), p. 88.

13. Brooks, *Well-Wrought,* p. vii.

14. W. K. Wimsatt, *Literary Criticism* (New York: Knopf, 1957), with Cleanth Brooks and Monroe C. Beardsley, *The Possibility of Criticism* (Detroit: Wayne State University, 1970).

15. Eagleton, *Literary Theory,* p. 44.

16. Ibid., p. 49.

17. Ibid., p. 51.

18. Ibid., p. 49.

19. My original citation was from Yves-Alain Bois, "Modernisme et post-modernisme," p. 187 of *Creation et Culture*. I have lost the full reference for this, but Brian Walles's introduction to *Art After Modernism* (Cambridge, MA: MIT Press, 1984) makes much the same point.

20. Clement Greenberg, "Modernist Painting," in *Modern Art and Modernism*, edited by Francis Frascina and Charles Harrison (New York: Harper and Row, 1982), pp. 5–6.

21. Ibid., p. 6.

22. In another place, Greenberg mentions that the reason why flatness was paramount was that it made illusionistic readings of space impossible, thereby preventing the possibility of a figure's existence.

23. See Francis Frascina, *Pollock and After* (New York: Harper and Row, 1984); and Serge Guilbaut, ed., *Reconstructing Modernism* (Cambridge and London: MIT Press, 1990), for a start.

24. Roger Fry, "An Essay in Aesthetics," in *Vision and Design* (New York: Peter Smith, 1924), p. 16, p. 32.

25. Greenberg, "Modernist Painting," in Frascina, *Modern Art*, p. 10. See also, Greenberg's essay on "Collage" for a formalist reductivism.

26. Meyer Schapiro, in *Modern Art*, p. 185.

27. Ibid., p. 218.

28. Herbert Read, *Philosophy of Modern Art* (New York: Meridian Books, 1954), pp. 250–51.

29. Cited by David Carrier in *Artwriting* (Amherst: University of Massachusetts Press, 1987), p. 58—only the quoted section is Lewis.

30. Read, *Philosophy*, p. 47.

31. Schapiro, *Modern Art*, p. 156.

32. Michael Fried, "Three American Painters," in Frascina, *Modern Art*, p. 115.

33. Schapiro, *Modern Art*, p. 143.

34. This exclusion is marked in the pages of the works of such art historians as Seuphor and others. The landmark essay by Robert Rosenblum, "Picasso and the Typography of Cubism," stood out in conspicuous contrast when it was first published in 1973 (see *Picasso 1881–1973* [London, 1973], Roland Penrose and John Golding, eds.). In the nearly twenty years since, as the modernist paradigm has dissolved, the switch in emphasis and critical bias has made itself apparent in the increased attention to precisely those forms and practices which were anathema to high modernist critics.

35. Alfred Barr, *Bauhaus* (New York: Museum of Modern Art, 1936); Ruari

McClean, *Tschichold* (Boston: David R. Godine Publishers, 1975); Jan Tschichold, *Die Neue Typographie* (1928).

36. Christine Lodder, *Constructivism* (New Haven, CT: Yale University Press, 1983); Khan Magomedov, *Rodchenko* (Cambridge and London: MIT University Press, 1987).

37. Arthur A. Cohen, *Herbert Bayer* (Cambridge and London: MIT University Press, 1984).

38. Mike Mills, in *The abc's of [triangle] [circle] [square]*, edited by Ellen Lupton (New York: Cooper Union, Herb Lubalin Center, 1991), p. 43.

■ Bibliography

Primary Sources: Journals

Action. Dir. Florent Fels and Marcel Sauvage. Paris, no. 1 (February 1920) to no. 12 (March/April 1922).

Aventure. Dir. Roger Vitrac. Paris, no. 1 (November 1921); no. 2 (December 1921); no. 3 (January 1922).

Blind Man. 10 April 1917, Henri-Pierre Roché, Marcel Duchamp, and Beatrice Woods, eds., New York.

Cabaret Voltaire. Dir. Hugo Ball. Zurich, 1916 (reprint: Jean-Michel Place, Paris).

Un Cadavre. Paris, 1924.

Cannibale. Dir. Francis Picabia. Paris, no. 1 (25 April 1920); no. 2 (25 May 1920).

Le Carnet Critique. Dir. Gaston Ribière-Carcy. Paris, 1917–22.

Le Coeur à Barbe. Dir. Tristan Tzara. Paris, no. 1 (April 1922), Au Sans Pareil.

Le Coq. Dir. Jean Cocteau. Paris, no. 1 (May 1920); no. 2 (June 1920); no. 3 (July/August/September 1920); no. 4 (November 1920).

Dada, 1916–22. Dir. by Tristan Tzara. *Cabaret Voltaire,* 1916; *Dada 1 & 2,* 1917; *Dada 3,* 1918; *Dada 4–5, Bulletin Dada; Dadaphone; Dada au Grand Air* (reprint: Jean-Michel Place, Paris, 1981).

Dada Almanach. R. Huelsenbeck, ed. Berlin: Erich Reiss Verlag, 1920.

Der Dada. Berlin, no. 1 (June 1919); no. 2 (December 1919); no. 3 (April 1920).

Le Disque Vert. Dir. Frans Hellens. Paris, Brussels, 1923; (reprint: Éditions Jacques Antoine, Brussels, 1971).

Les Écrits Nouveaux. Dir. Paul Dermée. Publisher, Émile-Paul. January 1918 to December 1922.

The Egoist. Dirs. Dora Marsden, Harriet Weaver, Richard Aldington, H. D. (Hilda Doolittle), T. S. Eliot. London, vol. 1, no. 1 (January 1914) to vol. 6, no. 5 (December 1919).

L'Élan. Dir. Amédée Ozenfant. Paris, no. 1 (April 1915) to no. 10 (December 1916).

L'Esprit Nouveau. Dir. Paul Dermée. Paris, no. 1 (1920) to no. 28 (1928).

Festin d'Ésope. Dir. Guillaume Apollinaire. Paris, no. 1 (November 1903); no. 2 (December 1903).

Les Feuilles Libres. Dir. Marcel Ravel. Paris, no. 1 (November 1919) to no. 48 (May/June 1928).

Le Futurisme. Dir. F. T. Marinetti. Milan, no. 4 (1 October 1922).

Harikari. Berlin, 1920.

Lacerba. Firenze, no. 1 (1912) to no. 24 (December 1913).

Littérature. Dir. Louis Aragon, André Breton, Philippe Soupault. First Series, March 1919 to April 1921; Second Series, Dir. Aragon and Breton, 1922–24.

Maintenant. Paris, no. 1 (April 1912) to no. 5 (March/April 1915).

Manomètre. Dir. E. Malespine. Lyon, no. 1 (July 1922) to no. 9 (January 1928).

Mécano. Dir. Theo van Doesburg. Leiden, no. 1 to no. 4 (1922).

Merz. Dir. K. Schwitters. Hannover, no. 1 (January 1923) to no. 24 (1932); (reprint by Verlag Herbert Lang & Cie., Bern und Frankfurt).

Nord-Sud. Dir. Pierre Reverdy. Paris, no. 1 (March 1917) to no. 16 (October 1918).

Nouvelle Revue Française. Gallimard, Paris.

L'Oeuf Dur. Paris, no. 1 (1921) to no. 16 (Summer 1924).

Paris. Dir. Pierre Albert-Birot. Paris, no. 1 (1924).

Le Pilhaou-Thibaou, supplement to *391.* Dir. by Francis Picabia. Paris (10 June 1921).

Poesia. Milan, no. 1 (February 1909) to no. 2 (March 1909).

La Pomme de Pins. Dir. Francis Picabia. Saint Raphael, 25 February 1922.

Projecteur. Dir. Céline Arnauld. May 21, 1920, Imprimerie Littéraire, Paris

Proverbe. Dir. Paul Eluard. Paris, no. 1 (February 1920) to no. 6 (1 July 1921).

La Révolution Surréaliste. Dirs. Pierre Naville, Benjamin Péret, André Breton. Paris, no. 1 (December 1924) through nos. 9–10 (October 1927); (reprint, Jean-Michel Place, Paris, 1975).

SIC. Dir. Pierre Albert-Birot. Paris, no. 1 (January 1916) to nos. 53–54 (December 1919).

Bibliography

Les Soirées de Paris. Dir. Guillaume Apollinaire. Paris, no. 1 (February 1912) to no. 15 (April 1913).

De Stijl. 1917–21 (reprint, Athenaeum, Amsterdam, 1968).

Surréalisme. Dir. Ivan Goll. Paris, no. 1 (October 1924).

Surréalisme au Service de la Révolution. Dir. André Breton. Paris, no. 1–6 (1930–33) (reprint, Jean-Michel Place, Paris, 1976).

391. Dir. Francis Picabia. Barcelona, nos. 1–4; New York, nos. 5–7; Zurich, no. 8; Paris, nos. 9–19.

Les Trois Roses. Dir. Justin Franz Simon. Grenoble, no. 1 (June 1918) to no. 12 (May 1919).

291. New York, no. 1 (March 1915) to no. 12 (February 1916).

La Vie des Lettres. Neuilly-Paris, no. 20, 1924.

Z. Dir. Paul Dermée. Paris, no. 1 (February 1920); no. 2 (March 1920).

Der Zeltweg. Flake, Serner, Tzara, eds. Zurich, November 1919, Verlag Movement Dada.

Primary Sources in Poetics, Aesthetics, and Art

Apollinaire, Guillaume. *Calligrammes: Poèmes de la paix et de la guerre.* Paris: Mercure de France, 1918.

———. *The Cubist Painters.* New York: Wittenborn, 1944.

———. *Les Peintres Cubistes.* Paris: Collection Savoir, Herman, 1980.

———. *Œuvres Complètes.* Edited by Michel Decaudin and Marcel Adema. Paris: Balland-Lecat, 1965.

———. *Petites Flâneries d'Art.* Edited by Pierre Caizergues. Montpellier: Bibliothèque Artistique et Littéraire, 1980.

———. *Selected Writings.* Edited and translated by Roger Shattuck. New York: New Directions, 1948.

Breton, André. *Point du Jour.* Paris: Gallimard, 1970.

Duchamp, Marcel. *The Writings, Salt-Seller.* Cambridge: Oxford University Press, 1973.

Hughnet, Georges. *L'Aventure Dada.* Paris: Galerie de l'Institut, 1957.

Kandinsky, Wassily. *Point to Line to Plane.* New York: Dover, 1979; reprint of 1944 edition.

Lista, Giovanni. *Marinetti.* Paris: Seghers, 1976.

Livshits, Benedikt. *The One and a Half Eyed Archer,* translated by John Bowlt. Newtonville, Oriental Research Partners, 1977.

Mallarmé, Stéphane. *Écrits sur le livre.* Edited by Henri Meschonnic. Paris: Collections Philosophie Imaginaire, Éditions de l'éclat, 1985.

———. *Œuvres Complètes*. Paris: Bibliothèque de la Pleiade, Gallimard, 1948.

Marinetti, F. T. *Enquête Internationale sur le Vers Libre et Manifeste du Futurisme*. Milan: Poesia, 1909.

———. *Marfaka le Futurista*. Paris: Christian Bourgeois, Ed., 1984.

———. *Les Mots en Liberté Futuristes*. Milan: Edizioni Futuriste de Poesia, 1919.

———. *Selected Writings*. Edited by R. W. Flint. New York: Farrar Straus & Giroux, 1971.

———. *Zang Tumb Tuuum*. Milan: Edizioni Futuriste de Poesia, 1914.

Massot, Pierre de. *De Mallarmé à 391*. St. Raphael: Au Bel Exemplaire, 1922.

Mondrian, Piet. *Le Neo-Plasticism*. Paris: Éditions de l'effort Moderne, 1920.

Paulhan, Jean. *Jacob Cow, Le Pirate, ou, Si Les Mots Sont Des Signes*. Paris: Au Sans Pareil, 1921.

———. *Œuvres Complètes*. Paris: Cercle du Livre Précieux, 1966.

Picabia, Francis. *Exposition Dada*. Paris: Au Sans Pareil, 16–30 Paril 1920.

———. *Pensées sans langage*. Paris: E. Figuière, 1919.

Pound, Ezra. *Instigations*. Freeport, NY: Books for Libraries Press, 1920.

Ribemont-Dessaignes, Georges. *Déjà-Jadis*. Paris: Julliard, 1958.

Tzara, Tristan. Mss. correspondence with Pierre Albert-Birot, 23 August 1917 to December 1919, Bibliothèque Littéraire, Jacques Doucet.

———. *De Nos Oiseaux*. Paris: Éditions Kra, 1929.

———. *Œuvres Complètes*, Tome I, *1912–1924*, edited by Henri Behar. Paris: Flammarion,1975.

———. *Seven Dada Manifestos and Lampisteries*, translated by Barbara Wright. London: John Calder, 1977.

Secondary Sources in Literature and Visual Arts

Abastado, Claude. "Écriture automatique et instance du sujet." *Revue des Sciences Humaines*, Tome LVI, no. 184 (October–December 1981), pp. 75–106.

———. *Introduction au Surréalisme*. Montreal: Bordas, 1971.

Adema, Marcel. *Guillaume Apollinaire*. Paris: La Table Ronde, 1968.

Ades, Dawn. *Dada and Surrealism Reviewed*. London: Arts Council of Great Britain, 1978.

Alquie, Ferdinand. *Philosophie du Surréalisme*. Paris: Flammarion, 1977.

Andersen, Troels, ed. *Art et Poésie Russes 1900–1930*. Paris: Centre Georges Pompidou, 1979.

Apollinaire: Les Actes de la Journée Apollinaire Université de Berne 1981 (Fribourg: Éditions Universitaires, 1983): especially, Daniel Grojnowski, " 'Et moi aussi je suis peintre' 'Ondes' dans *Calligrammes*," pp. 43–58; and Pasquale A. Jannini, "Tavole parolibere *Calligrammes*: Apollinaire et Cangiullo," pp. 83–96.

Austin, Lloyd. *Poetic Principles and Practice.* New York and Cambridge: Cambridge University Press, 1987.

Bagwell, Timothy. *American Formalism.* Houston: Rice University Press, 1986.

Bailly, Jean-Christophe. *Au-delà du Langage.* Paris: Terrain Vague, 1971.

Bakhtin, Mikhail, and Pavel Medvedev. *The Formal Method in Literary Scholarship.* Cambridge, MA: Harvard University Press, 1985; first English edition, Johns Hopkins University Press, 1978; originally published 1928.

Balakian, Anna. *Surrealism: Road to the Absolute.* London: George Allen and Unwin, 1970.

———. *The Symbolist Movement.* Budapest: Akadémiai Kindó, 1982.

Barron, Stephanie, and Maurice Tuchman. *The Avant-Garde in Russia, 1910–1930.* Los Angeles and Cambridge: Los Angeles County Museum of Art and MIT Press, 1980.

Bates, Scott. *Guillaume Apollinaire.* Boston: Twayne Publishers, 1989.

Bayer, Herbert, with Ise and Walter Gropius and Alfred Barr. *Bauhaus, 1919–1928.* New York: Museum of Modern Art and Arno Press, 1938.

Behar, Henri, and Michel Carassou. *Dada: Histoire d'une Subversion.* Paris: Fayard, 1980.

Bergounioux, G. "La science du langage en France de 1870 à 1885, du marché civil au marché étatique." *Langue Française* 64 (September 1984): 7–41.

Berry, David. *The Creative Vision of Guillaume Apollinaire.* Saratoga, CA: Anma Libri, 1982.

Bigongiari, P. *L'opera complète di Carra, 1910–1930.* Milan: Rizzoli Editione, 1970.

Bishop, Michael. "Pierre Reverdy's Conception of the Image." *Forum for Modern Language Studies* 12, no. 1 (January 1976): 25–36.

Bonnefoy, Claude. *Apollinaire.* Paris: Éditions Universitaires, 1969.

Bonnet, Marguerite. *André Breton.* Paris: Librarie José Corti, 1975.

Bordat, Denis, with Bernard Veck. *Apollinaire.* Paris: Hachette, 1983.

Bradbury, Malcolm, and James McFarlane. *The Names and Nature of Modernism.* New York: Penguin, 1976.

Brooks, Cleanth. *Modern Poetry and Tradition.* Chapel Hill: University of North Carolina Press, 1939.

———. *The Well-Wrought Urn.* London: Dennis Dobson, 1947.

Burgin, Victor. *The End of Art Theory.* Atlantic Highlands, NJ: Humanities Press International, 1986.

Cahiers Dada et Surréalisme, no. 3 (1969), Association Internationale Pour L'Étude de Dada et du Surréalisme.

Calinescu, M. *Five Faces of Modernity.* Durham: Duke University Press, 1987.

Calvesi, Maurizio, and Luce Marinetti. *Filippo Tomasso Marinetti.* Florence: Tellini, 1988.

Campbell, James. "Littleness in Literature." *Times Literary Supplement* (12–18 October 1990): 1098.

Canfield, William. *Francis Picabia.* Princeton, NJ: Princeton University Press, 1979.

Carmean, E. A. *The Great Decade of American Abstraction.* Houston: Museum of Fine Arts, 1974. Contains Michael Fried's "Art and Objecthood."

Caws, MaryAnn. *About French Poetry from Dada to TelQuel.* Detroit: Wayne State University Press, 1974.

—————. *The Poetry of Dada and Surrealism.* Princeton, NJ: Princeton University Press, 1970.

Caziergues, Pierre. *Apollinaire: Journaliste.* Paris: Minard, 1981.

Chiari, J. *Symbolism from Poe to Mallarmé: The Growth of a Myth.* New York: Gordian Press, 1970.

Clough, Rosa Trillo. *Looking Back at Futurism.* New York: Cocce Press, 1942.

Cohen, Arthur A. *Herbert Bayer.* Cambridge and London: MIT Press, 1984.

Cohn, Robert Greer. *Mallarmé's Prose Poems.* New York and Cambridge: Cambridge University Press, 1987.

Compton, Susan. *Worldbackwards: Russian Futurist Books, 1912–1916.* London: British Museum Publications, 1978.

Courrier du Centre Internationale d'Études Poétiques, no. 47 (1963), Maison Internationale de la Poésie, Chaussée de Haecht, Brussels.

Culler, Jonathan. *Saussure.* Middlesex: Penguin, 1976.

Decaudin, Michel, and Pierre Marcel Adema. *Album Apollinaire.* Paris: Gallimard, 1971.

Decaudin, Michel. *Apollinaire: Inventeur des Langages.* Paris: Actes du Colloque de Stavelot, Lettres Modernes, Minard, 1973.

—————, ed. *Apollinaire en son temps.* Actes du quatorzième colloque de Stavelot 31 Aout–3 September 1988. Paris: Publications de la Sorbonne Nouvelle, Spadem, 1990.

—————. *La Crises des Valeurs Symboliste, 1895–1914.* Toulouse: Privat, 1960.

Depero, Fortunato. *Depero Futurista.* Firenze: Edizione Italiana Dinamo Azavi, Libreria Salimbeni, 1927.

Derrida, Jacques. *Speech and Phenomenon*. Evanston, IL: Northwestern University Press, 1973.

———. *Of Grammatology.* Baltimore and London: Johns Hopkins University Press, 1974.

Dews, Peter. *The Logics of Disintegration*. London and New York: Verso, 1987.

Doubrovsky, Serge. *The New Criticism in France*. Chicago: University of Chicago Press, 1973; originally published in French in 1966.

Douglas, Charlotte, ed. *Velimir Khlebnikov: Collected Works,* translated by Paul Schmidt. Cambridge: Harvard University Press, 1987.

Dubon, Claude. *Guillaume Apollinaire après Alcools*. Paris: Minard, 1987.

Eagleton, Terry. *Literary Theory: An Introduction*. Minneapolis: University of Minnesota Press, 1983.

Eco, Umberto. *A Theory of Semiotics*. Bloomington: Indiana University Press, 1976.

Erlich, Victor. *Russian Formalism: History and Doctrine*. New Haven, CT: Yale University Press, 1981.

Falqui, Enrico. *Bibligraphica e Iconografia del Futurismo*. Firenze: Sansoni Antiquaraiato, 1959.

Faulkner, Peter. *A Modernist Reader*. London: Batsford Ltd., 1986.

Florence, Penny. *Mallarmé, Manet and Redon*. Cambridge: Cambridge University Press, 1986.

Forrester, John. *Language and the Origins of Psychoanalysis*. New York: Columbia University Press, 1980.

Fraenkel, Ernest. *Les Dessins transconscients de Stéphane Mallarmé: A propos de la typographie de "Un Coup de Dés."* Paris: Librairie Nizet, 1960.

Frascina, Francis. *Pollock and After*. New York: Harper and Row, 1985.

Freeman, Judi, with John Welchman. *The Dada & Surrealist Word-Image*. Cambridge and London: MIT Press, 1989.

Fry, Edmund. *Cubism*. New York and Toronto: McGraw-Hill Book Co., 1968.

Fry, Roger. *Vision and Design*. New York: Peter Smith, 1924.

Le Futurisme 1909–1916. Paris: Musée Nationale d'Art Moderne, 19 September–19 November 1973.

Gaffe, René. *Peinture à travers Dada et le Surréalisme*. Brussels: Édition des Artistes, 1952.

Gibson, George, and H. W. Tjalsma. *Russian Modernism*. Ithaca, NY: Cornell University Press, 1971.

Gillian, Garth. *From Sign to Symbol*. Atlantic Highlands, NJ, and Sussex: Humanities Press and Harvester Press, 1982.

Godel, Robert. *Les Sources Manuscrits du Cours de Linguistique Générale de Ferdinand de Saussure.* Geneva: Librairie Droz, 1969.

Grosz, Georg, John Heartfield, and Wieland Herzfelde. *Art Is in Danger.* Willimantic, CT: Curbstone Press, 1987.

Hanson, Anne Coffin. *The Futurist Imagination.* New Haven, CT: Yale University Art Gallery, 13 April–26 June 1983.

Hawkes, Terence. *Structuralism and Semiotics.* Berkeley and Los Angeles: University of California Press, 1977.

Hedges, Inez. *Languages of Revolt.* Durham, NC: Duke University Press, 1983.

Higgins, Dick. *Pattern Poetry: Guide to an Unknown Literature.* Albany: State University of New York Press, 1987.

Hjelmslev, Louis. *Prolegomena to a Theory of Language.* Madison: University of Wisconsin Press, 1963.

Holdercraft, David. *Signs, System and Arbitrariness.* Cambridge: Cambridge University Press, 1981.

Houston, John Porter. *Patterns of Thought in Rimbaud and Mallarmé.* Lexington, KY: French Forum Publishers, 1986.

Husserl, Edmund. *Phenomenology and the Crisis of Philosophy.* New York: Harper & Row, 1965.

————. *The Origin of Geometry.* Translated by John P. Leavey, Jr., and with an introduction by Jacques Derrida. Lincoln, NE: University of Nebraska Press, 1989.

Jakobson, Roman. *Questions de Poétique.* Paris: Aux Éditions du Seuil, 1973.

————. "Responses." Interview with Tzvetan Todorov. *Poétique* 57 (February 1984): 3–25.

————. *Language in Literature.* Edited by Krystyna Pomorska and S. Rudy. Cambridge, MA: Belknap, Harvard University Press, 1987.

Jameson, Fredric. *The Prison-House of Language.* Princeton, NJ: Princeton University Press, 1972.

Janacek, Gerald. *The Look of Russian Literature.* Princeton, NJ: Princeton University Press, 1984.

Janover, Louis. *La Révolution Surréaliste.* Paris: Plon, 1990.

Jones, Gilbert J. *Apollinaire: La Poésie de la Guerre.* Paris and Geneva: Editions Slatkin, 1990.

Jouffroy, Jean-Pierre, and Edouard Ruiz. *Picasso: De l'image à la lettre.* Paris: Temps Actuels, 1981.

Koerner, E. F. K. *Ferdinand de Saussure, Origin and Development of His Linguistic Thought in Western Studies of Language.* Vieweg, Schriften zur Linguistik, 1973.

Kristeva, Julia. *Kristeva Reader.* Edited by Toril Moi. New York: Columbia University Press, 1986.

La Charité, Virginia. *The Dynamics of Space.* Lexington, KY: The French Forum, 1987.

Lacote, René, and Georges Haldas. *Tristan Tzara.* Paris: Pierre Seghers, 1952.

Langages 17 (March 1970). (Paris: Didier Larousse) special issue on "L'Énonciation."

Langan, Janine D. *Hegel and Mallarmé.* Lanham, New York, London: University Press of America, 1986.

Lanne, J.-C. *Velimir Khlebnikov.* Paris: Institut d'Études Slaves, 1983.

Latal, Jiri. "Mots et Parole chez Tristan Tzara." *Acta Universalis Palackianae Olomucensis, Philologica.* No. 43, 1979.

Lawton, Anna, and Herbert Eagle, eds. *Russian Futurism through Its Manifestos.* Ithaca, NY: Cornell University Press, 1988.

Legris-Bergmann, Françoise. *Iliazd: Maître d'Œuvre du Livre Moderne.* Montreal: Université de Montreal, 1984.

Lehrman, Graziella. *De Marinetti à Maiakovski. Destins d'un mouvement littéraire occidental en Russie.* Fribourg: Université de Fribourg, 1942.

Leighten, Patricia. *Re-Ordering the Universe.* Princeton, NJ: Princeton University Press, 1989.

Leitch, Vincent. *Deconstructive Criticism.* New York: Columbia University Press, 1981.

Lemaître, George. *From Cubism to Surrealism in French Literature.* Cambridge, MA: Harvard University Press, 1945.

Lemon, Lee T., and Marion Reis. *Russian Formalist Criticism.* Lincoln, NB: University of Nebraska Press, 1965.

Le Sage, Laurence. *The Rhumb Line of Symbolism.* University Park, PA: Penn State University Press, 1978.

Levenson, Michael. *A Genealogy of Modernism.* Cambridge: Cambridge University Press, 1984.

Levin, Harry. *Refractions.* Oxford: Oxford University Press, 1966.

Lewis, Paula Gilbert. *The Aesthetics of Stéphane Mallarmé in Relation to His Public.* Cranbury, NJ: Fairleigh Dickinson University Press, 1976.

Leymarie, Jean. *Iliazd.* Paris: Musée de l'Art Moderne, 1976.

Lista, Giovanni. *Futurisme.* Lausanne: L'Age d'Homme, 1973.

Lodder, Christine. *Russian Constructivism.* New Haven, CT: Yale University Press, 1983.

Lodge, David. "Modernism, Anti-Modernism and PostModernism." In *Working with Structuralism.* London: Routledge and Kegan Paul, 1981.

Lupton, Ellen, ed. *The abc's of [triangle] [circle] [square].* New York: Herb Lubalin Center, Cooper Union, 1991.

Magovedov, Khan. *Rodchenko.* Cambridge and London: MIT Press, 1985.

Marin, Louis. *Détruire la peinture.* Paris: Éditions Galilee, 1977.

Markov, Vladimir. *Russian Futurism.* Berkeley: University of California Press, 1968.

Martinet, Jeanne. *Clefs pour la sémiologie.* Paris: Seghers, 1973.

Massot, Pierre de. *De Mallarmé à 391.* St. Raphael: Au Bel Exemplaire, 1922.

Matejka, Ladislav, and Irwin R. Titunik, eds. *Semiotics of Art.* Cambridge and London: MIT Press, 1976.

Mathews, Timothy. *Reading Apollinaire.* Manchester: Manchester University Press, 1987.

McClean, Ruari. *Jan Tschichold.* Boston: David R. Godine, Pub., 1975.

Meshonnic, H. *Stéphane Mallarmé: Écrits sur le livre.* Paris: Éditions de l'Éclat, 1985.

Milman, Estera, ed. *The Text and the Myth of the Avant-Garde,* special issue of *Visible Language* 21 (Summer/Autumn 1987).

Motherwell, Robert. *Dada Poets and Painters: An Anthology.* New York: Wittenborn Schulz, 1951.

Ortega y Gasset, José. *The Dehumanization of Art.* Princeton, NJ: Princeton University Press, 1968.

Oster, Daniel. *Guillaume Apollinaire.* Paris: Seghers, 1975.

Pedersen, Holger. *The Discovery of Language: Linguistic Science in the 19th Century.* Translated by John Spargo. Bloomington: Indiana University Press, 1959.

———. *A Glance at the History of Linguistics with Particular Regard to the Historical Study of Phonology.* Amsterdam and Philadelphia: John Benjamins Publishing Co., 1983.

Perloff, Marjorie. *The Futurist Moment.* Chicago: University of Chicago Press, 1986.

Peterson, Elmer. *Tristan Tzara, Dada and Surrational Theorist.* New Brunswick, NJ: Rutgers University Press, 1970.

Peyre, Henri. *What Is Symbolisme?* Tuscaloosa, AL: University of Alabama Press, 1980.

Pia, Pascal. *Apollinaire.* Paris: Éditions du Seuil, 1954.

Plantier, René. "L'Écriture et la voix." *Europe,* nos. 517–18 (May–June 1972), Éditions Rieder, Paris.

Porter, Laurence. *The Crisis of French Symbolism.* Ithaca, NY: Cornell University Press, 1990.

Poupard-Lieussou, Yves, and Michel Sanouillet. *Documents Dada*. Geneva: Weber, 1974.

Presence de Saussure. Actes du Colloque International de Genève, 21–23 March 1988. Geneva: Droz, 1990. Especially, Raffaele Simone's "The Body of Language," pp. 121–41.

Raymond, Marcel. *De Baudelaire à Surréalisme*. Paris: José Corti, 1940.

Read, Herbert. *The Philosophy of Modern Art*. New York: Meridian Books, 1954.

Renaud, Philippe. *Lecture D'Apollinaire*. Lausanne: L'Age d'Homme, 1969.

Revue de l'Association pour l'Étude du Mouvement Dada, no. 1 (1965), Paris.

Rey-Debove, Josette. *Lexique Semiotique*. Paris: Presses Universitaires, 1973.

Ribemont-Dessaignes, Georges. *Déjà-Jadis*. Paris: Julliard, 1958.

Richards, I. A., C. K. Ogden, and James Wood. *The Foundations of Aesthetics*. New York: Lear Publishers, 1925.

Richter, Hans. *DADA: Art and Anti-Art*. Oxford: Oxford University Press, 1965.

Riding, Laura, and Robert Graves. *A Survey of Modernist Poetry*. London: William Heinemann Ltd., 1927.

Robins, R. H., *A Short History of Linguistics*. London: Longman's Green & Co., Ltd., 1967.

Robinson, Alan. *From Symbol to Vortex*. New York: St. Martin's Press, 1985.

Romantisme, nos. 25–26 (1979); Special Issue: "Conscience de la langue." Issue includes Hans Aarsleff, "Taine: Son importance pour Saussure et le Structuralisme"; André Chervel, "Le Débat sur l'Arbitraire du signe au XIX siècle"; Claude Abastado, "Doctrine Symboliste du langage poétique."

Rosenberg, Leonce. *Cubisme et Tradition*. Paris: Éditions de l'Effort Moderne, 1920.

Saussure, Ferdinand de. *Cours de Linguistique Générale*. Edited by Charles Bally and Albert Sechehaye. Paris: Payot, 1949.

Saussure, Ferdinand de. *Course in General Linguistics*. Translated by Wade Baskin. New York: Philosophical Library, 1959.

Schapiro, Meyer. *Modern Painting*. New York: Braziller, 1978.

Schnapp, Jeffrey. "Politics and Poetics in Marinetti's *Zang Tumb Tuuum*." *Stanford Italian Review* 5, no. 1 (Spring 1985): 75–92.

Schwartz, Sanford. *The Matrix of Modernism*. Princeton, NJ: Princeton University Press, 1985.

Seaman, David. *Concrete Poetry in France*. Ann Arbor: UMI Research Press, 1981.

Sebeok, Thomas. *The Tell-tale Sign*. Lisse, Netherlands: Peter de Ridder Press, 1975.

Seuphor, Michel. *Abstract Painting*. New York: Abrams, 1964.

Sheppard, Richard. *New Studies in Dada*. Driffield, England: Hutton Press, 1981.

Shklovsky, Viktor. *Mayakovsky and His Circle*, translated by Lily Feiler. London: Pluto Press, 1972.

————. *Sur la Théorie de la Prose*. Paris: Éditions L'Age de l'Homme, 1973.

Starobinski, Jean. *Words upon Words*, translated by Olivia Emmet. New Haven, CT: Yale University Press, 1979.

Steiner, Peter. *Russian Formalism: A Metapoetics*. Ithaca, NY: Cornell University Press, 1984.

Steiner, Wendy. *The Colors of Rhetoric*. Chicago: University of Chicago Press, 1982.

Sullerot, François. "Des Mots sur le Marché." *Cahiers Dada/Surréalisme*, no. 3: 63–69.

Tisson-Braun, Micheline. *Dada et le Surréalisme*. Brussels, Paris and Montreal: Bibliothèque Bordas, 1973.

Todorov, Tzvetan. *Theories of the Symbol*. Ithaca, NY: Cornell University Press, 1982.

Vallier, Dora. "L'avant-garde russe et le livre éclaté." *Revue de l'art* 44 (Paris, 1979).

Verkauf, Willy, and Arthur Niggli. *Dada, Monograph of a Movement*. London: Academy Editions; New York: St. Martin's Press, 1957 reprint.

Watts, Harriet. *Chance: A Perspective on Dada*. Ann Arbor: UMI Research Press, 1975.

Weinberg, Bernard. *The Limits of Symbolism*. Chicago: University of Chicago Press, 1966; Midway Reprint 1973.

Whitfield, Agnes. "Review Article: L'Énonciation, Théories et Applications Récentes." *Recherches Sémiotiques* 4 (1984).

Williams, Raymond. *The Politics of Modernism*. London and New York: Verso, 1989.

Young, Alan. *Dada and After*. Manchester: Manchester University Press, 1981.

Sources in Typography, Graphology, and Linguistics

Ballet, Gilbert. *Le Langage Intérieur*. Paris: Felix Alcan, 1886.

————. *Le Langage Intérieur et les Diverses Formes de l'Aphasie*. Paris: Ancienne Librairie Germer Baillière, 1888.

Barbe, Paul. *Telle Écriture, Telle Caractère*. Paris: Jules Rouff et Cie, 1904.

Barrière, L. *Le Livret du Typographie et de l'Imprimeur*. Paris: Librairie de l'Enseignement Technique, 1923.

Bary, Louis de. *Rapport sur L'Exposition Universelle Internationale de Bruxelles*. Paris, 1910.

Beaumont, S. *Découpage en Typographie, Ses Applications Pratiques*. Paris, 1893.

Bulletin officiel des cours professionels, organe trimestiel de propagande technique. Paris: Chambre syndicale typographique parisienne, 1904–56.

Cazaux, Jean. *Surréalisme et la Psychologie, Endophasie et Écriture Automatique*. Paris: José Corti, 1938.

Chatel, Edmond du. *Enquête sur des cas de psychometrie*. Paris: Leymarie, 1910.

Cinquième Congrès des Matières Imprimeurs en France. Exposition Retrospective de l'Art Typographique. Limoges: Imprimerie Henri-Charles la Vauzelle, 1898.

Claye, J. *Manuel de l'Apprenti Compositeur*. Paris: A. Quantin, 1883.

Combe, J. *Notions de la Typographie*. Paris: Berger Lerault, 1915.

Delalain, Paul. "Rapport du Comité d'Installation." Musée Retrospectif de la Classe II, Typographie, Exposition Internationale de 1900 à Paris.

Delanne, Gabriel. *Le Phénomène Spirite*. Paris: Chaumeul, 1893.

———. *Recherches sur la Mediumité*. Paris: Librairie des Sciences Psychiques, 1902.

Depoin, J. *Les Écritures à la Mode et L'Evolution de l'Écriture en France*. Conférences faites à la Sorbonne en 1916–17. Paris: Publications de la Societé de la Graphologie, 1920.

Derny, J. *Elements de la Typographie*. Paris: Maison de la Bonne Presse, 1930.

Desormes, E. *Notions de la Typographie*. Paris: L'École Professionelle, 1888.

Duville, D. *L'Art du Trace Rationnel de la Lettre*. Paris: Societé Française d'Éditions Littéraires et Techniques, 1931.

Durville, Henri. *Notre Destinée*. Paris: Collection Psychique, 1921.

Flournoy, Th. *Des Indes à la Planète Mars*. Paris: Alcan, 1900.

———. *Esprits et Médiums*. Paris: Conférence faite à L'Institut Générale Psychologique, 1909.

Fontenay, Guillaume de. *La Photographie et l'étude des phénomènes psychiques*. Paris: Gauthier Villars, 1912.

Fournier, H. *Traité de la Typographie*. Paris: Librairie Garnier Frères, 1925.

Frey, A. *Nouveau manuel complèt de la typographie*. Paris: 1857.

Fursac, Rogues de. *Les Écrits et les Dessins dans les Maladies Nerveuses et Mentales*. Paris: Maron et Cie, 1905.

Gray, Nicolette. *Nineteenth Century Ornamental Typefaces*. London: Faber and Faber, Ltd., 1977.

Greffein, D. *Les Règles de la Composition Typographique*. Ministère de l'Education Nationale, Publications Officielles.

Guernier, Louis. *Conseils Pratiques sur la Composition*. Paris: Typographie de l'École Estienne, 1903.

Gyle, E. *L'Être Subconscient*. Paris: Felix Alcan, 1899.

Hrdlicka, Ales. "Art and Literature in the Mentally Abnormal." *American Journal of Insanity* 40, no. 3 (January 1899).

Jacoby, H. J. *Analysis of Handwriting*. London: George Allen and Unwin, Ltd., 1939.

Janet, P. "Un Cas de Possession et l'Exorcisme Moderne." *Bulletin de l'université de Lyon*, 23 December 1894.

———. *Le Subconscient*. Paris: Felix Alcan, 1910.

Jaubert, Jean. *Procédés de Typographie*. Marseilles: Imprimerie de la Societé du Petit Marseilles, 1927.

Jespersen, Otto. *Fonetik*. Kobenhaven: Set Schubotheske Forlag, 1897–99.

Joire, Paul. *Traité de Graphologie Scientifique*. Paris: Vigot Frères, 1906.

Journal des Imprimeurs. Organe Independent de l'Imprimerie et des Industries Diverses, nos. 6–24 (March 1895 to October 1896).

Latrobe, Charles. *Typographie, Petit Manuel d'Imposition*. Perpignan: Printed at Imprimerie de Charles Latrobe.

Maser, Julius. *Typografiche Jahrbucher*. Leipzig: 1880 and 1881.

Mazure, A. *La Pratique des Impositions*. Paris: Cours Professionel de la Chambre Syndicale Typographique Parisienne.

McMurtie, Douglas. *Advertising Typography*. National Printer Journalist, 1932.

Michon, Jean Hippolyte. *Méthode Pratique de la Graphologie*. Paris: Ghio, 1885.

Morin, Ed. *Documents Typographiques, L'Art de l'Imprimerie*. Thorigny sur Marne: Didot le Jeune, 1913.

———. *Petit Cours de Typographie*. Paris: Edmond Morin, 1929.

Morison, Stanley. *Les Plus Belles Pages de la Typographie Moderne depuis le Début du Vingtième Siècle*. London: Ernest Benn, Ltd., 1925.

Motteroz. "Essai sur la Mise en Train Typographique." *Journal de L'Imprimerie*. Paris: Librairies, Imprimeries, Réunis, 1891.

Normand, Y. *Jeu des Langues Vivants, Lecture et Écriture en caractères ordinaires apprises instantanement ou Alphabet Phonetique Universel en seul tableau à multiples applications pratiques*. Paris: Librairie Audot, 1907.

d'Ossau, J. *Le Spiritualisme Experimental et le Procédé Typologique*. Paris: Éditions de la Bibliothèque Spiritualiste Moderne, 1925.

Bibliography

Passy, Paul. *Petite Phonetique Comparée.* Leipzig: G. Teubner, 1922.

Pichot, Henri. *Exposition de Liège, Rapport de la Classe II.* Publications Comité Français des Expositions à l'Étranger, 1906.

Pingrenon, R. *Les Styles en Impressions Typographique.* Paris: La Fonderie Typographique, 1903.

La Publicité (no. 1), 15 Aout 1903; and following to Janvier 1913 (Paris: P. Raveau et Cie, Editeurs).

Publicité en France, Guide Pratique. Paris: Imprimerie Centrale des Chemins de Fer, 1879.

Publicité Moderne (no. 1), Janvier 1908 to Octobre/Novembre 1908 (Paris).

Richet, Charles. *Traité de Metaphysique.* Paris: Felix Alcan, 1930.

Rosset, Théodore. *Recherches Experimentales pour L'Inscription de la Voix Parlée.* Paris: Armand Colin, 1911.

St. Denis, Hervey de. *Les Rêves et les Moyens de les Diriger.* Paris, 1867.

St. Paul, G. *Le Langage Intérieur et les Paraphasies.* Paris: Felix Alcan, 1904.

Spencer, Herbert. *Modern Typography.* London: Lund Humphries, 1969.

Stricker, S. *Du Langage et de la Musique.* Paris: Ancienne Librairie Germer Baillière et Cie, 1885.

Thibaudeau, F. *Manuel Français de la Typographie Moderne.* Paris: Bureau de l'Édition, 1927.

Thireau, M. *Typographie Moderne.* Paris: Au Bureau de l'Édition, 1925.

———. *L'Art Moderne et la Graphie.* Paris: Au Bureau de l'Édition, 1930.

Toureaux, L. *Typographie, Grammaire de la Composition.* Paris: Champion Librairie, 1884.

Troubetzkoy, N. S. *Principes de Phonologie.* Paris: Klincksieck, 1949.

Truyts, V. *Notions Elementaires à l'usage des Compositeurs et Compositrices Typographes.* La Roche sur Yon: Imprimerie Centrale de l'Ouest, 1922.

■ Index

Page references to illustrations are set in **boldface** type.